Early Medieval Archi

D0846572

Oxford History of Art

Roger Stalley is Professor of the History of Art at Trinity College, Dublin. His previous books include *Architecture and Sculpture in Ireland 1150–1350* (1971), *The Cistercian Monasteries of Ireland* (1987), *Irish High Crosses* (1991), and *Ireland and Europe in the Middle Ages* (1993). He has published over 50 articles on various aspects of medieval sculpture and architecture. He is a member of the Royal Irish Academy and an Honorary Member of the Royal Institute of Architects of Ireland.

Oxford History of Art

Titles in the Oxford History of Art series are up-to-date, fully-illustrated introductions to a wide variety of subjects written by leading experts in their field. They will appear regularly, building into an interlocking and comprehensive series. In the list below, published titles appear in bold.

Oxford History of Art

Early Medieval Architecture

Roger Stalley

OXFORD
UNIVERSITY PRESS

Oxford University Press, Walton Street, Oxford OX26DP

Oxford New York

Athens Auckland Bangkok Bombay
Calcutta Cape Town Dar es Salaam Delhi
Florence Hong Kong Istanbul Karachi
Kuala Lumpur Madras Madrid Melbourne
Mexico City Nairobi Paris Singapore
Taipei Tokyo Toronto
and associated companies in Berlin Ibadan

Oxford is a trade mark of Oxford University Press

© Roger Stalley 1999

First published 1999 by Oxford University Press

All rights reserved. No part of this publication may be reproduced, stored in a retrieval system, or trans-
mitted, in any form or by any means, without the proper permission in writing of Oxford University
Press. Within the UK, exceptions are allowed in respect of any fair dealing for the purpose of research or
private study, or criticism or review, as permitted under the Copyright, Design and Patents Act, 1988,
or in the case of reprographic reproduction in accordance with the terms of the licences issued by the
Copyright Licensing Agency. Enquiries concerning reproduction outside these terms and in other coun-
tries should be sent to the Rights Department, Oxford University Press, at the address above.

This book is sold subject to the condition that it shall not, by way of trade or otherwise, be lent, re-sold,
hired out or otherwise circulated without the publisher's prior concent in any form of binding or cover
other than that in which it is published and without a similar condition including this condition being
imposed on the subsequent purchaser

British Library Cataloguing in Publication Data
Data available

Library of Congress Cataloguing in Publication Data
Data available

0–19–284223–4 (pbk)
0-19-210048-3 (hbk)

10 9 8 7 6 5 4 3 2

Picture research by Elisabeth Agate
Designed by Esterson Lackersteen
Typeset by Paul Manning

Printed in Hong Kong on acid-free paper
by C&C Offset Printing Co., Ltd

Contents

Acknowledgements

Over the years many friends and colleagues have given me pieces of information or offered ideas which have contributed to the writing of this book. I should mention Peter Kidson, who first introduced me to the subject 30 years ago. I am particularly grateful to Lawrence Hoey of the University of Wisconsin-Milwaukee for reading the entire text through in draft, an exercise which saved me from numerous errors. In different ways I have been helped by Britta Kalkreuter, Eric Fernie, and Malcolm Thurlby. I should also like to acknowledge the encouragement and help received from colleagues in Trinity College, Dublin, notably Edward McParland, Terence Barry, Kathleen Coleman, Rachel Moss, Aisling O'Donoghue, Leo Dungan, and Brendan Dempsey. The Benefactions Fund of the Faculty of Arts and BESS in Trinity College provided a number of travel grants, which allowed me to visit far more buildings than would otherwise have been the case. I am especially grateful to Lisa Agate for her energetic work in tracking down suitable illustrations, and I should also like to thank Polly Buston and Paul Manning for their care in editing and designing the book. Finally I must acknowledge a debt to Simon Mason, editor of the Oxford History of Art, without whose enthusiastic support the text would not have been written.

Roger Stalley

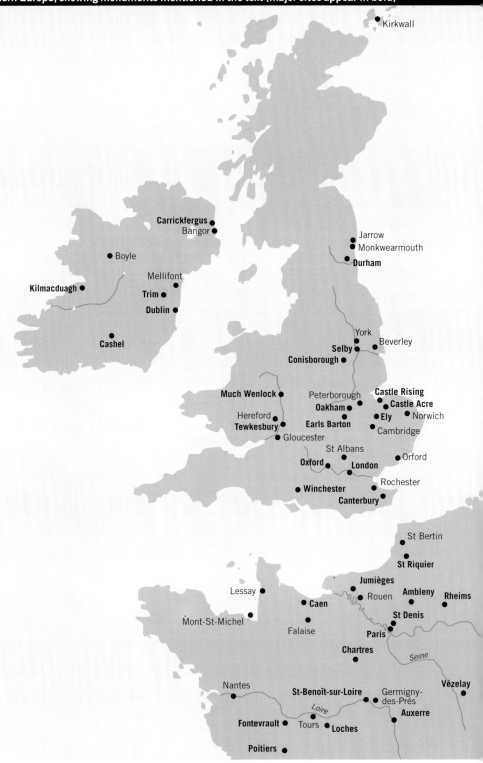

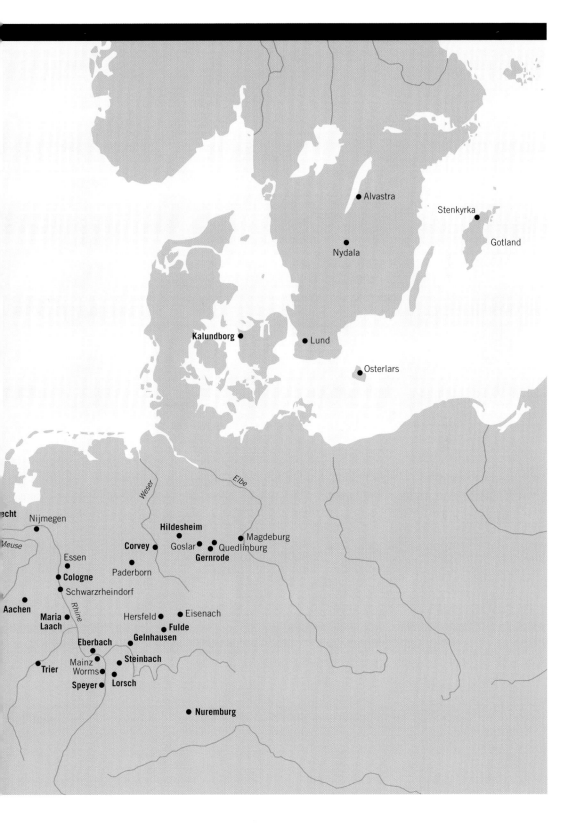

Alvastra

Stenkyrka

Gotland

Nydala

Kalundborg

Lund

Osterlars

Weser

Elbe

echt

Nijmegen

Meuse

Hildesheim

Magdeburg

Corvey

Goslar

Quedlinburg

Gernrode

Essen

Paderborn

Cologne

Schwarzrheindorf

Aachen

Maria
Laach

Hersfeld

Eisenach

Rhine

Fulde

Eberbach

Gelnhausen

Mainz

Steinbach

Trier

Worms

Speyer

Lorsch

Nuremburg

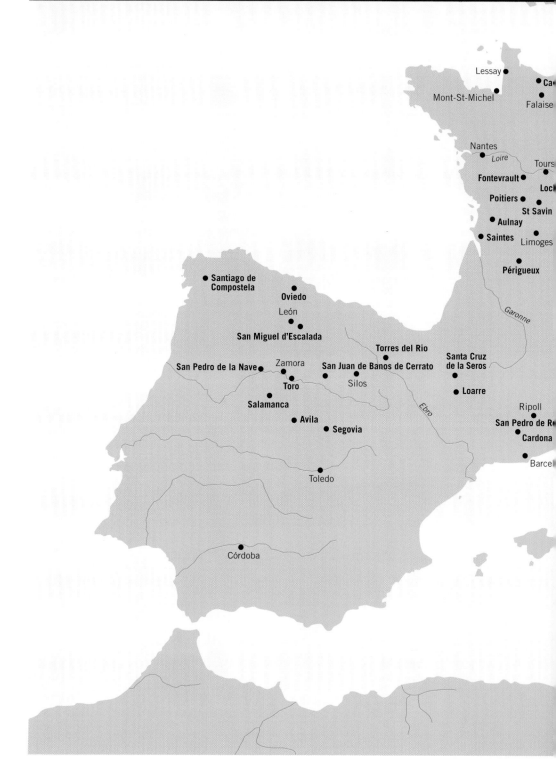

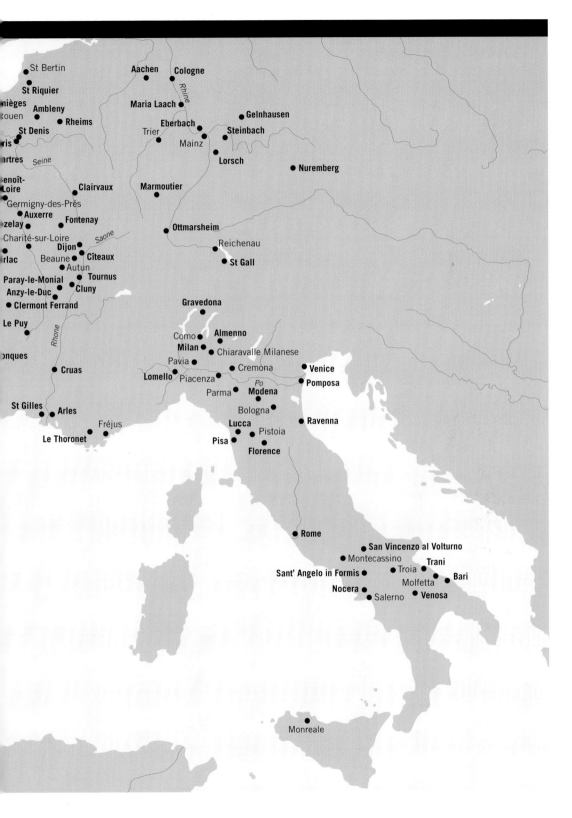

St Bertin
St Riquier
nièges
Amxebeny
Rouen
St Denis
Chartres
Benoît-Loire
Germigny-des-Prés
Auxerre
vezelay
Fontenay
Charité-sur-Loire
Dijon
Beaune
Aurlac
Autun
Paray-le-Monial
Anzy-le-Duc
Clermont Ferrand
Le Puy
onques
Cruas
St Gilles
Arles
Le Thoronet
Fréjus

Aachen
Cologne
Maria Laach
Eberbach
Trier
Mainz
Steinbach
Gelnhausen
Lorsch
Nuremberg
Marmoutier
Clairvaux
Ottmarsheim
Reichenau
St Gall

Gravedona
Como
Almenno
Milan
Chiaravalle Milanese
Pavia
Lomello
Piacenza
Cremona
Parma
Modena
Bologna
Venice
Pomposa
Lucca
Pistoia
Pisa
Ravenna
Florence

Rhine
Seine
Saone
Rhone
Po

Rome
San Vincenzo al Volturno
Montecassino
Trani
Sant' Angelo in Formis
Troia
Bari
Nocera
Molfetta
Salerno
Venosa

Monreale

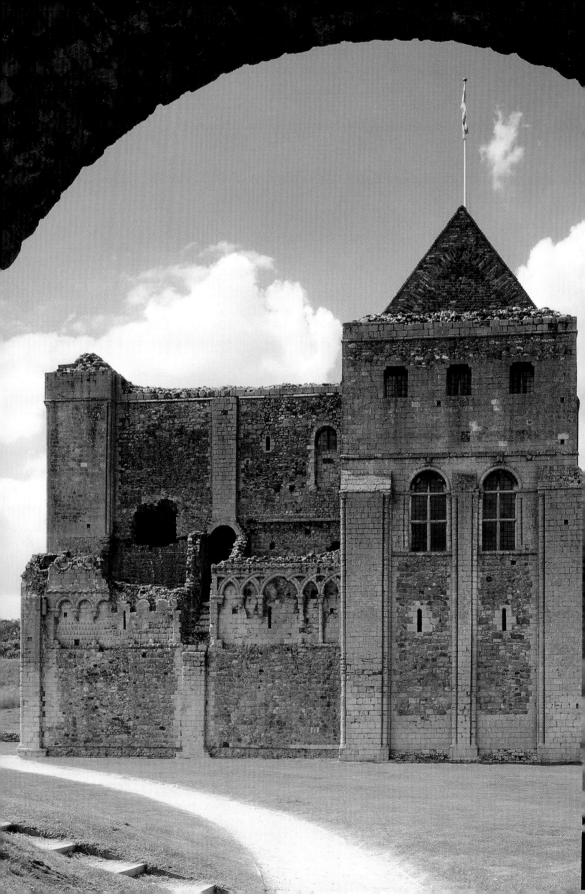

Introduction

This book examines the architecture of western Europe over a 900–year period, from the edict of Milan in 313 AD to the gradual demise of the Romanesque style in the years around 1200. These two chronological boundaries deserve a brief explanation. As architectural development during the period was dominated by the Christian Church, the edict of Milan forms a logical starting point, the moment when the emperor Constantine gave Christianity an official status within the Roman Empire. Within a few years some of the most famous churches of Christendom had been founded, including St Peter's in Rome and the church of the Holy Sepulchre in Jerusalem. Buildings of this so-called 'Early Christian era' provided a core of ideas which lay at the heart of medieval architecture. The year 1200 provides a less precise chronological boundary. It relates to the shift from Romanesque to Gothic, which represents a fundamental change in architectural style. It is difficult to say exactly when this break occurred, for in some countries (including Germany, Spain, and Italy) Romanesque traditions flourished well into the thirteenth century. Historians of style sometimes forget that spectacular Romanesque monuments were still being erected long after the first Gothic churches were complete.

In historical terms, the period extends from the late Roman world, with its sophisticated urban society, to the rise of feudalism in the eleventh and twelfth centuries. During this time the political geography of Europe was reshaped on a number of occasions. After the fall of the Roman Empire in the fifth century, and the era of mass migrations, western Europe disintegrated into a confused pattern of locally based principalities. The Carolingian Empire in the eighth century brought a semblance of unity, but by the end of the ninth century this in turn collapsed under the onslaught of Vikings, Magyars, and Moslems. By the eleventh century greater stability and economic progress had been attained, though in political terms much of Europe remained a patchwork of separate feudal states. Throughout these centuries, the one institution that provided a measure of unity was the Christian Church.

Castle Rising (Norfolk), c.1140

In 313 no more than a third of the population of Rome was Christian; by the twelfth century Christianity was taken for granted by virtually all the peoples of Europe. Recent converts included the Viking populations of Scandinavia, along with the Slavs on the eastern borders of Germany, whilst further south Christian warriors were driving hard against Moslem enclaves in Spain. The spread of Romanesque architecture to almost every corner of Europe reflects the ultimate triumph of the Christian church.

One of the difficulties in presenting a picture of architecture in these years is that the sample of surviving buildings is desperately uneven. While the history of Romanesque architecture can be written largely on the basis of existing monuments, for earlier periods the historian is heavily dependent on archaeological research. We have many thousands of churches in the Romanesque style, but very few from earlier ages, at least few that remain intact, and those that do survive are not necessarily representative. Most of the great churches of Europe have been rebuilt, often on several occasions, and where the Romanesque building survives, it is usually the last in a sequence of structures. In terms of architectural 'stratigraphy', we have been left only with the top level. The history of the famous abbey church of St Denis in Paris provides a good illustration of the process. Beginning life as a small funerary chapel in the fifth century, it was enlarged under the Merovingian kings before being replaced by a great Carolingian basilica between 750 and 775. This itself was extended on various occasions, before being dramatically remodelled between about 1135 and 1144. The last sections of the Carolingian building were replaced by a Gothic design in the thirteenth century. While the detective work involved in unravelling the history of such buildings can be fascinating, architectural fragments and reconstruction drawings are no substitute for complete monuments. The Carolingian era was a creative period in European architecture, but it is difficult for non-specialists to grasp the full measure of what was achieved.

Architectural historians have been criticized for their preoccupation with ecclesiastical building, as if nothing else was constructed during the early Middle Ages. Houses, palaces, castles, and other fortifications have been left in the domain of the archaeologist. The traditional response to this accusation is that church architecture attained a level of sophistication which was rarely matched in secular buildings. Although this reflects the accumulation of wealth by the Church, it was not simply a case of money. Even in castles, it was the chapel that received the most architectural attention. In devoting so much attention to religious buildings, early medieval society was scarcely unique: the architecture of the Greeks—or that of the Khmer in Cambodia for that matter—is principally associated with temple building. There is no ignoring the fact that, after the fall of the Roman

Empire, church building became the highest form of architectural expression.

The traditional picture, however, remains one-sided. Architectural history tends to be concerned with stone and brick, an inheritance from the classical emphasis in European scholarship. Yet throughout the so-called Dark Ages the natural building material in northern Europe was timber. The royal halls uncovered in England at Yeavering and Cheddar were elaborate structures, so too Hrothgar's great hall as described in *Beowulf*, but the fact they were built of wood has relegated them to the second class. It is sometimes forgotten that prior to the eleventh century many a church was built of timber. But where stone survives, timber decays; it is not easy to analyse the quality of a building when all that remains are rows of post holes. A modern history of timber building between 300 and 1200 has still to be written, despite the amount of valuable information hidden in archaeological journals and reports.

Although some topics are covered in chronological sequence, the aim of this book is not to provide a linear narrative. Nor is it designed to be comprehensive. Each chapter is designed to explore a particular issue or group of issues, and they can be read in almost any order. Given the complexities of the traditional 'developmental' approach, it seems worth asking, in general terms, what the architects and builders of the early Middle Ages managed to achieve. A number of things come immediately to mind. There was the transformation of the Early Christian basilica through the addition of towers, transepts, crypts, and ambulatories. In addition there were numerous experiments with centralized buildings, some of them quite bizarre. The rational organization of monastic buildings around a central cloister was an innovation which had consequences far beyond the Middle Ages. Indeed the concept of the enclosed cloister garth, surrounded by arcaded passageways, was to become one of the most delightful features of European architecture. Then there was the development of the fortified dwelling, illustrated by the great keeps of Norman England. In engineering terms, builders mastered various types of stone vaulting, and managed to construct, often on the basis of faith rather than judgement, towers of unprecedented height. In artistic terms, masons learnt to model the basic structure of their buildings with extraordinary finesse, through the addition of shafts, mouldings, and sculptured decoration. By the twelfth century the often rudimentary structures of earlier ages had been transformed into great works of art. These were no mean achievements; they represent the main themes of this book.

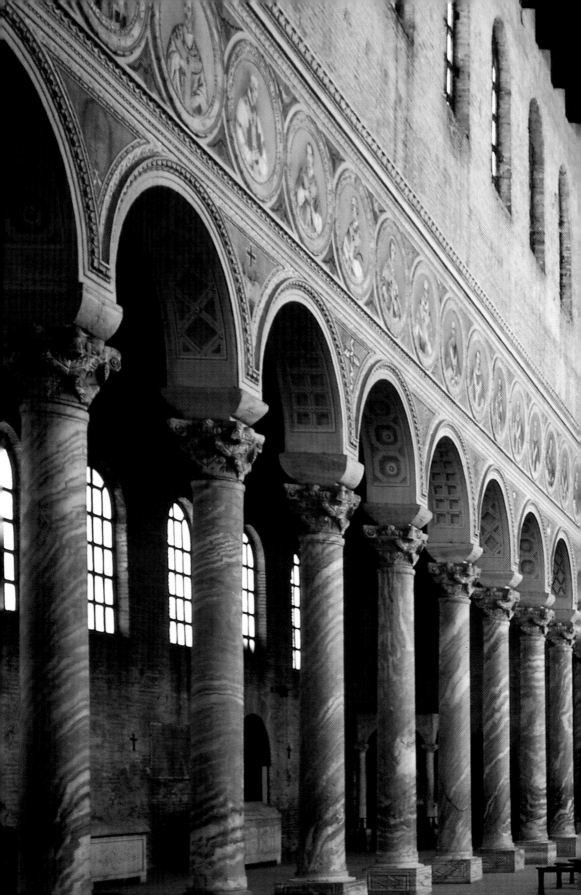

The Christian Basilica

1

Anyone who travels through the towns of southern Europe will sooner or later encounter the word 'basilica', frequently used to describe a large Christian church, normally one belonging to the Roman Catholic faith. For architectural historians, however, the term has a more precise meaning, relating to a specific type of building, the origin of which goes back several centuries before the advent of Christianity. Once adopted for Christian worship in the fourth century AD, the basilica remained at the heart of church building in western Europe for the next 1,500 years. It has proved to be one of the most enduring and adaptable inventions in the history of architecture.

By the mid-fifth century AD, the city of Rome possessed a series of splendid basilicas, amongst which was the church of Santa Sabina, a building of simple elegance, situated on the Aventine Hill above the valley of the Tiber [1]. Santa Sabina gives a good impression of the maturity which Christian architecture had achieved by this time. Its design is characteristic of the 'basilica', with a high central nave, separated by colonnades from aisles on either side. Above the columns, clerestory windows bring light to the central space, and the building has a pronounced longitudinal axis, as the eye is led forward to the semicircular apse at the east end.

Between the fourth and sixth centuries most of the great cities of the Roman Empire were furnished with churches of basilican design, those in Rome and Ravenna being among the best known. The beauty of these early churches is derived from their interior space and decoration, and this is very much the case at Santa Sabina. Immediately noticeable are the 24 marble columns, 12 on each side, cut from the quarries at Proconnesus in the Sea of Marmara. Each column has flutes that are delicately reeded for a third of their height, a finesse matched in the carving of the Corinthian capitals. Above the capitals, the spandrels of the arches are filled with coloured marble inlays (known as *opus sectile*) bearing emblems of the Eucharist—the chalice and the paten [2]. A soft light, coming from a series of huge clerestory

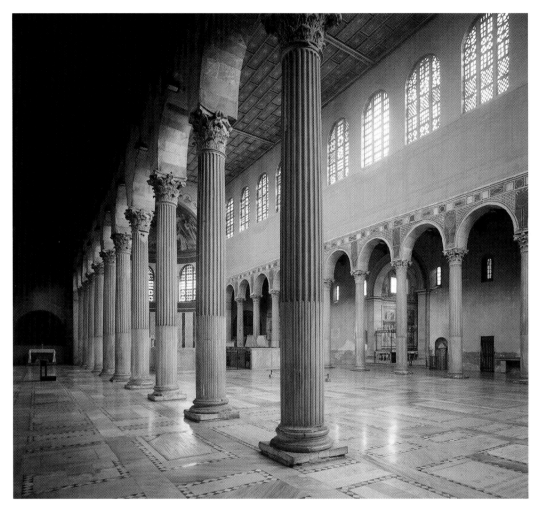

1 Rome, Santa Sabina, 422–32

The columns and capitals were already two or three centuries old when reused by the Christian builders.

windows, 14 feet in height, illuminates the central space of the church. The completion of these windows was one of the more demanding technical tasks confronting the fifth-century builders, for they were filled not with glass, but with thin semi-translucent sheets of mica, originally fitted into latticework made of stucco (*transennae*).[1]

An inscription in mosaic indicates that Santa Sabina was founded by the 'presbyter', Peter the Illyrian, sometime between 422 and 432. The dates are significant, for only a few years had elapsed since Rome, the seemingly impregnable city, had been plundered by Alaric and his 'barbarian hordes', an event which came as a devastating shock to the citizens of the empire (in some quarters the disaster was blamed on Rome's abandonment of the ancient gods, an argument to counter which St Augustine was persuaded to write his *City of God*). Yet there is no indication of the calamity in the serenity of Santa Sabina, except perhaps in the presence of recycled masonry. The south door, for example, is made up of pieces of reused classical architrave, gathered

2 Rome, Santa Sabina, 422–32

The spandrel decoration is made from inlaid marble, known as *opus sectile*. The motif of the chalice and paten is a reminder that celebration of the Eucharist was the chief ceremony that took place in the Christian basilica.

from some derelict or abandoned building, and scholars are convinced that the 24 gleaming columns along with the capitals were taken from a monument of the second century AD. Many a Christian basilica was, like Santa Sabina, built out of the spoils of ancient Rome.

One of the key elements of Santa Sabina is that, contrary to traditional Roman practice, the columns support brick arches, not horizontal architraves of stone. When the Romans built structural arches—as in the Colosseum or the Theatre of Marcellus—they were supported on solid piers of square or rectangular form. The use of free-standing columns to support arches was not in fact a Christian innovation, for the technique had already been employed occasionally, as in Diocletian's palace at Split (*c.*300–306), but it was Christian architecture that popularized the technique. This development in the years around 300 AD was of fundamental importance, for the round arch supported on columns or piers was to become a basic feature of medieval church design. It is also worth noticing that the arches at Santa Sabina spring abruptly from the top of the capital, without any intervening abacus or impost (in fact there is an impost of stone, but it is hidden under the plaster and not expressed as part of the design). Later basilicas, particularly those built under Byzantine influence, overcame this problem with the insertion of a large wedge-shaped dosseret or impost block, providing a transition between capital and arch.

By the time that Santa Sabina was completed, the basilica had been in use by Christians for over a century. It came to be accepted as an appropriate form for church design in the aftermath of Constantine's edict of Milan in 313, which, for the first time, gave Christianity an official status within the Roman Empire, bringing, in the words of Eusebius, historian of the early Church, 'unspeakable happiness' to all those who believed in Christ. In a matter of months the position of the Church was transformed. Only ten years earlier Christians had endured a brief but violent persecution under the emperor Diocletian, when churches had been ransacked or even demolished, sacred books burnt, bishops arrested, and the more inflexible believers tortured or sent for execution. Constantine's rise to supreme power and his support for the Christian faith represented an extraordinary change of fortune, which for many Christians was scarcely credible. Although not baptized until he was close to death in 337, Constantine was active in promoting the Church. With official support, the size of the Christian community grew rapidly. At last secure in the ownership of property, it now had the confidence and wealth to build on a scale as never before. While the new religion flourished, it is important to remember that Rome was still fundamentally pagan, and remained so until the old cults were finally banned by the emperor Theodosius (379–95). For many centuries to come, classical temples, not Christian churches, dominated the layout of the ancient city.

There has been much debate about whether a distinctive Christian architecture existed before 313. During the first three centuries of Christianity, observance involved two major activities, one centred on regular weekly meetings of the faithful, the other on commemorative ceremonies at the graves of the dead. In both cases some form of shelter or meeting hall was required. Despite the occasional outbursts of persecution, Christianity was generally tolerated, though viewed with considerable suspicion: it is not difficult to understand how the private meetings of Christians, their emphasis on brotherly love, and their interest in a sacrament that involved 'the body and blood' of Christ could lead to wild theories about the true nature of the cult. Before 313 it seems that Christians already possessed some quite substantial buildings, to judge from accusations that they were imitating the structures of temples. Before the edict of Milan Christian observance was concentrated on private houses, adapted to suit the needs of worship. The architecture of these buildings, known as *tituli*, after the 'title' of the person who possessed the rights of ownership, did not possess any distinctively Christian character. Twenty-five such *tituli* existed in Rome, most of which were replaced by basilicas during the course of the fourth century. A remarkable instance of this came to light at San Clemente, the twelfth-century church not far from the Colosseum. Since the seventeenth century the building has been owned by the Irish Dominicans and in 1857 the prior, Joseph Mullooly, began to excavate below his church. He not only discovered a fourth-century basilica, much of it substantially intact, but below that a domestic house which may have functioned as a *titulus*. Since Joseph Mullooly's discoveries, Christian meeting houses have been uncovered in various parts of the empire, their designs tending to confirm the view that before 313 Christian architecture was essentially utilitarian and discreet.

All this changed dramatically with the edict of Milan and the enthusiastic patronage of Constantine. The emperor himself founded a series of splendid churches not just in Rome, but also in his new city of Constantinople, and in the Holy Land. At Jerusalem the bishop was instructed to build a basilica more beautiful than any other, and was allowed to draw on the imperial treasury for marble columns and the gilding of the coffered ceilings. The latter was spectacular in appearance, to judge from the report of Eusebius: 'the inside of the roof was decorated with sculptured coffering, which, like some great ocean, covered the whole basilica with its endless swell, while the brilliant gold with which it was covered made the whole temple sparkle with a thousand reflections'.[2] In Rome Constantine's generosity is underlined by the list of gifts bestowed on the Lateran basilica of St John: these included a large quantity of gold weighing 500 pounds for covering the vault of the apse, a huge ciborium of hammered silver, as well as 70 silver chandeliers and 50 silver candelabra.[3]

3 Trier, Aula Nova, 305–12

Built by the emperor Constantine. This was a secular basilica, designed as an imperial audience hall. The giant arcades which frame the windows exerted considerable influence in the Middle Ages.

Although actively involved as a patron of the Christian Church, neither the emperor nor his officials appear to have exercised any centralized control over the designs, for the various basilicas he endowed differed quite substantially in appearance. At Jerusalem, for example, the basilica built between 326 and 335 was provided with galleries above the aisles and there was a circular structure at the west end (the church was 'orientated' to the west) [34]. Eusebius explained that the head of the basilica was 'encircled as a wreath by 12 columns, like the number of the apostles'.[4] Even in Rome the basilicas founded by Constantine differed significantly from each other. What was expected of imperial patronage was not so much uniformity as an appropriate degree of magnificence, a magnificence that, in contrast to pagan temples, was lavished on interiors rather than exteriors. Only when entering the church would the full splendour of the Christian setting have become apparent—the polished marble columns, the silver and gold of the liturgical furnishings, the coloured mosaics on the walls, and the flickering lights of chandeliers. As befitted one of the 'mystery' religions of the East, the architecture of the Early Christian church was essentially inward-looking.

The basilica as an architectural type had a long history before it was adopted by the Christians. To the Roman populace the word 'basilica' was not so much a designation of an architectural form as a description of a general meeting hall that was used for a variety of functions. Virtually every Roman city had its basilica, serving as a market hall, a court house, or as a place for business or commercial transactions. Basilicas were also constructed by the emperors to serve as imperial audience chambers, like the huge aisleless basilica which still remains at

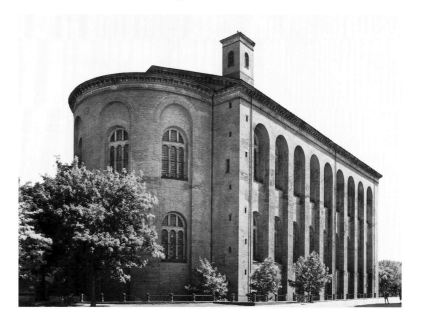

Trier [3]; some were constructed within imperial palaces, as in Domitian's palace in Rome or in Hadrian's 'villa' at Tivoli. Indeed the word basilica, Greek in origin, means royal, which suggests the term was initially applied to royal halls. Just as the functions varied, so too did the designs. Basilicas were usually rectangular in plan and frequently had an apse or exedra opening off one side to provide a point of authority, which might be used for a presiding judge or, in the case of imperial basilicas, for the throne of the emperor himself. The more splendid basilicas were given aisles, which were divided from the main space by colonnades, like the huge example in Rome, known as the Basilica Ulpia, erected under the emperor Trajan (97–117 AD).

In purely structural terms, the public basilicas of Rome were not very exciting buildings, especially when compared with the great palaces and bath houses constructed by the emperors. They were usually covered by timber roofs and timber ceilings, so the builders avoided the sort of engineering challenges encountered when constructing stone vaults and domes. It is not difficult to understand why Constantine and the leaders of the fourth-century Church opted for traditional building types. For their acts of worship the Christians needed a communal meeting hall, and this is precisely what the basilica provided. In essence it was like a great shed, which could be adapted to local requirements, with sections divided off by curtains or screens to suit the needs of the liturgy. As later centuries were to prove, it could be augmented and extended with relative ease. The system of clerestory lighting ensured that the central area was adequately lit, so there was plenty of space and light. The very fact that the structure was not particularly complex meant that it could be erected quickly and cheaply. Moreover, the design was familiar to builders throughout the Roman world. Although based on traditional models, however, the Christian basilica was far from being a mere continuation of what had gone before, and there is much debate about its origins. It has been described, appropriately, as a 'new variant within the framework of a traditional genus'.[5] In a Christian basilica aisles were usually restricted to the long sides only, and the main entrance was always on the short side opposite the apse, giving the building a longitudinal axis. In many cases this axis was further emphasized by the presence of an atrium or courtyard in front of the main entrance.

While the main elements of the building were familiar enough, the construction of a Christian basilica was not necessarily without its problems. Suitable monoliths to serve as the columns had to be found, something which became an increasing problem as time progressed. Another area of potential difficulty was that of the windows, in particular the question of how to obtain translucent materials to fill them. Coloured glass as well as thin sheets of alabaster and mica were used in the Early Christian era, but they were expensive and their supply could not be taken for granted.

4 Ravenna, Sant'Apollinare Nuovo, mosaic of the palace of Theodoric (491–526)

Although depicted here in a secular palace, arcades filled with curtains were a feature of the early basilicas. The curtains replaced figures that were originally set within the arches (a hand can be seen on one column). The palace itself no longer survives.

Despite these potential difficulties, the traditional basilica was well suited to the needs of the Christian faith, but how exactly was it used? It is not easy to form a clear picture of the furnishings or indeed of the services in the fourth century, though Eusebius and other writers do provide some clues. The more spacious and highly decorated churches constructed after 313 evidently contributed to an increase in the formality of proceedings, and in this respect it was the architecture that had a direct impact on the liturgy. In a characteristic basilica the altar, covered by a canopy or ciborium, was located close to the chord of the apse, with the clergy seated in a semicircle around the wall behind. There was usually a throne for the bishop, who sat within the apse like a magistrate in a secular basilica. The altar and the area in front of it were enclosed by screen walls (or *cancelli*) approximately one metre in height, which acted as a barrier to the general public. Often these were made of marble, decorated with ornament and Christian symbolism; fragments survive in a number of early churches, and at Santa Sabina an attempt has been made to recreate the early layout [1]. According to Eusebius, the screens at Tyre consisted of wooden trellis work, 'wrought by craftsmen with exquisite artistry'.[6] In front of the enclosed chancel there was sometimes a ceremonial pathway or *solea* which extended down the nave towards the main doors of the church. When excavations were carried out at the Lateran basilica in Rome in 1934–8, socket holes designed to support the side panels of the *solea* were found under the floor.[7] But what happened to the laity and were they expected to stand throughout the services? Although Eusebius mentions 'benches arranged conveniently throughout', it is unlikely there was a seat for everyone. Men and women occupied different areas and distinctions were also made between full members of the Christian community and catechumens who had yet to be baptized. At Tyre the latter

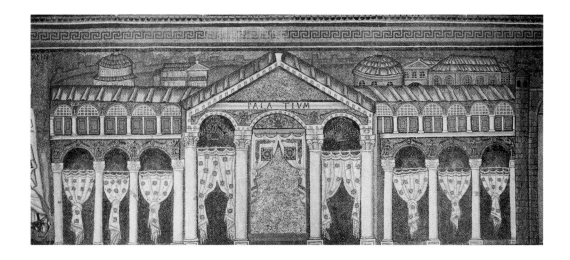

were restricted to the aisles. Mosaics and ivory carvings frequently show curtains hung between columns or tied to one side, and there is no doubt this became a traditional practice in both palaces and churches [4]. Under Pope Hadrian I (772–95) 65 curtains were presented to St Peter's to hang between the nave columns, 70 for San Paolo fuori le mura, and a further 57 for the Lateran. With the curtains drawn and the aisles obscured, in effect reducing the church to a single undivided hall, the spacious impression of the basilicas, so often admired today, must have been badly compromised.

History tends to be written by the victors and not everyone in the Roman world was happy with the triumph of Christianity. Many of the older aristocratic families of Rome clung to their traditional beliefs, hoping perhaps that a future emperor might reverse Constantine's policy, something which actually happened for a while during the reign of Julian the Apostate (361–3). Eventually, under the emperor Theodosius (379–95), the temples were closed for good, their revenues confiscated, and pagan sacrifices banned. As Gibbon concluded, with characteristic gravity, 'Rome submitted to the yoke of the gospel' and 'the solitary temples were abandoned to ruin and contempt'.[8] The defeat of paganism left the problem of what was to be done with hundreds of redundant temples, not just in Rome but throughout the empire. In some places Christian fanatics destroyed the buildings out of fear of a return to the old ways, but in Rome there was a reluctance to see the splendour of the city defaced by wanton destruction. In 408 a decree recommended that temples were to be put to new uses, while being protected as public monuments. This was wishful thinking, however. The buildings began to deteriorate and ancient sites were soon overgrown with bushes and trees. In 459 despoliation was officially permitted, at least in those cases where a structure, temple, public building, or mansion was 'beyond repair'. As the fabric of ancient Rome began to disintegrate, the recycling of architectural features became one of the most successful businesses in the city. The Church showed little interest in taking over redundant monuments, though it was ready to cannibalize them when the need arose. In fact it was not until 609 that a pagan temple was adapted for Christian use and this was a rather unique case, involving the Pantheon in Rome, the vast circular temple built by the emperor Hadrian (98–117). In Rome there are several well-known cases where the church took over secular buildings: Santa Pudenziana was fashioned out of the hall of a *thermae* or bath house and a guardroom in the Forum became the church of Santa Maria Antiqua.[9]

Constantine is reputed to have founded seven churches in Rome, of which the most important were unquestionably St John Lateran and St Peter's. The Lateran was the official seat of the bishop and functioned in effect as the cathedral of the city. Although rebuilt in the seventeenth century by Borromini, a fair amount is known about the

design of the original church.[10] Parts of the building have been excavated, some decorative fragments survive, and there are a number of drawings made before the reconstruction. The most curious feature of the architecture was the pair of projecting chambers at the east end of the outer aisle, a sort of proto-transept. Their purpose is far from clear, though they may have functioned like later sacristies or as places for collecting the offerings of the faithful. The interior of the church was filled with magnificent decoration. The beams of the ceiling were covered in gold, and near the entrance to the apse was a splendid ciborium made of silver. Across the opening to the apse was a colonnaded screen or *fastigium*, echoes of which can be detected in many other churches throughout the early Middle Ages [12, 65].

St Peter's has a more unusual early history. It lay outside the walls of Rome and was not initially designed as a regular place of worship. It corresponds to the site of a Christian cemetery, where the apostle Peter had been buried after his execution. The church founded by Constantine in about 321 or 322 AD was intended to cover his burial place and to provide a shelter for visitors and pilgrims.[11] St Peter's was also a cemetery church where Christians could bury their dead and celebrate their anniversaries. These were not necessarily the quiet, dignified ceremonies that one might imagine, for the commemorations involved banquets with plenty of eating and drinking. In the late fourth century, for example, we know that the senator Pammachius gave a feast to the poor in St Peter's on the anniversary of the death of his wife.[12] Gradually, however, these activities waned and the church came to be regarded almost exclusively as a great shrine built in honour of the apostle. As the chief of the apostles, the first bishop of Rome, the 'rock' on which Christ had built his church, and the saint who held the keys of heaven, St Peter assumed an immense stature within the Christian world. It is no surprise that his church in Rome became one of the most influential buildings of the Middle Ages. While not the most distinguished monument of the Early Christian era, it was the association with St Peter that mattered, not the quality of the design. The reputation of the apostle guaranteed the building a vibrant future as an architectural model.

Although demolished in the sixteenth century to make way for the great church of Bramante and Michelangelo, drawings made both before and during the demolition provide plenty of information about the architecture of Old St Peter's [5]. The fourth-century church was a huge structure, the top of the clerestory walls rising 120 feet above the pavement. Flanking the nave was an imposing sequence of columns, 22 on each side, which varied both in colour and in size. The lack of consistency in the dimensions is a sure sign that these were spoils, recovered from some Antique building. As Krautheimer noted, the columns were tightly spaced, and since their diameters ranged from three to

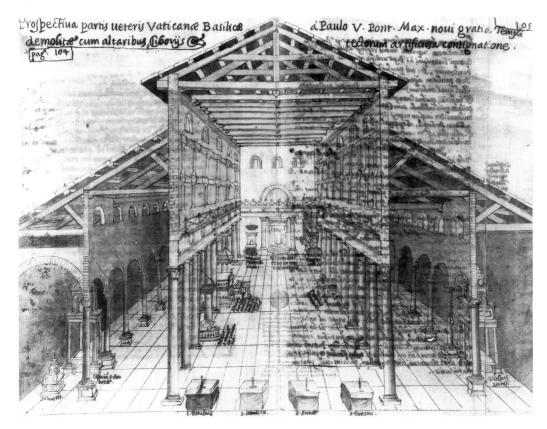

Prospectiua partis ueteris Vaticanæ Basilicæ demolitæ cum altaribus, Ciboriis &
[pag. 104]

a Paulo V. Pont. Max. noui gratia Templos tectorum artificiosa continuatione.

5 Rome, Old St Peter's, founded c.321–2

Drawing by Giacomo Grimaldi (c.1620) showing section of the nave

The contrast between the arches in the outer aisle and the straight architraves flanking the central nave are very apparent, so too the relative fragility of the upper walls.

four feet, this must have produced a dense, solemn effect, not obvious in the ancient drawings. The classical dignity of the building was further enhanced by the use of horizontal architraves rather than arches. Either side of the nave lay a double set of aisles, separated from each other by further colonnades. The nave and aisles alone contained some 88 columns.

In one important respect, the plan of St Peter's differed substantially from other Early Christian basilicas. Between the nave and the apse was an extensive transept, stretching continuously across the building [6]. It opened into the nave through a great arch, and at a much lower level there were triple openings into each aisle. The transept was a huge uninterrupted space, roofed at almost the same level as the nave. At each end three arches led into chambers projecting north and south beyond the main walls of the building. The purpose of this transept has occasioned much discussion, but there is general agreement that it must have had something to do with the shrine of St Peter, located on the chord of the apse. Evidently it provided a convenient space for those gathering to venerate the burial place of the apostle. The shrine itself was identified by a great 'baldacchino' or canopy, supported on twisted columns, forming one of the most memorable features of the church. Although the 'continuous' transept of St Peter's

This plan shows the church as it was modified c.590 with the insertion of a ring crypt under the apse. The focus of the church lay to the west, not the east as was normal in Christian churches.

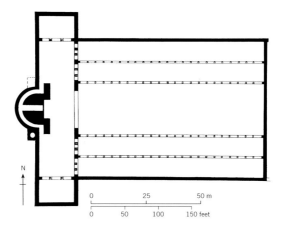

was unusual in the context of Early Christian architecture, it came to be copied in a number of medieval buildings. It was one of the defining characteristics of Old St Peter's.

Before reaching the main doors of the church, the visitor had to pass through a great colonnaded court or atrium, finished in about 390 AD. In this respect Christian builders followed Roman precedent, for most of the grander temples of the empire had been approached through a colonnaded forum. Eusebius provided an elegant description of the Christian atrium at Tyre, where there was a fountain, with an 'ample flow of fresh water' so that everyone could purify themselves before entering the church. Eusebius also explains that the atrium was 'the first stopping-place, lending beauty and splendour to the whole and at the same time providing those still in need of elementary instruction with the station they require'.[13] In Italy the atrium continued to be a feature of church planning until the twelfth century. One of the most attractive is found at Salerno, where the atrium was rebuilt in about the year 1100 with coloured marble inlays. Better known is the rather dour brick example which precedes the Romanesque church of Sant'Ambrogio in Milan.

St Peter's was just one of several large cemetery churches that were erected outside the walls of Rome in the fourth and fifth centuries.[14] These were huge buildings, basilican in form, to which a variety of private mausolea were attached along the sides. In some cases, as at San Sebastiano and Sant'Agnese, a significant modification was introduced to the basilican structure. Instead of the aisles terminating at the entrance to the apse, they were continued around the apse as an ambulatory, an arrangement to be followed many centuries later by Romanesque church builders. Most of the great cemetery churches survive only as fragments, but one remained virtually intact until 1823 when it was badly damaged in a great fire. This was the church built in honour of St Paul, generally known as San Paolo fuori le mura (c.382–400) [7]. San Paolo was obviously modelled on St Peter's, for it

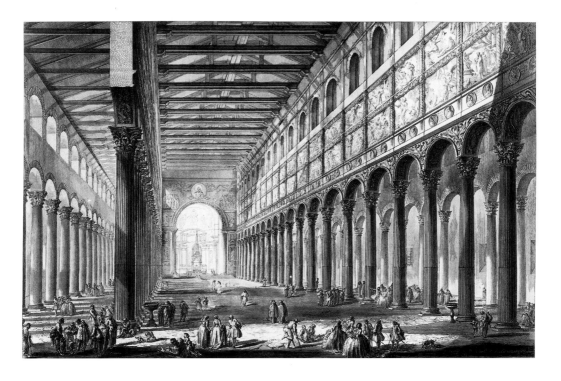

7 Rome, San Paolo fuori le mura, *c.*382–400

Engraving by Piranesi, 1749

This enormous basilica, along with its painted decoration, was badly damaged by fire in 1823.

was given a colonnaded forecourt, double aisles, and a continuous transept (though without the extensions north and south). Moreover, the columns employed in the nave were spoils, the builders in this case managing to acquire examples that were consistent in size. In contrast to St Peter's the columns supported a sequence of arches. Until the middle of the fifth century the choice between arch or horizontal architrave seems to have remained open, but thereafter arches became the norm. This change, which marks a departure from the formality of classical architecture, may have had something to do with the problem of finding suitable blocks of stone for the architraves; but there is no doubt that, from a technical point of view, the arch provided a far more effective structural form. It is possible that in some of the older basilicas cracked architraves were already a cause for concern.

Throughout the fourth and fifth centuries Christian basilicas were erected in many parts of the Roman Empire, both in the Byzantine east and in the Latin west. At Trier, which had been Constantine's headquarters before he became sole emperor, a pair of basilicas were constructed alongside each other. Further south the cathedral at Lyon appears to have been a five-aisled basilica, and outside the town a cemetery basilica was erected in *c.*500 with transepts and external porticoes. In about 470 a huge church with 120 columns and 52 windows, almost certainly some form of basilica, was built at Tours in honour of St Martin. Following the conversion of the Franks to Christianity a five-aisled basilica was erected in Paris under the auspices of King

Childebert (511–18). This was the cathedral of St Etienne, the foundations of which have been discovered below the pavement in front of Notre Dame.[15] In Spain traces of a fourth-century basilica have been revealed under the cathedral of Barcelona and fragments of another fourth-century basilica have recently been uncovered in central London.[16]

While the political fabric of the Roman Empire disintegrated during the fifth century, the Christian Church continued to provide a measure of unity and continuity. The seizure of power by so-called 'barbarian' kings from the north did not have an immediate effect on ecclesiastical architecture, a point well illustrated in the buildings of Ravenna. The city experienced three different regimes in just over a century and impressive basilicas survive from each period. There were certainly changes and developments, but the continuities are equally striking. Situated close to the Adriatic coast of Italy, Ravenna was open to eastern influences long before Byzantine troops occupied the city in 540. This is reflected in a number of architectural details found in the churches: for example, apses were given a polygonal outer wall, an impost block was inserted above the capitals of the main colonnades, and ready-carved capitals were imported from quarries in the Aegean. These features can all be found at Sant'Apollinare Nuovo, erected around 490 AD during the reign of Theodoric, king of the Ostrogoths. Theodoric, who had been educated in Constantinople, made Ravenna his capital, building an elaborate palace there. Many of the features encountered at Sant'Apollinare Nuovo reappear 50 years later at Sant'Apollinare in Classe, a church consecrated in 549 after the Byzantine conquest of north Italy. Even without its full complement of mosaics, Sant'Apollinare in Classe must be regarded as one of the most beautiful of all the early basilicas, spacious in proportion, abundant in its lighting, and sumptuous in its choice of materials [8]. The distinctive marble of the columns, with its white diagonal streaks, was imported from the East, either from Proconnesus or from quarries at Hymettus in Greece.

After dominating church building in western Europe for over 200 years, the popularity of the basilica began to wane. The reasons for this are not hard to discern. The basilica was introduced to cope with large congregations in the populous cities of the Roman Empire, but by the sixth century the Church was confronting a very different world. In the West the empire had disintegrated and the provinces were now governed by new dynasties from the north, many of them pagan. The new 'barbarian' kingdoms were rurally based, and urban life was in decline. Even in Rome there were huge demographic changes. A population which is thought to have stood at 800,000 in 400 AD dwindled to perhaps 100,000 in the course of a century. In these circumstances the technological skills associated with brick or stone building were diffi-

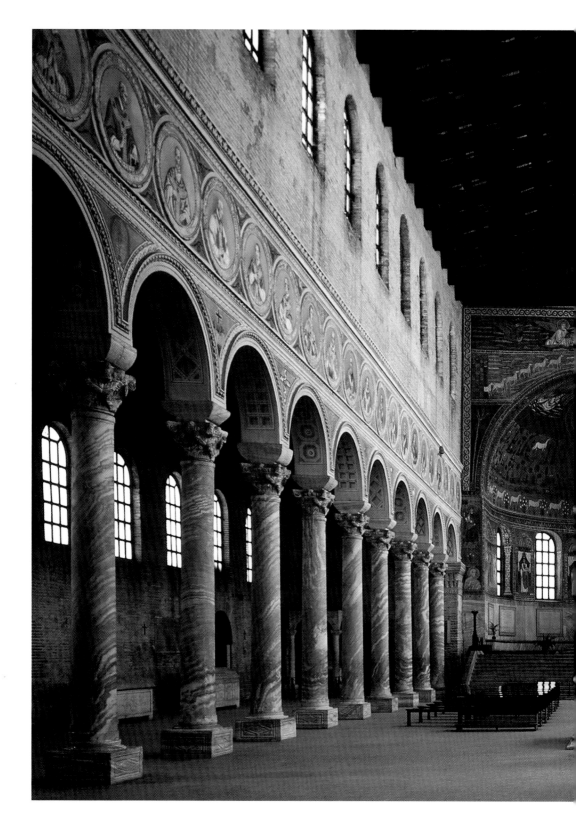

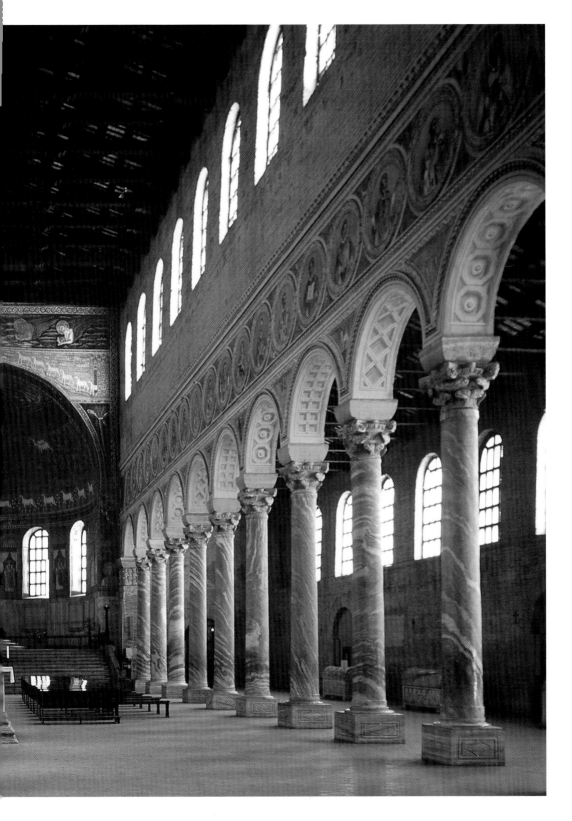

8 Ravenna, Sant'Apollinare in Classe, consecrated in 549

Built following the Byzantine reconquest of northern Italy. With its richly-veined marble columns, this is one of the finest of all the early basilicas. The floor of the apse was raised in the ninth century when a crypt was inserted below.

cult to sustain, particularly in remote areas. Spacious basilicas were scarcely suited to rural communities with small congregations and limited resources. Nor were they necessarily suited to the needs of monks, who were playing an increasingly prominent role in the life of the Church. Almost everywhere there was a drift towards relatively small, simple buildings, divided into separate chambers or compartments. Fragmented space replaced the unified interiors of the Early Christian basilica.

An impression of these developments can be obtained by a glance at the architecture of Visigothic Spain and Anglo-Saxon England. The Visigoths were already Christian (though initially followers of the heretical teachings of Arius) when they established themselves in Spain in the second half of the fifth century. Over the course of two centuries they developed a remarkable architecture of their own, characterized by the horseshoe arch and by the employment of large blocks of superbly crafted ashlar, fitted together without the use of mortar. There has been much debate about the origins of Visigothic architec-

9 San Juan de Baños (Palencia) c.661

This tiny church built by King Recceswinth takes the form of a miniature basilica, complete with arcade and clerestory. Note the horseshoe arches, characteristic of Visigothic building in Spain.

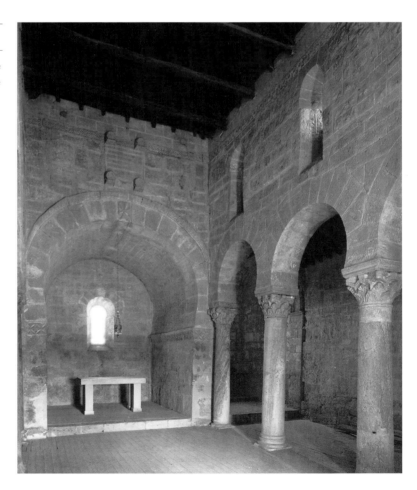

A cruciform-planned church, parts of which are covered by stone barrel vaults. The detached columns have a strong entasis, suggesting that they were recycled from a Roman monument.

ture, and buildings in both Africa and Syria have been invoked to explain it. While familiar with basilican models, the Visigoths tended to prefer the Greek-cross plan, with the side compartments taking on the appearance of mini-transepts. There is, however, an intriguing adaptation of the basilican theme at San Juan de Baños de Cerrato (Palencia), a church founded in 661 by King Recceswinth, a ruler who is best known for the splendid votive crown bearing his name, discovered amidst the Guarrazar treasure in 1858. The church at Baños was in effect a miniature basilica, with small, reused columns supporting the horseshoe arches of the nave, the latter not much more than 30 feet in length [**9**]. The capitals are valiant, though rudimentary, attempts by the Visigothic sculptors to reproduce classical Corinthian forms. Tiny windows, filled with decorative stone lattices, allow narrow shafts of light to filter into the interior. This was a far cry from the spacious basilicas of Italy, and the curious plan of the east end, with mini-transepts and eastern chapels, sets it even further apart. Intimate and secluded, at Baños the basilica was transformed into a very private place of worship.

The chancel at Baños was covered by a stone barrel vault, one of the first examples in medieval architecture. Barrel vaults were employed more extensively in the Visigothic church of San Pedro de la Nave (Zamora), a building which was moved stone by stone in 1930 and 1931, when the valley of the Esla was flooded to form a reservoir. Here the centre of the building is marked by a 'regular crossing', with equal arches opening towards all four arms of the church [**10**]. The central piers are embellished with monolithic columns, probably antique in origin. Like other Visigothic churches, the exquisite masonry of San

11 San Pedro de la Nave
(Zamora), *c.*691, north wall
of the chancel

Visigothic architecture is
distinguished by superb
ashlar masonry and bands of
crisply cut ornament.

Pedro was decorated with a series of crisply cut friezes, comprising foliage and abstract motifs [**11**]. Historians have for long been intrigued by the way in which Visigothic buildings foreshadow the emergence of Romanesque architecture four centuries later, for the decorative carving, the use of barrel vaults, and the presence of the 'regular crossing' all seem to point to the future. How Visigothic architecture might have developed we shall never know, for in 711 the Iberian peninsula was overrun by Moslems from North Africa. Christian building came to an abrupt halt.

As in Spain, the basilica had only a limited influence on the architecture of seventh-century England. In some ways this is puzzling, for unlike the Visigoths the Anglo-Saxon Church maintained close contacts with Rome and the Papacy. The first Christian mission had been sent from Rome in 597 and throughout the seventh century Anglo-Saxon churchmen looked to Rome for guidance and inspiration. The abbot of Monkwearmouth-Jarrow, Benedict Biscop, who made five visits to Rome bringing back books, relics, and pictures, had plenty of opportunities to admire the great basilicas of the city. His churches were dedicated to the Roman saints, Peter and Paul, and he even managed to persuade the arch-chanter of St Peter's to come to Northumbria to teach his monks the Roman liturgy and chant. Despite these contacts, most of the stone churches of seventh-century England were simple, aisleless buildings, like the example that survives at Escomb. There was, however, one Northumbrian church that was evidently more ambitious in conception. This was erected at Hexham by Wilfrid, one of the most colourful and controversial ecclesiastics of his day, a man who had travelled extensively in Europe, with long stays in both Rome and Lyon. The church at Hexham (672–8) had side aisles (or 'porticus') and 'galleries', as well as a crypt (the only part of Wilfrid's church to survive), and the different levels of the building were reached by 'various winding passages with spiral stairs leading up and down'.[17] The twelfth-century historian William of Malmesbury states that Wilfrid brought masons from Rome and cited contemporaries who claimed that at Hexham one could see 'the glories of Rome'. Although the precise design has been the subject of much confusion and argument, Wilfrid's church appears to have been some form of basilica.[18] To the Anglo-Saxons, whose natural building material was timber, the very use of stone was regarded as a 'Roman custom'. While their modest churches might seem far removed from the Christian buildings of Italy, the mere fact that they were built of masonry was itself a huge symbolic link.

In the south of England there are the remnants of a group of churches erected not long after the conversion of the Anglo-Saxons to Christianity. One of the finest was that built in the old Roman fort at Reculver (Kent) in 669 by a priest called Bass, a church demolished as

recently as 1805 [12]. Although lacking aisles, it was furnished like other churches in the group with side chambers or 'porticus'. Its most distinctive feature was the triple arch which divided the nave from the apse, a simplified version perhaps of the *fastigium* that existed at St John Lateran and other Early Christian churches.

In the history of the basilica, it is customary to see the sixth and seventh centuries as a period of decline. The social consequences of the fall of the Roman Empire and the scarcity of expertise that accompanied it meant that in most parts of Europe this type of structure was no longer a practical model, and there was a danger that it would become obsolete. In the second half of the eighth century, however, the Carolingian Renaissance brought a renewed vigour to Christian architecture, and with it a renewed status for the basilican form.

12 Reculver (Kent), St Mary's church, 669

Plan of the church

This Anglo-Saxon church was demolished in 1805. Side chambers or 'porticus' were eventually erected around three sides of the building. Note the two columns which supported arches at the entrance to the chancel and the indication of a bench for the clergy around the inner wall of the apse.

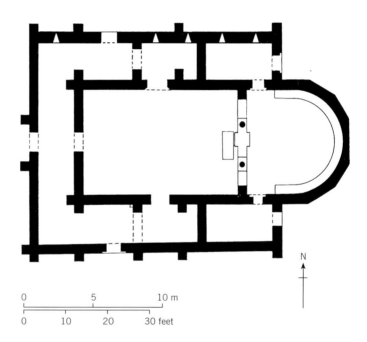

0 — 5 — 10 m

0 — 10 — 20 — 30 feet

N

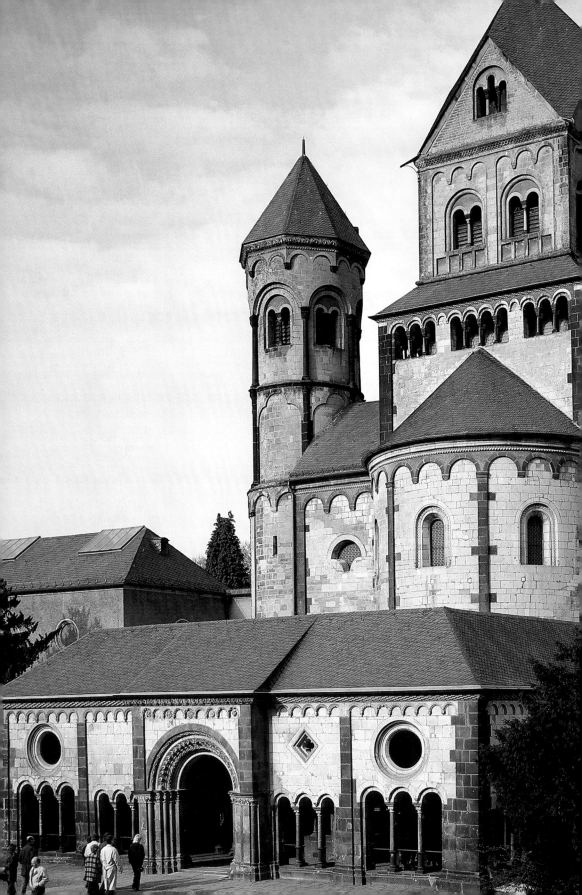

The Carolingian Renaissance: The Basilica Transformed

2

The Benedictine abbey church of Maria Laach (c.1093–c.1250) is one of the more spectacular monuments of Romanesque Germany, its broken silhouette of towers and turrets conveying the impression of a romantic fortress rather than a church [**13**]. At first sight the building appears to have little in common with the architecture of the Early Christian world. In the hands of medieval builders the long horizontal form of the early basilicas has been translated into a dynamic, vertically oriented composition. In fact the design of Maria Laach demonstrates very effectively the way in which the traditional basilica was manipulated by medieval architects. Squeezed between the towers at each end of the building is a basilican nave, flanked by the customary aisles and illuminated by clerestory windows. A courtyard or 'paradise' in front of the west portals furnishes an even more specific link with the churches of late Antiquity. These traditional features provide a nucleus to which have been added a variety of extra elements, most obviously the towers and turrets, additions which it is easy to take for granted. Like many early medieval buildings, Maria Laach is a composite structure, an amalgam of separate parts, and one of the tasks of the historian is to explain how the various components came to be united. Indeed, a useful way of analysing medieval churches is to begin by identifying those elements which have been added to the basilican core. At Maria Laach the list would include the western group of towers, the transepts, the extended chancel, the western apse, the crypt, the eastern stair turrets, and the crossing tower. To understand the origin and meaning of these features, one must go back three centuries, to the so-called Carolingian Renaissance, a period of remarkable invention in the history of European architecture.

During the long reign of Charlemagne (768–814) a new breed of confident and ambitious clerics redefined the nature of Christian architecture. The scale of operations and the sheer quantity of building was quite breathtaking: in Charlemagne's reign alone, it has been reckoned that some 16 cathedrals and 232 monasteries were either newly

13 Abbey church of Maria Laach (Rhineland Palatinate), begun c.1093, but not finished until the thirteenth century

The addition of towers was one of several features that transformed the appearance of the basilica. The low buildings in the foreground enclose a small courtyard in front of the church

founded or reconstructed.[1] The list includes the monastery of St Riquier (also known as Centula), rebuilt by Angilbert, one of Charlemagne's friends and advisers. Designed to accommodate 300 monks, it was, as a later chronicler explained, constructed with 'extraordinary industry' and 'superb lavishness' [18]. Equally ambitious was Ratger, abbot of Fulda from 802 to 817, whose monks complained that they were exhausted by his relentless building campaigns. They took their complaints to the emperor, and so bad were relations with the abbot that they compared him to a wild unicorn attacking a flock of sheep. While Angilbert and Ratger may have been exceptional individuals, the Carolingian clergy in general displayed a remarkable degree of enterprise, the impact of which extended to all parts of the empire and beyond its frontiers. The passion for architectural renewal is well illustrated by recent excavations at San Vincenzo al Volturno, a Benedictine monastery 60 miles south of Rome, where the remains of a Carolingian basilica have been uncovered within the last few years. It was known that Abbot Joshua had embarked on a new church in 808, but its site, some distance from the old monastic buildings, was hitherto unknown. In the early years of the ninth century, the process encountered at San Vincenzo was being repeated throughout the Carolingian world. A spirit of optimism seemed to prevail, along with the conviction that a new Christian order had arrived, feelings no doubt encouraged by the improved economic conditions of the age.

How much was this due to Charlemagne himself? By consolidating and extending the empire that he inherited from his father, by attracting learned and intelligent advisers to his entourage, and by accepting an ideology of power which looked back to the Roman past, the emperor certainly influenced architectural developments, albeit in an indirect way. When he acceded to the throne in 768, Frankish power already stretched across much of western Europe. His grandfather, Charles Martel, had dramatically raised the prestige of the Franks in 732 by repulsing an invading Moslem army, and just over 20 years later his father Pepin forged a crucial alliance with the Papacy in Rome. Charlemagne himself undertook five expeditions to Italy, the first from 773 to 774 when he captured Pavia and crushed the kingdom of the Longobards. By the time of his fifth visit in 800 the Frankish Empire stretched from central Germany to northern Spain, from the river Elbe to the Pyrenees. The relative stability which these vast territories enjoyed was to a large degree the product of Charlemagne's ferocious military energy and the wisdom of his administration, a stability which helped to nourish the more grandiose architectural ambitions of the age. There were however other factors at work, not least the extraordinary collection of learned men who gathered around him (creating what in modern terms might be regarded as a cultural 'think-tank'). Charlemagne conversed easily with his friends and advisers—even when he was dress-

ing and putting on his shoes, according to his biographer, Einhard. He enjoyed receiving foreign visitors, and his entourage included an extraordinary mix of peoples from all over the known world. Fluent in Latin, the emperor built up an extensive library, one of his favourite books being St Augustine's *City of God*, a text which could scarcely be described as light reading. The Carolingian court was thus a place where ideas were allowed to flourish and ambitious projects were given encouragement. According to Einhard, Charlemagne often took the lead, commanding bishops and churchmen 'to restore sacred edifices which had fallen into ruin … wherever he discovered them throughout the whole of his kingdom'.[2]

On Christmas day 800 Charlemagne was crowned Roman Emperor by Pope Leo III. The ceremony took place at St Peter's in Rome, a church for which the emperor had a special reverence. Soon after, his royal seal proclaimed the event with a symbolic image of Rome accompanied by the inscription RENOVATIO ROMANI IMPERII, 'the revival of the Roman Empire'. Charlemagne made four visits to Rome and there is no doubt that he was impressed by the glories of classical Antiquity. But it was the Christian era that was most admired, with Carolingian concepts of power centring on the notion of an IMPERIUM CHRISTIANUM. Even before he was crowned emperor, Charlemagne was being hailed as a 'New Constantine'. By exploiting models from the Early Christian era, artists and craftsmen helped to authenticate the imperial ideology of the Carolingian court. Roman imagery was even transferred to Aachen, the site of Charlemagne's palace: a bronze she-wolf was carried across the Alps and a bronze pine cone, like that in the atrium of St Peter's, was set up in front of the palace chapel. To complete the picture a bronze equestrian statue (of Theodoric, the Ostrogothic king) was brought from Ravenna, along with a batch of marble architectural components.

In architecture this 'renaissance' was expressed in a variety of ways. Charlemagne himself took a practical interest in the early churches of Rome, providing timber and lead for the reconstruction of the roof of St Peter's. The Early Christian churches of Rome were copied by Carolingian architects and the basilica once again became a dominant type. In the monastery at Lorsch an explicit homage to Rome was provided in the form of a curious three-arched structure, with a chamber on the first floor, reached by stair turrets at either end [**14**]. Now known as the 'Torhalle', this was not a gateway, but a free-standing monument, the function of which has provoked considerable discussion. The arches are supported on Roman-style piers, with engaged columns, and the building stands like a triumphal arch in the middle of a forum. While the polychrome masonry conveys a rather bizarre impression, it is hard to avoid the conclusion that the building was inspired by the Arch of Constantine, a structure which in the Carolingian era was seen as a symbol of Christian triumph.

14 Lorsch (Hesse),
'gatehouse' of the monastery,
late eighth century

Inspired by the Arch of
Constantine in Rome, this is
one of the first structures in
medieval architecture on
which engaged columns were
used. The patterns of coloured
tiles may have been derived
from the Roman technique
known as *opus reticulatum*.

The most famous building associated with Charlemagne is his palace chapel at Aachen (792–805) [37], a double-shell structure with an octagonal core, modelled on the church of San Vitale in Ravenna (consecrated 547) [35]. The design was simplified, however, and the Carolingian composition lacks the subtlety of the curved *exedrae* found in the Byzantine-inspired model. The cultural aspirations of Charlemagne's court are reflected in the classical details found on both the bronze railings of the gallery and the splendid set of bronze doors. The design of Aachen became an architectural icon, intimately associated with the prestige of Charlemagne and notions of Christian power. Although frequently copied in later centuries, it was an exceptional monument, and the Carolingian contribution to church architecture is more explicit in the realm of monastic building, not least in the work of Abbot Ratger at Fulda.

The monastery at Fulda had been founded in 744 by a disciple of St Boniface, the Anglo-Saxon missionary who came to be venerated as the apostle of Germany. By the 790s a huge new church was being constructed in honour of the saint. It took the form of a columnar basilica, terminating at the east in an apse and with a crypt below [15]. While

Ratger was abbot (802–17) a huge transept was added at the west end of the building, together with a second apse, designed to accommodate the shrine of St Boniface. The fact that the transept was continuous and located at the west end of the building (rather than the east) leaves no doubt that the model was St Peter's in Rome [6]. In fact the architect at Fulda went so far as to repeat the extensions at the north and south extremities of the transept, as found at St Peter's. The choice of model is not hard to explain: the monks of Fulda were demonstrating the status of St Boniface, the apostle of Germany, by equating his shrine with that of the prince of the apostles in Rome. The Roman flavour of the architecture at Fulda was maintained under Ratger's successor, Eigel, who in 822 laid out a new cloister, not to the south of the church, but 'in the Roman custom' to the west, on the model of an Early Christian atrium. Unfortunately none of this Romanizing work is to be seen, for the church at Fulda was rebuilt in the Baroque style by Johann Dientzenhofer at the beginning of the eighteenth century.

Long before the coronation of Charlemagne in 800, the Carolingian church had established a close relationship with Rome. For two years between 753 and 755 Pope Stephen II stayed in France, spending much of his time in the abbey of St Denis, the church which housed the tombs of the Frankish kings. One of the consequences of this sojourn was the replacement of the Gallican liturgy by the Roman liturgy, a change which involved a range of alterations in religious ritual, chanting, and ceremonial processions. At St Denis the liturgical changes encouraged Abbot Fulrad to transform the architectural set-

15 Fulda (Hesse), monastic church, c.790–819

Built in honour of St Boniface. The continuous transept at the west end of the building was derived from St Peter's in Rome.

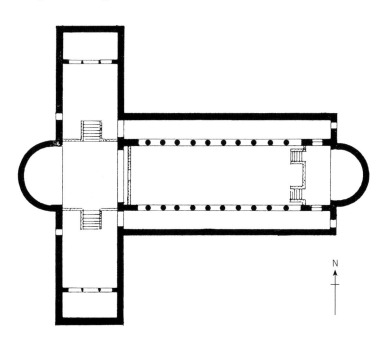

16 Seligenstadt (Hesse), Sankt Marcellinus and Sankt Petrus, founded in *c*.831

North arcade of the nave

The church at Seligenstadt was built by Einhard to house relics brought from Rome. The replacement of columns by square piers became common practice in the early Middle Ages.

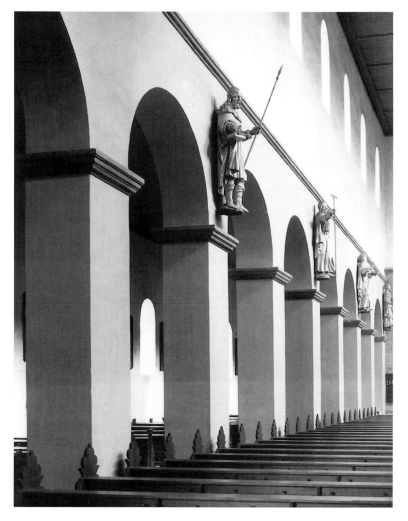

ting as well and between 755 and 775 he reconstructed his church in the form of a large basilica. Like many Carolingian churches, Fulrad's building was furnished with a crypt below the chancel. The development of crypts, with their subterranean network of passages and chambers, forms one of the most intriguing episodes in early medieval architecture, a development intimately related to the collection of relics and the elaboration of the liturgy (see chapter 7).

The monolithic shafts required for basilicas, as at Fulda, St Denis, or in the small basilica at Höchst in the suburbs of Frankfurt, were not always easy to obtain. An obvious alternative was to replace the columns with square or rectangular piers, which is what Einhard, Charlemagne's friend and biographer, did in the two churches he founded at Steinbach (827) [17] and Seligenstadt (*c*.831) [16]. A broad pier offered solid support, particularly when the walls above were made of rubble. Although the technique was not new, a rectangular pier,

built of brick, ashlar, or even rubble masonry, became a respectable alternative to the column. The visual implications were important, for the smooth surface of the pier encouraged continuity with the wall above; two centuries later this visual connection was to be further emphasized with the introduction of pilasters and engaged shafts, leading to the compound pier of the Romanesque style.

Excavation has shown that St Denis may have had a second or 'counter' apse at the west end of the church, as was the case at Fulda.[3] Given that most churches erected in the basilican tradition have a doorway in this position, the arrangement at first sight seems very odd. An apse at either end of the building is occasionally found in late Antiquity—there are a number of examples in north Africa, for example—and it became quite common in Carolingian architecture. The church outlined on the famous plan of St Gall (c.830) [123] followed this scheme, and so too did the cathedral of Cologne (consecrated 873). The 'double-ended' scheme survived for several centuries in Germany, and later examples include the church at Maria Laach [13]. One of the more curious examples can be found at Essen, in a church (1039-58) belonging to a highly aristocratic community of nuns; in this case the counter apse consisted of three sides of an octagon, the elevation borrowed from Charlemagne's palace chapel at Aachen, complete with galleries. The advantage of the western apse was that it offered a second liturgical focus, providing locations for two altars of equal status at either end of the church. This reflects the growing tendency for churches to multiply the number of altars within the building, a trend which had been gathering strength since the fourth century. It also had the advantage that northern churches could follow the exact arrangements laid down in the *ordines Romani*, the liturgy of the Lateran basilica in Rome, where the apse was located at the west. Despite these liturgical attractions, the counter apse never became a universal feature in medieval architecture, no doubt because its location at the west end conflicted with the preferred location for the main entrance.

It was during the Carolingian era that transepts became established as a standard component of Christian building, though they varied considerably in location and form. Fulda had a 'continuous transept', where the transept remained undivided, creating a great transverse block of space quite distinct from that of the nave [15]. Sometimes described as a 'T' transept, the effect is of two separate buildings placed at right angles. The prototype is to be found in the great Early Christian buildings of Rome, most notably St Peter's and San Paolo fuori le mura [6]. When a continuous transept was employed in medieval architecture, a direct reference to Rome was frequently intended. The best place to judge the effect of such transepts, which were not however widely employed after the Carolingian age, is in the ruined church at Hersfeld, a Carolingian foundation rebuilt after a fire in 1037 or 1038.[4]

17 Steinbach im Odenwald (Hesse), St Marcellinus and St Petrus, consecrated in 827

Plan of the church

Founded by Charlemagne's biographer, Einhard. An extensive 'corridor' crypt survives under the church.

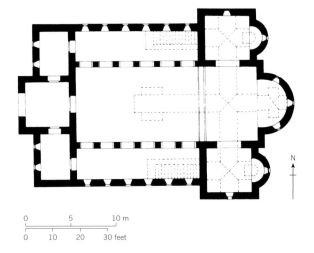

A second form of transept, known as a 'low transept', is illustrated by the church at Steinbach, which was built by Einhard, and consecrated in 827 [**17**]. It was designed to house relics of St Peter and St Marcellinus, which had been brought from the catacombs in Rome. According to legend, the saints were not impressed with their new home and they managed to persuade Einhard to transfer their relics elsewhere (they were subsequently transferred to Seligenstadt). Steinbach takes the form of a basilica, with rectangular piers rather than columns. The space of the nave ran unbroken through to the eastern apse; the transepts, which were roofed at a lower level, were entered by arches opening off the final bay of the nave. They were thus very much subsidiary elements in the design. By the twelfth century 'low transepts' of this type had become relatively rare, though they survived in the region of the Meuse and in some Cistercian churches.

The classic form of transept was the 'regular transept', centred on a crossing from which four equal arches opened towards both transepts, as well as towards the choir and the nave. In contrast to the continuous transept, the space was divided, each arm having its own identity. Regular transepts, combined with a well-defined central crossing, eventually became the standard form in medieval architecture. There are no well-preserved examples from the Carolingian era, though many scholars believe this was when they became established in northern Europe. One of the earliest surviving examples is that in the Ottonian church of St Michael at Hildesheim (1010–33) in Saxony [**25, 26, 27**].

But what exactly was the purpose of the transept? There is no straightforward answer to this question, as both function and meaning seem to have changed quite considerably over the course of time. The

continuous transept at St Peter's and San Paolo fuori le mura helped to define the area of the main shrine, providing a gathering point for pilgrims and worshippers outside the main body of the basilica. But its functional value came to be overshadowed by its associations with Rome. As a piece of architectural 'iconography', it provided a visible link with the great shrines of Christendom. In later centuries the continuous transept was exploited as a convenient location for additional altars, usually through the construction of chapels in the eastern walls. The eleventh-century church at Ripoll in Catalonia (*c*.1020–32) has a huge continuous transept, inspired by St Peter's, with no fewer than six apsidal chapels. In most cases, therefore, transepts played a liturgical role, either containing or providing access to additional altars. But there is no doubt that the symbolical connotations of churches laid out in the form of a Latin cross proved attractive to clergy from an early period and there are many references to churches *in modum crucis* (in the form of a cross). The precise layout did not matter much. An early example of the practice came in 382 when St Ambrose laid out the church of the Holy Apostles in Milan, stressing that it was meant to symbolize the victory of Christ and His cross. With the whole structure embodying a reference to Christ's crucifixion, it is no surprise that such plans became part of the very image of what a great Christian church should be.[5]

The crossing tower, positioned at the junction of the nave and transepts, was another feature that became established during the Carolingian age. The reconstructed church at St Denis (755–75) had a tower 30 feet high, and a rare example still survives at Germigny-des-Prés, admittedly over a very different type of building. Crossing towers provided an impressive visual accent, and their location, often close to the high altar, served to pinpoint the main liturgical focus of the church. They represent one of the more audacious structural developments of early medieval architecture, but as we shall see (chapter 6), they were also a source of potential disaster.

Two circular towers dominated the church at St Riquier, as seen in a famous eleventh-century drawing of the abbey, known through seventeenth-century copies [18]. St Riquier was burnt by the Vikings in 881, so there is some doubt about how much of these towers belonged to Angilbert's time.[6] The low outer crypt, seen to the extreme right of the church, was definitely a later addition, being constructed under abbot Gerwin (1045–75). Nonetheless the drawing provides a spectacular impression of a great Carolingian monastery, along with some precious architectural details. In the foreground is a huge courtyard with covered arcades, leading to two separate churches dedicated to St Benedict and St Mary.[7] The main church had a basilican section, and the low aisle and the clerestory windows are clearly visible (excavations have shown that the nave was considerably longer than it appears in the

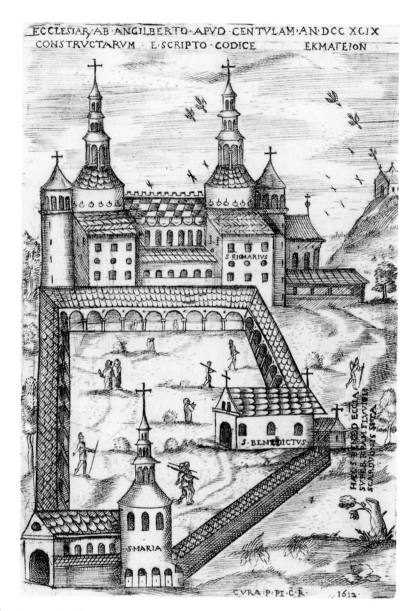

Engraving text:

ECCLESIAE·AB·ANGILBERTO·APVD·CENTVLAM·AN·DCC·XCIX
CONSTRVCTARVM E·SCRIPTO·CODICE EKMATΣION

S·RICHARIVS

S·BENEDICTVS

S·MARIA

HAEC·S·BENED·ECCLA·
SVPER·RELAY·FLVVIOR·
SCARDVIONIS·SITA

CVRA·P·PE·C·R· 1612

18 St Riquier, also known as Centula (Somme), built c.790–9

Engraving of 1612 based on a lost drawing of the eleventh century

This was the elaborate monastery constructed by Angilbert, who belonged to Charlemagne's circle of advisers. Excavation has revealed that another courtyard, not shown in the engraving, lay immediately to the south of the church.

drawing). There were eastern transepts, probably furnished with galleries. The church terminated in an apse (the curve identified by a half window), and this was preceded by a short chancel. Circular stair turrets were fitted into the angle of the transepts. The composition was repeated at the west end of the building, giving the church a dual emphasis. Indeed the structure at the west end of St Riquier appears to be the earliest known example of a 'westwork', one of the most dramatic innovations of the Carolingian era.

The term 'westwork' was invented in the nineteenth century to describe what Carolingian writers called a *castellum* or *turris* at the west end of a church. Although there are plenty of references to them in the

documents, the only Carolingian example to survive intact is that at Corvey in Germany, built between 873 and 885 [**19, 20**]. The structure at Corvey was heightened in the twelfth century, but it is not difficult to distinguish the original rubble masonry of the ninth-century building. Approaching from the west, the façade is dominated by two square towers and by a tall central porch, the latter projecting from the otherwise flat surface of the building. On the ground floor is a crypt-like chamber, its groin vault supported in the centre by four stout columns with Corinthianesque capitals. To the east the chamber opened into the main body of the church, long since reconstructed in the Baroque style. Each tower contains a staircase which leads up to one of the most impressive interiors of the Carolingian age, albeit much restored. It consists of a huge central space, roughly square in plan, surrounded by an aisle and (on three of the sides) by a gallery [**21**]. Square piers, with moulded bases and imposts, support the arches which lead into the aisles. A broad tower once existed above this upper chamber, creating, along with the stair towers, a formidable external silhouette. The design is a more developed version of the scheme seen earlier at St Riquier (*c.*799), the elimination of the round towers allowing for a more compact and coherent plan.

The function of the Carolingian westwork has been debated for over a century. German scholars have claimed that such forceful-looking structures must have had a political dimension, arguing that westworks were associated with the emperors, serving as royal chapels or even audience chambers. In support of the argument, it has been pointed out that a type of westwork existed in the palace chapel at Aachen, where Charlemagne's throne was located in the adjoining gallery. The emperor was the protector of the Church, and so, it is ar-

19 Corvey (Westphalia), westwork of abbey church, *c.*873–85

Cross-section and plan of upper chamber

The ground floor served as an entrance passage, with stairs in the corner turrets leading to the upper chapel.

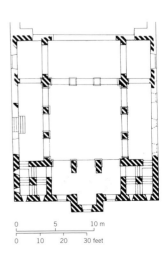

0		5		10 m
0	10	20		30 feet

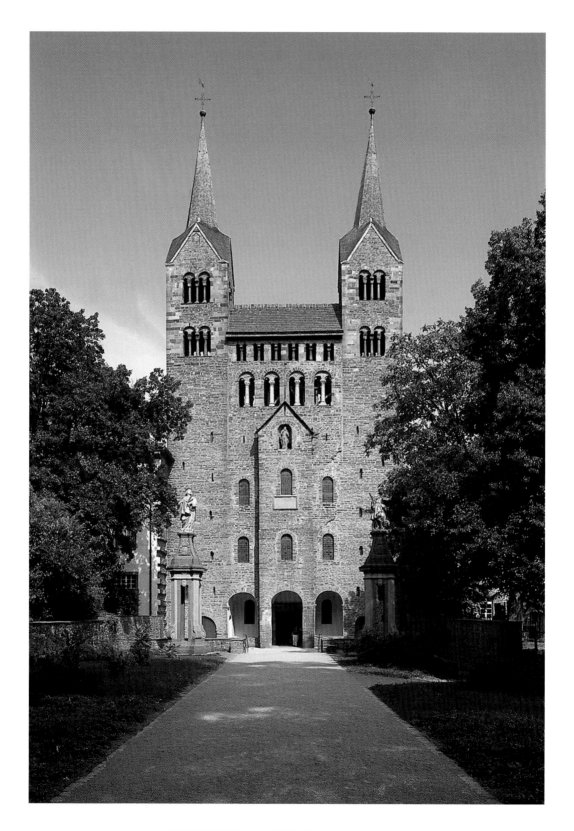

20 Corvey (Westphalia), westwork of abbey church, c.873–85

This is the only Carolingian westwork to survive. The upper sections were added in the twelfth century, as indicated by changes in the character of the masonry.

gued, 'the towers must be seen as symbols of power and justice' (Hans Thümmler).[8] Not all the churches with westworks, however, had imperial connections, and it is now accepted that these complex structures evolved from the liturgical demands of the Carolingian church. They were in fact an ingenious solution to the problem of how to combine an impressive entrance to the church with a liturgical focus at the west end of the building. At St Riquier the main upper chamber of the westwork contained an altar dedicated to the Saviour, which became the centre of attention on great feast days. The entire community would gather here at Easter to watch the unfolding of the liturgy and the drama associated with it. On these occasions a boys' choir was positioned in the galleries: at Corvey 'neumes', an early form of musical notation using letters of the alphabet, have been discovered engraved on the plaster of the gallery walls. The ground floor at St Riquier contained the *capsa maior*, a collection of 25 Christological relics, which the faithful encountered as they entered the building. The westwork thus functioned like an independent church, a sort of vertical shrine, emphasized by the great tower above. In his chronicle of St Riquier (1088), Hariulf tells a story of a monk named Hugh, who was sitting in the choir stalls at the east end of the church when he heard 'sweet voices emanating from the tower where the altar of St Saviour was located … Lifting his gaze to this place, which was sanctified by the presence of angels and the Holy Innocents … he saw a light filling the whole tower', which then spread across the rest of the church. The religious connotations of the westwork could not be more explicit.[9]

Although the westwork was a common feature of major Carolingian churches, it is significant that only one ninth-century example has survived. In its complete form with an upper chapel, as seen at Corvey, it soon became obsolete. As early as 976 the westwork at Rheims Cathedral, which like St Riquier contained an altar to St Saviour, was demolished by Archbishop Adalbero on the grounds that he wished to lengthen the nave. When westworks were erected in the tenth century at Werden (St Saviour) and Cologne (St Pantaleon) substantial changes had been effected in the design. Instead of a crypt supporting an elevated sanctuary, a single space now filled the main body of the structure, and at Cologne this was linked to the rest of the church. On the outside, however, the structures looked as impressive as ever, the three (rebuilt) towers at Cologne forming an architectural composition of immense power. The decline or rather the transformation of the westwork is best explained by changes in the pattern of worship: it was no longer regarded as a suitable setting for the altar of the Saviour; instead the cult of St Michael, the saint associated both with 'high places' and the Last Judgement, came to occupy the space provided by upper chapels and galleries. In England a westwork constructed at Winchester (971–80) was evidently designed to house the

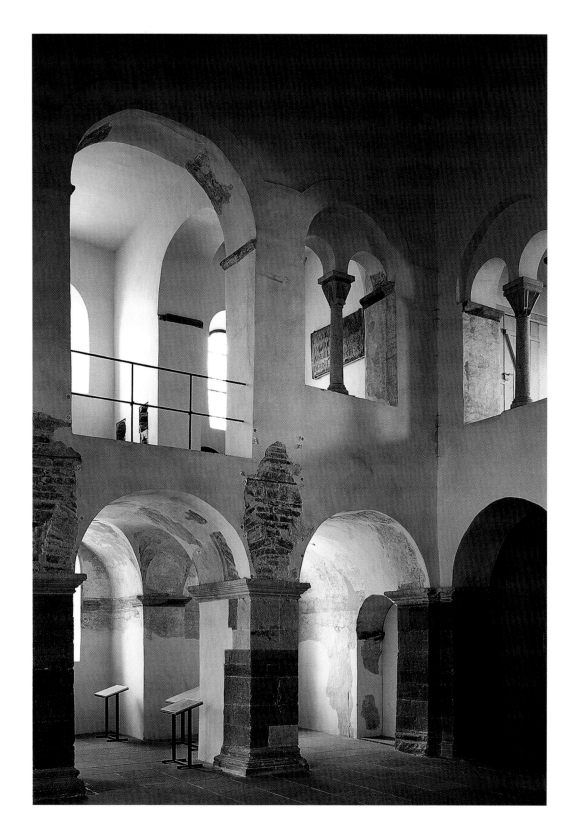

21 Corvey (Westphalia), westwork of abbey church, c.873–85, the upper chapel

It is now known that the elevated chapel within the Carolingian westwork contained an altar dedicated to the Saviour, as at St Riquier

shrine of the local saint, St Swithun. The construction of westworks, along with crossing towers, belfries, and wooden spires, gave early medieval churches a vertical élan that was lacking in the Early Christian period. Compared with the unbroken horizontal mass of buildings like Santa Sabina, it was as if the main architectural emphasis had been rotated 90 degrees.

Many variations on the theme of the westwork appeared between the tenth and the twelfth centuries, especially in Germany, France, and the Low Countries. The famous narthex at Tournus (Burgundy) is in effect an elongated westwork, complete with two turrets as found in Carolingian examples. In this case the large upper chapel was dedicated to St Michael. One of the final echoes of the Carolingian formula can be found in the twelfth-century church at Marmoutier in Alsace [22]. In many instances the two alternative solutions to the design of the west end—the counter apse and the westwork—were ingeniously combined. At Celles-les-Dinant (in modern Belgium), for example, an eleventh-century tower, flanked by stair turrets, contains a choir complete with its own crypt and side galleries. A more ambitious solution was to construct a large apse projecting from the centre of the westblock, as hap-

22 Marmoutier (Alsace), west façade of abbey church, c.1150–60

The composition of a square central tower flanked by two smaller turrets continues the tradition of the Carolingian westwork.

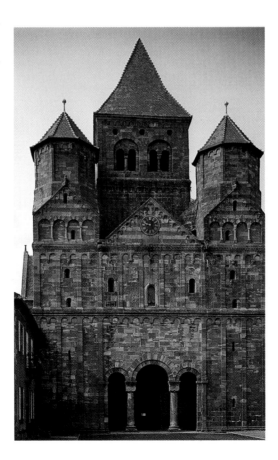

23 Jumièges (Seine-Maritime), abbey church, west façade, 1040–67

The projecting porch along with the chamber above have antecedents in the Carolingian westwork. Compare **20**.

pened at Maria Laach [**13**] and St Gertrude at Nivelles. In the latter case the western massif has a central tower, with turrets north and south; the apse is preceded by a choir opening to the rest of the church, and hidden high above is a series of impressive domed chambers. There are many parallels for this type of structure amongst the Romanesque churches of the Rhine and Meuse. The westwork was destined to leave a complex and exciting architectural legacy, which far outlived the liturgical practices that brought it into being.

Specific features of this legacy include the tower porch, a chapel or gallery over the doorway, and the concept of the twin-towered façade, the so-called 'harmonic façade' which became a fundamental ingredi-

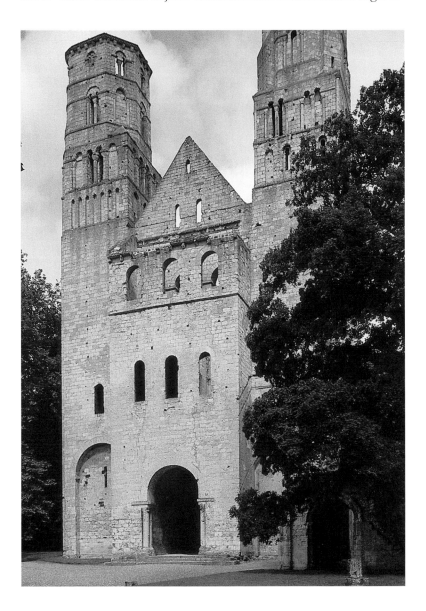

ent of both Romanesque and Gothic design. In the case of the twin-towered façade the link with the Carolingian world is well illustrated at Jumièges, one of the more celebrated abbey churches of Normandy (1040–67) [**23**]. Here the two western towers are separated by a porch with a gallery above, the whole arrangement forming a sort of compressed westwork. The projecting porch is reminiscent of that at Corvey, underlining the Carolingian antecedents of the design. After Jumièges the twin-towered arrangement was repeated in William the Conqueror's church of St Etienne at Caen, whence it passed into general use in Anglo-Norman architecture.[10]

As the Carolingian Empire began to disintegrate in the later years of the ninth century, monasteries in France, like those in Britain, were exposed to the onslaught of the Vikings, for whom monastic settlements offered easy pickings of food and treasure. Monasteries along the Mediterranean coast were equally vulnerable to raiding Moslem armies, while in the east the Magyars made a series of devastating forays into the lands of the former empire, 30 of them between 898 and 955. Monastic chronicles are filled with reports of churches ablaze, treasuries looted, and monks suffering violent deaths. San Vincenzo al Volturno was one of hundreds of monasteries that suffered in this way: on 10 October 881 the abbey was attacked by 'Saracens', and the horror of the event has been underlined in the recent excavations, which have uncovered the debris of a great fire and numerous heavy arrowheads fired from a bow of Moslem type. Faced with relentless attacks, the political fabric of Europe disintegrated into a series of locally based principalities. It was in Germany that a measure of stability was first re-established, with the rise of the Ottonian dynasty in Saxony. Otto I (936–73) gradually established control over the German duchies, and his prestige received a huge boost when he destroyed the Magyars at the battle of the Lech (955). In 962 he was crowned emperor in Rome. Otto I was a hard-headed individual and his revival lacked the ideology of Charlemagne's. Nonetheless the Church prospered and it became one of the main bastions of imperial power. Although based on the legacy of the Carolingians, Ottonian architecture included a number of new features, two of which can be seen at Gernrode.

The church at Gernrode belonged to a nunnery, which was founded in 961 by Margrave Gero, Otto I's lieutenant on the Thuringian march. Although savagely restored between 1859 and 1865, the church provides a good insight into Ottonian design [**24**]. There is a basilican nave, an eastern transept, and a square-planned choir, with a crypt below. The west end, which was remodelled in the twelfth century, originally had a large upper gallery with circular stair turrets on each side. The two most original features are the galleries which run the full length of the nave and the presence of both piers and columns to support the main arcades.

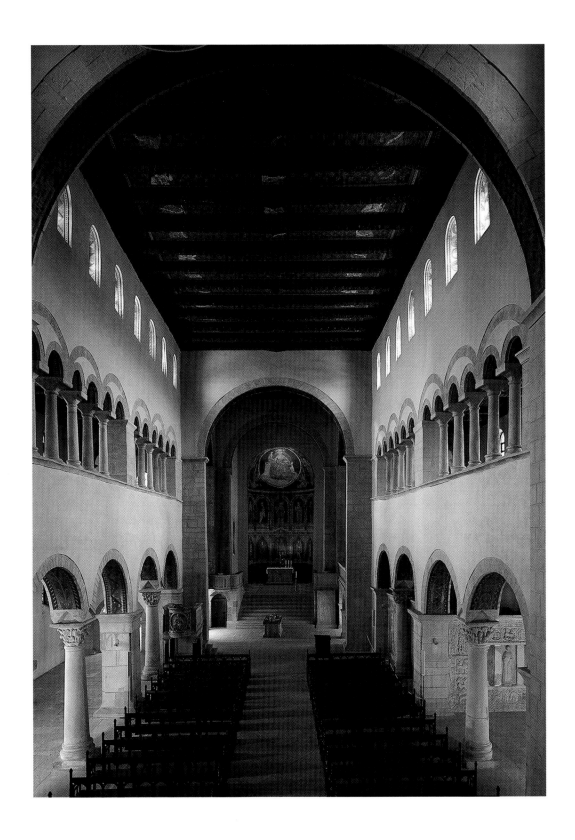

24 Gernrode (Saxony Anhalt), founded 961

Built as a church for nuns by Margrave Gero after 961. The alternating supports of the nave are subtly linked to those in the gallery. Gernrode was one of the first basilican churches in northern Europe to include galleries.

These galleries have attracted much interest. Although rare in Ottonian architecture, they became a feature of many of the great churches of Europe during the eleventh century and their origin and function are hotly debated topics. Several Early Christian basilicas in the East were provided with them (including the basilica at Jerusalem) and two fifth-century examples still survive at Salonika. They were also present in one of the Early Christian basilicas at Trier, so the concept was not unknown in northern Europe. It is not so much the origin that presents a problem, but the purpose. How were the galleries used by the nuns at Gernrode and why did they become such a fundamental element in Romanesque churches? It has been claimed that in the Byzantine world galleries were used by female members of the congregation, but there is no evidence to suggest that this was how they were employed in the West.

In many instances altars were located in the galleries, particularly towards the east end of the church. At Santiago de Compostela, for example, the author of the *Pilgrim's Guide* (*c*.1130) mentioned three altars, the principal one dedicated to St Michael. Research on the liturgy of the early medieval church has demonstrated that upper chapels could occupy an important role in the routine of worship: in some cases galleries were used for antiphonal singing on feast days. But these requirements scarcely justified the enormous galleries found in Romanesque buildings such as St Etienne at Caen [152], Ely Cathedral [142], and Santiago de Compostela [101]. It has been suggested that in some of the great pilgrimage churches galleries provided additional accommodation, particularly during major celebrations, and one scholar has even claimed that pilgrims slept there. However, without stepping to the very edge (a dangerous undertaking), the eager pilgrim would have found it difficult to get a view of what was going on below; indeed, the low parapets would have posed a serious hazard when large crowds gathered together (the palace chapel at Aachen was one of the few buildings where the architect was sufficiently security conscious to provide railings). An alternative explanation, in aesthetic and emotional terms, is offered by the *Pilgrim's Guide*. Having compared Santiago de Compostela with a regal palace, the author suggests that 'he who visits the galleries, if sad when he ascends, once he has seen the pre-eminent beauty of this temple, is rejoiced and filled with gladness'. The words in fact come from Tertullian, but the architectural feeling appears genuine enough. While the purpose and meaning of galleries in medieval architecture remain uncertain, they seem to have been a mark of status rather than a functional necessity. Galleries were usually quiet, secluded places, as a monk from St Martin's at Trier appreciated: he retreated there to sleep off periodic bouts of drunkenness.[11]

The second novelty at Gernrode, the insertion of a square pier into a line of columns [24], may have had some structural rationale, though

25 Hildesheim, St Michael, 1010–33

Built under Bishop Bernward. The unusual sequence of columns and piers enhances the sense of geometrical order.

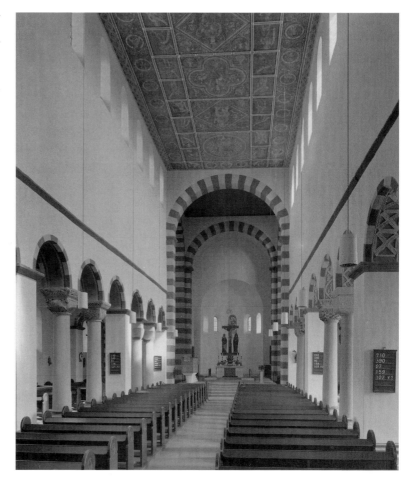

the arrangement was probably valued as an aesthetic device. A solitary pier in each arcade, acting like a punctuation mark, divides the nave into two sections, a division which is carried through into the gallery. The visual consequences of this are significant: in place of the smooth horizontal flow found in a columnar basilica, one can begin to read the elevation as a pair of vertical elements.[12] This 'alternation' of piers and columns was exploited in a number of Ottonian churches in Saxony, the best known being St Michael at Hildesheim (1010–33), where there are two columns for each pier [**25**]. St Michael's was founded by Bishop Bernward, a colourful individual, who had served as tutor and adviser to Otto III. The design of St Michael's has a remarkable sense of geometrical clarity, for the square space of the crossing is repeated in each transept and is then repeated three times to establish the length of the nave [**27**].[13] The alternation coincides with this geometry, for the three units of the nave are defined by the location of the square piers. This visual definition of the space was to become a feature of the Romanesque style.

26 Hildesheim, St Michael, 1010–33

External form. The arrangement of 'masses' at both ends of the building was a feature derived from Carolingian architecture.

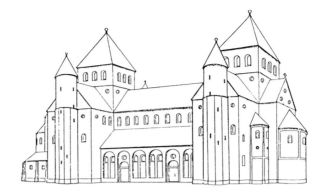

27 Hildesheim, St Michael, 1010–33

Plan

A large crypt was built under the western choir. Note the manner in which the presence of piers divides the nave into three sections.

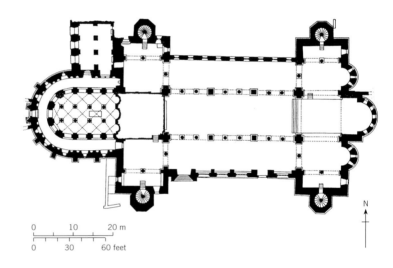

0 10 20 m

0 30 60 feet

N

Symbolic Architecture

<div style="font-size:large">3</div>

Large buildings for congregational worship were not the only architectural requirements of the early Church. Baptism was an important ceremony, a solemn rite of initiation, which usually took place in a separate building, or at least a separate room. In addition, following Roman funerary traditions, private mausolea were required by affluent and powerful members of the Christian community. Then there was the desire to preserve the memory of saints and martyrs through the construction of monuments which would glorify their achievements, a class of building generally known as martyria. What unites these different categories—baptisteries, mausolea, and martyria—is that they were almost invariably centralized in design, in other words the plan was symmetrical around a central vertical axis. Simple geometrical forms—squares, circles, octagons, cross shapes, and a variety of polygons—were all exploited to produce designs which were remarkable for their visual impact and subtlety. The forms adopted for each type of building were not discrete; there were occasions when virtually the same layout was employed for each of the three categories, despite their different functions.

The geometrical purity of centralized buildings made them particularly susceptible to symbolic interpretation. As the medieval world regarded almost everything in terms of symbol and allegory, architectural forms were readily associated with specific Christian beliefs. In many cases the symbolic meaning of the structure, in effect its 'iconography', proved to be more important than its utilitarian function. Unravelling the layers of meaning in medieval architecture has proved a complex process: meanings were not immutable, and, as modern scholarship has emphasized, interpretation could differ according to the situation of the onlooker.

In the early Church baptism was usually administered by the local bishop at Easter or Pentecost, the catechumens normally being adults. Within the baptistery, the ceremony took place around a large piscina, set in the floor, with two or three steps allowing access down into the

28 Fountain of Life

From Gospel Book of St Médard of Soissons, early ninth century

Imbued with symbolic meaning, a font surmounted by columns like that found in many early baptisteries (compare **29**) lies at the centre of Paradise.

water [**29**]. Once candidates had been immersed, they were anointed and received a white robe to signify entry into a new, purified life. Most baptisteries were relatively straightforward buildings, sometimes square or circular in plan, though by the fifth century the most popular shape was the octagon. In some cases alternating rectangular and semi-circular niches opened off the central space, as at Lomello, south-west of Milan [**30**]; elsewhere the octagon was incorporated into a square, with niches set into the four angles. This was the case at Fréjus, in southern France, where eight granite columns define the interior of the octagon, above which is a circular drum and a dome. The more elaborate interiors were furnished with blind arcades and engaged columns, as in the Orthodox baptistery at Ravenna. Some baptisteries were more ambitious in design, employing a double-shell structure, with an interior colonnade. Such was the case at the Lateran in Rome, where the baptistery had an octagonal core defined by eight free-standing columns. Perhaps the finest baptistery is that at Nocera, east of Naples, where there is a tight inner ring, made up of 15 paired columns [**29**]. This belongs to the sixth century, and like most baptisteries it was covered by a dome.

The provision of a large water basin within a vaulted chamber has led scholars to assume that the Christian baptistery was adapted from the Mediterranean bath house. While there are certainly parallels, there are equally strong links with funerary architecture. This may sound surprisingly morbid, but it is important to remember that during the rite of baptism candidates experienced what was regarded as a mystical death, being born again in Christ. St Paul in his teaching equated baptism with Christ's death and resurrection,[1] a link that was made explicit when the ceremony was held at Easter. It is not difficult

29 Nocera (Campania), baptistery, sixth century

Engraving by L. J. Desprèz, 1783

The twin columns defining the central space are reminiscent of those at Santa Costanza (**31**), though at Nocera they lack an entablature. The columns surrounding the font add to the veritable forest of columns inside the building.

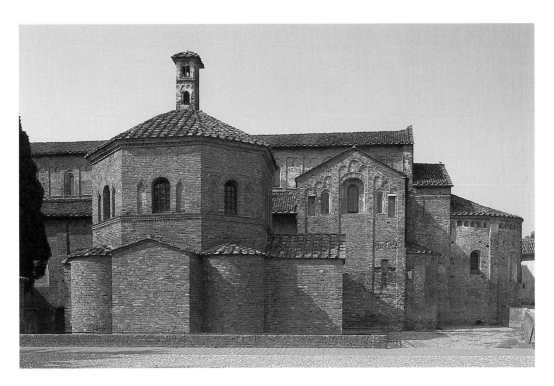

30 Lomello (Lombardy), Santa Maria Maggiore, eleventh-century church with baptistery attributed to the eighth century alongside

The octagonal baptistery has a sequence of semicircular and rectangular projections at ground-floor level. Although much restored, the church is a good example of the style known as 'first Romanesque'. Note the line of niches below the roof of the apse at the extreme right.

to see why the octagon became a favourite shape. Eight was a symbol of regeneration—the world started on the eighth day of Creation—and it was also a symbol of resurrection, for Christ rose from the dead on the eighth day of the Passion. St Ambrose and other Early Christian fathers emphasized that, as a spiritual regeneration, baptism was represented by the number eight. But the symbolism of baptisteries extended beyond mere numerology. The basin of water, often enclosed by a 'ciborium' or canopy as at Nocera, was interpreted as the Fountain of Life.[2] The meaning is made very clear in a Carolingian gospel book, in which a baptismal water basin, surrounded by eight thin columns, is adored by the animals of Paradise [28]. Here was an allusion to 'the pure water of the river of life', which in Christian teaching was equated with the blood that Christ shed on the cross.[3] The symbolism of baptism operated at many levels, which in the minds of onlookers were wedded to the architecture and decoration of the baptistery itself.

There is a heavy concentration of baptisteries in northern Italy, where they are almost invariably built of brick. The distribution extends along the south coast of France and also into Dalmatia. North of the Alps baptisteries are rare and it is curious that so few seem to have been erected in the seventh and eighth centuries, when mass conversions were taking place among the Germanic peoples of the north. Perhaps the numbers were too great and time too short. As infant baptism gradually became the norm, separate baptisteries were abandoned and replaced by fonts set up in the nave of the church. One is clearly

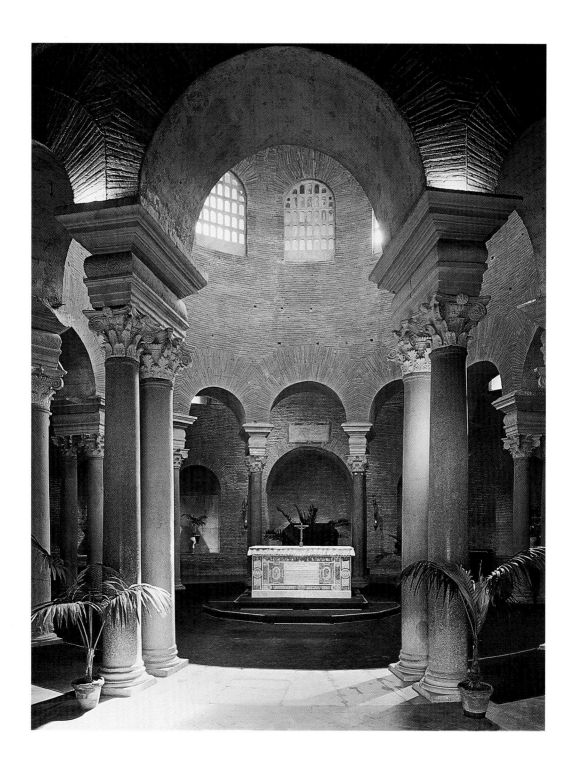

31 Rome, Santa Costanza,
*c.***350**

Built for Constantina (d. 354), daughter of the emperor Constantine. Designed as a mausoleum adjoining the church of Sant'Agnese; recent research suggests it was erected on the site of a baptistery.

32 Rome, Santa Costanza,
*c.***350**

Plan

Centralized in design, although a slight variation in the spacing of the piers, along with niches in the outer walls, provides a subtle allusion to the Cross.

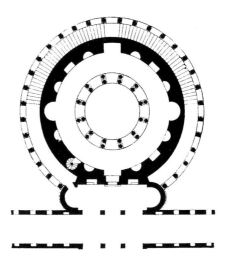

marked, for example, on the plan of St Gall (*c.*830) [**123**]. Italian cities, however, clung to the tradition of a separate building, and the towns of Florence, Parma, Cremona, and Pisa built monumental examples in the eleventh and twelfth centuries. These were far grander than anything required by the rite of baptism, a point which underlines the strength of religious and historical tradition over the practical requirements of the liturgy.

Turning to Christian mausolea, the outstanding example in Rome is the church of Santa Costanza, built for Constantine's daughter, Constantina (died 354), apparently on the site of an earlier baptistery. Originally attached to the church of Sant'Agnese, it was designed on concentric principles, with the central circular space being surrounded by a colonnade, followed by an ambulatory, and, outside the main walls, a circular portico (the latter now destroyed) [**32**]. The colonnade, formed of 12 pairs of Corinthian columns, has an extraordinary dignity, like a group of mourners moving in a dignified, circular procession [**31**]. Sixteen clerestory windows throw light into the central space, which is covered by a hemispherical dome. Although circular in plan, the building includes a subtle allusion to the Cross: the arches on the four cardinal points are slightly wider than the others, and they correspond to apses set within the outer wall. Constantina's splendid porphyry tomb, which stood under the eastern arch, is now in the Vatican museum (a copy remains in the church). While Santa Costanza was a Christian building, its design owed much to the tradition of Roman imperial mausolea, not least the combination of the circle and the dome. Between the fourth and sixth centuries, similar mausolea, though usually much smaller in scale, were added to the flanks of Old St Peter's and other great cemetery churches of Rome.

33 Ravenna, mausoleum of Theodoric (d. 526)

Planned in the form of a decagon and built in ashlar masonry, with a roof made of a single block of stone, this is one of the best-preserved mausolea from the late Antique era. A gallery originally surrounded the upper level. Note the joggled joints in the stones of the arches.

Two well-preserved mausolea at Ravenna illustrate the variety of centralized forms that were open to Christian patrons. One was built about 424 (perhaps initially as a chapel rather than a mausoleum), for Galla Placidia, sister of the emperor Honorius. Constructed beside the church of Santa Croce, its architectural interest is rather overshadowed by the fame of its mosaic decoration. It is built of brick, with a central tower, and its plan is that of a Greek cross. Very different in design is the mausoleum of Theodoric, the Ostrogothic king, who died in 526. Constructed of ashlar masonry, unusual in Ravenna, it is a two-storey structure, with a ten-sided base supporting a cylindrical drum [33]. The exterior of the cylinder was originally furnished with colonettes and arches, making it somewhat less dour than it now appears. The gloomy lower chamber has a cross-shaped plan, while the room above is circular. The monument is celebrated for its domed roof, cut out of a single block of Istrian limestone, 35 feet across, a *tour de force* in terms of quarrying, carriage, and construction. The pierced spurs around the roof were presumably intended to help in lifting the stone, though it is

curious that they were never shaved off. Although the general shape recalls imperial mausolea of an earlier age, certain details of the design, including joggled voussoirs and the use of stone rather than brick, suggest the involvement of craftsmen from the East. It is worth noting that the mausolea of Constantina, Galla Placidia, and Theodoric were planned, respectively, on the basis of concentric circles, an equal-armed cross, and a circle within a decagon, a geometrical range which gives an indication of the diversity of funerary architecture in the Early Christian world.

Closely related in design were the martyria, churches designed to commemorate the burial places of saints and martyrs, to shelter their relics, and to honour places associated with the life of Christ. During the fourth century concerns for the memory of those who had been killed or executed for their faith, allied to the new architectural confidence of the Church, meant that martyria began to appear in many parts of the empire. At Bethlehem an octagon, attached to a basilica, was built over the grotto which marked the site of the Nativity, and in about 378 another octagon (known as the Imbomen) was erected on the Mount of Olives from where Christ ascended into Heaven. This had an inner circular core, supported on 16 columns, encircling the footprints of Christ, the latter miraculously preserved after more than three centuries. The most sacred martyrium of all, however, was that constructed over the tomb of Christ, the Holy Sepulchre in Jerusalem. The construction of a church on this site was no easy task. The rock-cut tomb lay buried under a Roman temple, which first had to be demolished, a task begun in 325 on the orders of Constantine. For some time the tomb was left in the open, covered only by a baldacchino, but between 348 and 380 it was enveloped by a large centralized building, known as the Anastasis Rotunda (*anastasis* being the Greek word for resurrection).[4]

Unfortunately only fragments of this original building survive. It was burnt in 614 by the Persian king Chosroes Parviz, and then in 1009 the Arab ruler Caliph Al Hakim made a systematic attempt to demolish it. Reconstructed in 1048 under the direction of the Byzantine emperor Constantine Monomachus, the Rotunda was again ravaged by fire in 1808. Despite this troubled history, descriptions by early pilgrims, miscellaneous drawings, and a steadily accumulating body of archaeological evidence have allowed scholars to establish the broad outlines of the building as it appeared in 380 and after 1048. As the church was much copied in the West during the early Middle Ages, it is important to distinguish the two main phases of its architectural history.

The Rotunda was designed as a double-shell construction, with an outer polygonal wall and an inner arcade supported on piers and arches [34]. The central space, enclosing the tomb, was thus surrounded by an

34 Jerusalem, church of the Holy Sepulchre

Plan of *c*.380. (1) atrium; (2) basilica; (3) Rock of Calvary; (4) courtyard; (5) repository of True Cross; (6) tomb of Christ; (7) Anastasis Rotunda

The Anastasis Rotunda housing the Holy Sepulchre was linked to a courtyard, beyond which lay a large five-aisled basilica.

ambulatory. There were 20 supports in all, 8 piers and 12 columns, the latter over 23 feet high. Two piers were placed together on the four main axes, which gave the impression to some visitors that they formed a solid stretch of wall with an opening in the centre. Between the twin piers came the columns, arranged in groups of three. The symbolism implied by the 12 columns must have been deliberate and it was certainly not lost on later generations of pilgrims. The inner ring supported a wooden roof, conical in shape, apparently with a hole or oculus in the centre to provide a direct link between the tomb and the Heavens. The outer wall of the ambulatory included three apsidal projections, placed on the northern, western, and southern sides, providing a discreet allusion to the Cross, as at Santa Costanza. On the eastern side, the ambulatory was interrupted by a portico, which communicated directly with the central space of the Rotunda. The portico opened onto a courtyard, at the south-east corner of which lay the Rock of Calvary.

Substantial modifications were introduced to the design of the Rotunda when it was reconstructed under Constantine Monomachus in 1048. The main columns were reduced to half their original height, and a gallery was inserted above the ambulatory. Both the ambulatory and the gallery were vaulted in stone. The portico was replaced by a huge apse, which was itself removed when the church was extended by the Crusaders in the twelfth century. The present condition of the Anastasis Rotunda, patched and remodelled over the years, is very disappointing, giving little indication of the building that greeted the Crusaders when they arrived in Jerusalem in 1099.

There is general agreement among scholars that the design of martyria owed much to Roman mausolea. The circular form, the presence of niches in the wall, and the masonry domes can all be traced to this source. In a funerary context the circle suggested both perfection and eternity, while the shape of a hemispherical dome evoked thoughts of the cosmos. As martyria were 'the mausolea of the saints', it was natural for Christian architects to exploit these well-established traditions. Often referred to as *heroa*, imperial mausolea were far more than

mere burial places; they developed into quasi-temples, which provided a focus for the cult of the deceased emperor. The fact that some of these *heroa* were associated with the enemies of the Church did not seem to matter. Ironically, the huge domed mausoleum at Split, built for the emperor Diocletian, a persecutor of Christians, has often been compared with Christian martyria. But the architecture of the Christian buildings drew on a far wider range of sources, particularly in the use of 'double-shell' designs, with interior colonnades and peristyles; these invite comparison with palace architecture, garden buildings, and the great bath houses, rather than with the traditional mausoleum.

Unusually complex in its geometry is the church of San Lorenzo in Milan, built about 370. By this time Milan had become one of the principal cities of the empire and it produced an exciting array of Christian buildings. San Lorenzo, which was founded outside the walls of the city, has a centralized plan of extraordinary beauty, composed of interlocking squares and quatrefoils. The central space can be read as a a a square, the corners defined by L-shaped piers, with arcades curving outwards on each side. Surrounding the central core are ambulatories and galleries. As Richard Krautheimer explained, 'the double-shell construction, the ensuing complexity of the spatial design, and the overlapping views combine with the contrasts of light and shade to create an interplay of superb richness'.[5] From the outside the silhouette of the building was equally extraordinary, with the central dome (its original form is unclear) rising between four corner towers. San Lorenzo was substantially rebuilt during the Renaissance, and, while one can appreciate the design, the interior has unfortunately lost its original decoration and its ancient atmosphere. But what exactly was the church built for? It does not appear to have housed the body of a saint or martyr, so it was not a martyrium in the strict sense. Some authorities believe it was an imperial chapel, an argument which is supported by its apparent similarities to the 'Golden Octagon', a centralized church founded by Constantine at Antioch (327–41). What seems clear is that double-shell structures, with arcades that curved outwards from the central space, had a background in palace architecture, specifically in the design of imperial audience halls.

The ideas expressed at San Lorenzo were later exploited in a group of buildings erected during the reign of the eastern emperor Justinian. Hagia Sophia in Constantinople was the supreme example, but a related design was used for the church of San Vitale in Ravenna (*c.*530–47). The church is said to have been funded by a local banker, known appropriately as Julianus Argentarius. The interior has an opulence worthy of the benefactor's profession, and, with many of its mosaics and marble revetments still intact, its atmosphere of mystic splendour is unforgettable [**35**]. The central octagon, which is defined by massive piers at each angle, is surrounded by an ambulatory and

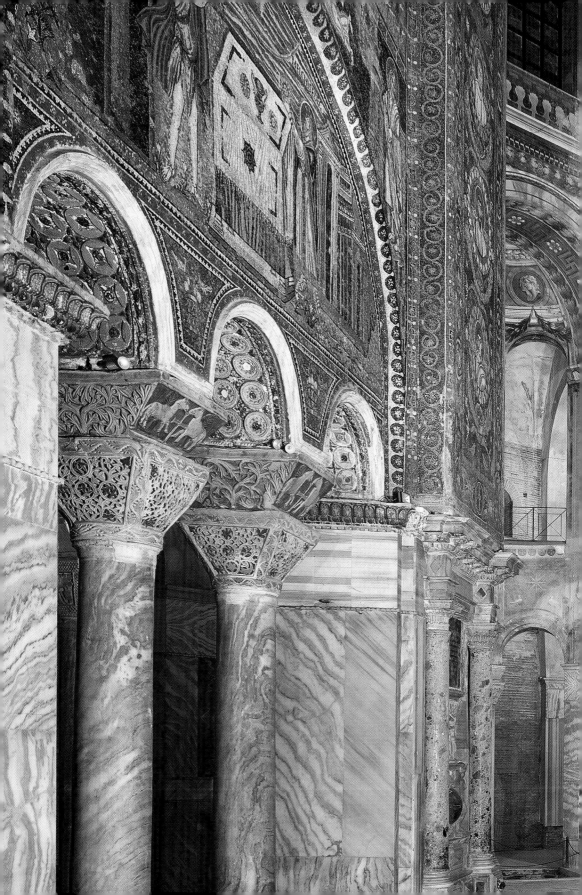

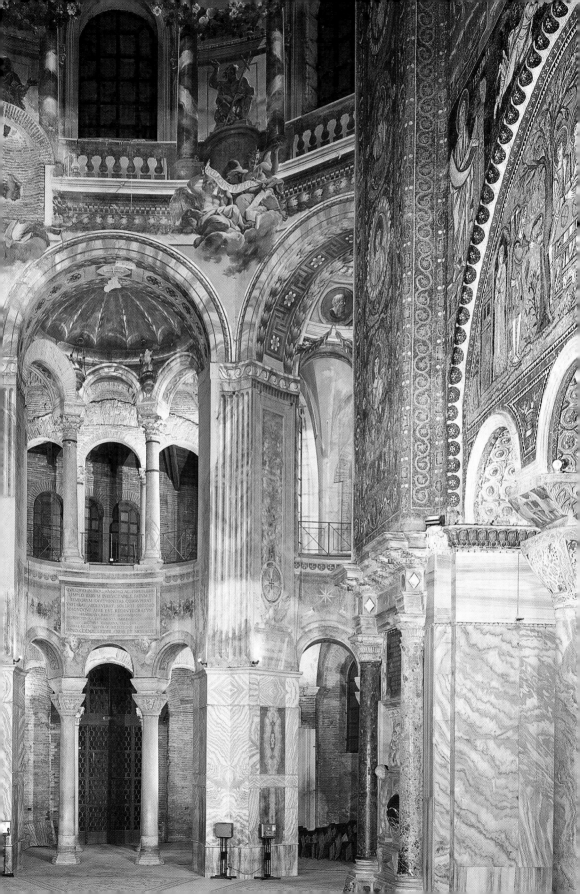

35 Ravenna, San Vitale, consecrated 547

One of the most complex designs of the late Antique era, with its galleries and 'billowing niches' surrounding the central octagonal space. The design is closely related to buildings in Constantinople.

gallery, both originally with timber ceilings. Seven of the octagon's eight sides open into monumental *exedrae* or niches, composed of superimposed groups of triple arches. The effect is to create screens of curving arcades, a dynamic feature which suggests that the central space is bursting out of its confines. The eighth side leads into a square chancel and an apse, adding a longitudinal accent to what is otherwise a symmetrical design. There has been much discussion over the issue of whether San Vitale is a Byzantine or a western building. The marble columns and capitals were evidently imported ready-carved from the Byzantine quarries at Proconnesus and at least some of the mosaics appear to be by artists from Constantinople. The overall design must also have come from the East. But some of the building techniques are local and these include a curious way of constructing the central dome. This is in reality an eight-sided 'cloister vault', formed out of a continuous series of clay tubes, in effect hollow cylinders of brick (the same method was used in the Orthodox baptistery at Ravenna). San Vitale is the most accomplished of all the centralized churches in the West, its simple geometrical forms producing an interior space which is truly visionary.

The addition of a chancel, which compromised the logic of the centralized design, illustrates a widespread reluctance on the part of the Church to place the altar in the centre of the building. Yet this was the spot where the altar and its relics would have acquired most emphasis. Instead the central space came to be used like the nave of a basilica. Soon after it was finished, San Vitale was actually described as a basilica, an indication that by the sixth century the functions of basilica and martyrium were thoroughly confused. Initially the two architectural types appear to have served different purposes. Basilicas were intended for the regular liturgy of the Church, to accommodate large crowds meeting for mass on Sundays and during Christian festivals, while centrally planned martyria were erected for commemorative purposes. The distinction, which had never been absolute, became increasingly blurred over the course of time. In the Byzantine Empire centralized buildings with domes eventually became the dominant form of church building, while in the West basilicas began to absorb some of the features of centralized buildings. Once ordinary churches began to acquire relics of their own, they took on the commemorative functions of the martyrium. Indeed one of the principal tasks confronting western architects in later centuries was the design of appropriate settings for relics within the context of a basilican structure. It is interesting to observe that in a few instances the problem was resolved by adding a complete rotunda to a church of basilican type, an arrangement already foreshadowed in the fourth century at Bethlehem.

The baptisteries, mausolea, and martyria of the Early Christian period shared a common repertoire of forms, the majority of which were inherited from Roman imperial architecture. To appreciate these in-

terconnections one only has to compare the mausoleum of Constantina with the church of Santo Stefano in Rome or the baptistery at Nocera, each consisting of a double-shell building, an inner ring of columns, and a central dome. While this might seem puzzling, it is important to remember that in allegorical terms the buildings had much in common. Ideas of death, burial, resurrection, and salvation were associated with baptism, just as they were with the graves of the saints. Baptism and death, the two poles of Christian existence, were thus firmly linked in iconographical terms, being represented by buildings that were centralized in plan and covered with a dome or vault.

Two and a half centuries after it was completed, the church of San Vitale was employed as a model by the architects of the palace chapel at Aachen [**36, 37**]. Charlemagne had visited Ravenna and it seems likely that, at a personal level, he was deeply impressed by the architecture and decoration of the church.[6] He evidently ordered his own version, transferring the architecture of Ravenna north of the Alps, just as he had transferred more portable objects like the statue of Theodoric. San Vitale was an ambitious model to take, and certain features of its design were simplified [**36**]. The curved *exedrae* were removed and the triple-arched screens were restricted to the gallery. Without the curve, the columns of the upper screen hit the main arch of each bay in an arbitrary fashion, a solecism that no classically trained architect would have tolerated. Yet only the most perceptive members of the Carolingian court would have spotted these details; with its mosaics (now lost), marble veneers, domed interior, and triple screens, the chapel must have seemed a good approximation of the great church in Ravenna.

From the start the palace chapel was intended to be viewed as an image of the Heavenly Jerusalem, as suggested by an inscription on the interior cornice.[7] It cannot be a coincidence that the circumference of

36 Ravenna, San Vitale (left), and Aachen, palace chapel (right)

Comparative plans

The 'billowing niches' seen at Ravenna were probably too complex for the Carolingian builders. Note also the different shape of the outer walls.

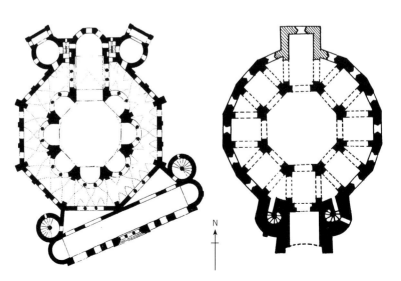

N

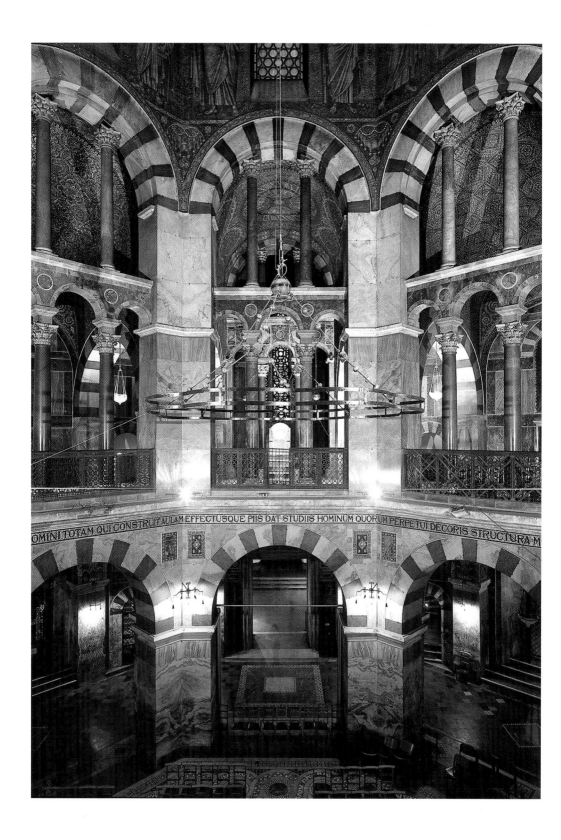

37 Aachen, palace chapel,
completed 805

Although simplified in design,
the architecture was inspired
by San Vitale in Ravenna,
which Charlemagne had seen
during his expeditions to Italy.
The quality of the materials,
including the bronze of the
railing, is very evident.

the inner octagon (measured along the inner face of the piers) comes to 144 Carolingian feet, just as the walls of the Heavenly Jerusalem described in the Book of Revelation (21:17) came to 144 cubits. The use of variegated marbles heightened the celestial atmosphere, which culminated in the dome, where the four and twenty elders were depicted adoring the throne of God (Revelation 4:1–4). Charlemagne's own throne was situated in the gallery, an elevated position halfway, it must have seemed, between earth and Heaven. Carol Heitz described the arrangement as presenting a 'pyramid of power', demonstrating the emperor's status both in relation to God and to ordinary mortals, most of whom would have been restricted to the ground floor of the building.[8] The Carolingians thus adapted the architectural form of San Vitale to a new context, using the design to express the ideological assumptions of the imperial court. It is interesting to observe that the double-shell scheme may well have originated in the palace architecture of the Roman emperors, before being exploited for Christian churches; in historical terms, therefore, it was a highly appropriate choice for the design of a palace chapel. Whether or not Charlemagne and his advisers were aware of this is an open question.

The palace chapel at Aachen was one of the most influential buildings of the Middle Ages, a popularity that had more to do with its associations than with its design. As the burial place of Charlemagne, as well as the setting for imperial coronations, it became both a dynastic shrine and an icon of imperial power. The influence of the chapel operated in two distinct ways, producing visual copies and what might be called 'functional copies'. In several cases the plan was reproduced quite accurately, as at Nijmegen in Holland and Liège in Belgium. The example at Liège was commissioned by Bishop Notger (972–1008), apparently as his private chapel and burial place. While this was a logical use of the model, it is not so easy to explain why, during the eleventh century, the Aachen design attracted the interest of nuns: the interior elevation was repeated in convent churches at Essen, where it was used for three bays of the west choir, at St Maria im Capitol in Cologne, where one bay was employed as a screen across the west end of the nave, and at Ottmarsheim in Alsace, where the entire plan was reproduced, albeit in a somewhat simplified form [38].[9] In each case the architect must have travelled to Aachen to examine the prototype. At Essen the nuns may have wanted to remind everyone of the convent's imperial connections, but the other nunneries were probably more interested in the fact that Aachen was dedicated to the Virgin Mary and possessed the remains of her shroud. The architecture of the palace chapel thus came to be associated with a variety of ideas, not all of which were connected with notions of imperial power or the heroic exploits of Charlemagne.

The English chronicler William of Malmesbury cited Aachen as

38 Ottmarsheim (Alsace), abbey church, c.1030

Built to serve a community of nuns, the church was clearly modelled on the palace chapel at Aachen (**37**).

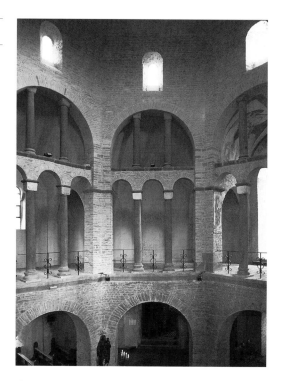

the source for a chapel at Hereford, which at first sight bears little resemblance to the supposed model. William explained that Robert, bishop of Hereford (1079–95), built 'a church of elegant form, having copied for its design the basilica at Aachen'. Historians have for long identified this building with a double chapel belonging to the bishop that was demolished in 1737 and is now known only from engravings; whether or not this was the building William of Malmesbury had in mind is an open question.[10] Nonetheless the building that survived until 1737 is of great interest as its design is linked to a group of episcopal chapels within the German Empire, the so-called *Doppelkapellen*. Roughly square in plan, the chapel at Hereford contained two storeys linked together by an open well in the centre of the building. While the rather meagre square opening at Hereford could scarcely be compared to the great octagonal space at Aachen, the bishop could nonetheless worship in the elevated position of the gallery, while his more humble retainers gathered below. It was the hierarchical arrangement, conveniently expressing the social order of the time, that may have suggested the comparison with Aachen.

Within the empire the concept of the double chapel was well established by the end of the eleventh century, when it became a common formula for both imperial and episcopal chapels, no doubt because of the supposed connection with Charlemagne. There are (or were) examples at Goslar, Speyer, and Mainz, along with another in the castle at Nuremburg. The twelfth-century chapel of St Godehard at Mainz

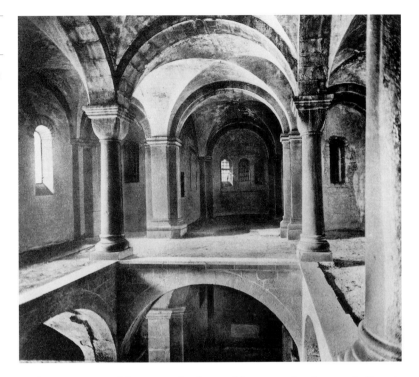

39 Mainz Cathedral, St Godehard's chapel, twelfth century

A characteristic example of the German *Doppelkapelle*, in which a ground-floor chapel was linked by a central opening to the upper level.

is characteristic of the group [**39**]: roughly square in plan, each floor is divided into nine bays by four piers or columns; both storeys are vaulted but the centre bay of the ground floor is left open, connecting the two levels, as was the case at Hereford. A small chancel with an apse opens to the east. A more sophisticated *Doppelkapelle* exists at Schwarzrheindorf, where it formed part of a castle belonging to Count Arnold von Wied (archbishop of Cologne, 1151-6). The original design had a cruciform plan, but shortly before Arnold's death the chapel passed to a community of nuns, who compromised the centralized emphasis by adding a short nave. In this case the two floors of the building are connected by an octagonal opening. With its external arcades and galleries, the chapel at Schwarzrheindorf is like a miniature version of the great Romanesque churches of the Rhineland, though this local identity should not obscure the fact that in its plan it belongs to a class of buildings whose ultimate pedigree can be traced back to the palace chapel at Aachen.

The square plan, with four internal piers or columns, as seen in many of the German *Doppelkapellen*, provides the core of the brick-built church belonging to the fortress at Kalundborg (Denmark) [**40**]. However, the parallels cease at this point, for Kalundborg did not have two storeys and its plan was extended in each direction to form a Greek cross. Four slender granite columns in the centre support a square tower, and four other towers, octagonal this time, rise from the extremity of each arm to produce a silhouette which is one of the most memo-

Founded by Esbern Snare.
Built in brick in the form of a
Greek cross, with a central
tower and four corner towers.
The church was extensively
rebuilt in the nineteenth
century, following the collapse
of the central tower.

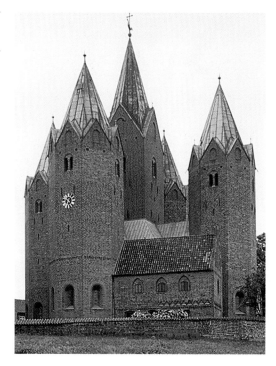

rable architectural sights in Europe. Its builder, Esbern Snare, was particularly agitated by the fall of Jerusalem to the Moslems in 1187 and his church at Kalundborg managed to convey an emphatic image of militant Christianity.

The most frequently copied building in medieval Europe was not in fact the chapel at Aachen but the church of the Holy Sepulchre in Jerusalem. The copies usually take the form of a rotunda, with an inner space separated from an ambulatory by a ring of columns. The 'round church' at Cambridge (c.1125) is a good example of the genre. In this case the inner core is supported on eight stout Romanesque columns, with a low gallery and a clerestory above [41], reflecting the three levels found at Jerusalem after 1048. The fact that the number of columns rarely coincided with the number used in Jerusalem did not seem to be a matter of concern (it is worth remembering that there were 12 in the Holy Sepulchre until 1009, 14 after the rebuilding of 1048). The builders at Neuvy-Saint-Sépulcre (Berry) managed to produce an inner ring with 11 columns, which is difficult to explain unless they were relying on reports of pilgrims who could not count. Perhaps the most puzzling 'copy' is that erected by Bishop Meinwerk of Paderborn in 1036. He had taken the trouble to send an emissary to the Holy Land to collect the measurements, but the building that emerged was a cruciform structure without an ambulatory, bearing no apparent relationship to the supposed model.[11]

In 1942 Richard Krautheimer attempted to explain these inconsis-

41 Cambridge, St Sepulchre, c.1130

Engraving by Rupricht Robert

Furnished with massive cylindrical piers, typical of Anglo-Norman Romanesque, its centralized form alludes to the Anastasis Rotunda in Jerusalem (**34**).

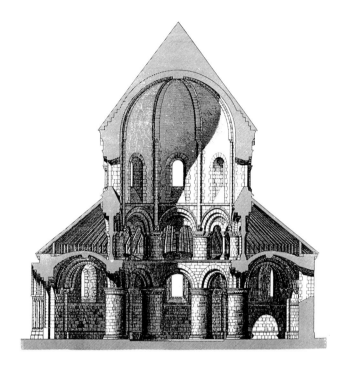

tencies in a study that has proved highly influential.[12] He argued that imitation was a selective process and that in the minds of the medieval clergy a few points of resemblance were sufficient to make a connection. This might include copying certain measurements, or repeating the number of the piers, or incorporating an ambulatory and gallery, but not necessarily reproducing them all. The essential requirements were that the building should be round or polygonal and include a dedication to the Holy Sepulchre. Krautheimer's argument put an intellectual gloss on the distinctions, some of which can be explained in more prosaic terms. At Paderborn for example the bishop chose the wrong moment to copy the Holy Sepulchre, for it had been almost obliterated by Caliph Al Hakim 25 years before. Medieval builders could make reasonably accurate copies when the opportunity arose—witness the unknown architect at Ottmarsheim. The problem with the Holy Sepulchre was that it was so far away and builders had to depend on the rather amateurish recollections of clergy and other pilgrims.

But why were the clergy and their patrons keen to reproduce the church of the Holy Sepulchre? One reason is that by repeating the physical setting of the Resurrection they could encourage devotion to one of the central mysteries of the Christian faith. The Easter liturgy, with its dramatic re-enactments of the Passion and Resurrection, must have had a special intensity in such a setting. Moreover, by constructing an image of Jerusalem, the copies allowed everyone to share in the spiritual benefits of pilgrimage, without having to experience the

42 Almenno (Lombardy), San Tomaso, twelfth century

Although the function and early history of this Lombard church remains unclear, it shares many of the features associated with copies of the Anastasis Rotunda. Inside, the central space is defined by eight columns and there is a gallery above the surrounding aisle. Note the series of square putlog holes used to take the scaffolding.

rigours of the journey. At Bologna several of the holy places at Jerusalem were replicated, not just the Anastasis Rotunda.[13] This was a medieval equivalent of a modern theme park, allowing visitors to move through a cluster of buildings and courtyards as if touring Jerusalem itself. A twelfth-century polygonal church, which represented the Anastasis, is a double-shell structure, best known for the exotic patterns of coloured brickwork on its exterior walls. As was normally the case in such copies, it contained a model of the tomb of Christ. Exotic masonry is a feature of another copy of the Anastasis Rotunda, the famous baptistery at Pisa, designed with marble stripes by the master mason Diotisalvi in 1153. What makes the comparison with the Holy Sepulchre unusually precise in this case is the steep conical roof, which still survives within the outer dome. As we have already observed, baptism and resurrection were closely related in Christian thinking, so the choice of the Holy Sepulchre as a model was not inappropriate.

Attempts to assess the influence of the Anastasis Rotunda are complicated by the fact that many circular churches were not dedicated to the Holy Sepulchre and have no documented link with Jerusalem. The church of San Tomaso at Almenno near Bergamo is an example. This is a delightful building, its exterior mass composed of three diminishing cylinders, its walls articulated by a sequence of engaged shafts [42]. The smallest 'cylinder' at the top forms a cupola which rises from the central dome. Inside there is a ring of eight columns, and both the ambulatory and gallery are stone vaulted. A small chancel opens to the east. The history of the church is obscure and, as with other rotundas in northern Italy, a formula ultimately derived from the Holy Sepulchre may have been overlaid with other more local meanings.

A further complication is the fact that even when medieval churches were dedicated to the Holy Sepulchre they were not necessarily modelled on the prototype in Jerusalem. At Torres del Rio (Navarre) there is an octagonal church (c.1200), beautifully articulated on the exterior with blind arcades and engaged shafts, which, despite a dedication to the Holy Sepulchre, owes nothing to the Anastasis. It contains a spectacular vault with intersecting ribs, clearly derived from the Islamic architecture of southern Spain [43]. More intriguing is the church of La Vera Cruz (dedicated in 1208), constructed on a rocky plateau outside Segovia, a site which must have been chosen because of its analogies with Calvary. In this case an inscription confirms the dedication to 'the blessed sepulchre'. The plan is based on a dodecagon, the outer wall broken by three apses which open to the east. Instead of an inner ring of piers or columns, there is what initially appears to be a huge hollow pier in the centre, also shaped as a dodecagon [44]. This is a 'model' of the tomb, designed with two storeys, stairs leading up to a tiny chapel on the upper level. The surrounding space is covered by a continuous annular barrel vault.[14] The hollow central pier also appears

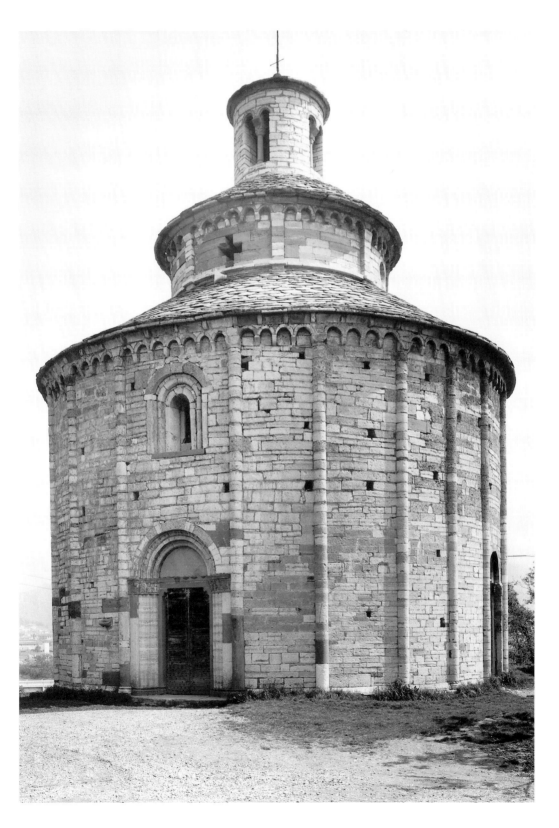

43 Torres del Rio (Navarre), *c.*1200

Despite a dedication to the Holy Sepulchre, this octagonal building has little resemblance to the Anastasis Rotunda, apart from the centralized plan. The unusual display of ribs under the dome is clearly derived from Islamic prototypes in southern Spain.

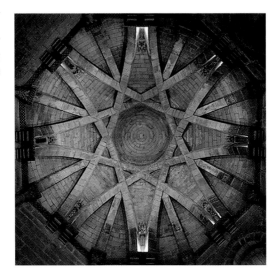

44 Segovia, La Vera Cruz, *c.*1200

The church is situated outside the walls of the ancient town, its dedication to the true cross suggesting a link with the Holy Land. The unusual structure in the centre of the building was evidently intended as a model of the tomb of Christ.

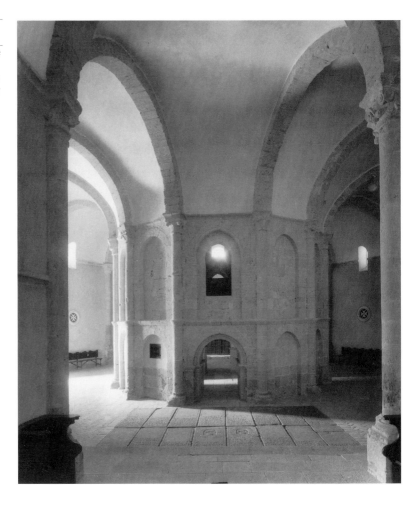

at Østerlars in Denmark, one of a group of circular churches on the island of Bornholm.[15] These formidable tower-like churches have usually been interpreted in military terms, but it is not impossible that the circular form was inspired by visits to the Holy Land, like that undertaken by King Sigurd between 1107 and 1111.

By the twelfth century centralized plans were thus being exploited in a variety of contexts, as private chapels, as churches dedicated to the Holy Sepulchre, and as funerary chapels. The schemes employed were equally varied, from double-shell rotundas to simple octagons and circles. In some cases the buildings attained a geometrical purity normally associated with Renaissance architects such as Bramante or Giuliano da Sangallo: the tiny funerary chapel at Montmajour (Provence), planned as a perfect quatrefoil, is a good example.

One final category of centralized buildings, usually interpreted exclusively in utilitarian terms, is the monastic lavabo. During the twelfth century many Benedictine and Cistercian monasteries erected separate pavilions in the cloister to house the water fountain, where the monks washed before proceeding into the refectory. At first sight it seems odd that so much prominence was given to a building that was in effect the bathroom. Washing was, however, an act of purification, which awakened memories of baptism; moreover, it seems likely that the continuous flow of water in the lavabo was associated with the Fountain of Life, the means of salvation. To monastic communities the lavabo offered a range of symbolical connotations. Such buildings could be planned as a square or a hexagon, though the most common form was the octagon, as with the ancient baptisteries. There is a richly decorated example in the Cistercian monastery at Mellifont in Ireland, where the very name of the monastery, Fons Mellis (Fount of Honey), awakened thoughts of Paradise. When building their lavabo (about 1210), the Irish monks, without perhaps realizing it, were drawing on an architectural iconography that was at least seven centuries old.

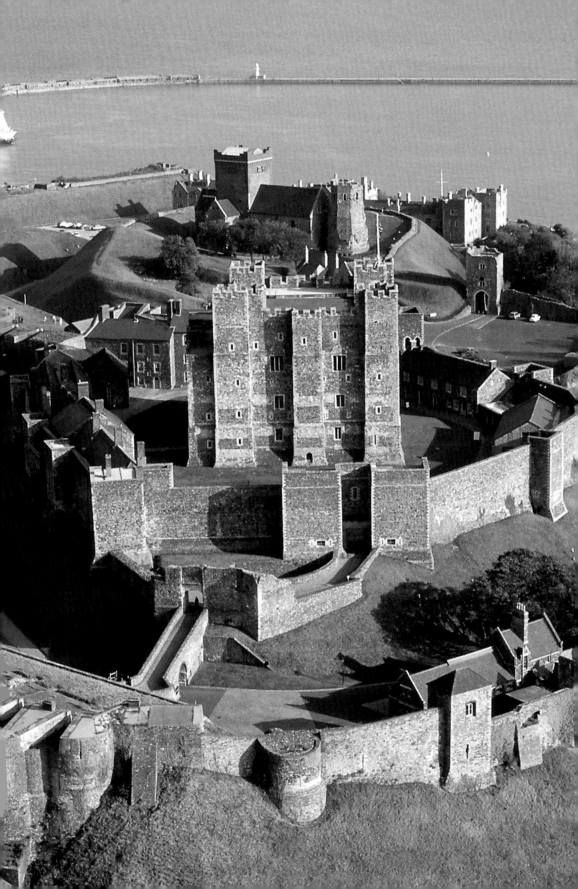

Secular Architecture in the Age of Feudalism

4

In 864 Charles the Bald, king of the western Franks, issued an order that anyone who had made 'castles and fortifications and enclosures without our permission shall have them demolished by 1st August', a command that represents one of the earliest indications of the existence of castles in the sense in which they came to be known in the Middle Ages.[1] The rise of the castle, which has traditionally been defined as the fortified residence of an independent lord, was a direct consequence of feudalism, the social structure which emerged in Europe following the disintegration of the Carolingian Empire. The switch from communal, urban defence to private fortifications in the countryside represents one of the fundamental distinctions between late Antiquity and the Middle Ages. As power descended to local level, the castle became the principal means through which a military aristocracy exerted its authority.

When considering the design of their castles, medieval lords had a fairly consistent set of requirements: a decent hall was needed for feasting and entertaining, along with private sleeping quarters, a kitchen, and a chapel. There was also a need for workshops and stables, the latter best located in a fortified courtyard or 'bailey', where horses could be watered and fed in safety. As a mark of status, at least one tower was essential. But the way these requirements were expressed varied enormously and there is little sign of the consistency of layout seen in ecclesiastical architecture. Most castles were in fact an amalgam of separate buildings, erected at different times by different owners, forming an agglomeration of structures rather than a single monument. The preference for sites with natural fortifications, on a cliff edge or rocky outcrop, was a further impediment to unified planning. This was the case at Loarre, a fortress built in the eleventh century by the kings of Aragon, close to the frontiers with the Moslem world [46]. Here the original castle included two rectangular towers, which, together with a chapel, were enclosed by various curtain walls. In the closing years of the eleventh century a more impressive chapel was added outside the

45 Dover Castle

View from the north. The outer curtain wall belongs to the early thirteenth century, but the inner curtain, defended by square flanking towers and a twin-towered gateway, was built late in the reign of King Henry II (1154–89). Beyond is the great keep, constructed at enormous expense in the 1180s. In the distance is the Anglo-Saxon church of St Mary-de-Castro. The lower parts of the tower to the right of the church belonged to a Roman lighthouse.

46 Loarre Castle (Aragon), eleventh century

The irregular layout of walls and towers was conditioned by the mountain location.

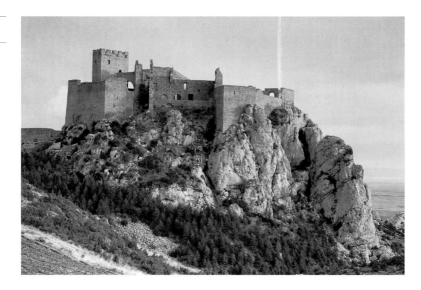

original enceinte (enclosure), the new chapel taking the form of a substantial Romanesque church, covered with a dome.[2] In its parched mountain setting, Loarre illustrates the sort of additive and fragmented approach to building encountered almost everywhere in the castles of the early Middle Ages.

This lack of consistency is one reason why the study of castles has never been given much prominence in books on architecture. They have been seen as robust, functional buildings, in which design was dictated by defensive rather than visual considerations. They appear to lack the sophistication of contemporary Romanesque churches, giving the impression that there was a fundamental difference in quality between secular and religious architecture. While castle builders certainly had different priorities, the distinctions were not as acute as sometimes imagined. Part of the problem is the lack of continuity: whereas churches have remained in use, castles generally survive as ruins, the bare rubble walls leaving a lot to the imagination. In most cases all the internal fittings have gone—floors, roofs, doors, external timber hoardings, drawbridges etc.—making it difficult to comprehend the original form. As for the many hundreds of wooden castles that once existed, they have vanished altogether. In recent years the main emphasis of castle studies has been to recover the design of individual monuments and to establish sequences of construction, chiefly through archaeological investigation. In this world of detailed analysis and careful reporting, general architectural issues relating to design, planning, proportional relationships, and the use of decoration, as well as the symbolic and romantic associations of the buildings, have often been overlooked. Medieval lords took great pride in their castles and we should not take the appearance of their buildings for granted.

One proud owner was William d'Albini, a Norman magnate who

47 Castle Rising (Norfolk), c.1140

Keep built by William d'Albini. The entrance and stair passage are embellished with an array of Romanesque ornament.

constructed a magnificent keep at Castle Rising (Norfolk), one of the finest dwellings to be built in twelfth-century England [**47**]. Like many such keeps, it takes the form of a rectangular block, built of rubble masonry with cut-stone dressings. The exterior walls are articulated by pilasters and there is a substantial sloping plinth, conveying an impression of enduring solidity. The entrance is contained in a forebuilding. To reach the main floor one climbs a broad staircase, protected by three separate doors, before reaching a vestibule. This has a decorated doorway (now blocked) which opened into a spacious hall, served at the far end by a kitchen and buttery. Alongside the main hall is a smaller, more private chamber, and to one side of this is an ornate chapel, complete with its own nave and chancel [**48**]. The building is well supplied with garderobes, both public and private, their shutes neatly fitted into the thickness of the walls. The whole structure is the result of thoughtful planning, with the requirements of aristocratic living neatly integrated into one rectangular shell. But there was more to Castle Rising than security and domestic convenience; it was intended

48 Castle Rising (Norfolk), c.1140

Plan of the keep at first floor level

Note the elaborate door leading into the hall and the chapel fitted alongside the main chamber.

First floor

to look impressive and the design incorporated many features usually associated with church architecture: Romanesque decoration around the doorways, pilasters articulating the walls, intersecting wall arcades, sculptured corbels, as well as stone vaults, all demonstrating that there was nothing uniquely ecclesiastical about the Romanesque style. In 1138 William d'Albini had married Queen Alice, widow of King Henry I, and, as a local chronicler explained, this had a dramatic effect on his lifestyle: 'William now became intolerably puffed up, would recognize no one as his peer, and looked down upon every other eminence in the world except the king'.[3] The keep at Castle Rising was designed as a house fit for a queen, a visual proclamation of William's new-found status.

'Keep' has long been a favourite term in castle studies, but the word was unknown in the Middle Ages. At that time such buildings were usually described as *turris* or *magna turris*. Nowadays a keep is assumed to be a well-fortified tower, providing the ultimate point of defence within a castle, an interpretation which places too much emphasis on its military functions. The French term *donjon* (derived from the Latin *dominium* meaning lordship) is more instructive since it conveys the idea that such towers were intended as a demonstration of power. Even when castles were built of timber, as most were until the twelfth century, an essential ingredient was a substantial tower, frequently placed at the summit of an earthen motte. The political connotations were quite explicit: a French chronicler described how Seguin, lord of Châtillon-Coligny (Loiret), built 'a tower of wood', adding the words 'for he was a powerful man'.[4] This was in the 1060s. The upper storeys at Châtillon-Coligny contained an apartment for Seguin and his fam-

REPRODUCED BY SPECIAL PERMISSION OF THE CITY OF BAYEUX

**49 Bayeux tapestry,
c.1066–82 (detail)**

King Harold feasting at
Bosham before his voyage to
France. The action evidently
takes place in a 'first-floor
hall', reached by an external
staircase and constructed
above what may have been
intended as a vaulted
basement.

ily, with cellars and chambers of various sorts underneath. A tower was
thus a defining characteristic of a castle, though the way such towers
were designed and the uses to which they were put varied enormously.
At one extreme were the great stone keeps like those at Loches [**50**],
Falaise, Caen, Rochester, Dover [**45**], and Castle Rising, where a sin-
gle multi-purpose building contained a network of domestic cham-
bers, as well as a hall and chapel. Then there were more modest towers,
designed for residence, but with just a single room on each floor, a type
sometimes described as a chamber or 'solar' keep. Finally there were
towers designed almost exclusively for defence and military display,
without fireplaces or latrines, like the *Bergfriede* of Germany, which
were never intended as living accommodation.

From an architectural point of view, most interest centres on the
huge rectangular keeps of France and England, where the integration
of residential needs into a single building called for a high degree of or-
ganization and planning. A crucial monument is the Tower of
London, the so-called 'White Tower', founded as a royal residence by
William the Conqueror, probably in 1078. This was a gigantic struc-
ture, measuring 118 by 107 feet (externally), and rising to a height of 90
feet. At ground level the walls were 15 feet thick. No secular building on
this scale had been seen in England since the fall of the Roman Empire
and, by casting a shadow over the city of London, the citizens were left
in no doubt about the authority of the new Norman regime. In the
twelfth century it was appropriately described by William FitzStephen
as an '*arx palatium*', a palatial fortress. The design of the White Tower
established the fundamentals of the English keep: the rectangular plan
with corner turrets, external pilasters, a cross wall to provide support

for the floors and roofs, wall passages, and the incorporation of a hall and a chapel. At the White Tower the chapel took the form of a large barrel-vaulted church, terminating in an apse which projected outside the building. A similar keep, on an even larger scale, was built at Colchester, and over the course of the next hundred years there followed a succession of related designs, culminating in Henry II's keep at Dover in the 1180s [45]. None were planned in exactly the same way and in some cases the hall was given particular emphasis. At Rochester, for example, the central spine was replaced by Romanesque arches, allowing the hall to encompass the full width of the building; it also rose through two storeys, so that a gallery could be built around the upper walls like the clerestory passages in a contemporary church. A similar arrangement can be found at Castle Hedingham (Essex), but in this case the spine wall was replaced by a single arch [137]. Clothed throughout in ashlar masonry, and relatively tall in proportion, Castle Hedingham is the most elegant of the English keeps. But it remains a puzzling building. There are no private chambers and it is difficult to see how it could have functioned as a residence, for most of the space is occupied by the splendid hall. Built by Aubrey de Vere at about the time he was created earl of Oxford (1142), it was evidently intended primarily for show.[5]

There has been much speculation about the origin of the residential or 'hall' keep. It has been argued that it was a Norman invention, devised after the conquest of England in 1066; it has also been suggested that it evolved from timber towers, some of which are known to have been structures of great complexity. A wooden castle at Ardres, designed by a carpenter called Louis in 1117, included a series of private rooms, as well as a kitchen and a chapel, all apparently fitted into a single tower perched on the top of a motte.[6] But timber buildings scarcely provide a precedent for keeps on the scale of those at London or Colchester. Some scholars have searched for an origin in Normandy, where there is at least one keep—at Ivry-la-Bataille (Eure)—with many of the same features.[7] However, there is plenty of evidence to suggest that the residential keep evolved from the simple stone hall, and that the key developments took place in the Loire valley. By the eleventh century, many castles were equipped with rectangular halls, with the hall itself being placed on an upper level over some form of basement. Access to the upper storey was usually by means of an external staircase, generally made of wood. As early as 950 a building of this type, belonging to Theobald, count of Blois, existed at Doué-la-Fontaine (Maine-et-Loire), and over the course of the next two centuries it became a standard form, especially in France. When Brionne was besieged by William the Conqueror between 1047 and 1050, the castle was described as 'a stone-built hall serving the defenders as a keep (*arx*)'.[8] There is a good example of the type in the Bayeux tapestry,

at the point where King Harold is shown feasting at Bosham [49]. In the early years of the eleventh century masons in the Loire valley transformed this concept into a far more monumental structure, a change which marks the genesis of the residential keep. The person responsible appears to have been Fulk Nerra, duke of Anjou (987–1040), one of the more notorious barons of the Middle Ages.

Fulk is familiar to historians as a man of extraordinary brutality who interspersed his evil deeds with bouts of remorse and atonement. During his reign he systematically extended his territories along the Loire, capturing most of Touraine, though not the city of Tours itself. To support his strategy, he is said to have built 13 castles, which included Langeais, Montbazon, and Loches. The keep at Langeais (Indre-et-Loire), founded about 994, was an enlarged version of the stone hall, with two turrets projecting on the east face, linked by a gallery. The main chamber on the first floor was reached by an external staircase, and it is possible that there was a more private chamber above. Altogether more sophisticated is the keep at Loches; in fact so sophisticated that until recently it has been assigned to the years around 1100 and not to the reign of Fulk Nerra. With its smooth walls of ashlar masonry, divided by engaged shafts, this is a mature piece of Romanesque architecture [50]. The keep is unusually high, containing three storeys as well as a tall basement. The main staircase, which was located in a forebuilding, leads up to the first floor, where there is a large hall illuminated by a row of five windows and equipped with ac-

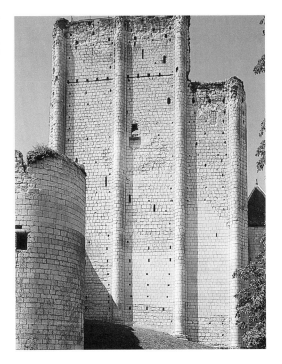

50 Loches, castle (Indre-et-Loire), *c.*1012–35

Keep built by Fulk Nerra, duke of Anjou. One of the first examples of the multi-storeyed keep, its early date belied by the use of ashlar masonry and engaged shafts.

51 Loches, castle (Indre-et-Loire), c.1012–35

Plan of the keep at first-floor level

A sequence of five windows illuminated the main hall, which is surrounded on two sides by a passage in the thickness of the wall.

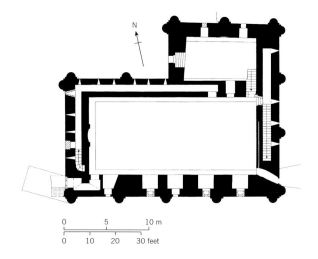

N

```
0          5          10 m
|----------|----------|
0    10    20    30 feet
```

cess to latrines. The floors above contained more private chambers, the upper level being reached only by a spiral stair. In several ways Loches anticipates the great keeps of the twelfth century: the multiplication of storeys, the chapel placed on the upper storey of the forebuilding, and the passageways through the thickness of the walls [**51**]. Although the design would not be out of place in the early years of the twelfth century, dendrochronology has proved otherwise, the analysis of construction timbers revealing that the keep was built in three stages between c.1012 and c.1035.[9] These results, published in 1996, have had a sensational impact, requiring a dramatic reappraisal of the early history of the keep. The evidence from Loches demonstrates that most of the elements of the great keep were in place by the 1030s and that Fulk Nerra played a key role, bringing about the fusion of the residential hall and the fortified stone tower. Moreover, some of the architectural features—engaged shafts, passageways in walls, and the use of ashlar masonry—appeared at Loches before they became widespread in church architecture, demonstrating that the distinction between secular and religious architecture was not as sharp as is sometimes thought.

The great keeps of England and France were not necessarily the most attractive buildings in which to live. There were a lot of stairs to climb, the thick walls meant that living accommodation was often dark and cramped, they were difficult structures to alter or extend, and there was a limit on the size of the hall. They also took a long time to build, perhaps a decade or more, and involved operations which required a huge annual investment. It has been suggested that, on average, construction progressed at a rate of only 10 to 12 feet per year.[10] A unique insight into matters of speed and finance is supplied by the English pipe rolls, which record the expenditure on several royal castles during the reign of Henry II (1154–89). Between 1172 and 1177 the sum of £912 10s 9d was spent on building the keep at Newcastle, the annual expen-

**52 Carrickfergus Castle
(Antrim), *c.*1180**

Keep built by John de Courcy,
soon after his conquest of
Ulster. Latrines serving three
different levels were gathered
together at the south-west
corner.

diture in the busiest years ranging between £142 and £185. These were modest sums compared with the £4,000 expended between 1181 and 1188 on the massive keep at Dover.[11] For a nobleman with limited means, the construction of a great keep could tie up resources for years on end and there was no guarantee that one would live to see it finished. Dendrochronology has suggested that construction of the elaborate keep at Trim in Ireland came to a halt in 1186, when its founder, Hugh de Lacy, was clubbed to death with an axe.[12]

During the course of the eleventh and twelfth centuries there were many improvements to the domestic amenities of the castle. A healthy water supply was obviously crucial, particularly when a large contingent was in residence. In contrast to the average monastery, it was not normally possible to divert a stream or local spring into the bailey, so water either had to be stored in a cistern or extracted from the ground. Most castles had a well, in many cases incorporated into the keep. At Rochester it was fitted into the spine wall in such a way that it was accessible at different levels, and at Dover and Newcastle lead pipes conducted the water around the building. The well at Dover is most impressive: lined in Caen stone to a depth of 172 feet, it continues a further 70 feet through the bare chalk. Latrines were also more systematically organized, with the chutes often linked neatly together in a single turret, as at Castle Rising or Carrickfergus [**52**]. Access was usually along a passageway with at least one sharp turn, an arrangement assumed to be a way of restricting the spread of unpleasant odours. All too frequently, however, excrement was splattered outside at the base of the walls, which, together with the inevitable staining of the masonry, must have done little to enhance the beauty of the buildings.

Heating was another important consideration. In single-storey buildings an open fire or a brazier could be lit in the centre of the floor, with smoke being drawn out through a louvre in the roof. Where this was not practical, a fireplace had to be built in the side wall. In the keeps at Rochester and Castle Hedingham [**137**] the halls are equipped with arched fireplaces decorated with Romanesque chevron ornament. By the closing decades of the twelfth century, builders had discovered the advantages of the straight hood, a well-preserved example of which, with joggled joints, exists at Conisborough (Yorkshire). Early fireplaces usually had short flues, fitted into an adjoining pilaster or buttress, but, by the time the keep at Conisborough was designed (*c.*1180), it was known that an extended flue produced a stronger draught. A further development worth noting is the introduction of the window seat. By fitting benches into the reveals of the windows, residents could make better use of the light and relax while contemplating the view.

These domestic improvements tend to be overshadowed by advances in the technology of defence; by 1200 many of the military fea-

tures associated with medieval castles had already made an appearance. The gradual shift from timber to stone was fundamental, for wooden structures were always vulnerable to fire. The first castle that Hugh de Lacy erected at Trim, for example, was burnt by the Irish (1172–3). As well as being more durable, stone buildings also *looked* more permanent. While a great tower usually remained as the ultimate stronghold, the twelfth century saw a shift of emphasis towards the defence of the curtain walls, with timber palisades being replaced in stone. Flanking towers, which gave defenders better control over what was happening outside, also became more common, and they were systematically organized in the royal castles at Orford (1165–73) and Dover (c.1185) [45].

The main gateway, a point of potential weakness, was another feature subject to progressive improvements. In the twelfth century the gate was usually located within a tower, which allowed for the incorporation of a portcullis as well as murder holes over the entrance passage. At Dover the gate was formed by a pair of towers, one of the first examples of the so-called twin-towered gateway, which became a standard form in the later Middle Ages. During the course of the century arrow slits became more common, allowing defenders to fire through the walls with little risk of being hit themselves. Further protection was provided by wooden 'brattices', fighting galleries which projected forward from the upper walls of a keep or curtain wall. A more permanent alternative was the use of machicolation, stone corbels which supported a solid defensive platform. In primitive form the technique was employed by Richard I at Château Gaillard (c.1196–8), the fortress built on a cliff above the river Seine with the aim of protecting Normandy from invasion by the French. It should be noted that several of the techniques mentioned above were not invented in the Middle Ages. The Romans, for example, were familiar with both the portcullis and the arrow slit, and for much of the Middle Ages Gallo-Roman walls with flanking towers could be seen in many a French town. There is a popular view that the improvements were a direct result of the Crusades, during which Christian knights became hardened in siege warfare. The advantages of flanking towers, deep rock-cut ditches, and a strong enceinte protected by arrow slits were all appreciated in the Holy Land, but in general it was new techniques of attack, rather than architectural forms, that the Crusaders brought back to Europe. The first Crusader castles were not all that radical in design, and were built with different functions in mind.

The interest in military matters has encouraged historians to interpret almost every feature of castle design in defensive terms, ignoring any aesthetic or romantic considerations which might have influenced the builders. The late-twelfth-century poet Chrétien de Troyes often alluded to the beauty of contemporary castles, speaking of wonderful buildings, situated beside rivers or lakes, the architecture 'superbly

strong and rich'.[13] In a passage worthy of a modern estate agent, the ecclesiastic Gerald of Wales described his family castle at Manorbier in thoroughly nostalgic terms, dwelling not just on the turrets and crenellations, but also on the beautiful orchard, the vineyards, the fish ponds, the surrounding woods, and the wonderful views across the 'Severn sea' towards Ireland.[14] While towers and turrets undoubtedly had a defensive role, they also contributed to an image. Some twelfth-century keeps are so unorthodox in form that they can only be explained as a way of cutting a dash and impressing the neighbours. At Ambleny (Aisne), for example, a structure built by the lord of Pierrefonds in about 1140, the keep was planned like an extended quatrefoil, with four semicircular projections attached to a polygonal core [53]. Although two of the projections were separated from the main space to form a private chamber and a latrine, the plan is hard to explain in terms of practical convenience, or indeed in terms of defence. With its moulded walls built of high-quality ashlar, the shape of Ambleny, however, was instantly memorable. The design may have been inspired by the royal keep at Étampes (c.1130) [54], which followed a more regular quatrefoil plan. Equally unorthodox was the keep at Provins (Seine-et-Marne), built between 1150 and 1175, which has an octagonal core, from which circular turrets project on four of the eight faces. There were also some startling experiments in England. In terms of visual impact the most remarkable was the keep at Conisborough, built in the 1180s by Hamelin Plantagenet, half-brother of Henry II. It has a cylindrical core, from which six enormous buttresses project like the spokes of a

53 Ambleny (Aisne), the keep, c.1140–3

Built by the lord of Pierrefonds, Ambleny was one of several French keeps designed to a quatrefoil plan.

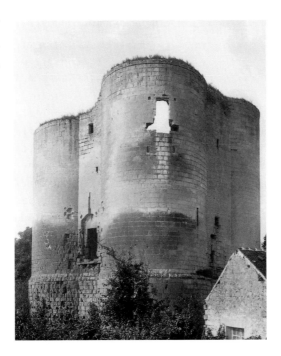

54 Twelfth-century keeps

Comparative plans:
(a) Ambleny; (b) Étampes;
(c) Provins; (d) Conisborough;
(e) Orford; (f) Trim

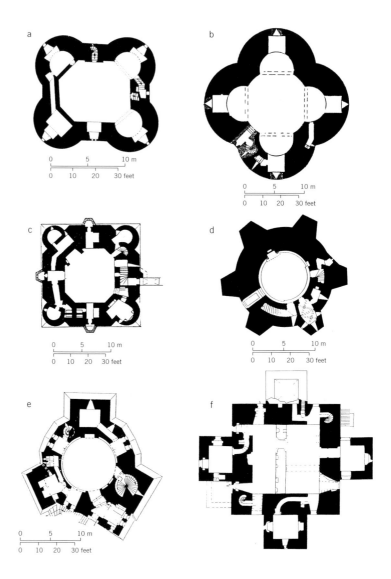

wheel [55]. At a high level one of the buttresses contains an exquisite chapel, covered with its own ribbed vault. The power of Conisborough is enhanced by the steep plinth and by the fact that it was constructed throughout in ashlar masonry. The plan is difficult to explain in exclusively military or structural terms, for, given the width of the walls, the buttresses were scarcely necessary. It looks utterly impregnable and it was looks that mattered as much as actual strength. Even today the stark geometry seems menacing and formidable.

One change which has been attributed to military progress was the growing fashion for circular rather than square towers. A series of keeps erected by the French king Philip II (1180–1223) took a cylindri-

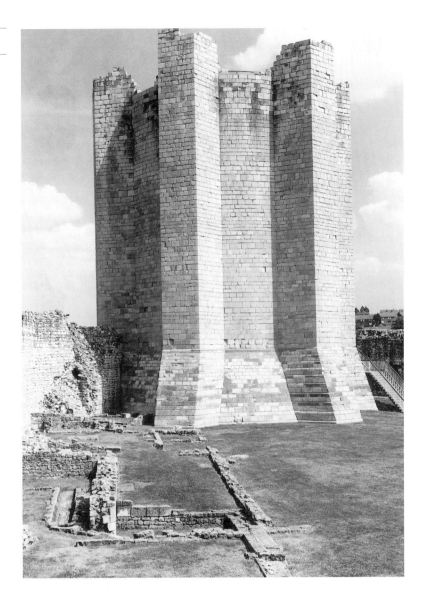

55 Conisborough Castle (Yorkshire), *c.*1180

Keep built by Hamelin Plantagenet. The six 'buttresses' were probably intended for visual effect as much as for added strength.

cal form, and by 1200 similar designs were appearing in Wales and Ireland. Flanking towers built to a semicircular plan had already appeared by the middle years of the twelfth century, an approach which became universal in the following century. It has been argued that the quoin stones of a square tower were vulnerable to picking and that round towers were less easily undermined. This explanation is only part of the story. The keep which Hugh de Lacy was building at Trim in the 1180s contained no fewer than 12 external angles, so he was not perturbed by the dangers of picking or mining; more important to him was the geometrical symmetry of the Greek-cross plan [**54**]. Nor can circular towers be regarded as a new discovery. In France a cylindrical

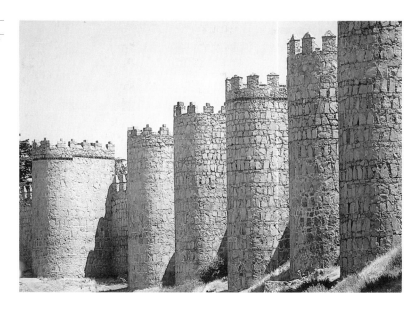

56 Avila, city walls, *c*.1090

The sequence of semicircular towers reproduces a technique familiar in Roman fortifications.

keep had been erected at Fréteval by 1100, and flanking towers built to a semicircular or 'D' plan were to be seen in Roman cities and forts all over Europe. After the battle of Toledo in 1085, the Spanish king Alfonso VI fortified the town of Avila with a powerful circuit of walls, reinforced with a regular sequence of 'D' towers [**56**]. While the shift to circular forms in the late twelfth century may owe something to military theory, Roman precedent and aristocratic fashion also played a part. In addition, there were practical considerations. By avoiding the need for well-dressed quoin stones, circular towers may have been more economical to build.

Throughout the early Middle Ages a substantial hall remained the focus of communal life within a castle, and indeed within all types of aristocratic dwelling. For kings, princes, bishops, and feudal lords, a splendid hall was a mark of status just as much as a great tower or other fortifications. This was a building designed for ceremonies, where kings entertained their barons, conducted business, received officials, or met with foreign ambassadors. It was the place where political decisions were made, where councils assembled, and where matters of state were scrutinized and debated. It was also the setting for periodic feasts, and for the singing and dancing which accompanied such events. Whether one is dealing with the Germanic kings of the seventh century, the emperors of the Carolingian world, or the Norman rulers of England after 1066, a spacious hall provided the setting for the great ceremonial events of the age.

There were two distinct strands which contributed to the architecture of the medieval hall, one of which descended from the imperial architecture of late Antiquity, the other from the timber feasting halls associated with the Germanic kings of northern Europe. The design of

the great audience hall built by Charlemagne at Aachen was clearly based on Roman precedent. Although only fragments remain, it is known that this formed the northern flank of the huge palace complex, laid out by Charlemagne's builders on a square grid of 360 Carolingian feet (reckoned to be 33.29cm compared with the English foot of 30.48cm). The hall was constructed on an ambitious scale, the external walls measuring 138 by 68 feet and, like many a Roman (secular) basilica, it culminated in a broad apse at one end; there were further apses midway along each of the side walls. The external walls were decorated with pilasters, probably linked at the top to form arches like those on the late Roman audience hall not far away at Trier [**3**]. The choice of Roman models was both practical and ideological: the emperor now had an architectural stage on a par with that of the Roman emperors, one that was worthy of his status at the head of a universal Christian empire. There were other great halls belonging to the Carolingian emperors, at Paderborn and Ingelheim, the latter celebrated in a famous poem written in *c.*825-6 by Ermoldus Nigellus. The royal palace 'with a hundred columns' was furnished with a vast cycle of paintings depicting scenes from Greek and Roman Antiquity, which were juxtaposed with the heroic achievements of the Carolingians.[15] As at Aachen, the hall terminated in an apse. Little now remains of the splendid Carolingian palaces; for buildings which survive intact we have to look outside the frontiers of the empire.

On the slopes of Mount Naranco, a couple of miles north of the Spanish city of Oviedo, is an enchanting hall built by Ramiro I, who ruled over the small Christian kingdom of the Asturias between 842 and 850. Like the palaces of the Carolingian world, Ramiro's building contains some very deliberate references to the architecture of late Antiquity, while at the same time anticipating several features of the Romanesque style. The hall at Naranco is a long rectangular building, the main floor being lifted well above the ground over a vaulted undercroft [**57**]. At each end there is a loggia, which is defined by meticulously worked arches, resting on ornamental columns. The main chamber is barrel-vaulted, with a series of transverse arches dividing it into bays. The sides walls are furnished with arcades, supported by clusters of decorated shafts. As well as crosses and other Christian emblems, the building is decorated with sculptured discs, a motif known to have been employed in the palace architecture of late Antiquity. Built in roughly-dressed masonry, with tufa in the vaults, Ramiro's hall was much admired by contemporary chroniclers, who seemed to appreciate that a completely vaulted structure of this sort was quite rare.

The timber halls of northern Europe, like Hrothgar's 'large and noble feasting hall', described in *Beowulf*, represented a very different tradition. It is difficult to know whether the architecture was as magnificent as the literary sources suggest. When the monster Grendel de-

Subsequently the church of Santa Maria. The hall was built over a vaulted basement, with an open loggia at either end; its unique qualities were celebrated by local Spanish chroniclers.

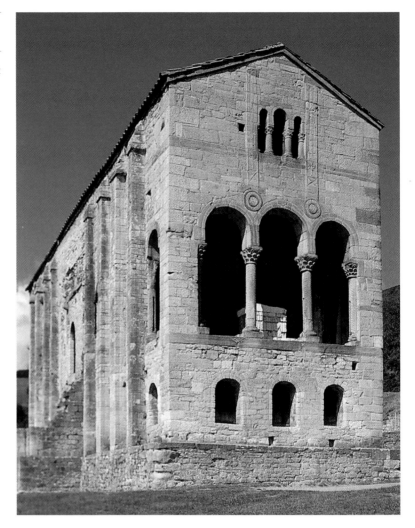

scended on Hrothgar's gabled hall, he saw 'the mead-drinking place nailed with gold plates' and the door he ripped open was toughened with iron bands and hinges. 'Gold embroidered tapestries glowed from the wall.'[16] The poem is thought to have been composed in England about 700 AD and its words no doubt reflect the splendour of the royal halls of the Anglo-Saxon kings. But what did such buildings look like? Did they have aisles and were they made of solid timber? Excavations at such places as Yeavering (Northumbria) and Cheddar (Somerset) have provided some answers, though the fact that timber buildings had a relatively short life complicates the picture. Yeavering was the site of the palace of King Edwin (616–33), and one of the halls there was erected with cut planks, using a form of tongue-and-groove jointing. For archaeologists the problem is that the workmanship at foundation level is often crude and it may fail to provide an accurate impression of the architecture as a whole.

58 Oakham Castle (Rutland), aisled hall, c.1180

Furnished with capitals and mouldings well abreast of fashions in ecclesiastical architecture.

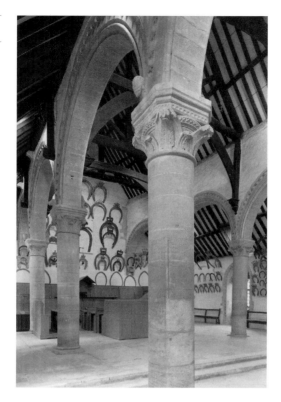

Just how much the great timber buildings of northern Europe contributed to the architecture of the later stone halls is a debatable question. After the Norman conquest in 1066, several fine secular halls were erected in England, including an enormous example, 240 feet in length, in the palace at Westminster, completed in 1099 at the behest of William Rufus, who was said to have 'spared no expense to manifest the greatness of his liberality'.[17] The internal span of 67 feet is so wide that, before the insertion of the famous hammerbeam roof in the fourteenth century, it must have had intermediate piers. The walls contained arcaded passageways running in front of the windows, foreshadowing the type of arrangement seen in the keeps at Rochester and Castle Hedingham [137]. The castles at Leicester, Farnham, and Hereford possessed halls which, though built with stone walls, had aisle posts of timber, complete with wooden capitals, a technique that certainly implies some continuity from the timber halls of the Anglo-Saxon era. The ground-floor hall reached its apogee in the castle at Oakham (c.1180), where stone arcades were built with all the finesse of contemporary church architecture [58]. By this stage the alternative ways of designing a hall were very clear: either it was built at ground level and, if necessary, provided with aisles, or it was raised up over a basement, following the tradition established in France in the eleventh century. In most castles the hall was an independent building, and even

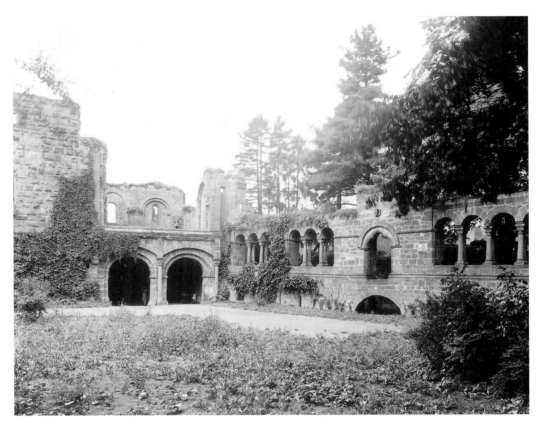

**59 Gelnhausen (Hesse),
palace, 1170–1200**

Founded by the emperor,
Frederick Barbarossa. As in
many German palaces, the
residential block (to the right)
was ornamented with
decorated arcades. To the left
is the main gateway, above
which was a chapel.

when there was a substantial chamber within a keep, a further hall was often built outside. Thus at Caen, one of the main dwellings of the Norman kings, a spacious ground-floor hall, now known as the Exchequer, was erected by Henry I (1100–35) within a few years of the construction of a great residential keep. It is also worth remembering that many of the more sumptuous halls of the twelfth century were built not by secular lords but by bishops. The episcopal castle at Durham, for example, still retains a magnificent hall, the entrance to which was embellished with extravagant late Romanesque ornament. The bishops of Durham wielded vast powers in the north of England and the symbolic connotations of their palatial buildings should not be underestimated. Indeed, the style and design of a hall conveyed political signals, as Henry II was well aware when he came to Ireland (1171–2). A hall was erected in Dublin especially for his visit, a 'wonderful structure of wattlework', built deliberately in the native style to avoid giving offence to the Irish kings.[18]

The most powerful ruler in Europe at this time was the German emperor, Frederick Barbarossa (1152–90), who is credited with building numerous castles and several fine palaces. The German approach to secular architecture was very different from that found in England and France. In the imperial palaces, there was less emphasis on fortifica-

tion, the main focus of the design consisting of a large residential block, without defensive characteristics. There are the ruins of such a building at Gelnhausen (Hesse), a castle founded by Frederick Barbarossa in about 1170. The domestic range, which was not finished until after his death, was an elegant two-storey structure, built in red sandstone over a basement [**59**]. The main façade was designed with two levels of arcaded windows, furnished with twin columns and intricately sculptured capitals. These arcades appear to have opened into galleries or corridors, with the main chambers set further back. The palace at Gelnhausen was surrounded by a curtain wall and the entrance was protected by a substantial gatehouse, which incorporated a chapel on the upper level. The ruins illustrate several features common to German princely architecture: the residential block with arcaded openings, the interior gallery, and the combined chapel and entry gate. The chief means of display in these monuments came from the horizontal bands of windows and arcades, an arrangement magnificently expressed in the Wartburg, a castle built by the margrave of Thuringia at Eisenach.

The design of the arcades at Gelnhausen would not be out of place in a monastic cloister. Such parallels make it difficult to sustain the oft-quoted opinion that developments associated with Romanesque and early Gothic had little relevance for secular architecture, in particular for castle building. In both areas one encounters the gradual shift from timber to stone; the recent discoveries relating to the origin of keeps show that the early decades of the eleventh century were a turning point, just as they were in ecclesiastical architecture (see chapter 9); the proportional methods used by the architects were also similar and the study of sculptural details and masons' marks shows that the workforce moved freely amongst all types of building; finally, the increasing concern for order, regularity, and geometrical precision evident in church design undoubtedly had an impact on castle building, as the keep at Conisborough amply testifies [**55**].

Patron
and Builder

5

Medieval chroniclers had no doubt about who deserved the credit for the great buildings of their age. When the Romanesque cathedral of Chartres was completed, it was, we are told, largely the work of Fulbert, bishop from 1006 to 1028: 'It is by his industry, his labours, and his money that he rebuilt the cathedral from its foundations and led the enterprise almost to completion, with a grandeur and a beauty worthy of all praise.'[1] There is no mention of an architect or builder. Even Abbot Suger of St Denis, who wrote at great length about the way in which he had reconstructed his abbey church, found no space to mention the names of his master craftsmen. In our eyes this attitude seems outrageously self-centred, a massive injustice to those who designed and actually constructed the buildings. But the situation was not quite as straightforward as it sounds. Modern conceptions of the role of the architect, a person with creative skills and in complete control of the design, are founded on humanist values derived from the Renaissance; what might seem an injustice today would have been viewed in a different light in the eleventh century. Although the term 'architect' was used in the early Middle Ages, it was employed loosely, sometimes referring to a cleric who commissioned a building, sometimes to the leading masons or carpenters.[2] It is misleading to think in terms of one individual planning and designing the work and supervising its construction through to completion. The duties of the patron and builder were not sharply defined, and, as a consequence, it is difficult to determine with any precision who was responsible for the design of early medieval buildings. The tasks of patron and builder could, and often did, overlap.

It is important not to minimize the role of the patron. In church building the bishop or abbot usually took the initiative, sometimes in the face of considerable opposition: monastic communities could be very conservative institutions, as Ratger discovered to his cost when he continued the reconstruction of the abbey church at Fulda between 802 and 817. The patron had to raise the cash (often sacrificing much of his

60 Desiderius, abbot of Montecassino (1072–87)

Painting at Sant'Angelo in Formis (Campania)

The image of the patron presenting a model of his church to Christ or the saints is found throughout the early Middle Ages. The portico in the model has obvious similarities with the example which still survives at Sant'Angelo in Formis (**66**), though this is probably later in date.

own income), seek out suitably qualified craftsmen, and resolve difficulties over the supply of stone and other materials. It was a task that demanded self-belief, energy, and determination. The responsibilities of one enlightened patron are vividly described by Leo of Ostia in his account of the rebuilding of Montecassino by Abbot Desiderius [**60**]. The abbot conceived a plan for a new church which involved demolishing the old one: 'To most of our leading brethren this project seemed at that time entirely too difficult to attempt. They tried to persuade him from this intention by prayers, by reasons, and *by every other possible way* [my italics], believing that his entire life would be insufficient to bring such a great work to an end.' In fact Desiderius confounded his critics and rebuilt the church in five years, from 1066 to 1071. According to Leo, it was Desiderius who decided to level the top of the mountain as a platform for the new building. He also went to Rome where, 'after consulting each of his best friends', he purchased huge quantities of columns, bases, epistyles, and marble. He organized the transport of these materials back to Montecassino, no easy feat given that the monastery lies at the summit of a precipitous mountain. On his return from Rome he hired 'highly experienced workmen'.[3] No doubt Desiderius had assistants, but he clearly took most of the decisions himself. To a considerable extent he was the architect of Montecassino.

There are many recorded instances in which bishops and abbots acquired reputations as great builders, men such as Angilbert, abbot of St Riquier around 800, Oliva, abbot of Vich, who was active on both sides of the Pyrenees in the early eleventh century, or Roger, bishop of Salisbury from 1102 to 1139, who built castles and palaces, as well as a splendid new choir for his cathedral. We know that some senior clergy possessed a considerable degree of technical expertise. Bernward, bishop of Hildesheim, for example, was an accomplished craftsman whose talents included architecture. According to his biographer, Thangmar, he 'taught himself the art of laying mosaic floors and how to make bricks and tiles'; he also had a taste for polychrome masonry, arranged in alternating patterns of white and red stone.[4] It was Bernward who constructed the church of St Michael at Hildesheim (*c.*1010–33), and, in the light of Thangmar's comments, he presumably had a major voice in its design [**25, 26, 27**]. Wilfrid, the Anglo-Saxon bishop of Hexham, is said to have 'made many buildings *by his own judgement* [my italics] but also by the advice of the masons whom the hope of liberal reward had drawn hither from Rome'.[5] It is worth remembering that the St Gall plan, a wonderfully systematic piece of design dating from *c.*830, was almost certainly drawn up by an ecclesiastic [**123**]. In their work as scribes and illuminators, monks were well used to laying out complex designs on vellum, sometimes employing the same proportional ratios that are found in contemporary buildings.[6]

The difficulty confronting historians is to decide how far the role of ecclesiastics extended beyond organizational matters. Gundulf, bishop of Rochester, who supervised the building of the Tower of London between *c.*1078 and 1087, was said to be 'knowledgable and effective in the work of masonry', but it is unlikely that he had any practical experience in the art of cutting stone. While he may have devised the plan of the Tower, his skills no doubt lay in the field of administration. A century later the construction of the royal keeps at Dover and Newcastle was supervised by an engineer ('*ingeniator*') called Maurice, a significant change in personnel, suggesting that by then professionals were in control.

There are many references to monks participating in the physical work of construction. Thus in the seventh century the Irishman Columbanus, despite his great age, assisted in the building of a new monastery at Bobbio in northern Italy. Aethelwold, when abbot of Abingdon in the years after 960, paid a physical penalty for his architectural enthusiasm. He had a reputation as a '*magnus aedificator*', but when he was assisting in the construction of his church, a huge post fell on him, breaking his ribs and knocking him into a pit. On a few perhaps rare occasions, monasteries included monks who had been trained as masons: this was the case at La Trinité, Vendôme, where a monk named John was allowed to work for the bishop of Le Mans (*c.*1097–1125). His reluctance to return provoked a series of angry letters from his abbot.[7]

With their emphasis on the value of manual labour, Cistercian monks were often involved in building operations. The Norman chronicler Ordericus Vitalis explained how 'all Cistercian monasteries are constructed in deserts and in the middle of woods, and the monks build them with their own hands'. This claim has usually been treated with scepticism by historians, the quality of Cistercian stone architecture being so high that it must have been the work of professionals. What Ordericus probably had in mind were the timber buildings erected in the first months of a monastic settlement. Certainly St Bernard of Clairvaux thought there was nothing odd about the clergy wielding axes and chopping timber. In his biography of St Malachy of Armagh, he explains the saint's none too proficient involvement in building a wooden church at Bangor (Down): 'It happened one day that while he was cutting with an axe that one of the workmen accidentally got in his way while he was raising the axe and it fell on his spine with full force.'[8] Miraculously the workman escaped unhurt. During St Bernard's lifetime the Cistercian order possessed at least three experts in building, who were sent from Clairvaux to advise newly established communities. While the order depended on professional masons, recruited from outside the order, the monks maintained some control over the design and layout of their buildings. In remote abbeys

61 Setting-out marks

Christ Church Cathedral, Dublin. Section of engaged shafts, *c.*1200.

A series of circles with differing radii were used to define all the main elements of the design. This stone probably served as a template for cutting further sections of the shafts.

62 Masons' marks at Sénanque (Vaucluse)

The incised marks of individual masons reflect the growing professionalism and improved organization of the building trade.

like that at Boyle (Roscommon), the church included a number of specific features derived from Burgundy that could have been transmitted only by the monks. The details of the stonework, however, reveal that the work was carried out by local masons.

Given the nature of the documentary sources, it is difficult to distinguish between those in charge of organization and those responsible for design and construction. By the twelfth century the operations might be administered by a *custos operis*, a *magister operis*, or an *operarius*, who was not usually a mason by training. This was a task for a well-educated clerk, used to handling figures. One such individual is commemorated on the south wall of the ornate church at Chadenac (Charente-Maritime) [**144**], where there is an inscription which reads: 'Here lies William the Poitevin, clerk of William, builder but not the carver' ('*structor non fictor*').[9] The author of the inscription was evidently concerned to point out that William the Poitevin was not personally responsible for the sculptured portals, though he was in charge of the overall building. At the monastery of Grandmont, *c.*1140–63, a master of the works called Gerald made the mistake of venturing too close to building activities. The workers, we are told, inconsiderately allowed a stone to fall from an arch which flattened Gerald, who fell to the ground, apparently dead. The prior rushed to the scene and ordered Gerald to rise and return to work, which, miraculously, he did.[10] The incident at Grandmont is just one of dozens of accidents recorded in the sources, which underlines the point that building in the early Middle Ages, as today, could be a hazardous occupation.

There can be little doubt that the increasing sophistication of architectural design during the eleventh century had repercussions on the way building was organized. The use of engaged shafts, compound piers, and complex systems of ornament called for forward planning which only an experienced mason could handle. While difficult to

63 Durham Cathedral, pier in the nave, c.1104–28

For each pier over 200 stones were pre-cut using just one or two different patterns; once these were brought to the site the pier could be assembled very rapidly.

prove, it is clear that the development of the Romanesque style enhanced the status of the professional builder. The technical demands of the style—the fitting together of sculptured archivolts for example—must have diminished the role of the patron and clerical advisers. The development of quarries, the expanded use of ashlar masonry, and the increase in sculpture and ornament, along with the sheer growth in the amount of building, were all factors that helped to make building an increasingly technical operation. Anyone who has handled Romanesque masonry will be aware of the practical geometry that was needed to shape the individual stones. In some cases the incised lines of the square and compass are still visible on the inner surface [**61**]. It is no coincidence that masons' marks, the personal signs of individual craftsmen used for the purpose of payment, first become common at this time [**62**]. Another sign of professionalism is a drift towards greater standardization of parts. In most early medieval structures employing ashlar masonry, the individual stones that make up a wall or pier can vary considerably in dimensions; by the twelfth century buildings were being erected in which dressed stone was cut far more systematically, as if mass-produced. Obvious examples are the decorated piers of Durham Cathedral [**63**]. The incised spirals, lozenges, and zigzags which are such a prominent feature of the cathedral were carved on the stones in advance, with the patterns so arranged that only one or two different types were required for each pier. In the nave 288 blocks, all approximately the same size, were required for the cylindrical piers.

The conventional view of the architect in the early Middle Ages is of a humble, anonymous craftsman who was not accorded much respect. The official teaching of the Church suppressed the notion of individual genius, insisting that creative skills were a gift from God. Theophilus, the author of an early-twelfth-century treatise on the arts,

urged artists to retain their humility, and a contemporary theologian, Rupert of Deutz, warned that 'skilled craftsmen ought to be admonished lest they devote divine skill to the pursuit of gain, for their talents are not their own, but bestowed on them by their creator'.[11] But for all the assertions of humility, the creative skills of master craftsmen were frequently admired. Thus at Modena and Pisa inscriptions on the walls of the cathedral celebrate the talents of the architects concerned: Lanfranco at Modena [**133**], Buschetto at Pisa. The latter was compared with Daedalus, who 'built dark labyrinths whereas Buschetto's temple was as white as snow'.[12] A master carpenter in the north of France was also compared with Daedalus. This was Louis, who built the tall and elaborate timber house for the lord of Ardres in 1117, the chapel of which was likened to Solomon's temple. Contrary to general impression, dozens of names are recorded in documents from the eleventh century onwards, such as that of Blitherus, a top-ranking figure who worked at St Augustine's, Canterbury after 1070, or Bernard the elder, the chief mason at Santiago de Compostela, who was praised in the *Pilgrim's Guide* as a '*mirabilis magister*'.[13] The use of the epithet '*magister*' is especially interesting. Generally employed for academic qualifications in the liberal arts, its extension to architecture implies a recognition of the expertise of the man in charge. An early example comes at Conques, where a Magister Hugh was in control of operations at some point between 1035 and 1065. We hear of Hugh because of an incident that occurred during the transport of stone from a quarry on a nearby mountain, when his leg was trapped under the wheel of a loaded cart.[14]

Procuring stone was just one of many tasks for which the master mason was responsible. On arrival at the building site, he had to work out the dimensions of the new work and lay out the plan on the ground. He had to prepare templates for his masons and ensure a smooth flow of material from the quarries. He was also responsible for the scaffolding as well as the cranes and pulleys needed for lifting stone and timber. Among the few relics of this process are the square 'putlog' holes, visible in dozens of medieval buildings, showing where the timber scaffolds were once inserted [**42, 134**]. The best insight into building practice as it had developed by the twelfth century can be found in Gervase's account of the rebuilding of the choir of Canterbury Cathedral after it was destroyed by fire in 1174. Gervase gives the impression of a thoroughly professional operation, led by the master mason William of Sens. By this stage in the Middle Ages it is clear that the architect, not the patron, was the controlling force; there is little sign of ecclesiastical involvement, at least not until William had the misfortune to fall from the scaffolding in 1178.

Sadly, almost nothing is known about the education and training of masons. Even in the twelfth century some were clearly illiterate, to

judge from mistakes in inscriptions. Nor is anything known about the way in which master masons were appointed, the sources merely telling us that they were summoned from distant parts or 'from lands across the seas'. William of Sens was said to have had a good reputation, but how did the monks of Canterbury know about this in advance and how did they go about contacting architects? Presumably much depended on word of mouth, information being passed along both ecclesiastical and aristocratic channels.

Throughout the period, masons were prepared to travel great distances. In about 670 Benedict Biscop, abbot of Monkwearmouth and Jarrow, managed to recruit masons from Gaul, and shortly afterwards Wilfrid brought masons all the way from Rome to Hexham. The broad distribution of churches in the 'first Romanesque' style along the Mediterranean seaboard, and across the Alps and up the Rhône valley, also implies the presence of mobile groups of masons. Buildings in this area have been attributed to the 'Comacini', supposedly groups of Lombard masons taking their name from the town of Como (though the etymology of the word is far from secure). In any building enterprise the selection of the architect is a decisive moment, but how did patrons in the early Middle Ages ensure that their master masons would stay to complete the job? During the Gothic era, written contracts became normal, but evidence for them in our period is scarce. In 1175 a certain Raimond Lombard, architect and *operarius*, came to an agreement with the bishop and chapter of Seo d'Urgell in Spain, in which he promised to work for seven years, building all the vaults of their church along with stair turrets and a lantern tower. It is possible that the drawing up of such contracts was already a standard practice. Between 1073 and 1088 the abbot of the monastery of Lérins on the island of St Honorat, off the south coast of France, drew up an agreement with certain masters to build a new tower at a cost of 500 solidos. The abbot was to pay for the transport of stone and the workmen were to be fed in the monks' refectory.[15]

Raimond Lombard agreed to bring four assistants with him to Seo d'Urgell. This group, all presumably experienced masons, must have represented only a fraction of the workforce required, the intention no doubt being to hire others locally. In major projects the master mason was required to supervise a large team, comprising masons, carpenters, labourers, glaziers, plumbers, and smiths, these last crucial for sharpening saws, axes, chisels, and other tools. Bernard the elder is said to have had 50 masons working under his direction at Santiago de Compostela—a rare statistic; in most cases we can only guess at the size of the workforce.

The chronological sequence of building is a subject that has for long fascinated historians. Religious communities were usually impatient to occupy at least part of their new churches, and for this reason the choir

and transepts were often finished in advance of the rest of the structure. Where an older building existed on the site, this could make sense for practical reasons as well. In such cases the existing church was retained until at least part of the new building was ready for occupation; only then could the old work be demolished and the new structure be completed. This approach led to churches being constructed section by section, a method often visible in the archaeology of the fabric. This is evident at Durham Cathedral, where a pause in building occurred just west of the crossing [146]. The break is highlighted by the presence of chevron ornament which was introduced only after work resumed on the nave, providing a 'fossilized' record of the building sequence. Durham Cathedral is one of many Romanesque churches in which the design 'evolved' as work progressed. Indeed at Durham some fairly radical changes—including the extension of ribbed vaulting to the whole building—were introduced during the course of construction. The unity of a building could be badly compromised by such changes. At St-Savin-sur-Gartempe, one of the most resplendent hall churches of western France, compound piers (replacing cylindrical piers) were introduced in the western bays of the nave, along with transverse arches in the vault, disrupting what is otherwise a harmonious design [140]. When building extended over many years, it was evidently hard to resist the temptation of bringing the design up to date. But for every church that was modified in this way, there are many more that are remarkable for their consistency over a long period—Santiago de Compostela, for example, or St Sernin at Toulouse.

While many large churches were constructed section by section, there are plenty of cases in which the walls rose uniformly all around the building. This made good sense if the site was clear of other structures and if there was no immediate hurry to move into the new church. It has been argued that this happened at Cluny after 1088. The new church (Cluny III) lay to the north of the existing building (Cluny II), so the monks could worship without interruption while construction continued. Cluny also had the resources to maintain a huge labour force, allowing it to build on a 'wide front' across the whole of the site [110]. The same approach is illustrated in a remarkable manner at Venosa in the south of Italy, the location of a Benedictine abbey founded by the de Hauteville family, the Norman conquerors of Apulia. A church designed in a traditional Early Christian manner had been erected soon after 1059, but during the early years of the twelfth century a sumptuous replacement was under construction. This building was never finished. Today the walls stand much as they were when the workforce was withdrawn from the site: the nave, transepts, choir, and ambulatory are all built to approximately the same height, with the east end slightly in advance of the west [64].[16] Venosa was designed to be a spectacular building, one of the few in Italy to have a French-style

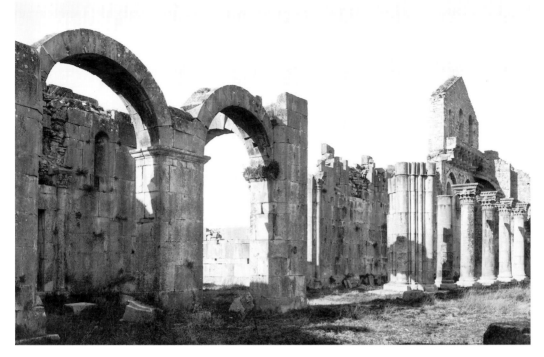

64 Venosa (Basilicata), La Trinità, early twelfth century
Unfinished church. Built with excellent masonry, the new building was taken to the top of the aisle walls before being suddenly abandoned. The new work was laid out to the east of the old church, a practice which allowed building to continue without causing any interruption to the liturgical life of the monastery.

ambulatory and radiating chapels. Massive quantities of well-dressed stone, cannibalized from the Roman town of Venusium, were used for the walls, with Roman sculptures and inscriptions incorporated into the Christian building (one, ironically, commemorates a team of gladiators!). The reason for the abrupt halt in building remains a mystery. The church was intended as a mausoleum for the de Hauteville family, and its abandonment may represent a transfer of patronage away from Apulia to Sicily, where the Norman dynasty now had its base.

The style of building at Venosa is consistent, perhaps the product of a campaign lasting two or three years. There is a widely accepted fallacy that all early medieval buildings were constructed at a very slow pace. Some certainly took decades to complete: Durham took 40 years (1093–1133), Cluny 42 years (1088–1130), and Santiago de Compostela 44 years (1078-1122). But these lengthy time spans conceal periods of intense activity, interspersed with periods when progress was slow or ceased altogether. At Durham, for example, Bishop Flambard (1099–1128) 'concerned himself with the work of the church with greater or less energy according as money from the offerings to the altar and burial fees flowed in or was lacking'.[17] Even at Canterbury Cathedral, one of the richest sees in Europe, work came to a halt in 1183 for a whole year for want of money. But when adequate resources were available, medieval builders could move with remarkable speed. The new church at Montecassino was erected in five years (1066–71), a basilica at Lorsch was built in eight years (767–84), and Lanfranc's

**65 San Miguel de Escalada
(Léon), consecrated in 913**

View looking west down the
nave. The horseshoe arches
underline the Spanish
character of what is otherwise
a fairly standard basilican
church. A screen of arches
separates the nave from the
chancel. Compare the
arrangement at Reculver,
(Kent) (**12**) and San Nicola,
Bari (**105**).

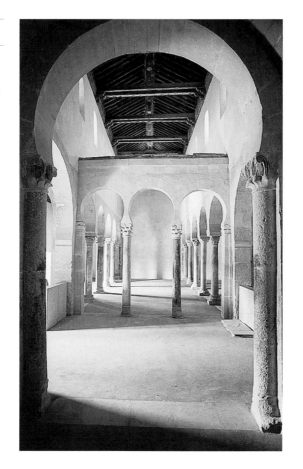

huge Romanesque church at Canterbury was almost finished in seven
(1070–7). Smaller buildings were obviously built faster, though much
depended on the amount of dressed masonry involved. The church
which Benedict Biscop erected at Monkwearmouth in 674 was com-
pleted in one year; so too apparently the church of San Miguel de
Escalada (913) near León [**65**].

Good progress was impossible without a steady supply of materials,
both timber and stone. There are several stories about abbots and other
churchmen leading the search for suitable quarries or scanning the
forests for oaks of the right size. With the collapse of the Roman
Empire in the fifth century, most commercial quarries were gradually
abandoned, though the island of Proconnesus in the Sea of Marmara
continued to export its white marble to Italy for some considerable
time. Elsewhere stone was quarried sporadically, as and when it was
needed, and it was not until the eleventh century that quarrying was
revived on a major scale. It proved far easier to recycle stone from aban-
doned Roman buildings than to cut new stone from the rock face:
throughout Europe there were columns, capitals, lintels, slabs, and un-

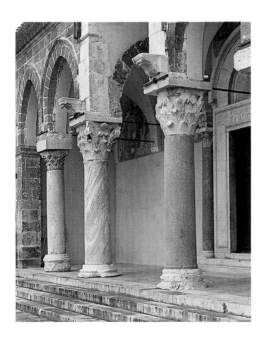

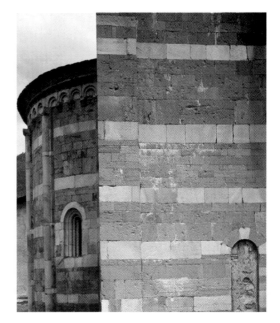

66 Sant'Angelo in Formis (Campania), west porch

The columns, capitals, and bases were assembled from a heterogeneous collection of Antique fragments.

67 Gravedona (Lombardy), Santa Maria del Tiglio, banded ashlar masonry, twelfth century

An arrangement of beautifully-cut ashlar, exploiting different types of stone. The widespread use of ashlar masonry was one of the characteristics of Romanesque architecture from the late eleventh century onwards.

68 Pomposa (Emilia-Romagna), Santa Maria, narthex, eleventh century

A stunning combination of brick, marble, terracotta, and stone sculpture.

carved blocks there for the taking, and many patrons did not hesitate to reuse them [66]. In the ninth century the Gallo-Roman walls of Rheims were dismantled to provide stone for rebuilding the cathedral and in the tenth century the abbots of St Albans assembled their own stockpile of Roman brick, taken from the neighbouring town of Verulamium. Some Anglo-Saxon churches contain complete arches made from Roman material, as at Escomb, Barton-upon-Humber, and Alkborough.[18] It was not just Roman stone that was exploited: any suitable stone would do, and Norman builders in England were quite ready to cut up redundant Anglo-Saxon crosses when the opportunity arose. These examples of random reuse should be distinguished from the occasions when ancient material was deliberately exploited, both for its quality and for the status it conveyed. Thus Charlemagne's builders at Aachen brought columns and marble slabs from Rome and Ravenna, and Otto I's new cathedral at Magdeburg (*c.*955) was one of many buildings deliberately furnished with Roman *spolia*.

Between the fifth and the eleventh centuries the majority of stone buildings were constructed using some species of rubble masonry, the techniques of which varied considerably. In late Antique structures, relatively small blocks of stone, roughly dressed, were arranged in neat horizontal courses, sometimes with brick separating bands (as in the early basilica at Siponto). This type of masonry (though normally without the brick) survived in many areas of Europe and is often encountered in Carolingian buildings. At the opposite extreme are walls of random rubble, where the stones are laid without much dressing and without any attempt at regular coursing. The early stone churches of Ireland provide some wonderful examples of this, including a type dubbed 'Cyclopian' in which large slabs were set on edge and fitted together with remarkably fine joints. One of the characteristics of the so-called 'first Romanesque' style was a quick, economical style of masonry, made up of roughly coursed blocks with a limited amount of dressing, a technique mastered by builders over a wide area of southern Europe [128].

Already by this stage a revolution in the art of building was under way in the north, with the development of ashlar masonry. One of the celebrated features of the tower which Abbot Gauzlin built at St-Benoît-sur-Loire (*c.*1026) was the use of 'squared blocks', brought down the Loire from the Nivernais [126], and at about the same time Fulk Nerra, duke of Anjou, was using well-dressed ashlar in his castle at Loches [50].[19] Over the course of the next hundred years the use of ashlar spread almost everywhere: thus in the 1130s the historian William of Malmesbury enthused over the new choir at Sarum, explaining that the stones were so precisely laid that the joints escaped the eye. The production of ashlar required the opening up of good quarries, along with experienced craftsmen to work the stone [67]. For reasons

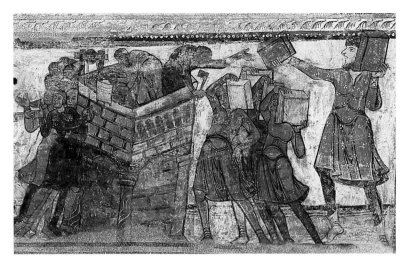

of cost, local quarries were exploited whenever possible. Ox carts were the chief means of transport and the maximum they could shift was about 10 tons per load. When the distance exceeded 12 miles or so, the cost of transport was likely to exceed the cost of the stone. The bias towards local quarries contributed much to the appeal of Romanesque: yellow limestone in the Saintonge, dark arkose in the mountains of the Auvergne, warm-coloured granite in Galicia [**101**], and red-flecked marble in the eastern Pyrenees. A few quarries managed to extend their trade beyond the immediate locality, one or two developing an international status. The limestone from Caen in Normandy was shipped all over southern England after the invasion of 1066, when the rapid expansion of building placed huge demands on local supplies. Both the major churches of Canterbury imported three different types of stone by sea: Caen from Normandy, Quarr from the Isle of Wight, and Marquise from the neighbourhood of Boulogne on the French coast. Water-borne transport was of course infinitely cheaper than carriage overland, but it was not without its problems. Heavily laden ships were easily submerged beneath the waves: sometime between 1070 and 1087 14 vessels laden with Caen stone destined for Westminster were lost in a storm in the English Channel.[20] Among the achievements of Buschetto, the architect of Pisa Cathedral, was his skill in transporting immense columns across the sea and, it should be noted, his skill in recovering them after a ship sank.

When William of Sens took over the workshop at Canterbury in 1174, one of his first tasks was to send templates to the quarry at Caen. This indicates that some carving was carried out at the quarry, a practice which no doubt helped to reduce the costs of transport. In the late Antique era quarries manufactured complete components, ready for assembly at the site. Capitals from Proconnesus were about 75 per cent complete at the time they were despatched to their final destination.

A sunken ship discovered off the Sicilian coast was found to be carrying marble from Proconnesus, already shaped into an ambo, chancel screens, and columns for a ciborium, the complete furnishings for a Christian church.[21] There are occasions when the same practice was adopted in the Romanesque era. The stone purchased from Marquise by St Augustine's Abbey at Canterbury between 1070 and 1087 had already been cut into capitals, columns, and bases and it has been suggested that the concept of the cushion capital, new to England at the time of the Norman Conquest, was introduced from the continent in prefabricated form. It is an indication that quarries may have played a small but perhaps significant role in the transmission of stylistic ideas.

One of the most challenging questions concerning early medieval building is the extent to which theoretical ideas affected the practice of architecture. It is known that certain proportional ratios were favoured, but it is unclear whether these were merely formulae passed down from one mason to another or whether they were actively debated and understood. Scholars were familiar with classical works on architecture and geometry, notably the writings of authors like Vitruvius, Vegetius, and (in the twelfth century) Euclid, but whether this knowledge had any significant effect on architecture is far from clear. Cassiodorus, writing on behalf of King Theodoric (490–526), urged an architect at Ravenna to study Euclid, as well as Archimedes and Metrobius.[22] This was probably wishful thinking, and few if any master masons in the Middle Ages acquired such erudition. A further problem is the extent to which architects made preparatory drawings. Apart from the St Gall plan [**123**], none survive. Even the monk Gervase, who was so well informed about the reconstruction of Canterbury Cathedral after 1174, makes no mention of them. It is known that buildings were marked out on the ground with ropes and pegs—as if being drawn at full scale—and that specific details were worked out *in situ* as building progressed. But for more elaborate works some preparatory diagrams and drawings could scarcely be avoided; this certainly ocurred at Auxerre, where the plan of the ninth-century crypt at St Germain is said to have been worked out in wax by the builder, presumably a reference to wax tablets.[23] Before cutting the templates of a pier or arch, a master mason had to be certain of the overall form. In Gothic design such features were drawn at full scale on walls or plaster floors, and it is possible that some equivalent technique was adopted by Romanesque masons. There were well-documented occasions when patrons sent emissaries to study other buildings in search of ideas: in 1026 the bishop of Arezzo provided his architect, Maginardo, with the cash needed to visit Ravenna to make a study of the monuments there, and it is hard to believe that such expeditions ended without a single sketch or drawing. Whatever happened, these episodes illustrate the way in which existing build-

70 Lomello (Lombardy), Santa Maria Maggiore, eleventh century

Plan of the church

Irregular plans were frequently the result of piecemeal rebuilding, though this does not appear to have been the case at Lomello.

ings were taken as the basis for new designs, the choice of an appropriate model being of critical concern for the patron.

For over a century scholars have scrutinized monuments in an attempt to discover medieval principles of proportion. The task is far from easy. Some buildings, especially those that were reconstructions of earlier works, are so irregular in layout that they appear to make nonsense of this approach, the church at Lomello being an extreme case [**70**]. But the layout of medieval buildings—churches, monastic buildings, castles, and halls—was not an arbitrary process, and one of the greatest weaknesses in studies of medieval architecture has been the failure to recognize the importance of proportional systems. Although Romanesque building has been praised for its clarity and order, in most cases we do not know how this was achieved. In the past there has been an assumption that design was based on modular principles or 'square schematism' as it has sometimes been called.[24] Thus the German scholar Hanno Hahn argued that Cistercian abbeys were laid out through the use of two large squares, the sides of which had a 3:4 ratio to each other [**71**].[25] Unfortunately, accurate surveys of individual abbeys have demonstrated that Hahn's proposed scheme rarely fits ex-

71 Eberbach (Hesse), Cistercian church, completed *c.* 1170–86

Plan showing Hahn's suggested schema based on two square units in the ratio to each other of 3:4. The validity of this interpretation has been questioned in recent years.

actly. It can be argued that this is just what one should expect. As walls were first outlined by ropes on the ground, and as they could measure four or five feet in width, an underlying proportional system might easily be compromised, depending on whether foundations were dug to the right or left of the rope, or down the centre. A further complication affecting all such investigations is the fact that the medieval foot was not a consistent unit of measure, its value differing according to time and region.

In some buildings Hahn's system involves squares which have sides of 42 and 56 (English) feet. The use of a dimension of 42 feet is significant. This was a measurement generated using one of the favoured ratios of the Middle Ages, one to the square root of two, which in geometrical terms represents the ratio of the side of a square to its diagonal. Its mathematical equivalent is 1:1.414. The way this was used by the Cistercians was quite simple. If a cloister garth was laid out as a 100-foot square, a rope swung from the diagonal to the side would generate an extra 41½ feet [**72**]. At Jerpoint Abbey the cloister was laid out in just such a manner, producing an east range 42 feet wide. In recent years numerous studies have underlined the importance of this procedure. At Norwich Cathedral (a good example since the building was laid out on an unencumbered site) the square root of two formula runs through all aspects of the design, including the plan of the piers [**73**];[26] at Durham it controls the main elements of the elevation.[27] There was nothing particularly mysterious about the method, which was also used by scribes and illuminators. Other ratios detected in Romanesque monuments include 1:√3 (1:1.73), 1:√5 (1:2.236) and the 'golden section' (1:1.618), all involving irrational numbers derived from geometrical shapes. The ratio of 1:√3 for example is taken from an equilateral triangle, a form which governed the section of a number of major buildings, including San Michele at Pavia and the abbey church at Fontenay [**116**]. Builders did not of course think in terms of square roots. They either worked directly from the geometrical forms that generated the ratios or from arithmetical approximations. Thus the ratio of 12:17 was employed as a convenient equivalent of 1:√2. Nor were the methods the

exclusive preserve of ecclesiastical builders. The plan of the royal castle at Orford in Suffolk begun in 1165 was based on an equilateral triangle, the design involving ratios of both $1:\sqrt{2}$ and $1:\sqrt{3}$.[28]

Why, it might be asked, were these systems employed? Some have argued that they introduced a symbolic harmony, which in church architecture endowed the building with divine or mystical connotations. Medieval churchmen were certainly disposed to think in this way, though writers such as Honorius of Autun and Durandus of Mende, who discussed the symbolism of churches, make no reference to ratios and proportions. For the master mason the ratios were probably regarded as a convenient way of making decisions, timeless principles of architecture which had been hallowed by centuries of use and which were known to produce satisfying results. Irrational ratios were fundamental to the aesthetics of Greek and Roman architecture, and for medieval architects, as Peter Kidson has pointed out, 'any suggestion of dispensing with them would have seemed as unthinkable as using a language other than Latin for the liturgy'.[29]

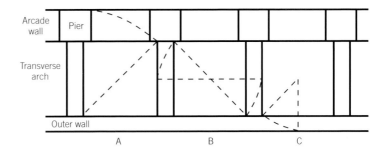

73 The square root of two

The aisle bays of Norwich Cathedral, showing the use of the ratio of one to the square root of two [after Fernie].

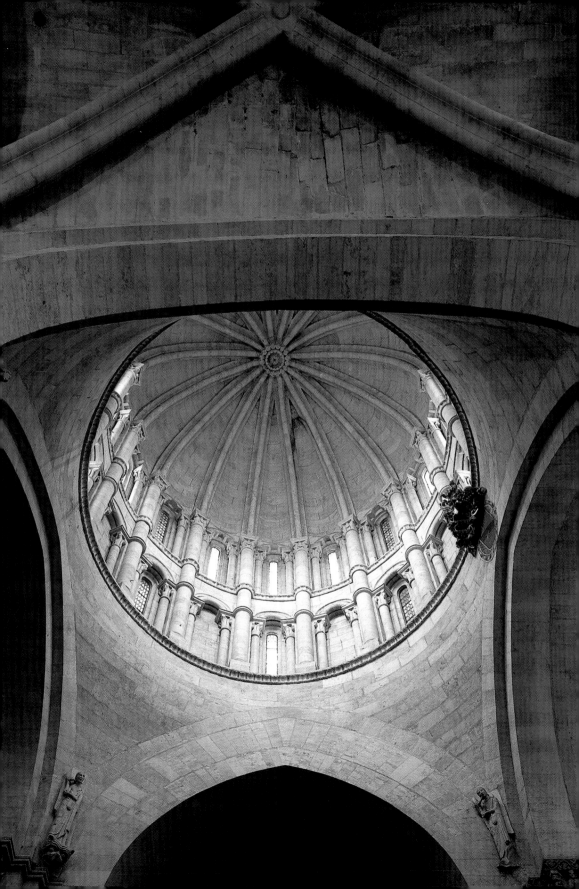

Art and Engineering

6

When the newly constructed tower at Beverley Minster collapsed in around 1200, a local writer had no doubt about the cause of the disaster: 'The craftsmen in charge of the work were not as cautious as they should have been, nor as judicious as they were outstanding in their art; they were intent on beauty rather than strength, on delighting the eye rather than ensuring stability'. According to the chronicler, the tower had been constructed on the existing piers of the church, like a new patch 'sewn into an old garment'.[1] When a stone spire was added, the piers were overloaded to such a degree that catastrophe became unavoidable. Medieval masons of course had no theoretical way of calculating the structural behaviour of their buildings. Experience was the best guide, but as projects became increasingly ambitious, some individuals were prepared to take extraordinary risks. The remarkable advances that occurred in architectural engineering were almost entirely the result of trial and error, an empirical process which is difficult to analyse, since, by definition, the failures have not survived. Disasters—or near disasters—were probably more common than we realize. Despite the setbacks, spectacular progress was made in two particular areas, tower building and vault construction, progress which prepared the way for the structural achievements of the Gothic era.

Towers and turrets are such an inherent part of our vision of the Middle Ages that it is easy to take their origin for granted. As far as we know, it was not until the Carolingian era that they became a common feature of church design, though their origin goes back to late Antiquity. Some early towers were quite extravagant, like that at Nantes (535–82), which started square but turned into a circular form. Its 'stupefying height' sent the poet Venantius Fortunatus into raptures, as he admired its 'ascending sequence of arches' and the way it dominated the church like 'the summit of a mountain'. While the lower parts of the tower at Nantes may have been made of stone, the upper parts were almost certainly constructed of timber. Several Carolingian buildings are known to have had crossing towers; the rem-

74 Salamanca, Old Cathedral, begun 1152 and finished in the early thirteenth century

The ribbed dome rises above a two-storey drum or *cimborio*, which is supported on pendentives. The windows in the drum cast a pool of light into the centre of the church.

nants of one (though extended and much rebuilt) survive at Germigny-des-Prés. Two circular towers, apparently housing chapels, flanked the west end of the church depicted on the St Gall plan (*c*.830) [**123**], and the church at St Riquier (*c*.800) had substantial towers at both ends of the building, along with several circular stair turrets [**18**]. Many early towers, both in churches and castles, are known to have been timber-framed and, though none survive, there are drawings and carvings which give an impression of their appearance. In Anglo-Saxon England timber architecture inspired the design of the stone towers at Earls Barton [**75**] and Barton-upon-Humber, where the masons even replicated the mitred joints of the carpenters.[2] These two late-tenth-century towers provide a useful hint of the complexity of the lost wooden architecture of early medieval Europe.

On the continent of Europe the enthusiasm for tower construction continued unabated during the Ottonian era, and by 1100, towers, either at the west end of the church or over the crossing (or both), had become a standard feature of even quite modest buildings. The great Burgundian church at Cluny was built with six towers [**110**], so too was the abbey church of Maria Laach [**13**]; and the Norman cathedral at Winchester was planned with a combination of no fewer than nine.[3]

75 Earls Barton (Northamptonshire), Anglo-Saxon tower, late tenth century

The stripwork appears to be derived from timber-framed buildings. The bloated baluster shafts seen at belfry level are widespread in Anglo-Saxon building, so too the distinctive 'long-and-short' masonry used at the angles.

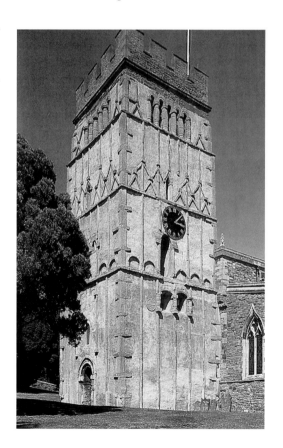

As stone had to be hoisted high above the ground, towers were expensive to build. Moreover, there were structural risks, particularly acute in the case of crossing towers, which were suspended on arches above the main body of the building. In England the collapse at Beverley was foreshadowed by similar disasters at Winchester (1107) and Worcester (1175). Given the expense and the dangers, why were medieval churchmen so anxious to spend their money on what to some observers were nothing more than towers of Babel?

The most obvious reason is human pride: towers conveyed an instant impression of status, and advertised the importance of a religious house, especially when seen from a distance. They looked impressive, no doubt exciting medieval spectators in the way that modern visitors are enthralled by the skyscrapers of Chicago, New York, or Hong Kong. From an artistic point of view, towers dramatically improved the external composition of churches: this is particularly the case with crossing towers, which provide a unifying focus, drawing the various parts of the building—nave, chancel, and transepts—into a synthetic whole. The construction of a tower over the crossing may also have offered some practical advantages, since the roof of each arm of the church could be built up against the walls, simplifying the joinery, and allowing each section of roof to be erected independently. In functional terms their chief purpose was for hanging bells, the ringing of which occupied a crucial place in the liturgical life of the Middle Ages. The higher a bell was located, the further its sound would travel. A tall belfry was thus seen as a way of instilling discipline and ensuring punctual attendance at the daily offices. These developments had repercussions far beyond the confines of religious communities, since, in an age without clocks, the sound of church bells came to govern the daily routine of people in every walk of life. But the need to make bells audible hardly justified the proliferation of towers that took place in the great churches of northern Europe. This was certainly the opinion of the Cistercian order, which concluded that bell towers were a needless extravagance and banned them in 1157.

Modern commentators have pointed out that towers may have enhanced the symbolic meaning of church architecture. A majestic array of towers provided the visual and emotional excitement necessary to invite comparisons with the Heavenly Jerusalem. In some cases towers were used more specifically to emphasize the position of altars or shrines, as at St Riquier, where one tower marked the site of the altar of St Riquier, the other that of the Saviour [18]. As we have already seen (chapter two), Carol Heitz believed that the Carolingian westwork, with a tower rising above, was intended as a reference to the Holy Sepulchre. Symbolic connotations are also suggested by the crossing towers of a number of twelfth-century churches in France and Spain, which took the form of a rotunda, as if a shrine or mausoleum had been

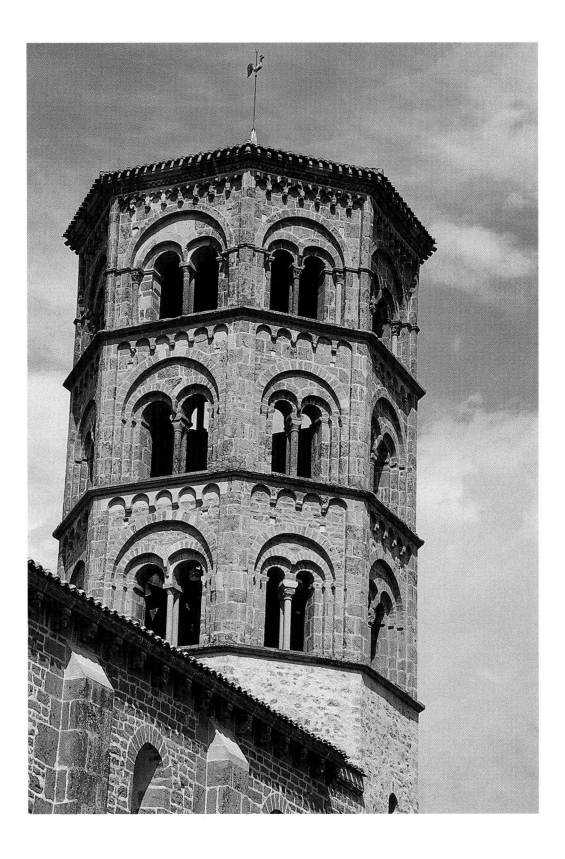

76 Anzy-le-Duc (Saône-et-Loire), Cluniac priory church, crossing tower, first half of twelfth century

The octagonal form, with clearly defined stages, is found in many Burgundian churches.

elevated above the rest of the building [80]. Whether the original architects chose these forms with deliberate symbolical intent, we do not know; some scholars feel they can be interpreted quite adequately in terms of aesthetic choice. It has been argued that the twin towers that flank the chancels of some Rhineland churches conveyed a political message about the status of bishops and, whatever the truth in this instance, there were certainly occasions when tower construction was motivated by political considerations.[4] The twin towers found at Cormac's Chapel (1127–34), Cashel (Tipperary), for example [131], provided a succinct way for a local king and his supporters to proclaim their international credentials.

Romanesque towers were normally square or octagonal in plan, the choice of arrangement tending to follow regional patterns. Thus the churches of Burgundy and the Auvergne are surmounted by octagonal towers, often constructed in two or more stages, like the elegant examples at Anzy-le-Duc [76] and St Saturnin [149]. When an octagonal tower was constructed over the crossing, special measures were required to effect the transition between the square plan of the crossing and the octagonal base of the tower. To solve this problem builders normally employed 'squinches', short bridges of stone cutting across the angles [149]. The problem did not arise when towers were built to a square plan, as was usually the case in England and Normandy. Compared with the elegant towers of Burgundy or the Auvergne, the Anglo-Norman examples, as at Lessay, Tewkesbury [77], Southwell, or St Albans, are altogether more monumental and robust in appearance.

One important distinction in the handling of a crossing tower concerns the way in which it relates to the internal space of the building. Normally the existence of the tower is concealed by the insertion of a ceiling or vault at the same level as the adjoining nave; in some cases, however, the lower storeys of the tower were left open, producing the so-called 'lantern tower'. With the windows high above casting a pool of light into the centre of the church, the effect can be very dramatic, as in the (rebuilt) tower at St Etienne at Caen or in the pilgrimage church at Conques. Similar effects were achieved in three major Spanish churches, the cathedrals at Salamanca and Zamora, and the collegiate church at Toro. In these examples the space of the crossing is covered by a dome set above a drum filled with continuous windows, the whole arrangement embellished with a rich display of mouldings and arcades [74]. The transition from the square space of the crossing is achieved effortlessly by the use of pendentives, rather than the more awkward squinches generally employed elsewhere. The sublime composition of space, light, and pattern created inside these churches is matched on the exterior by the sheer power of the central drum, its appeal enhanced by blind arcades and extra turrets [78].

77 Tewkesbury Abbey (Gloucestershire), crossing tower, first half of twelfth century

This is one of the more ornate examples of the square crossing tower, which was a feature of Romanesque building in Normandy and England.

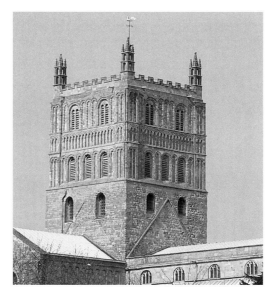

78 Toro (Zamora), collegiate church of Santa Maria Mayor, dome over crossing, *c.*1200

Compared with an earlier dome at Zamora, the dramatic effect is enhanced by the two-storeyed drum and the isolation of the four corner turrets.

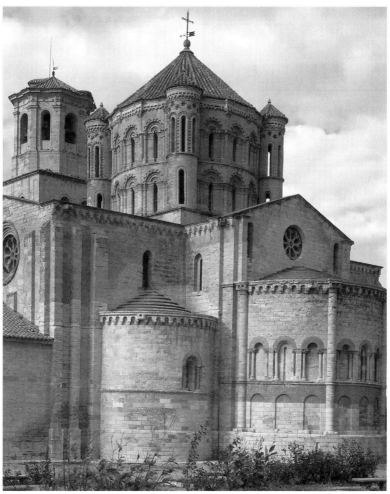

79 Selby Abbey (Yorkshire), settlement in the nave, c.1100–20

The north-west crossing pier (to the right) dragged down the first bay of the nave. To save the situation, the gallery arch was partially blocked.

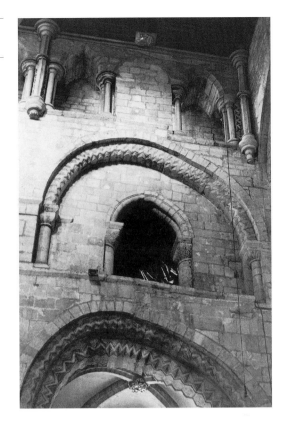

The main structural problem encountered in the erection of crossing towers was the danger of differential settlement. The extra load placed on the four crossing piers meant that they were liable to sink further into the ground than neighbouring parts of the structure, thus introducing distortions into the fabric, with the eventual possibility of complete collapse. The best guarantee of stability was to ensure that the foundations laid out at the beginning of the work were capable of sustaining the additional weight, a principle that was not universally understood. The problem was compounded by the fact that, as at Beverley, towers were often added to existing buildings or increased in height, thereby adding loads which the original masons had never envisaged. A remarkable illustration of this problem can be seen, fossilized in the fabric, at Selby Abbey, where the construction of a central tower (c.1120) seriously distorted the adjoining bays of the nave [**79**]. Rather than dismantle the damaged masonry, the builders patched and strengthened the existing stonework as best they could.

At Beverley disaster came with the addition of a stone spire, a feature usually associated with Gothic architecture. In fact the origin of the spire can be traced back to at least the sixth century, though it was only in the Carolingian era that it became a common feature of church design. The early spires were constructed around a wooden framework

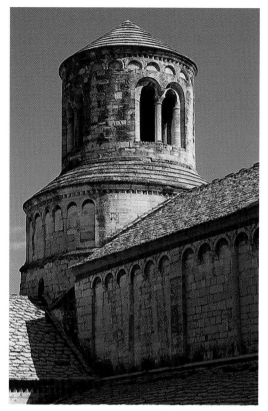

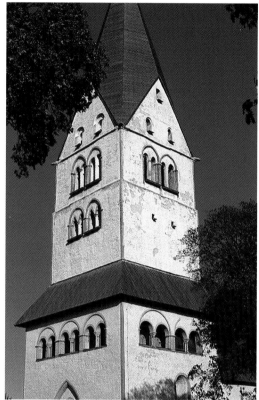

80 Cruas (Ardèche), abbey church of Sainte-Marie, twelfth-century crossing tower

The circular tower at Cruas is unusual in this region of France. Built in two stages, with a narrow upper storey, the design is reminiscent of Roman mausolea, as well as centralized buildings inspired by the Holy Sepulchre at Jerusalem (**41, 42**).

81 Stenkyrka (Gotland), helm tower, late thirteenth century

The stone gables at the base of the spire and the open arcades in the body of the tower were derived from German Romanesque architecture, as seen for example at Maria Laach (**13**).

and covered by lead or wooden shingles. An ambitious example was erected by the monks of St Bertin in northern France soon after 860, when they constructed what they called a *tristegum*, a tall three-stage spire, in which each level was built like a wheel, with spokes coming out of a central post.[5] Some decades earlier, a more orthodox scheme had been commissioned by Abbot Ansegis (823–33) of St Wandrille, in the form of 'a square pyramid thirty-five feet in height, constructed of turned wood'. It was covered with lead, tin, and gilded copper, and contained three bells. The shape of the spire at St Wandrille became one of the standard forms of the early Middle Ages, consisting of a four-sided roof brought down to the outer edge of the stone tower which supported it. A variant of this type is the 'helm', in which the roof structure is rotated by 45 degrees, with gables terminating the masonry of the tower, allowing the flat surfaces of the spire to descend into the angles. This form, which was restricted to northern Europe, was employed in both England and Germany, and several fine examples survive in Gotland [**81**].

Wooden spires were vulnerable to both wind and lightning, and by the twelfth century there was a general realization that the stone spire offered greater security. In this the French were the pioneers and there is

82 Chartres Cathedral, south-west tower, third quarter of the twelfth century
The steep gable which carries the eye towards the spire was a motif with several precedents in the Romanesque architecture of western France.

a series of stunning examples in the western regions of the country. Some are conical in form, for example those at Poitiers (Notre Dame la Grande) and Saintes (Notre Dame), but the octagonal shape is more common. When a spire was erected over a square tower, as was often the case, the architects were faced with the problem of how to effect a smooth flow from one to the other. In many cases the transition was concealed by small turrets or miniature spires placed at the angles, which contribute to the vertical flow of the design. Elsewhere steep gables on the main faces of the tower enhanced the vertical emphasis, as at Brantôme (Dordogne), Vendôme (Loir-et-Cher), and St- Léonard-de-Noblat (Haute-Vienne), a type sometimes known as the *clocher Limousin*. These ideas were triumphantly brought together in the south tower at Chartres, where a combination of gables and corner turrets leads the eye effortlessly towards the spire, stretching over 300 feet into the sky [**82**].

From the tenth century onwards, in Italy and other parts of southern Europe, tall belfries were often built as independent structures, an approach which avoided any structural interference with the fabric of the church and allowed the shape of the traditional basilica to be maintained. Divided into regular stages by Lombard arcades (see pp. 195–6),

83 Kilmacduagh (Galway), round tower, probably eleventh century

The pronounced lean of this typical Irish bell tower was probably the result of building over earlier graves.

they are intimately associated with the style known as 'first Romanesque'. Particularly distinctive is the way in which the size and number of the window openings increase with each storey, bringing the composition to a natural climax at the belfry openings. A few of the Italian campanili are circular rather than square in plan, and there is a cluster of such towers at Ravenna, built in brick. But the most glamorous circular tower is that at Pisa, the famous 'Leaning Tower', which is enveloped by arcading and bedecked in white marble [**136**]. The circular belfry is also encountered in Ireland, where it is described in the local annals as *cloictheach* or bell house [**83**]. Such towers first appeared in the tenth century in circumstances which have never been satisfactorily explained; presumably there was some connection with Italy. Although somewhat gaunt compared with their Italian counterparts, the Irish towers were built with a subtle 'batter', tapering slightly as they rise, and they were surmounted by conical roofs of stone, a form conceived long before stone spires became widespread in Europe. Isolated towers were not immune from structural catastrophe: at Pisa the tower had already begun to lean while under construction and in Ireland several towers were blown over by high winds in 981, collapses which probably had more to do with inadequate foundations than with the exceptional weather.[6]

The outstanding engineering achievement of the early Middle Ages was unquestionably the development of the stone vault. Until the eleventh century Christian basilicas were normally covered by some form of timber roof, occasionally with a separate wooden ceiling fixed below. Although the architects of imperial Rome had mastered the mechanics of both groin and barrel vaulting, the upper walls of a colonnaded basilica were too lightweight to withstand the forces generated by a masonry vault. In the post-Roman world vaults were employed in crypts and other relatively small spaces, but nobody dared to construct them over the broad span of a large basilica. This was the challenge facing masons in the eleventh century, when various alternative solutions were put to the test.

The building of a masonry vault was no easy task. During construction, timber centering was required as a temporary support until the vault was complete. The top of the centring was made of planks or wattle mats, which provided a surface on which the stones of the vault were laid. Most early medieval vaults were made of rubble or roughly dressed masonry, which called for a liberal supply of mortar. As the mortar itself did not have the tensile strength to lock the masonry into a solid shell, the stability of the vault depended on its geometrical shape and the fact that the stone was disposed in such a way that it remained under compression. With the vaults complete, the centering could be removed, a nervous moment for the masons involved, providing the first independent test of the structure.

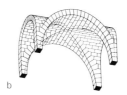

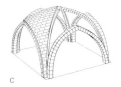

84 Stone vaulting in the early Middle Ages

(a) barrel vault; (b) groin vault; (c) ribbed vault

The two main types of vault used in the early Middle Ages, the groin vault and the barrel vault [84], both exerted substantial lateral force on the upper walls of the building. These pressures had to be neutralized in some way, the precise extent of the forces depending on the nature of the masonry employed and the thickness of the vault itself. Romanesque vaults were usually a foot or more thick, which means that in an average church, hundreds of tons of masonry were suspended above those who worshipped inside. The lateral forces generated by this weight often led to serious distortions in the fabric, as in the church of the Collegiata del Sar at Compostela, where the main piers are so badly twisted that the building was only saved from collapse through the addition of external buttressing [85]. Faced with such difficulties, Romanesque masons opted for massively thick walls, further reinforced by buttresses, as the best means of ensuring stability.

85 Santiago de Compostela, Collegiata del Sar, twelfth century

The piers of this hall church have peen pushed outwards in a classic demonstration of vault mechanics. The exterior walls have been provided with massive buttresses to counter any further movement.

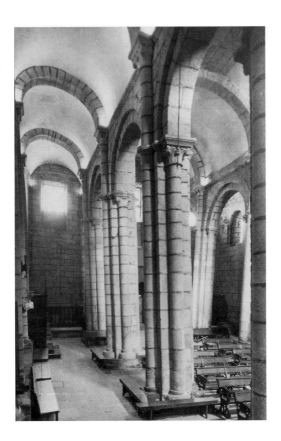

Of the two major types of vaults available, barrel vaults were easier to build, since they were regular in shape and the semicircular centering could be reused as work progressed. A disadvantage was the fact that the lateral forces were spread evenly along the supporting walls, making the introduction of windows a more hazardous operation. This problem could be avoided through the use of groin vaults, where the forces were directed to particular points of the wall, allowing windows to be opened in the intervening spaces. The centering of a groin vault, however, was more complex. The diagonal angles formed on the underside of such vaults do not normally prescribe a semicircle [**119**], which made the wooden supports complicated to assemble. As a result, it was never easy to achieve a smooth curve along the groin.

The difficulties and dangers involved in the construction of stone vaults raise the question of why patrons and builders were so anxious to erect them. The conventional explanation is that they were an insurance against the fires which devastated many a great church in the Middle Ages. The specific catalyst is often thought to have been the attacks on religious communities in the ninth and tenth centuries by the Vikings, Magyars, and Moslems. This oft-recited view is too simplistic, given that the areas of Europe which suffered most devastation were not those in the vanguard of structural development. Nonetheless stone vaults did have a protective value. Once fire caught hold in a wooden roof, it was virtually impossible to stop it destroying the whole building, as burning timbers fell into the church below. A stone ceiling constructed under the outer roof thus served as an effective barrier. Most fires were caused by accident, as at Canterbury in 1174, when sparks from a local house fire settled on the roof of the Romanesque choir. In an age which depended on candles for illumination, the risks were all too obvious. In 1015 a multitude of dignitaries, who had gathered at Mainz to celebrate the completion of a new cathedral, watched it burn down on the day of consecration. Stone vaults were, however, regarded as far more than an insurance against fire. When they were added to the church of St Hilaire at Poitiers in the twelfth century, a contemporary source explained that the purpose was to provide 'protection from fire' and improve the 'composition of the work'.[7] The juxtaposition of the two phrases is significant, leaving no doubt that vaults were prized for their aesthetic appeal. They transformed the atmosphere of the building, adding a dignity and monumentality which was lacking when the interior culminated in an open timber roof. These qualities were recorded by a chronicler at Angers around 1150 when he explained how the bishop 'took down the timber beams of the nave of the [cathedral] church, threatening to fall from sheer old age, and began to build stone vaults of *wondrous effect* [my italics], spending £800 of his own money on the work'.[8] It is also possible that stone vaults were appreciated for their acoustic properties, an important consideration as singing and chanting came to occupy a prominent role in the *opus Dei*.

The precise circumstances in which stone vaulting on a grand scale was mastered by Romanesque builders have proved difficult to establish: crucial monuments have been destroyed or reconstructed, and the chronology of those that survive is often the subject of debate. As early as 957 a church at Banyoles in Spain was covered in stone following a fire, and it is clear that by the early decades of the eleventh century some ambitious projects had been undertaken in Catalonia, notably at San Pedro de Roda and Cardona.[9] San Pedro de Roda is a spectacular monument, situated on the cliffs above the Mediterranean, just south of the modern Franco-Spanish border. The interior of the church is thoroughly Roman in flavour, with two superimposed sets of columns flanking the main piers, the latter set on high plinths, recalling the arrangement found on many a triumphal arch [**86**]. The barrel vault (*c.*1035), which adds to the spirit of *Romanitas*, is buttressed by quadrant vaults in the aisles, a system which allows the lateral forces of the

86 San Pedro de Roda (Catalonia), *c.***1035**

One of several examples of early barrel vaulting in Catalonia. The detached columns and high plinths are strongly reminiscent of Roman architecture.

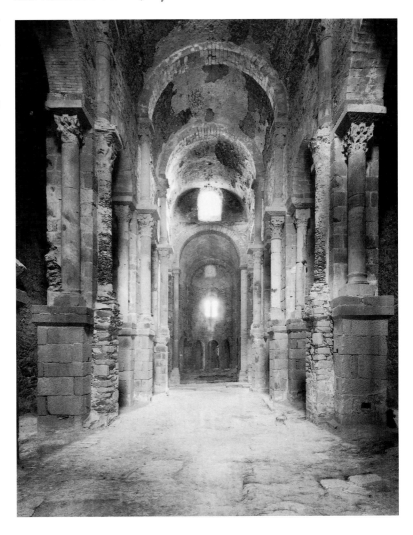

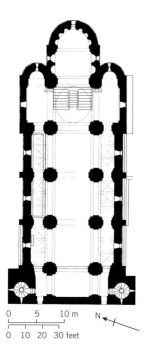

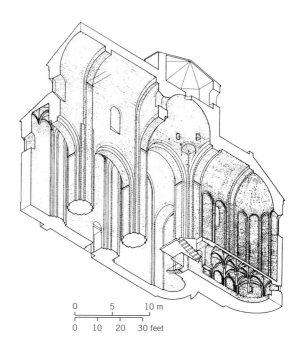

87 Cardona (Catalonia), San Vincente, consecrated in 1040

The barrel vault over the nave was supported with small groin vaults in the aisle, three per bay. The niches around the apse and the hall crypt under the chancel suggest a link with Italy.

nave vault to be transferred efficiently to the outer walls of the building. The masons in this case were cautious in their approach to structural matters: the aisles are narrow and there are no clerestory windows to weaken the upper walls of the building. The church at Cardona, consecrated in 1040, is a more compact and harmonious building, with barrel vaults throughout the main spaces of the church. It was designed to serve a religious community living within the castle of the local count. As at San Pedro de Roda, the aisles are narrow, but otherwise the structural system is quite different. Clerestory windows pierce the upper walls of the nave, and the aisles are covered by a series of small groin vaults, three per bay, which are too low to provide much support for the main vaults [87]. Several aspects of the design of Cardona relate to Lombardy (including the hall crypt and a series of blind niches around the interior of the apse and choir), raising the possibility that the vaults may have been inspired by lost monuments in northern Italy.

There is a mistaken assumption that medieval methods of vaulting followed a neat typological progression. In fact the masons of the eleventh century experimented with a number of different systems, at least some of which ended in failure. It was not particularly difficult to erect vaults over single-aisled buildings, where the walls could easily be buttressed, but in aisled structures the forces of the central vault somehow had to be transferred across to the outer wall. The way in which the aisle (or the gallery above) was vaulted thus became a crucial con-

88 Tournus (Saône-et-Loire), St Philibert, interior of the narthex, 1023–56, ground floor

The groin vaults in the main space are buttressed by transverse barrel vaults in the aisles, a sound structural arrangement which the Romans used on a grand scale seven centuries earlier in the Basilica of Maxentius.

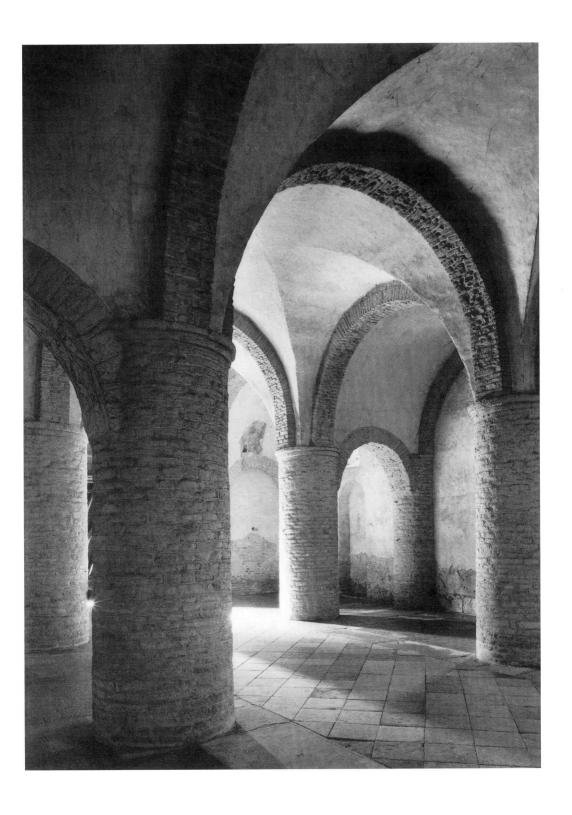

89 Alternative structural forms: cross-sections

(a) Santiago de Compostela;
(b) Notre-Dame-la-Grande,
Poitiers (hall church);
(c) Cluny III; (d) St Trophîme,
Arles (Provençal type)

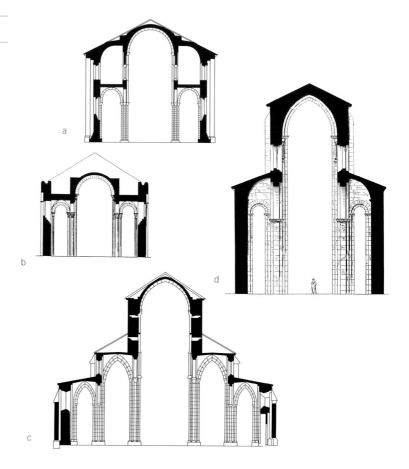

a

b

d

c

**90 Tournus (Saône-et-Loire),
St Philibert, nave vault,
c.1060**

The sequence of transverse
barrel vaults allowed for
excellent lighting effects, but
the system was rarely copied,
no doubt because of the
excessive load placed on the
transverse arches.

cern. One of the most successful solutions was that employed in the
pilgrimage churches at Santiago, Toulouse, and Conques, where quad-
rant vaults in the galleries reinforce the upper walls of the church just
below the springing point of the main vault [**89a**]. In these examples
the builders opted for stability rather than light. There are no windows
at clerestory level, so that even on the brightest days the churches pre-
serve a degree of shade and mystery.

An alternative approach to vaulting a three-aisled space is repre-
sented by the so-called 'hall' church, in which each aisle is constructed
at approximately the same height [**89b, 140**]. In structural terms this
has considerable advantages, since the vaults over the outer aisles are
high enough to buttress the central vault, allowing the lateral forces to
be transferred to the outer perimeter of the building. The compact
section of a hall church is thus quite different from that of the tradi-
tional basilica. The visual effects inside are also different, with the
more open space dominated by tall unbroken piers. Although hall
churches were not immune from structural problems (witness the
Collegiata del Sar [**85**]), they offered a reliable way of constructing a

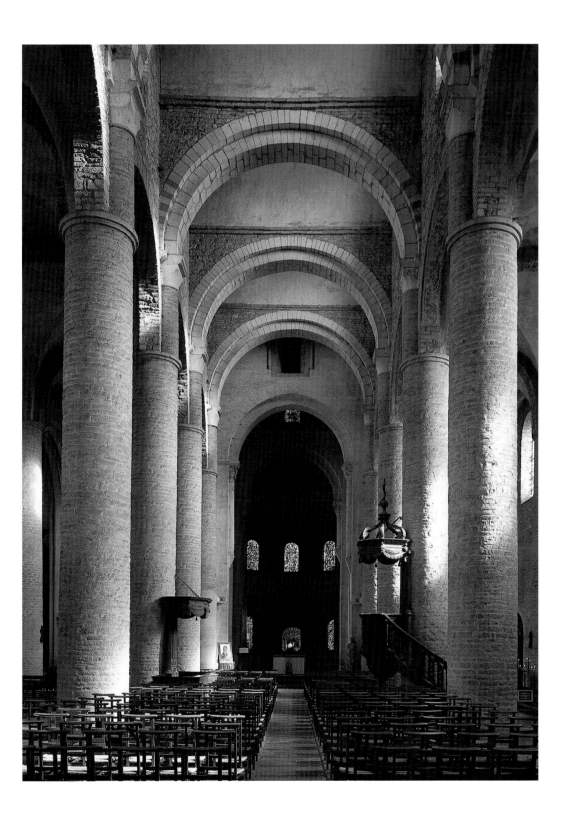

completely vaulted building, one reason perhaps why they became popular during the eleventh century, especially in western France and northern Spain.

The best illustration of the experiments that took place in vault construction are to be found in the Burgundian church of St Philibert at Tournus, where several different methods were employed within a few years of each other.[10] The ground floor of the westwork (1023–56) has an arrangement which can be traced back to imperial Rome: here the central space is covered by groin vaults, reinforced in the aisles by a sequence of transverse barrel vaults [88]. This is a logical arrangement, with the solid mass of masonry in the haunches of the barrel vaults buttressing the central vaults. Transverse barrel vaults in the aisles were subsequently employed elsewhere in Burgundy and the system was later exploited by the Cistercians, most notably in the church at Fontenay [116]. In the upper storey of the westwork at Tournus, known as the chapel of St Michael, the space was treated like an orthodox basilica, with a high nave and clerestory windows. Here the nave is covered with a barrel vault, which exerts considerable stress on the upper walls; wooden tie beams were therefore inserted to counter the danger of lateral movement. Quadrant vaults in the aisles were set too low to provide any serious reinforcement for the vault above. The arrangement is far from perfect, and it illustrates one of the main problems that confronted Romanesque builders: how to reinforce a high vault while at the same time retaining windows at clerestory level.

In the main body of the church at Tournus this problem was tackled in an ingenious way. Sometime after 1056 the nave was barrel vaulted, not with a single continuous vault, but with a series of barrel vaults set transversely across the building [90]. The main forces of the vaults descend onto the transverse arches, which were built of carefully cut stone. As the upper walls were relieved of much of their load-bearing function, clerestory windows could be inserted without weakening the structure. The system produced spectacular lighting and spatial effects, but the excessive stress on the transverse arches meant that it remained a brilliant though flawed solution; there is only one known copy.

In the last two decades of the eleventh century, Romanesque engineering became increasingly ambitious. Particularly adventurous was the great church at Cluny (Cluny III), begun in 1088, where the high vaults extended almost 100 feet above the ground [89c, 112]. What made this such a daring piece of architecture was the presence of a clerestory with three windows per bay, providing a continuous strip of glazing immediately below the vaults. Although pierced by windows, the upper walls were extremely thick; they were in fact wider than the piers which supported them below, creating an overhang known to French scholars as *porte à faux*. Perhaps sensing the structural dangers,

the builders employed barrel vaults with pointed profiles, a shape which helped to reduce the horizontal forces. This is one of the first uses of the pointed arch in Western architecture, a form commonly thought to have been borrowed from the Islamic world. Whatever its origins, the crucial fact is that the builders of Cluny were prepared to use an alien form. The willingness to depart from tradition must be linked to the scale of the building and to the realization that the pointed arch offered structural advantages. Pointed forms were used only in load-bearing positions, not for windows or doors, indicating that the change was made for structural rather than aesthetic reasons. It is ironic that a church with fluted pilasters and other explicit references to ancient Rome should abandon one of the fundamental components of classical design.

The structural audacity of the Cluniac masons was called into question even before the abbey church was finished. In 1125 a section of the high vaults of the nave collapsed, and subsequent repairs must have involved a reassessment of the original design. As a precautionary measure external arches—or flying buttresses—were used to reinforce the upper walls of the nave [110]. Although flyers are generally regarded as a Gothic 'invention', it is worth noting that they first came into use as an emergency repair.

Compared with other great buildings of the time the structural system of Cluny was far from perfect. A more solid and reliable approach was adopted by the masons at Speyer Cathedral, working under the patronage of the emperor Henry IV. In the years after 1081 the main body of the cathedral was covered by groin vaults, each vault extending over two bays of the elevation [148]. Where the stress of the vaults was greatest, the piers were enlarged through the addition of broad pilasters or 'dosserets', forming a system of interior buttressing. The fact that groin vaults were employed meant that clerestory windows could be incorporated without weakening the structure. The result is an interior of monumental power, albeit stark and prismatic when compared with contemporary French buildings, but one which conveys an impression of Roman *gravitas*, an impression singularly appropriate for a ruler with the political pretensions of Henry IV. There are many features of Speyer which relate to northern Italy, the area from which the German masons acquired their technological expertise.

In the closing decades of the eleventh century, high vaults were also erected in a number of Anglo-Norman buildings, though only over the chancels: two still survive at Caen, in the churches of La Trinité and St Nicolas. While there were perhaps economic and structural reasons for restricting the high vaults to the eastern limb of a church, the arrangement provided a convenient way of demarcating the most sacred part of the building, the vaults acting like a giant baldacchino over the high altar.

The introduction of ribbed vaulting has occasioned more debate and more misunderstanding than any other feature of medieval architecture. The origin of the rib has been hotly disputed, so too its structural and aesthetic functions. For over a century the arguments have been distorted by the opinions of Viollet-le-Duc and his followers, in particular the theory of structural rationalism, which imputes a structural function to almost every feature of Gothic design. The rib has been heralded as one of the great discoveries of the Middle Ages, many writers taking it for granted that, from the start, its purpose was to provide a structural frame. Given the importance of the rib in subsequent Gothic design, much energy has been devoted to tracking the 'invention' of the rib, that moment of creativity when the idea was supposedly first born. Unfortunately the issues are not quite so simple.

By the closing decade of the eleventh century, the technique of ribbed vaulting was familiar to masons in England, Germany, and Lombardy. It is often thought curious that some of the earliest ribs are to be found at Durham Cathedral [91], situated on the northern outposts of the Romanesque world. This remains a puzzle only if ribs are regarded as a technological feature. In fact Durham was the most richly articulated building of its time, massively adorned with engaged shafts and soffit rolls [146]. As we shall see in Chapter 9, one of the chief aesthetic aims of Romanesque architects was to emphasize and define the main components of their buildings. In a work as ornate as Durham, undecorated groin vaults would have looked badly out of place, and by stressing the angles of the vault the architect was merely following the approach used everywhere else in the building. In fact recent studies have shown that the early ribs, both at Durham and elsewhere, were not necessarily built as a separate frame to which the rubble cells were then added; the structural (and constructional) advantages of the rib emerged gradually over the course of time. At Durham the first ribs were erected in the choir aisles in 1096 and these were followed by the high vault of the choir in 1104. As the latter was replaced in the early years of the thirteenth century, the earliest high vaults to survive are those over the north transept [91]. When building began at Durham in 1093, it appears that the intention was to erect vaults only over the choir and not over the nave and transepts. As work progressed, the builders became more confident, constructing vaults over walls with clerestory passages, and effecting radical changes to the geometry of the vaults. The later vaults (1128–33) were also embellished with chevron ornament, adding an exotic flavour to the visual gymnastics already provided by the ribs [146].

The early ribbed vaults of Lombardy were quite different in form. They were usually applied to buildings with an alternating system and the vaults tended to have a domical shape, the centre rising well above the framing arches. The ribs themselves were rectangular in profile,

91 Durham Cathedral, ribbed vaults in the north transept, c.1104–10

These are the earliest high vaults to survive at Durham. In contrast to the later vaults of the nave, the transverse arches are rounded in form.

lacking the mouldings normally found in England. Although the history of ribbed vaulting in Lombardy is clouded by chronological argument, the technique appears to have been well established by the last quarter of the eleventh century; the ribs over the church of San Nazaro in Milan (c.1075–93) have some claim to being the earliest remaining. By the end of the century Lombard techniques had found their way to northern Europe. The Mariakerk at Utrecht (1081–99), complete with galleries and ribbed vaults, was as impressive as any Lombard church in Italy and we are fortunate that, before its destruction in the eighteenth century, the details were meticulously recorded in the paintings of Pieter Saenredam [92].[11]

Contrary to prevailing opinion, Romanesque masons did not regard ribs as an instant panacea which would render all other forms of vaulting immediately obsolete. Even in England groin vaults continued to be built in aisles and subsidiary spaces, suggesting that masons saw no immediate benefit from using ribs. In the Rhineland groin vaults were still being erected in the second half of the twelfth century [119], no doubt because they were not out of place in monuments where the articulation was relatively austere. Ribs were a visual enhancement, used as a means of drawing attention to important sections of a building. Those erected over the transepts at Speyer (c.1106), for example, have been interpreted as part of the general embellishment of

92 Utrecht, Mariakerk, view of the nave, built after 1081

Painting by Pieter Saenredam (1638)

Although the church was demolished long ago, the painting shows that it was erected in a Lombard style, complete with domical ribbed vaults. This may have been one of the first examples of ribbed vaulting in northern Europe.

this part of the cathedral, which Henry IV evidently wanted to turn into a pair of imperial burial chapels.[12] In such contexts ribbed vaults had an iconographical significance, marking out areas of special sanctity, a meaning aptly conveyed by the French term *croisée d'ogives*.

The emphasis on formal development, which has governed the writing of architectural history, has tended to obscure the symbolic and aesthetic qualities associated with the art of stone vaulting. Barrel vaults, groin vaults, and ribbed vaults did not follow each other in a neat technological sequence. In England many churchmen were not even convinced of the need for vaults at all, despite the spectacular achievements at Durham; in some parts of the country timber ceilings were regarded as a perfectly acceptable alternative. Opinions might have been different had the fate of the splendid ceiling of Canterbury Cathedral been known (it was destroyed in the fire of 1174). However, stone vaults were not necessarily a perfect solution either, as the canons of Lincoln discovered in 1186, when tons of masonry fell from the vaults, splitting their cathedral apart.

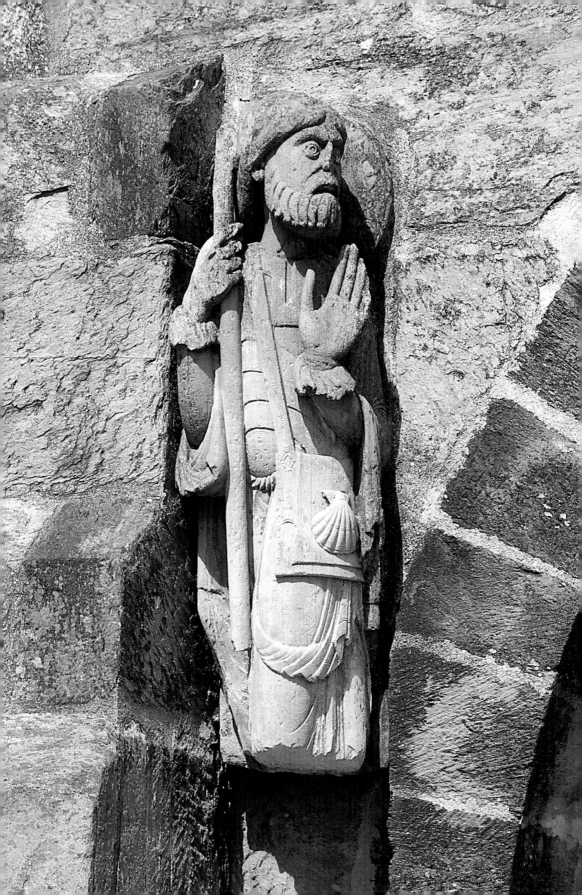

Architecture
and Pilgrimage

7

A solemn translation of relics was one of the highlights in the life of a medieval monastic community, a ceremony that underlined the bond between church architecture and the cult of the saints. At Durham such an event took place in 1104, when the remains of St Cuthbert were moved into the recently completed choir, 11 years after building operations had begun.[1] In the eyes of the local Benedictine monks the new structure was not just a monastery and cathedral church, but a shrine for their patron saint. With dozens of prelates and other dignitaries present, the *translatio* was both a religious occasion and a public relations exercise, a ceremony designed to enhance the reputation of the saint and to bolster the income of the building fund, the latter an important consideration. Throughout the Middle Ages relics, pilgrimage, miracles, money, and construction were closely entwined.

In architecture the impact of the cult of relics is particularly evident in the development of crypts and the proliferation of chapels around the choir. But indirectly the effects extended far beyond matters of planning and design. Relics were used to justify grandiose architecture and they helped to produce the cash to pay for it. They provoked competition between neighbouring monastic houses and they provided the *raison d'être* of pilgrimage, from which hundreds if not thousands of medieval churches benefited. Pilgrimage in its turn encouraged the spread of architectural knowledge as information about church design was disseminated along the pilgrimage routes: many a benefactor was inspired by what he had seen in Rome, Jerusalem, or some other distant shrine. But to what extent was church architecture dictated by the veneration of relics and how valid is the oft-used phrase 'pilgrimage church'? The issues are more complex than they might seem: between the eighth and eleventh centuries, relics and altars were incorporated into churches in all manner of disparate and unexpected ways. Even in the twelfth century there was no architectural consensus about the best way of accommodating shrines or about how to cope with the throngs of pilgrims who turned up for the great religious festivals.

93 St James as a pilgrim
St Marta de Tera (Zamora), south portal. Early twelfth century. The saint's bag is decorated with a scallop shell, the emblem of the pilgrimage to Santiago.

Religious communities took enormous pride in their relic collections, which might contain two or three hundred separate items. The monastery of Peterborough, for example, was the proud possessor of the right arm of St Oswald, 'more precious than gold', along with part of his ribs and some of the soil on which he fell when he was martyred. The monks also had portions of the swaddling clothes of the Christ-child, pieces of the manger, a shoulder-blade of one of the holy innocents, remains of the five loaves with which Christ fed the five thousand, and relics of six of the Apostles.[2] The monastery at Charroux in France claimed to have the foreskin of Christ; so too did the Pope in his collection in the chapel of San Lorenzo in the Vatican. As early as 831 St Riquier had 30 separate reliquaries, made of gold, silver, and ivory. The status of religious houses was defined by the relics they possessed, which explains why, in the twelfth century, Abbot Suger of St Denis was so anxious to discover how his collection compared with those at Constantinople and Jerusalem. It is tempting to regard the enthusiasm for relics as a product of the ignorance and credulity of the 'Dark Ages', a flight from the rationalism of the classical world. But in fact this 'pernicious innovation', as Edward Gibbon described it, started in late Antiquity and its origins can be traced back to the fourth century, if not before. From early times Christians had been accustomed to worship at the graves of saints and martyrs, which were generally located in cemeteries outside the walls of cities and towns.[3] A stone *mensa* or altar table was usually erected above the grave, so that, during the celebration of the eucharist, the sacrifice of Christ was equated with that of the martyr. The authorities in Rome prohibited the removal of corpses from their original burial site, which meant that commemorations had to take place within the cemeteries. But it was not long before the bones of the saints were on the move, as Christian leaders were tempted to transfer them to more convenient locations. In 385 Ambrose, bishop of Milan, transferred the relics of two obscure saints, Gervasius and Protasius, into a new basilica he had built for himself (Sant'Ambrogio), placing them in a grave under the altar, thus linking the altar with relics as had been the case in cemetery churches.[4] The practice was inspired or at least justified by a passage in the Book of Revelation (6:9): 'I saw under the altar the souls of them that were slain for the word of God, and for the testimony which they held'. In 401 the Council of Carthage declared that all altars should contain relics, a canon that was repeated at various times in later centuries. Initially most of the relics incorporated into altars were secondary items, things which had merely come into contact with the remains of a saint: portions of oil burnt alongside the grave, for example, or strips of linen known as *brandea*, which had been lowered into the tomb. But once bodies were being lifted and moved about, it was tempting to dismember them, so that the bones of a single saint might

Trier Cathedral Treasury. One of the many thousands of shrines made in the early Middle Ages to hold the relics of the saints. In this case a model of the saint's foot has been placed on a portable altar.

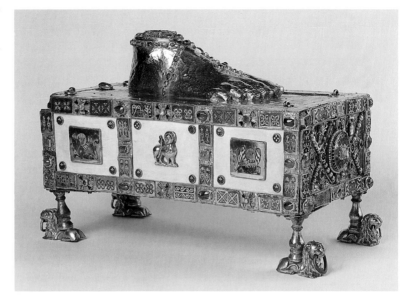

be shared out among different communities. Size did not matter too much, for all relics, however small, provided a tangible link with the supernatural, a point of contact between earth and Heaven. During the seventh and eighth centuries, they played a crucial role in the conversion of the Germanic countries and by the ninth century the demand for new relics had become almost insatiable, with unscrupulous dealers raiding the catacombs in Rome to supply the monasteries of the north.

Crypts originated in the Early Christian era, when a number of basilicas were furnished with a small chamber (or 'confessio') under the altar. The faithful could get a glimpse of the relics through a window (*fenestella*), from which *brandea* could be dangled down into the grave. However, the relics were still rather remote, so passageways were constructed to provide direct access into the chamber, allowing pilgrims to venerate the relics at close quarters. In about 590 a crypt of this form was installed at St Peter's by the future pope, Gregory the Great, and it was this work that really established the crypt as an important ingredient in Christian architecture. Gregory inserted a passageway around the inside wall of the apse, from the outer point of which a further passage led back to the confessio and to the grave of St Peter [6]. The system allowed for an orderly viewing of the relics, with a separate entrance and exit. On the floor above, the high altar and its ciborium were carefully sited over the confessio. Although crypts give the impression of being gloomy subterranean structures, they were not always built below the ground. Rather than excavate to a great depth, the floor above was sometimes raised instead, an arrangement which transformed the chancel into a stage, making the performance of the liturgy both more visible and more theatrical.

During the seventh and eighth centuries crypts of various types began to appear in churches north of the Alps. A design on the model of St Peter's was introduced at St Denis soon after 755, and by the early ninth century the annular or ring crypt, as it is variously known, was well established in the Carolingian world. It was this type of crypt that Einhard built in his second church at Seligenstadt, to which he transferred his prized relics from Steinbach [17]. A crypt was also included in the proposals for the reconstruction of St Gall (c.830), and the famous plan spells out the details quite carefully [123]. In this case the passageways are straight (crank-shaped) rather than semicircular in layout, the designer indicating with curved lines that they were to be barrel vaulted. A central passage leads back to the confessio with its relics of St Gall, the Irishman who had founded the monastery over a century before. The crypt envisaged at St Gall was relatively straightforward, but before long plans became increasingly complex, a point reflected in the well-preserved example at St Germain, Auxerre (841–59). Here the central confessio (which may date back to the sixth century) has three barrel-vaulted aisles, which are separated by columns lifted from some Gallo-Roman building [95]. The encircling passage (which is definitely Carolingian) has flanking chapels, north and south, and to the east it led round to a circular chapel on the axis, housing an altar to the Virgin Mary [96]. The crypt at Auxerre is especially important for two reasons: the Carolingian additions were constructed outside the walls of the original church, producing a form generally described as an 'outer crypt'; secondly, this once had upper storeys, so the crypt was like a two-storey building wrapped around the east end of the main church. When the crypt was consecrated in 859 in the presence of the emperor Charles the Bald, the monks had acquired space for at least six new shrines or altars, and this of course was the point of the operation.

Although early crypts are fascinating to explore, their architecture was often rudimentary, a surprising point perhaps, given that these were the most sacred parts of the church. But it should be remembered that the rough walls and vaults seen today were once enveloped in colour. Much still remains at Auxerre, where one of the chapels was painted with the stoning of the first martyr, St Stephen, a highly appropriate subject. At San Vincenzo al Volturno, south of Rome, a small Carolingian crypt discovered in the nineteenth century is still covered with paintings from the period 824 to 842 that have lost little of their original brilliance.

By the eleventh century crypts had developed into far more articulated pieces of architecture. This was the age of the 'hall crypt', in which a whole area was treated as a continuous entity, with a groin-vaulted ceiling supported on free-standing columns. An early example can be found at Agliate in Lombardy, where the three-aisled crypt ex-

95 Auxerre, St Germain, the 'confessio'

This was the inner chamber of a complex crypt which was enlarged c.841–59. Surprisingly the barrel vaults are supported on oak lintels.

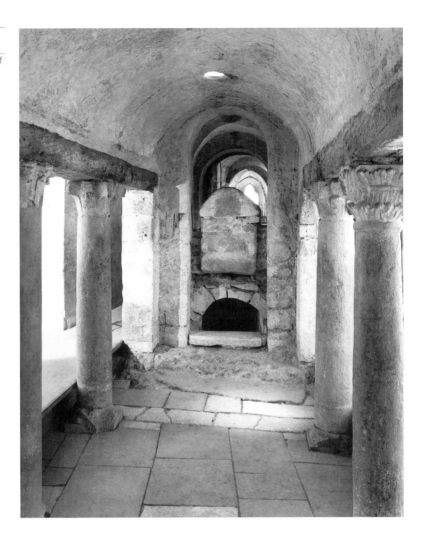

96 Auxerre, St Germain

Plan of the crypt

The confessio was surrounded by an ambulatory which gave access to a series of additional chapels.

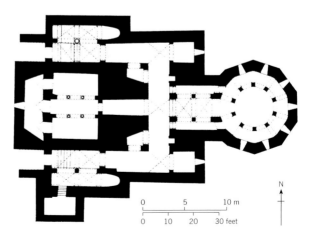

97 Agliate (Lombardy), San Pietro, crypt

The date of this 'hall crypt' is much debated; although sometimes placed in the late ninth century, it may belong to the early years of the eleventh.

tends under both the apse and the chancel [**97**]. The hall crypt became a standard form in Italy and Germany, and in both countries it was sometimes extended under the transepts as well as the chancel. In such circumstances it became a vast cavernous space, filled with a forest of columns. The monumental crypt at Speyer Cathedral (*c.*1030–61) has 42 bays of groin vaulting, supported on 20 cylindrical piers. In this case the architectural clarity is quite exceptional, a result of the precise execution of the base mouldings and the cushion capitals, together with the emphatic system of transverse arches. The cathedral at Speyer was built by the German emperors and its huge crypt, while providing space for altars, was primarily intended as a mausoleum for the members of the Salian dynasty.

Following the Norman Conquest of 1066, the hall crypt was introduced to England, where there is a magnificent example at Canterbury Cathedral. This stretched under the entire area of the extensive new choir, which was added between 1096 and 1130. The central space is filled with a double enfilade of 11 free-standing columns, which were given an exotic treatment: alternate columns were decorated with spi-

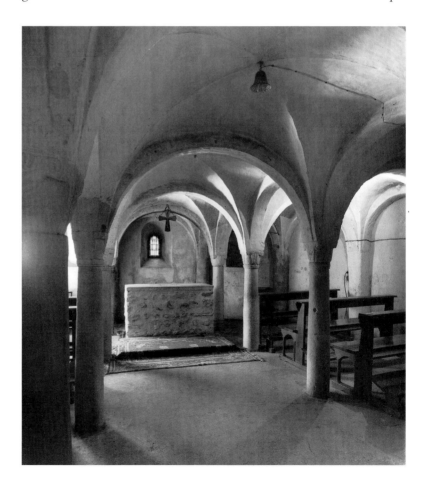

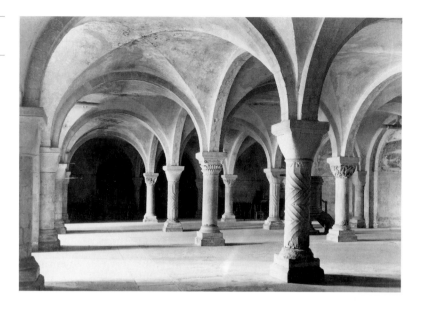

98 Canterbury Cathedral, crypt under Anselm's choir, begun c.1096

An unusual system of alternation was employed in which plain columns were given decorated capitals whereas the decorated columns received plain capitals, perhaps a device to increase the speed of building.

rals, zigzags, and other patterns, while the intermediate plain columns were furnished with ornate capitals [**98**]. Decorated columns were not unprecedented in crypt design. There are examples in the Low Countries, at Utrecht and Deventer, and there was an early example in the Anglo-Saxon crypt at Repton. Far from being a stylistic fashion, spirals were a way of adding a liturgical emphasis to the design, an arrangement derived from the twisted columns in front of the shrine of St Peter in Rome.

Over the course of seven or eight centuries crypts had developed from tiny chambers to vast semi-subterranean churches like those at Speyer and Canterbury. Yet by the time the Canterbury choir was completed (1130), they were already becoming obsolete, a consequence of changes in religious and liturgical fashion. It was now normal for major relics to be encased in sumptuous shrines, which were far more likely to be displayed behind the high altar than in the gloom of the crypt [**108**]. The growth of pilgrimage may have encouraged the trend. At major shrines it was not easy to manage the huge crush on feast days, if the turmoil experienced at St Denis is anything to go by. On many occasions, so Abbot Suger claimed, monks were forced to jump through the windows, relics in hand, to escape the rioting crowds.[5]

One of the most satisfactory ways of dealing with pilgrims was by constructing a church with an ambulatory and radiating chapels, the solution adopted at Santiago de Compostela (c.1078–1122) [**100**]. Visitors could pass up the side aisles and around the high altar, causing the minimum of interference with the daily offices in the chancel. The scheme also provided convenient access to the altars situated at the east end of the church. As well as being practical, the arrangement looked impressive [**113**]. Inside the church, the apse terminated in a semicir-

cular ring of columns, six or eight in number, which formed a backdrop to both the high altar and the reliquary shrines. Beyond lay the ambulatory and the low radiating chapels, forming a diminishing hierarchy of spaces. Exterior views were equally satisfying, the simple geometrical forms gradually building up through the chapels to the ambulatory, culminating in the sanctuary and a crossing tower, so creating the 'stepped massing' characteristic of Romanesque architecture [**111**]. At Santiago the arrangement has been submerged under Baroque incrustation, but it can still be seen in its original form at Conques, Toulouse (St Sernin), St-Nectaire, Paray-le-Monial, St-Benoît-sur-Loire, and many other places in France. Combining beauty and convenience, the ambulatory and radiating chapel plan was one of the finest achievements of early medieval architecture.

Not surprisingly, historians have been anxious to establish the origin of the scheme, and there is a lengthy and rather arid literature devoted to the subject. It is clear that the plan type was well established in France in the early years of the eleventh century, long before Santiago was begun. Part of the background lies in the design of crypts, for the semicircular ambulatory has much in common with the ring crypts of the Carolingian age. The relationship is well illustrated at Tournus in Burgundy, where a crypt, built soon after 1009, has an inner confessio surrounded by an ambulatory and radiating chapels, the latter rectangular in shape. The choir above followed the same plan. It is important to remember that the ambulatory was not in itself new in Christian architecture, having appeared in many centralized churches as well as in several of the cemetery churches of Rome.

Given the complexity of the arguments, the subject is better approached in conceptual rather than evolutionary terms. In effect the ambulatory scheme was the equivalent of half a martyrium attached to the end of a basilican church, and viewed this way the plan can be seen as a perfect synthesis of the two main building types of the Early Christian church. As early as the fourth century, notably at Bethlehem, there had been attempts to combine the two types, not always with much success, and at least three Carolingian crypts included rotundas at the east end. A more spectacular union of basilica and martyrium appeared at Dijon, in the church of St Bénigne (1001–18), where a massive circular structure survived until the French revolution [**99**]. An excellent series of engravings confirms the statement by the local chronicler that the oratory was 'encircled by three rings of columns, forty-eight in number, geometrically ordered'.[6] This was a multi-storeyed building, furnished with a crypt (that still survives), as well as galleries. The central space was surmounted by a dome, with a circular opening at the top, inspired no doubt by the Holy Sepulchre in Jerusalem. To the east was a rectangular chapel, also constructed in three levels. The relics of St Bénigne, revered as the apostle of

99 Dijon, Saint Bénigne, consecrated 1018, cross-section of the rotunda

Engraving by Dom Plancher

The three levels of the building, each of which was vaulted, were linked by an open well in the centre. Only the crypt level survives today.

Burgundy, lay in the crypt, and throughout the complex structure there was a carefully ordered sequence of altars. Flanked north and south by circular stair turrets, the great circular martyrium at Dijon was a most imposing structure, a veritable Pantheon of the medieval world. A similar building was erected at Charroux, where all that is left is an open tower, presenting an architectural conundrum to the uninitiated: it is in fact the central core of the rotunda, which, as at Dijon, contained three concentric rings of supports. One of the problems encountered at St Bénigne and possibly at Charroux was the complexity of linking the rotunda to the basilican section of the church. The ambulatory and radiating chapel scheme solved this problem with greater simplicity, and it is no surprise that the elaborate arrangements at Dijon and Charroux were rarely copied.[7]

By the early years of the twelfth century, the church at Santiago de Compostela had managed to turn itself into the most popular pilgrimage destination in Europe. The long journey across northern Spain and through the Cantabrian mountains, which might have been regarded as a deterrent, was turned to advantage and advertised as part of the penitential value of the route. The remarkable story of how the body of the apostle St James was brought by boat to Galicia in seven days and then lay unnoticed for centuries before being miraculously rediscov-

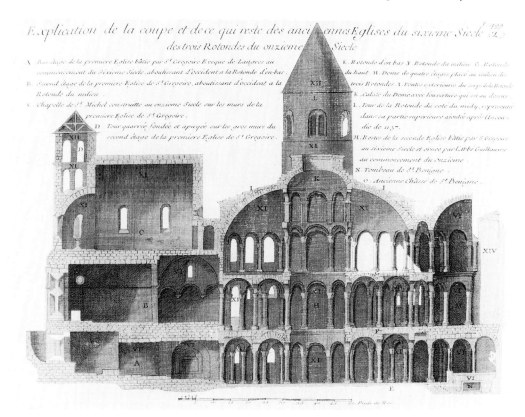

ered in 813 by a local bishop seems to have heightened rather than diminished the enthusiasm of the faithful. Towards the end of the eleventh century, Bishop Diego Peláez was determined that Santiago would become a second Rome; his successor Diego Gelmírez even got Papal permission to allow the canons to be described as cardinals. The start of an impressive new church in 1078 was all part of the strategy. Support from the Church in France, particularly from the abbey of Cluny, helped to ensure the success of the pilgrimage, which became one of the most extraordinary religious phenomena of the Middle Ages.

Despite the occasional use of cusped arches and other Spanish details, Santiago was essentially French in design, sharing many features with four important churches in France. These were situated on the routes taken by the pilgrims: Toulouse (St Sernin), Conques (Ste Foi), Limoges (St Martial), and Tours (St Martin). Although the churches at Limoges and Tours do not survive, it is known that all five buildings terminated in an ambulatory and radiating chapels and that each was furnished with aisled transepts [**100**]. All had two-storey elevations, with a high gallery above the main arcade; in four cases (the exception is Tours) the gallery arches were elegantly subdivided by a pair of columns [**101**]. The imposing interiors of the three surviving buildings owe much to a comprehensive system of vaulting: barrel vaults across the main spaces, quadrant vaults over the galleries, and groin vaults over the aisles. Engaged shafts, which rise to support the transverse arches beneath the vault, provide strong visual accents, dividing the space into clearly marked bays. Although separated by distances of up to 700 miles, the five churches formed one of the most distinct groups in Romanesque architecture. It is clear that some of the same skilled masons were employed at several of the sites.

The buildings were, however, far from exact copies. The choice of materials was one fundamental difference. St Sernin, for example, is built of red brick, whereas Santiago is made from a golden-coloured granite. Nor were the plans identical. Two of the churches, St Martin at Tours and St Sernin, Toulouse, were provided with double aisles in the nave; and Ste Foi at Conques, which is smaller in scale than the others, has only three ambulatory chapels (the rest were given five). There has been a rather futile debate about which building served as the prototype, a difficult question since all were under construction at more or less the same time. The architectural background was unquestionably French; the wide transepts and high galleries, for example, were already foreshadowed at St Rémi at Rheims before 1049, a building that was itself an important pilgrimage church.

The well-known *Pilgrim's Guide* (*c*.1130), which described the various routes that led from France to Compostela, mentions 26 shrines that a pilgrim might visit on the way. Few have much in common with

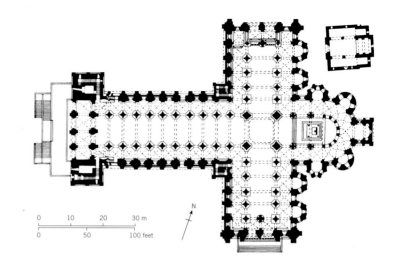

100 Santiago de Compostela

Plan of the church in the twelfth century.

The ambulatory with its five radiating chapels, together with the broad transepts furnished with aisles on each side, were features of the so-called 'pilgrimage group' of churches.

the five so-called 'pilgrimage churches', so it is important to appreciate that this group is not representative of pilgrimage churches as a whole. St Trophîme at Arles, for example, or St Eutrope at Saintes were both designed according to local fashion rather than to any specific pilgrimage formulae [**89d**]. The shrine of St Front at Périgueux was every bit as prestigious as others along the routes, yet the church begun about 1120 was conceived with five great domes, covering vast interior spaces [**102, 103**]. Although domes are characteristic of Romanesque in Périgord, St Front is not a locally inspired building. The domes are supported on wide arches which descend to broad piers, each of which is made up of four 'legs'. In effect these are hollow piers which allow a narrow aisle to run continuously around the building. St Front was a disciple of the apostle St Peter and one might have expected the clergy at Périgueux to have looked to Rome for their models. But it was the shrine of another apostle, that of St Mark in Venice (begun 1063), which caught their imagination. The structural system is so distinctive that there is no doubt about the relationship. The design of St Mark's was in turn derived from the church of the Holy Apostles in Constantinople (536–50), as reconstructed during the reign of Justinian, so Périgueux had an illustrious pedigree.[8] St Front was designed in grandiose terms, replacing an older basilican-style church, and one gets the impression that the authorities were determined not to be overawed by Santiago or St Sernin at Toulouse. In fact interest in eastern models was already well established. In 1077, almost half a century before the new church was started, the tomb of St Front had been 'built with the greatest care in a round form as the sepulchre of the Lord' by a certain Guinamundus, a monk from La Chaise-Dieu.[9] The shrine was surmounted by a pyramidal roof, which was later repeated like an advertising slogan at the corners of each of the five domes of the church.

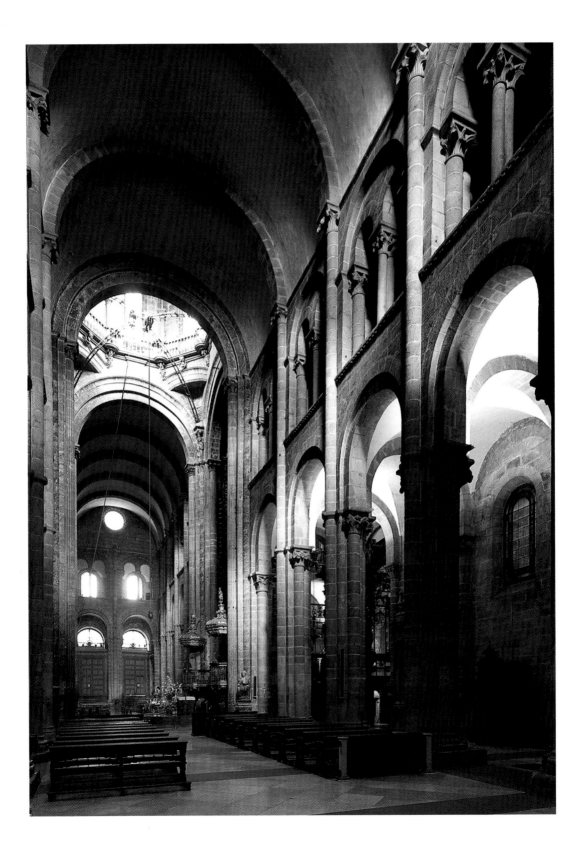

101 Santiago de Compostela, c.1078–1122

View across the transepts. The main piers have a subtle alternation in form, one of the features which distinguish Santiago from other buildings in the so-called 'pilgrimage' group.

A pilgrimage to Santiago was a major undertaking which could take up to 16 weeks for travellers from England and northern Europe. This was the amount of time the authorities at Hereford Cathedral allowed their canons if they wished to make the journey to Galicia; the same amount was allowed for a pilgrimage to Rome, compared with a whole year for the trip to Jerusalem. But most people had to be content with local shrines, whose reputation and popularity fluctuated over the years. In the second half of the twelfth century, for example, the shrine of St Frideswide at Oxford began to attract attention and the Augustinian canons, who owned the saint's relics, must have been well aware of the potential of her cult when they reconstructed their abbey church. In 1180 the remains of the saint were translated into the new building, designed in a characteristically English Romanesque manner, with giant cylindrical piers [**104**]. At Oxford the piers embraced both the main arcade and the triforium, creating a so-called 'giant order'. The main space of the chancel terminated in a straight east wall, without any specific arrangements to cater for pilgrims. The relics themselves were placed not in the choir itself but in a chapel on the north side.[10] Some English churches opted for the French system of an ambulatory and radiating chapels, but there was no consistent pattern. Whereas the four-bay choir at Durham (1093–1104) terminated in three apses [**147**], following the scheme favoured in Norman monasteries, the enlarged choir at Canterbury (1096–1130) was furnished

102 Périgueux, St Front, begun c.1120

The design of this important pilgrimage church, with its sequence of domes and 'four-legged' piers, can be traced to St Mark's, Venice. Regrettably it was reconstructed in the nineteenth century under the direction of Paul Abadie.

103 Périgueux, St Front

Plan

The Greek-cross structure with its five domes replaced a more orthodox basilican church, fragments of which survive at the west.

■ Original church (of various dates)

▨ Church with cupolas (apse & porch modern)

▨ Unfinished cupola

N

0 10 20 30 m

0 50 100 feet

104 Oxford, St Frideswide's (Cathedral), interior of the choir, 1160–80

The relics of St Frideswide became a focus of local pilgrimage, the relics themselves being kept in a chapel to the north of the high altar. The church is one of several English buildings which employed a 'giant order', embracing both main arcade and gallery.

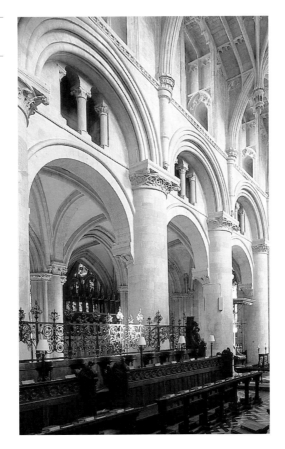

with an ambulatory and three radiating chapels, a layout repeated in both the main floor and the crypt.

One church built deliberately to attract pilgrims was that of San Nicola at Bari in southern Italy. The town was one of the chief commercial ports of the Mediterranean, a point of embarkation for both Constantinople and the Holy Land. In 1087 a group of Bari merchants, outwitting Venetian rivals, managed to seize the relics of Saint Nicholas from their resting place at Myra in Asia Minor. With Bari now firmly implanted on the pilgrimage map, a new church to house the relics was begun almost immediately. This had a 'T'-shaped plan, consisting of a six-bay nave and a transept with three apses [**105**]. In contrast to Romanesque churches in northern Europe, there was no eastern limb, the main apse opening directly into the space of the transept [**106**]. This was the Early Christian pattern, seen in Rome at St Peter's and San Paolo fuori le mura. An unusual feature of the design was a screen wall, running across the east end of the building, which enclosed the apses and also embraced towers at the north and south corners. There is no obvious explanation for this, though it has the effect of tidying up the east end into a monolithic rectangular block. Stretching under the whole of the transept is a spacious crypt, comprising 36 groin-vaulted bays, supported on 24 free-standing columns. This was where the body of San Nicola was placed in 1089 and where it still remains. The three-storey nave has a columnar arcade, with triple arches in each bay of the gallery. The whole design was new to Apulia and there has been considerable debate about its origin. Whatever the sources, the building had little in common with the so-called 'pilgrimage churches' of France and

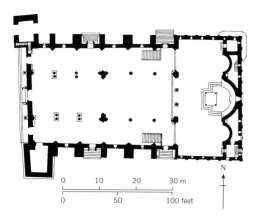

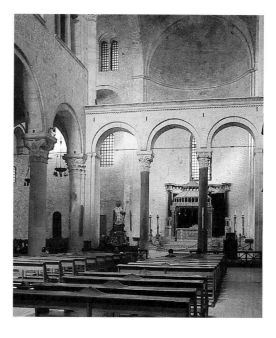

Spain. San Nicola helped shape the character of Apulian Romanesque, its influence being very obvious along the Adriatic seaboard.

Within a few years a rival pilgrimage church was founded a few miles north at Trani, though the local saint, Nicola Peregrino, was scarcely in the same league as San Nicola of Myra. This Nicola was a youth from Corfu who, having run around Greece and Dalmatia, brandishing a cross and crying '*Kyrie Eleison*', managed to get himself killed at Trani in 1094. The church built in his honour is one of the most striking monuments of southern Italy, its stark mass rising like a cruise ship beside the waters of the Adriatic [**107**]. As at Bari, there is a 'T'-shaped plan, but without the enclosing wall to the east. The three apses are thus fully visible, the cylindrical forms projecting boldly from the face of the massive transept. The eastern crypt (*c.*1099–1142) and the lower sections of the transept were initially built as additions to a seventh-century basilica and it was well into the thirteenth century before the entire cathedral was reconstructed. The nave has galleries like those at Bari, though it differs in having twin columns to support the main arcade. In both churches the crypt remained the premier location for relics, as it did in many of the churches of twelfth-century Italy.

Given the enormous differences that existed among the so-called 'pilgrimage churches' of Europe, what then was the effect of pilgrimage on church architecture? There is no doubt that the need to promote a shrine encouraged some churches to look at models outside their own locality, to Venice, Rome, or Constantinople, for example, as clearly happened at Périgueux and Bari, and in certain respects at Durham. There is no doubt too that pilgrimage encouraged sumptuous building: a splendid monument confirmed the importance of the relics inside and was a valuable way of reassuring pilgrims that their journey had been worthwhile. Customers were not always satisfied. In the ninth century when the German monastery of Prüm acquired relics of St Chrysantus and St Daria, a certain woman hurried to offer assistance, 'taking with her a wagon loaded with food, drink and other goods'. But on her arrival, the local chronicler explains, 'she saw that their tomb did not shine with gold and silver, she looked down on the place and ridiculed it, as dull and irreligious minds are accustomed to do'. She took her followers away claiming that 'nothing holy was contained there'.[11] Although it was the lack of a precious reliquary that disappointed the woman at Prüm, it is easy to see how the same attitude might be transferred to architecture. The twelfth-century historian William of Malmesbury noted that 'the more grandly constructed a church is, the more likely it is to entice the dullest minds to prayer and to bend the most stubborn to supplication'.[12] There are several instances in which the author of the *Pilgrim's Guide* stresses the beauty of churches on the route to Santiago and his careful description of the church at the final destination [**101**] was obviously designed to encour-

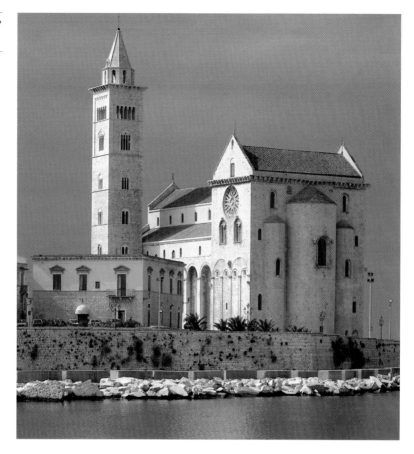

107 Trani Cathedral (Apulia), begun 1089, completed in thirteenth century

The Apulian churches were not provided with chancels, which meant that the main apse projected directly from the transept.

age potential visitors. He concludes in euphoric terms: 'In this church, in truth, one cannot find a single crack or defect: it is admirably built, large, spacious, luminous, of becoming dimensions, well proportioned in width, length and height, of incredibly marvellous workmanship, and even built on two levels as a royal palace', the last comment evidently a reference to the galleries. Scale was obviously an important consideration, for otherwise pilgrims would find it difficult to participate in the celebrations during religious festivals. From the clergy's point of view security was an equally serious matter. Relics were a precious commodity, which needed to be guarded against fire and theft, hence the advantage of having a crypt. In the 1180s the monks of Bury very nearly lost the relics of St Edmund when a fire broke out behind the high altar;[13] during the fire which destroyed the cathedral of Chartres in 1194, the tunic of the Virgin Mary was 'miraculously' preserved, simply because it had been stored in a stone-vaulted crypt. As for theft, there are many notorious episodes besides that associated with San Nicola of Bari, one of the best known being the capture of the relics of Saint Foi by the monks of Conques. Without this felony, one of the great pilgrimage churches of southern France might never have

been built. As early as the fourth century, fragments of the Holy Cross at Jerusalem had to be carefully guarded when the faithful took turns to kiss them on Good Friday, the fear being that someone would take a bite rather than a kiss. Many centuries later the monks of Fécamp looked on in horror as they showed their precious relic, the arm of St Mary Magdalene, to Bishop Hugh of Lincoln. Having sliced off the cloth bandages with a knife, he bit at a finger with his teeth, 'first with his incisors and finally with his molars'.[14] The bishop then proceeded to offer a spurious religious justification for his act of vandalism. By the twelfth century most pilgrims did not get within touching distance of relics, let alone biting distance. At some shrines relics were displayed only on special occasions—once every seven years at Charroux and at St Martial, Limoges—and there were riots at Conques when pilgrims discovered they were not allowed to see the relics of Saint Foi.

From at least the ninth century it was customary to display minor relics on a beam, usually fixed on columns in the vicinity of the high altar. In Conrad's choir at Canterbury two wooden columns, 'gracefully ornamented with gold and silver', supported a beam which was carried across the church above the high altar. As well as carrying three images (the Majestas Domini, St Dunstan, and St Elphege), the beam held seven chests 'covered with gold and silver, and filled with the relics of divers saints' (Gervase). The advantage of the arrangement was that the reliquary chests, while visible from afar, were safe from prying hands. When fire destroyed the choir in 1174, the beam collapsed, spilling the relics across the floor.[15] In northern Europe it was customary by this time for the relics of the patron saint to be placed in a casket behind the high altar, as was the case at Durham or Bury St Edmunds [108]. Where there was an ambulatory or aisles flanking the choir, the faithful could get relatively close without difficulty. One of the developments that took place later in England was to isolate the area around the shrine as a separate 'feretory', so that pilgrims did not have to encroach on the sanctuary.

The major contribution of pilgrimage to church architecture came in the form of cash. Saints were the fundraisers of the Middle Ages and, as Christopher Brooke observed, 'relics bred money'.[16] It is impossible to judge just how much of the income required to build churches like those at Santiago, Toulouse, Bari, or Périgueux came from the donations of pilgrims, but it was clearly a significant proportion. In the middle years of the eleventh century the monastery of St Trond near Liège was besieged with visitors and several men were needed in the evening to collect up the money. The local chronicler admitted that the offerings exceeded all the other revenues of the abbey combined.[17] At St Denis in the twelfth century, Abbot Suger put aside £200 a year for the building of the new choir, 75 per cent of which came from offerings. At Bury St Edmunds a special box was placed beside

108 Display of relics

By the twelfth century it was common practice for relics to be preserved in a casket placed above and behind the high altar.

Reliquary chest

Altar

the door to the choir to collect money for the construction of the great tower, and pilgrims were rarely left in doubt about the need to be generous when confronted with the money chests. The obligation was particularly heavy on those who had been cured at a shrine or had benefited from some other miracle. The sermon *Veneranda Dies*, associated with Santiago, states quite explicitly that pilgrims who die with money in their pocket will suffer the eternal torments of Hell.[18] Though valuable, pilgrim offerings could be a precarious source of income, as revealed by the crisis that occurred when a mason was badly injured in a fall at St-Benoît-sur-Loire. One monk explained:

We were afraid that if he died the whole building programme would be interrupted as a result of a sudden fall in contributions to the building fund. For the vulgar mob is very fickle and bends like a reed whatever way the wind blows it. If the mason had died they might have murmured that St Benedict did not care about his own monastery or the troubles that befell it.[19]

The three most popular destinations for Christian pilgrims were Santiago, Rome, and Jerusalem. In looking at the European shrines, it is important not to forget the huge numbers that travelled to the Holy Land even before the capture of Jerusalem by the Crusaders in 1099. In 1064–5 the bishop of Bamberg led a party that numbered approximately 7,000. The notorious duke of Anjou, Fulk Nerra, made three separate visits in the early years of the eleventh century and Robert, duke of Normandy is said to have made the journey barefoot from 1034–5. Seeing the places where Christ himself had lived and died— Bethlehem, the river Jordan, the Mount of Olives, Calvary—was a deeply emotional experience. It is no surprise that the church of the Holy Sepulchre exerted such an impact on western architecture. Nor should the influence of Rome be minimized. While many clergy travelled there on official business, pilgrimage to the tomb of St Peter was skilfully exploited by the Papacy as a way of buttressing its authority. The Christian shrines of the city, particularly St Peter's, were a constant point of reference for church builders throughout the Middle Ages. The continuous transept, double aisles in the nave, twisted columns, and the annular crypt were all features which could be exploited to express a relationship with Rome. The monk Eadmer, describing the Anglo-Saxon cathedral at Canterbury, claimed that it was 'duly arranged in some parts in imitation of the church of the blessed Prince of the Apostles, Peter', a comment that was obviously intended to convey instant status, regardless of its veracity.[20] By the twelfth century Santiago might have been competing in terms of numbers, but during the Middle Ages as a whole it was pilgrimage to Rome and Jerusalem that exerted the most impact on architecture.

Architecture
and Monasticism

8

Monks dominated religious activities in the early Middle Ages. Most of the great churches of Europe were built to serve monastic communities, a list of which includes such famous monuments as Cluny III, La Madeleine at Vézelay, Ste Foi at Conques, St Sernin at Toulouse, St Trophîme at Arles, and St Bénigne at Dijon, to name just a few. Already by the ninth century there were over 1,000 monasteries within the confines of the Carolingian Empire and by the twelfth century the number had increased quite dramatically. In England there were approximately 50 religious houses at the time of the Norman Conquest in 1066, a figure which had risen to over 500 by 1154.[1] Anyone travelling across Europe at this time would not have had to go many miles before encountering the walls of a monastery or a convent. As the various different orders of monks and nuns—Benedictine, Cluniac, Cistercian, Premonstratensian, Augustinian, Carthusian—had their own distinctive way of life, historians have long been interested in the way the ethos of each order affected the design of its buildings.

At one extreme lay the eremetical approach, consisting of communities that sought a life of utter simplicity and self-denial, where a regime of physical hardship and isolation was regarded as the only way to achieve a closer union with God. This was the ideal set by the first Christian monks and hermits of the Egyptian desert, an ideal espoused by the monasticism of the early Celtic Church. At the opposite extreme were communities that devoted their time to worship, where the main task of the monk was to participate in a rich liturgical pageant, with carefully rehearsed chanting and well-ordered processions, maintained according to a precise timetable throughout the year. Whatever its ideals, no community could survive without a body of rules to maintain order and discipline and it was the Rule of St Benedict (c.480–543), drawn up for the monastery that he founded at Montecassino in 529, that provided the foundations of medieval monasticism. For St Benedict communal worship or the *opus Dei* was the principal task of the monk. This was divided into seven major services or 'offices', a divi-

109 Rome, San Paolo fuori le mura, cloister arcades, c.1200

With its twisted columns and inlaid mosaic, this is one of the most extravagant cloister designs of the Romanesque era.

Plan and elevation of the
abbey church *c*.1700 by
Giffart (view from the north)

Designed on a monumental
scale with a five-aisled nave
and double transepts, the
building terminated in an
ambulatory and radiating
chapels. Note the flying
buttresses along the nave,
almost certainly added after
the collapse of the nave vaults
in 1125.

sion which echoed the words of the psalmist, 'seven times a day will I praise thee O Lord'. The different offices (matins or lauds, prime, terce, sext, nones, vespers, and compline) were spread throughout the day, the first beginning in the early hours of the morning. The remaining time was divided between reading and private prayer (*lectio divina*), and practical tasks required for the running of the monastery (*opus manuum*). St Benedict envisaged a self-contained, self-sufficient community, in which individual monks could work out their own spiritual relationship with God. The Rule, with its 73 short chapters, has always been admired for its humanity, common sense, and balance, qualities which explain why it eventually received universal acceptance. During the Carolingian Renaissance it became the basis of monastic reform: a common Rule observed throughout the empire was seen as a way of bringing order and coherence to a monastic world, hitherto fragmented by disparate local customs and observances.

The most magnificent of all Benedictine monasteries was the great abbey of Cluny, founded in southern Burgundy in the year 909 [**110, 111, 112**]. Cluny developed its own distinctive version of the Benedictine Rule, in which the liturgy and communal worship took precedence over every other aspect of monastic life. The number of offices was increased, the chants became more complex, and the daily ritual became so elaborate that the monks spent up to ten hours each day

Conspectus ecclesiæ Cluniacensis

Annal. Bened. Tom 5. pag 150.

Passus communes.

in church. The underlying concept was that of the *vita angelica*, a perfect life of almost continuous praise, in which the chants of the Cluniac monks rose to join the singing of the angels. Through their worship, the monks helped to ward off the forces of the devil, interceding with the Almighty on behalf of the local community. While life as a Cluniac monk was disciplined and ordered, it was not ascetic: performing the elaborate liturgy was a tough task, demanding concentration, and to be done properly it had to be carried out by well-fed monks, not by half-starved brethren, a point made by Hugh of Semur, abbot of Cluny (1049–1109).[2] During the course of the tenth and eleventh centuries, the splendour of Cluniac observance made such a deep impression on those who witnessed it that the abbey was called on to reform other monastic houses. In this way Cluny gradually built up an 'empire' of dependent monasteries and priories: it has been estimated that by 1109 there were at least 815 Cluniac houses in France alone, not to mention further houses in Spain, Germany, Italy, and England. The impact of Cluny, particularly its resplendent liturgy, was felt throughout much of western Europe.

The monastic values of Cluny were firmly expressed in architecture, particularly in the great church erected between 1088 and 1130, known as Cluny III. By this stage the abbey had acquired immense wealth, further boosted by a donation of 10,000 talents from King Alfonso VI of Aragon, following his victory over the Moslems at the battle of Toledo (1085). The new church, built to the north of its predecessor (Cluny II), eventually reached a length of 635 feet [**110**]. One practical objective was to provide space for the growing community, which included 460 choir monks by the time of Abbot Peter the Venerable (1122–56). Plenty of ancillary chapels were required, to allow those monks who were ordained priests opportunities to say individual masses. This was achieved by incorporating an ambulatory with five radiating chapels, as well as double transepts, which gave access to a further ten chapels. Other practical needs included room for processions and a choir large enough to accommodate all the monks. As a contemporary explained, the choir of the old church was so cramped that different grades of monks were mixed together and positions got confused, whereas in the new building 'the uncluttered spaces revive the monks as if they have been released from prison'.[3]

The sheer scale of the building, along with the choice of architectural detail, was intended to proclaim the status of Cluny within the Christian world. The abundant use of fluted pilasters and Corinthian capitals was a deliberate reference to the classical past, a means of equating the abbey church with the buildings of Early Christian Rome [**112**]. As at St Peter's there were double aisles in the nave. It is important to remember that Cluny was dedicated to St Peter and St Paul, the two principal saints of Rome. But governing the whole design was a

111 Cluny III

Reconstruction by K. J.
Conant

Conant's drawing conveys the
cumulative force of the
design, with its stepped
massing, characteristic of
Romanesque. Beginning with
the five radiating chapels in
the foreground, the design
reached a crescendo with the
four great towers that
dominated the east end of the
church. The tower to the south
(left) is the only one of the four
surviving today.

desire to express the beauty of Cluniac worship in material terms, to
provide a heavenly setting worthy of the angelic praises of the monks.
Contemporaries had no doubt that it succeeded, to judge from the
comments of the author of the *Life of St Hugh*: 'if it were possible for
those who dwell in heaven to take pleasure in a house made by human
hands, you would say this was the walk of angels' (*'deambulatorium
Angelorum'*), a fitting eulogy of the ambulatory of Cluny III with its
eight delicate and slender columns.[4] Sculpture and painting added to
the visionary power of this great building.

The design of Cluny III included many unusual features. The main
load-bearing arches were pointed in form, the first time such arches
had been used consistently north of the Alps.[5] The arches were also ex-
ceptionally high, supporting a relatively narrow triforium and
clerestory, both of the latter being ornamented with fluted pilasters
and Islamic-looking cusps [**112**]. Unlike many of the great churches of
eleventh-century France, there were no galleries. The main spaces of
the building were covered with barrel vaults, strongly pointed in the
transepts, less so in the nave. The use of the pointed arch was an auda-
cious decision, made apparently for structural reasons. The five-aisled
nave was graded in section, the outer aisle being 39 feet high, the inner
aisle reaching 60 feet, and the central space rising to 98 feet [**89c, 112**].
This 'triangular' profile, which had its roots in St Peter's, was later to

Reconstruction by K. J. Conant

The interior of the abbey church as envisaged by Kenneth Conant, showing the sanctuary and the entrance to the ambulatory. The design of the triforium with its fluted pilasters was derived from Roman antiquity, whereas the pointed arches and the use of cusped arches (seen in the triforium) have been attributed by some scholars to Islamic influence.

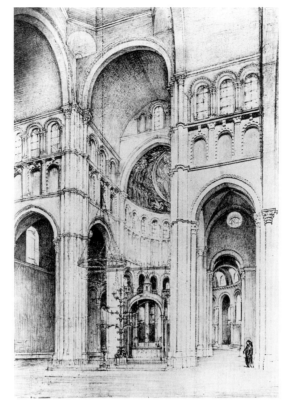

influence the Gothic design of Bourges Cathedral. The width of the building and the small scale of the clerestory windows made the interior very dark, '*tota subobscura*' in the words of one seventeenth-century visitor. But if the interior of Cluny III was gloomy, the exterior view from the east represented one of the most satisfying architectural sights of Europe: in characteristic Romanesque fashion, a series of clearly defined elements, beginning with the ambulatory chapels, led the eye upwards in a well-ordered crescendo, terminating in four mighty towers over the transepts [**111**].

The abbey of Cluny survived until the end of the eighteenth century before falling victim to the French Revolution, when its ostentatious wealth seemed to epitomize the evils of the *ancien régime*. Between 1800 and 1810 the great church was systematically demolished, only the south transept and adjacent parts of the choir being spared. The octagonal transept tower, with its rich bands of ornament, remains today as an isolated reminder of Cluniac artistic ideals. Although excavations carried out by the American scholar Kenneth Conant, along with his study of ancient drawings and plans, have done much to clarify the design of the abbey church, not everyone accepts Conant's conclusions and Cluny has become a *cause célèbre* in academic circles, a scholarly

113 Paray-le-Monial (Saône-et-Loire), priory church, first half of twelfth century
A faithful copy of Cluny III, the elevation includes fluted pilasters and the curious alteration to the main responds at the base of the triforium. Compare **112**.

'fault-line', where alternative approaches to medieval art confront each other.[6] There is, for example, disagreement over the sequence of building operations. Conant believed that construction began with the ambulatory chapels and that the church was erected steadily from east to west, an argument which is difficult to sustain given anomalies in the surviving fabric. There are disputes over the chronology of the building, Conant insisting that it was largely finished by 1109, 21 years before the dedication by Pope Innocent II in 1130. Then there is the question of the disaster of 1125. The Norman chronicler Ordericus Vitalis states quite explicitly that the 'great nave [*navis*] of the abbey church which was newly built fell in ruins [*corruit*], but thanks to God's protection injured no one'.[7] Local historians do not record the event, and it is difficult to assess the extent of a calamity which must have been a desperate blow to the pride of the abbey. Was it the nave vault that fell, as Conant believed, or the vault over the north transept, as the French scholar François Salet has maintained? And was the failure the consequence of faulty design? Equally controversial is the status of the architect. According to a local story contained in the *Life of St Hugh*, a retired abbot from Baume named Gunzo was shown the plan in a dream by St Peter and St Paul. This pious tale was a useful way of claiming divine sanction for what was by any standards a profligate building enterprise. Nevertheless Conant was ready to accept Gunzo as the architect, seeing him as the author of a beautifully conceived monument, worked out in detail at the start of operations according to a sophisticated dimensional system, and executed more or less as planned. This rather idealistic interpretation is hard to believe, especially in the light of some very odd features within the south transept. But who was the architect and where did he come from? Conant envisaged a cosmopolitan figure, who drew on a range of distant sources and revolutionized Burgundian architecture in the process, while others have stressed the extent to which the design grew out of local practice.[8]

The architecture of Cluny III had an immediate impact in the surrounding area. The church at Paray-le-Monial is a close copy, albeit on a reduced scale [**113**], and echoes of the great abbey church can be found in several other Burgundian churches. Further afield, the enormous church at La-Charité-sur-Loire, with its high arcade, pointed arches, and barrel vaults, was clearly inspired by Cluny, its ornament being even more exuberant. But while Cluny III set new standards of architectural splendour, it did not provide a model for the order as a whole. Cluniac communities generally followed local methods of building, though they were perhaps more willing than others to invest large sums on architecture and sculpture. This was certainly the case at Vézelay, the pilgrimage church in north Burgundy. In 1120 the nave was destroyed in an inferno which, according to one report, killed over a thousand people. Although sculptors from Cluny III were employed

114 Vézelay, La Madeleine, the nave, c.1120–32

The straightforward two-storey design was embellished with polychrome masonry, sculpted mouldings, and an array of carved capitals.

in the reconstruction, the architecture followed more traditional lines with a straightforward two-storey elevation [**114**]. The new work was, however, richly articulated with engaged shafts, pilasters, polychrome masonry, rich cornices, and a sumptuous array of carved capitals. It was the decoration rather than the architecture which provided the Cluniac identity. A taste for opulent effects can also be detected in some of the English Cluniac houses, as in the façade at Castle Acre [**115**], or the interior wall of the chapter house at Much Wenlock [**130**], though such displays were certainly not restricted to the Cluniac order.

The architecture of Cluny III represents one extreme of monastic thinking, the conviction that the more perfect the building, the greater the offering to the Lord. It was a conviction that brought Cluny close to bankruptcy well before 1125, the year in which the collapse of the vaults deepened the financial problems of the abbey. Even Cluny with its immense resources had overreached itself. Most Benedictine houses would, like Cluny, have taken it for granted that the worship of God required the most beautiful setting that man could devise (or afford). Abbots were consistently praised for their building achievements and it seemed undeniable that holiness and beauty went together, as the words

115 Castle Acre Priory (Norfolk), west façade of the church, mid-twelfth century

The elaborate system of blind arcades, while characteristic of English Romanesque, offered an appropriate degree of splendour for this Cluniac house.

of David implied: 'Lord I have loved the beauty of your house and the place where your glory dwells' (Psalm 26:8). This conviction was reinforced by the suggestion that artistic beauty, as a manifestation of the divine, had a spiritual function in guiding the mind towards an understanding of the eternal beauty of God, a neo-Platonic argument used by Hugh of St Victor, when he explained that a wise man could consider 'the external beauty of the work' and so comprehend 'how wondrous the wisdom of the Creator is'.[9] This rather abstruse line of reasoning was later seized on by Abbot Suger (1122–51) as a welcome means of justifying his lavish expenditure at the Benedictine abbey of St Denis. Both the Cluniacs and the Benedictines had their critics and as the eleventh century advanced these became more vociferous. Peter Damien, for example, was devastating in his comments on one of the great builders of the age, Richard, abbot of St Vanne (1004–46): in a vision of hell he claimed to have spotted Richard 'anxiously building towering machines as though constructed for besieging castles. For this abbot worked in death as he had lived, since he had expended almost all of his efforts in constructing useless buildings and had wasted much of the Church's resources in such frivolities.'[10] The ascetic strain in European monasticism had never completely vanished: as monastic building became more grandiose during the eleventh century, isolated hermits and small 'protest' groups abandoned conventional monasteries, seeking solitude amongst the woods and mountains. One such group settled at Cîteaux in 1098, an event which marked the birth of the Cistercian order, though at the time few people would have guessed that this was the start of one of the most powerful religious movements of the Middle Ages. By 1115 Cîteaux had attracted enough recruits to send out four daughter houses, one of which was founded at Clairvaux, with St Bernard as its abbot. It was Bernard who became the chief spokesman of the new monasticism and by the time of his death in 1153 over 300 monasteries belonged to the order. In their search for peace and solitude, 'far from the haunts of men', the Cistercians produced some of the most romantically situated buildings of the Middle Ages. While there is debate as to whether they were a reactionary or progressive force, there can be no doubt that they redefined the nature of monastic architecture.

The Cistercians objected to the wealth of the Benedictine houses, to their preoccupation with feudal rights and the management of estates. They disliked the extravagance of the Cluniac liturgy which allowed little time for private devotion or study and they condemned the comfortable life which many contemporary monks seemed to enjoy. Stripping away the excesses of Cluniac monasticism, they insisted on a more literal interpretation of the Rule of St Benedict. They dedicated themselves to lives of poverty, manual labour, worship, and prayer, stressing the virtues of humility and simplicity. Unlike some monastic orders, they were prepared to accept uncultivated or 'waste' land on the

margins of Europe, a strategy which eventually brought great prosperity to the order. But why did the austere life of the Cistercians, with its strict diet and rigorous discipline, appeal to so many young people? The poetic words of Ailred, abbot of Rievaulx, offer at least a clue: 'everywhere peace, everywhere serenity and a marvellous freedom from the tumult of the world'.

It was not until the 1130s that a distinctive Cistercian approach to architecture began to emerge. The key building was Clairvaux, where St Bernard, somewhat reluctantly, agreed to the construction of a new church in 1135. This was a crucial moment, for Bernard was an outspoken critic of contemporary monastic architecture. He had already attacked the immoderate length and height of Cluniac churches, as well as their sumptuous decoration, which, he argued, impeded devotion and diverted the attention of the monks. His condemnation of Romanesque sculpture is well known: 'those ridiculous monstrosities in the cloister where the brethren are reading—those extraordinary deformed beauties and beautiful deformities'.[11] Far from encouraging devotion, he argued, works of art were a distraction. Moreover, expensive architecture was quite contrary to the humility expected from a monastic community; the money expended would be better spent on the poor. Bernard's arguments were not new, but unlike earlier critics he had an army of followers to put them into practice.[12]

During the French Revolution Clairvaux suffered a fate similar to that of Cluny (the site is now a prison, so examination is not easy). Although St Bernard's church has been destroyed, its design is known from ancient descriptions and drawings. Its most distinctive feature was a short rectangular presbytery, flanked on each side by three transept chapels, the latter linked together by a common outer wall. This straightforward rectilinear planning, which reflects the simple liturgy of the Cistercians, purged of Cluniac accretions, was to be reproduced in countless Cistercian houses, particularly within the affiliation of Clairvaux. In the absence of Clairvaux and Cîteaux (which has also been destroyed), the church at Fontenay, consecrated in 1147, is frequently taken as representative of Cistercian design in the time of St Bernard [116]. With its bare walls and lack of sculptural ornament, Fontenay seems to be the very embodiment of Cistercian austerity, though there is more subtlety to the design than is sometimes allowed. Like the order as a whole, the church has an interesting mixture of archaic and contemporary features. The plan, which was to become something of a 'norm' in Cistercian circles, included a simple presbytery, along with two roughly square transepts, each with two chapels [117]. The entire church is covered by pointed barrel vaults, a structural form established in Burgundy with the building of Cluny III. Although the nave lacks both a triforium and a clerestory, it is firmly articulated by a series of pilasters and half columns. More conservative

116 Fontenay, Cistercian abbey church, begun 1139

Built in a simplified version of the local Burgundian Romanesque style, the design of Fontenay may reflect that of its destroyed mother house at Clairvaux.

117 Fontenay

Plan of the Cistercian abbey The form of the church, with two straight-ended chapels in each arm of the transept, was repeated in many churches belonging to the affiliation of Clairvaux. A square lavabo originally projected into the cloister garth, almost opposite the entrance to the refectory. The detached building, known as the 'forge', is now used by the community as workshops.

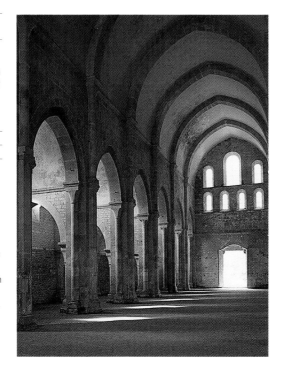

12th century ■; rebuilt ▨
13th century ▨; rebuilt ▨
16th century ▨

0 10 20 30 m
0 50 100 feet

118 Presentation scene

Dijon, Bibliothèque Municipale Ms 130, fol. 104, twelfth century Abbots of St Vaast and Cîteaux present their churches to the Virgin Mary, to whom all Cistercian churches were dedicated.

features include the transverse arrangement of the aisle vaults and the fact that both the presbytery and the transepts are vaulted at a relatively low level, making the nave the dominant space within the church. These features hark back to Burgundian buildings of the eleventh century, reflecting Cistercian nostalgia for the simplicity of the past. While far from rudimentary in design, the church at Fontenay certainly expresses the ideals of the order: it was intended to be a 'workshop of prayer', not a microcosm of the Heavenly Jerusalem. Restraint is equally apparent on the outside of the building, particularly the east end, with its low roof lines and simple rectangular forms. There are no towers, a small turret being all that was necessary to house the monastic bell. In 1157, not long after Fontenay was completed, the General Chapter prohibited the construction of bell towers on the grounds that they were signs of excess, contrary to the humility expected from the order. The contrast with the Cluniac approach was stark and deliberate. Purged of inessentials, the beauty of Cistercian building depended solely on architectural values: purity of form, clarity of proportions, functional efficiency, and a high standard of construction, all qualities which eight centuries later were espoused by the architects of the International Modern Movement. Mies van der Rohe's dictum 'less is more' would have delighted St Bernard of Clairvaux.

As each new Cistercian house was colonized from an existing monastery, architectural knowledge tended to radiate outwards from the centre. In practice this meant that a number of specific features associated with Burgundy were carried to diverse parts of Europe, where they were generally combined with local techniques. The 'Fontenay plan' was widely adopted, no doubt because of its practicality. It can be found, for example, at Boyle in the west of Ireland, where the earliest parts of the church (c.1161–70) reveal a clear debt to Burgundy in the form of pointed arches and pointed barrel vaults, along with a characteristic 'low' presbytery, as at Fontenay. The 'Fontenay plan' was also adopted in Sweden, as at Alvastra and Nydala, both founded as daughter houses of Clairvaux in 1143. To these remote corners of the world, where local traditions of church building were not particularly strong, the Cistercians brought European modes of design.

Where Romanesque architecture was more advanced, the Cistercian identity is not so obvious. At Eberbach, a daughter house of Clairvaux, the church (c.1170–86) was begun along Burgundian lines, but before construction had proceeded very far it was transformed into a thoroughly Germanic building [119]. The unadorned square piers and the double-bay system of groin vaulting have many analogies in the middle Rhine. By the end of the twelfth century the Burgundian elements in Cistercian architecture were increasingly submerged by local styles. This is apparent in northern Italy, where the two well-preserved churches of Chiaravalle Milanese and Chiaravalle della

119 Eberbach (Hesse), Cistercian church, c.1170–86

While the air of austerity is characteristic of Cistercian design, the construction of groin vaults over double bays relates to local practice in the Rhineland. Prominent pilasters, supporting the transverse arches, introduce an alternating rhythm in the piers.

120 Le Thoronet (Var), Cistercian church, founded 1146

Designed with characteristic simplicity, the church has many features which relate to the local neighbourhood of Provence.

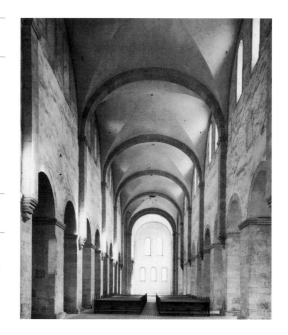

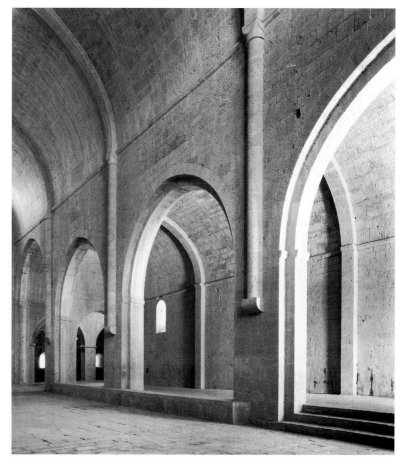

Colomba were built of brick in the Lombard manner, only the use of the 'Fontenay plan' exposing a clear link with the Cistercians.

In general the Cistercian identity was conveyed not by specific architectural features, but by a tone of simplicity and restraint. The absence of sculpture, the lack of towers, the rejection of triforia and galleries, the simplicity of mouldings around doors and windows, the use of monochrome glass (grisaille) rather than stained glass, and the lack of mural painting, all contributed to a distinctive atmosphere. The effects are beautifully illustrated in the three Provençal monasteries of Sénanque, Silvacane, and Le Thoronet. The church at Le Thoronet is a typical Cistercian blend, a mixture of local Romanesque and Cistercian austerity [120]. The exterior, with scarcely a window in sight, has a severity which is extreme even by Cistercian standards; the interior, though equally plain, has a tranquillity that few Romanesque churches can match, the eye being drawn to the main apse, the one part of the church that is brightly lit. To this day the simple purity of Le Thoronet seems to capture the ethos of the order.

The most enduring achievement of monastic builders lay not in the sumptuous design of Cluny III, nor in the purified architecture of the Cistercians, but in the invention of the cloister. The concept of an enclosed courtyard, surrounded on all four sides by arcaded passageways, was to survive far beyond the Middle Ages. It was a feature adopted by virtually all the different orders, regardless of their religious ideals, and it is not difficult to see why. The cloister—or *claustrum*—was completely separated from the outside world, a haven of peace in the heart of the monastery. It offered an efficient communication system between the various buildings of the monastery, providing a series of well-defined routes, sheltered from the elements. When the cloister lay to the south of the church, as was normally the case, the north walk was a sunny environment for reading or writing; it was also used for collation, a short reading that took place in the evening before compline. In visual terms the cloister walks brought order to what might otherwise have been a rather incoherent collection of buildings. With their rhythmic arcades, they helped to conceal the structures behind, giving the impression of a unified architectural ensemble. Few surviving cloisters predate 1100, but there are a large number from the twelfth century, heavily concentrated in southern France, Spain, and Italy. Not a single Romanesque cloister remains intact in England.

The character of a cloister was largely determined by the arcades, the design of which depended on how the passageways were covered. When a simple lean-to roof of timber was employed, the arches could be supported on a continuous line of columns, with the occasional pier to provide reinforcement. In the rebuilt cloister at St-Michel-de-Cuxa (Roussillon), there is a single row of columns, but the normal arrangement was to place the columns in pairs, as at St-Bertrand-de-

121 Sénanque (Vaucluse), Cistercian cloister, late twelfth century

Each bay contains three arches supported on coupled columns, a formula used extensively in twelfth-century Europe.

Comminges (France) or Silos (Spain). Each of these examples was richly embellished with sculpture. In some cases an alternating rhythm of single and double columns was introduced. When the cloister walks were vaulted, however, more reinforcement was required: two or three sub-arches might be set under an embracing arch, the latter resting on substantial piers. There are many well-preserved examples of this technique in Provence, at Montmajour, St-Paul-de-Mausole, Vaison, and in the Cistercian houses at Sénanque [**121**] and Le Thoronet. An alternative way of incorporating a vault can be found at the cathedral of Le Puy, where the cloisters were embellished with polychrome masonry. Here the masons devised a regular system of supports, in which

the square piers are furnished with a detached column on each face, the columns being neatly integrated with the two orders of arches above [122]. The most exotic Romanesque cloisters are to be found in the Benedictine houses of Rome [109] and southern Italy, where twisted columns and inlaid mosaics were introduced, a trend which reached a colourful climax at Monreale Cathedral (Sicily).

The concept of the cloister is such a familiar part of Romanesque art that it is easily taken for granted, despite the fact that its history before 1100 is far from clear. No doubt many monasteries were satisfied, at least on a temporary basis, with galleries made of timber, which was evidently the case at Cluny until the 1040s.[13] Late in his life Abbot Odilo (994–1049) constructed a cloister in stone 'admirably decorated with marble columns from the furthest parts of that province, transported not without great labour by the headlong currents of the Durande and the Rhône. In which he was wont to glory and to remark in jest, that he "had found it in wood and left it in marble", in imitation of Augustus Caesar, of whom chronicles say that he found Rome made of brick, and left it made of marble.'[14] There are indications that the columns of Odilo's cloister were grouped in pairs, as in most Romanesque examples.[15] But the origin of the medieval cloister goes back much further, for the basic principles were already established during the Carolingian Renaissance, as demonstrated by the famous plan of St Gall (c.830) [123].

The St Gall plan has been the subject of intense scrutiny and speculation for many decades. Drawn on five sheets of parchment, the plan is surprisingly large (1,120 x 770 mm). Carefully outlined in red ink is the layout of a monastery, including not just the church and conventual buildings around the cloister, but a host of ancillary structures, guest houses, a school, novitiate, infirmary, stables, workshops, animal pens, and even accommodation for chickens and geese. It should be stressed that the plan is a Utopian scheme and not a working drawing. Walls are indicated by single lines, with only an occasional indication of wall thicknesses. To make good use of the parchment, buildings are packed tightly together in a way that would have been quite impractical in real life: no community would have wanted workshops and animal sheds quite so close to the living quarters. Nonetheless the plan has been thought out with remarkable consistency: there are beds for approximately 110 brethren (77 of them in the monks' dormitory), which coincides with 112 seating places in the church. There are 6 places for visiting monks in the refectory and 6 beds in their lodgings. Even the latrines are carefully delineated, though a mere 9 'seats' in the main rere-dorter (latrines) might have created some strain if all 77 beds in the dormitory were occupied. At the other end of the dormitory a door gave direct access to the south transept of the church, so the monks did not have to go outside when getting up for matins and prime. As the

dormitory was on the upper level, stairs would have been needed, providing the first hint of a 'night stairs', which was to become a standard feature of the medieval monastery.

An inscription indicates that the plan was sent to Gozbert, abbot of St Gall (816–37), at a point when he was contemplating the reconstruction of his monastery. There is evidence (but not absolute proof) that it was composed at Reichenau under the direction of Haito, one-time abbot of Reichenau and bishop of Basle. Haito appears to have been offering advice to a colleague, though some scholars have tried to read far more into the situation. It has been claimed that the plan was a product of the reforming synods held in 816 and 817, and was intended as a model or 'paradigm' for the whole Carolingian Empire. It has also been argued that the plan is a copy of a master drawing that was made at Aachen at the time of the synods. Neither of these theories is tenable in the light of recent research, which has conclusively proved that the St Gall plan is an original drawing and not a copy.[16] Nonetheless the plan does reflect a general concern for consistent organization and discipline, and its careful allocation of functions represents a translation of the Benedictine Rule into architectural terms.

In the context of monastic architecture, the most interesting aspect of the St Gall plan is the design of the cloister and the buildings surrounding it. Many standard elements are already present. The cloister itself is tucked into the angle of the nave and the south transept, and on each side there are covered passages, with arches opening into the central garth. To the east lies the dormitory, situated on an upper floor above the 'calefactory' or warming room. To the south is the refectory and on the west side is the cellarer's storehouse, identified by two rows of barrels. Even the dimensions are significant: the cloister itself is almost a square, with two of the sides having an intended measurement of 100 feet, a favourite length in the layout of medieval cloisters. In drawing the cloister walks, the designer temporarily switched from vertical to horizontal projection, showing the arcades resting on a low wall as was the norm in the Middle Ages. The one major difference between the cloister of St Gall and later monastic plans is the lack of a chapter house, its place being taken by the calefactory. A caption indicates that the deliberations of the monks were to take place in the north walk of the cloister. But how much of this layout was common practice in the ninth century and where did the idea of the cloister come from?

The concept of an enclosed courtyard beside the church was certainly not new when the St Gall plan was devised around 830. Several Carolingian monasteries are known to have followed similar arrangements, though the exact location of the cloister tended to vary. At Lorsch—the Altenmünster (765–84)—and Fontanelle (St Wandrille) the cloisters lay to the north of the church, and at Fulda in 820 it was placed to the west in the manner of a Roman atrium. The arrange-

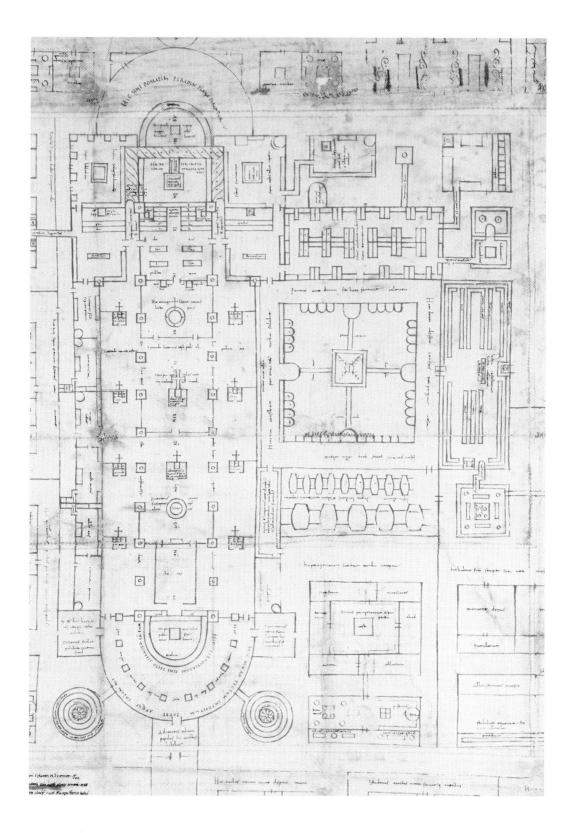

122 Le Puy Cathedral, twelfth-century cloister

The polychrome masonry, often attributed to Islamic influence, adds an exotic note to the cloister arcades. Each arch is supported by a pier with columns attached, instead of the customary coupled columns.

123 The plan of St Gall, *c*.830, detail showing the church and cloister

The church was designed with apses at both ends, and the aisles were clearly intended as locations for altars. A 'crank-shaped' crypt, marked with curved hatching, is visible under the chancel at the east end. The refectory with its benches and tables lies to the south of the cloister (right of the drawing) and storerooms to the west are identified by rows of barrels. The dormitory, with individual beds marked out, is situated to the east.

ments found in the St Gall plan were evidently based on practical experience and are not simply the result of creative draughtsmanship. Ultimately the idea of a courtyard surrounded by open porticoes was inherited from the Roman world, where the peristyle court was a feature of villas and luxury houses, like those at Pompei. One plausible hypothesis suggests that the idea passed into medieval architecture when monastic communities began to occupy defunct Roman villas. Certainly this would help to explain the classical approach to planning found in the St Gall plan, with its use of axes, open courts, and right angles. But the story is not quite so simple. The Roman peristyle normally consisted of a straight architrave supported by a single line of columns, placed at ground level. The medieval cloister arcade was a far more enclosed affair; the columns were smaller, they supported round arches not lintels, and by the eleventh century, if not before, they were arranged in pairs; moreover, the columns rested on a low wall, which separated the passageways from the central courtyard.[17] The medieval cloister walk is more a functional passageway than the open portico of the Romans. How this transition from the classical peristyle to the medieval cloister came about is one of the unsolved mysteries of the early Middle Ages.[18]

Although the plan of St Gall made no provision for a separate chapter house, Abbot Ansegis at Fontanelle did. He erected a special chamber to the north of the church, known as the *Bouleterion*, where the brethren could gather together 'to take counsel over anything whatsoever'. The local chronicler went on to explain that 'there is also a daily reading from a pulpit there, and deliberation over what the authority of the Rule advises should be done'.[19] Abbot Ansegis announced that he wished to be buried in the chapter house, establishing a precedent which was later to be followed by abbots throughout the western world. The transfer of the chapter house to the ground floor of the east range was not a major step, as it would have been logical to hold meetings in the calefactory in cold weather. It is possible that some Carolingian monasteries had done this before the end of the ninth century. As its name implies, the chapter house was associated with the reading of 'chapters' of the Rule of St Benedict. It became customary for monks to assemble there after morning mass; as well as spiritual advice from the abbot, various prayers were said, and in the Cistercian order the brethren made confession in the presence of each other. The chapter house was thus the focus of order and discipline within the monastery, the most important building after the church. Its location underneath the dormitory was, however, something of an impediment. There was often insufficient height to vault the chamber in one sweep, in which case it was subdivided by columns or piers into separate bays, as happened at Cluny.[20] This system was widely adopted in the Cistercian order. The chapter houses at Le Thoronet, Sénanque,

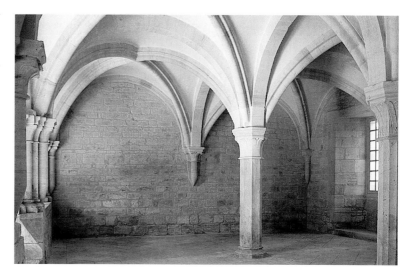

124 Noirlac (Cher), Cistercian chapter house, second half of the twelfth century

Two octagonal piers divide the space into six bays of vaulting, an arrangement adopted in a number of Cistercian monasteries. Benches placed around the walls provided seating for the monastic community.

and Silvacane, for example, have a pair of free-standing columns (or piers), dividing the space into six rib-vaulted bays. An elegant version of the same formula can be found at Noirlac (*c*.1170–90) [**124**]. The subdivided chapter houses tend to be more humble, intimate spaces than the great single-vaulted chambers more frequently encountered in contemporary Benedictine monasteries. One curious feature of Cistercian chapter houses is the way they were left open to the cloister walk, with unglazed windows flanking the entrance. It is said that this was to allow the lay brothers to attend occasional meetings, without actually crossing the threshold of the chapter house itself.

The fact that the key elements of the medieval monastic plan were established between 750 and 830, during the Carolingian Renaissance, underlines once again what a crucial period this was for the history of European architecture. This was also the time when the Benedictine Rule came to be accepted throughout Europe and it should be remembered that, whatever the ideological differences between the Cluniacs and the Cistercians, both were following the Rule, albeit with modifications of their own. In terms of stylistic development there is little doubt that the ethos of the different orders had a measurable impact. The more sumptuous versions of Romanesque were a natural counterpart to the rich liturgy of the Cluniacs and the more traditional Benedictine houses, whereas the Cistercians functioned as a catalyst for change. With their attacks on sculptural embellishment and their willingness to exploit the pointed arch, the Cistercians prepared the ground for the emergence of the Gothic style.

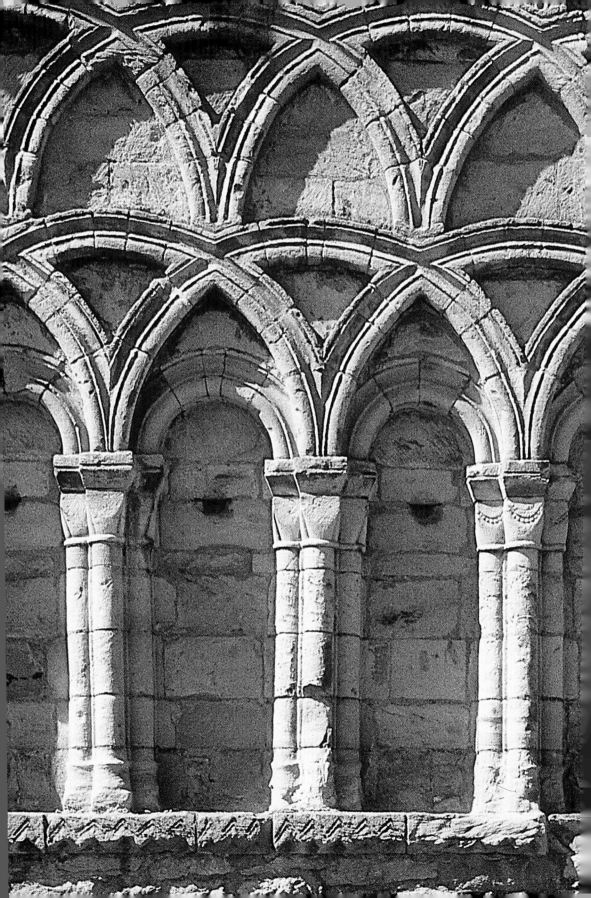

The Language of Architecture

9

During the course of the eleventh century a new architectural language emerged in western Europe, a language that imbued buildings with an expressive power that had not been seen since the days of the Roman Empire. Masons developed a range of techniques which, while enhancing the splendour of churches, castles, and even private dwellings, also conveyed a new sense of clarity and order. These techniques included the compound pier, the engaged shaft, roll mouldings, wall arcades, windows and doorways with recessed orders, and arcaded galleries and passageways, along with a wealth of applied ornament. Not all the methods were new, but by the twelfth century they were being used in combination to produce buildings of unparalleled richness.

The effects of this 'architectural revolution' are very obvious when we compare the nave of Vézelay [**114**] with designs of a century earlier, like that at Château Gontier (Mayenne) [**125**]. The latter was constructed as a wooden-roofed basilica, with its arches resting on unadorned square piers, a building type common in the years around 1000. The piers lie on the same plane as the wall above and no attempt has been made to articulate the bare surfaces. What appears today as a rather monotonous, even austere piece of architecture must have relied on painting to improve its sense of vitality. The smooth, uninterrupted surfaces of Château Gontier belong to a tradition which can be traced back to the Early Christian basilicas of Rome or Ravenna [**1, 16, 25**]. For 800 years Christian architects in the West had treated the wall as a continuous plane, which served to define both the interior space and the external mass of their buildings in the simplest possible way. Romanesque architects transformed the situation by dividing the surfaces into clearly articulated units and by treating the wall as a three-dimensional entity. Although the architectural framework of Vézelay is not dissimilar to that of Château Gontier, the architectural language is almost unrecognizable [**114**]. Engaged shafts, string courses, and ornamental mouldings (along with a stone vault) have converted the

Detail of 130

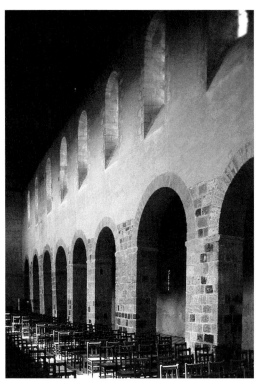 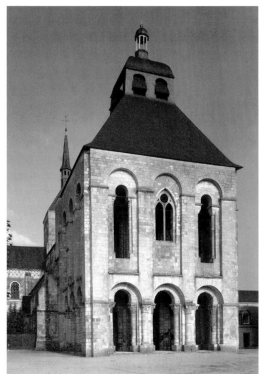

underlying basilican form into a lively and rhythmic space. Transverse arches, associated with engaged shafts on the walls, underline the division between one bay and the next, a formal device which is one of the defining characteristics of the Romanesque style.

The first indications of the new approach were already apparent by 1030, most notably in a number of buildings along the river Loire, which have for long been regarded as crucial in the formation of Romanesque. One such monument was the tower which Gauzlin, abbot of St-Benoît-sur-Loire, constructed in c.1026 at the west end of his church [**126**]. The open porch on the ground floor contains a variety of piers furnished with engaged shafts, which, in a somewhat unco-ordinated way, were linked to arches in the vault above. Gauzlin intended his tower to be 'an example to all Gaul', a sign perhaps that he himself appreciated the novelties of his achievement.[1] Not far away, similar techniques were used at Auxerre Cathedral, which was rebuilt after a fire in 1023. The crypt of the cathedral (the only part of the Romanesque building to survive) is a landmark in the history of Romanesque: as well as engaged shafts systematically placed to receive the arches of the vault, the arches themselves are furnished with mouldings on their soffits, a device which immediately imparts a sculptural quality to the design. At the same time, engaged shafts were used by the builders of the castle at Loches to embellish the outer walls

of the keep [50] and the technique soon spread to Normandy and to the Rhineland, where they appeared in the nave of Speyer Cathedral (*c*.1030–60) [148].

Although there is general agreement that the period 1020–40 marks a fundamental shift of direction, it is not clear what brought about the change. While the amount of building in Europe was on the increase in the early years of the eleventh century, it is difficult to believe that this in itself had a direct effect on style. Wealth was a more significant factor, since patrons were evidently prepared to commission buildings which went far beyond their basic functional requirements. In this respect the sumptuous architecture of the Romanesque era was a direct reflection of the expanding medieval economy. The increasing professionalism of the building trade also played a major role. It is significant that Gauzlin brought squared blocks of stone from the Nivernais, transporting the material in boats down the Loire. Good-quality stone, together with a growing cohort of experienced masons, provided two of the essential conditions for the development of the Romanesque style. But to what extent were the masons responding to the aesthetic demands of their clients? Until the eleventh century the magnificence of a church was largely expressed in terms of expensive metalwork, wall paintings, or floor decoration. What appears to have changed is that men like Gauzlin were prepared to look to architecture itself as a prime source of institutional splendour, so that the sensibility which had long been evident in the appreciation of painting and metalwork was now extended to the architecture. The variety and subtlety achieved by Romanesque masons would have been futile if it had not been matched, at least in a general way, by an equivalent level of visual sophistication on the part of those who paid for the buildings.[2] Some patrons became veritable connoisseurs of architecture, a good example being Roger, bishop of Salisbury from 1102 to 1139, who amassed enormous wealth while serving as justiciar to the king of England. The historian William of Malmesbury stressed that Roger took enormous personal pride in his buildings (which included both castles and churches), a pride 'unsurpassed within the recollection of our age'.[3]

Although historians have devoted a great deal of attention to the 'formal' analysis of Romanesque architecture, little attention has been paid to the ways in which it was perceived in the Middle Ages. Most comments by medieval writers tend to be brief and factual, a statement of dimensions perhaps, or a list of the number of piers and windows. Ecclesiastical writers were usually more concerned with the position of altars than with the refinements of the architecture. Nonetheless, authors often convey an impression of a building with various telling epithets—*spectabilis* (admirable), *sumptuosus, magnificans, incomparabilis, splendidus, formosus* (handsome), *ornamentissimus, pulcherrimus* (most beautiful)—and many a building was constructed *laudabile opere* or

opero miro. As with music, it has never been easy to translate the visual effects of architecture into words, a difficulty openly admitted by the eleventh-century chronicler of Saint Bénigne of Dijon.[4] While observers may not have been capable of analysing the fabric with the attention of a modern critic, they had no difficulty in appreciating the overall effect. A typical comment is that found in the chronicle of the abbots of St Trond, near Liège, reported under the year 1169: 'So much care did the industrious architect devote to the decoration of the monastery that everyone in our land agrees that it surpasses the most magnificent palaces by its varied workmanship.'[5] The stress on 'variety' is worth noting, so too the desire, keenly felt by Romanesque patrons, to surpass the achievements of their neighbours. In visual matters this was a highly competitive age.

The most crucial aspect of Romanesque aesthetics is the way in which the individual parts of a building were subordinated to the whole. Thus in a typical cloister arcade two or three subsidiary arches are frequently linked together under a single containing arch [121]. On a much grander scale, a related approach can be seen in the nave of Durham Cathedral, where pairs of arches are framed by massive compound piers, which define each of the double bays [146]. In many instances the relationship between major and minor elements can be very subtle, as in the design of windows at Aulnay [127]. In this case the relatively small east window is framed by a sculptured border, which in turn is framed by a decorated arch supported on nook shafts. The whole composition is then surrounded by a further arch, the shafts of which descend to the plinth. The window is thus integrated into a 'giant' wall arch, with each of the three elements set on a different vertical plane. Buildings in virtually every country of Europe afford examples of this structured, hierarchical approach to design, an approach which is the source of the order and clarity so often associated with the Romanesque style [134]. These qualities are unlikely to have come about by accident. Between 1000 and 1200 a demand for greater precision affected many aspects of political and social life; as historians have observed, a charter written in the late twelfth century is likely to be more exact and better organized than one composed 200 years before. When thinking of the carefully organized components of a Romanesque church, it is hard not to compare it with the precisely ordered structure of contemporary feudal society.[6]

At a more theoretical level, it is worth noting the way in which the hierarchical approach to design coincides with medieval notions of the concept of beauty. Here, for example, is the view of Robert Grosseteste, the thirteenth-century bishop of Lincoln: 'For beauty is a concordance and fittingness of a thing to itself and of all the individual parts to themselves and to each other and to the whole, and that of the whole to all things.'[7] It is a definition which could be applied without

127 Aulnay-de-Saintonge
(Charente-Maritime), church
of St Pierre, c.1130

The system of embracing
arches around the windows
was developed in many of the
churches of the Saintonge.
The clusters of vertical shafts
which emphasize major
divisions in the building were a
feature of Romanesque in
western France.

128 Santa Cruz de la Seros
(Aragon), church of San
Caprasio, last quarter of the
eleventh century

The combination of roughly
coursed masonry, together
with Lombard bands and
arcades, is characteristic of
the style known as 'first
Romanesque'.

too much difficulty to Romanesque architecture, though not to the Gothic style of Grosseteste's own time. Grosseteste was in fact repeating concepts which were taken straight from classical authors, whose opinions largely determined the way in which medieval scholars approached the issue. Men of learning were familiar with the treatise on architecture by the Roman author Vitruvius, whose definitions of proportion were echoed in several medieval texts. Metaphysical concepts of beauty might seem far removed from the physical activities of the building yards, but on occasions it is possible that they touched the realities of life. While it is most unlikely that the master masons responsible for the cathedral at Durham or the parish church at Aulnay devoted much time to philosophical speculation, their attitudes may have been affected indirectly by assumptions inherited from the remote classical past.

At this point it is time to examine in more detail some of the expressive techniques employed by Romanesque masons, beginning with the outer 'skin' of the building. In Mediterranean countries, the articulation of the external walls developed at an early period, in a phase of architecture that is usually described as 'first Romanesque'. This architectural epoch was defined by the Spanish historian Puig y Cadafalch, who spotted many parallels in building technique along a wide stretch of the Mediterranean coast, from Dalmatia and northern Italy to Provence and Catalonia. Despite being constructed in coursed rubble, first Romanesque churches were adorned with a system of vertical 'bands' or pilasters, along with a line of small arcades placed just below the eaves line [30, 128]. As the system was prevalent in

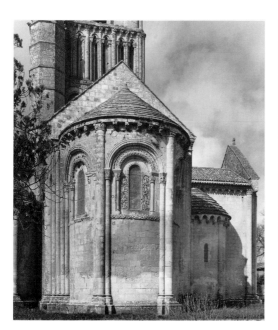

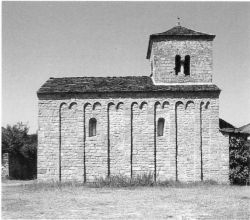

Lombardy (and probably originated there), the features are often described as 'Lombard bands' or 'Lombard arcades'. This system of decoration appears to have developed in the later years of the tenth century and it became widespread in the eleventh. It progressed up the valleys of the Rhône and Saône, and found its way across the Alps, appearing in many prominent buildings along the Rhine. As a system of decoration, it had several advantages. It was fashioned out of rubble masonry, so that no particular expertise was required on the part of the masons. Moreover, the system was flexible, since the arrangement of the bands and arcades could be adjusted to suit almost any space available. The techniques were used to good effect on the detached belfries, which, from Catalonia to the valley of the Po, form a major characteristic of the epoch. The majestic tower at Pomposa in northern Italy is a fine statement of the genre. The consistency with which first Romanesque decoration was used across southern Europe can be misleading, since it was applied to buildings which in some cases differed quite radically in plan and structure. The system survived into the twelfth century, especially in Italy and Germany, though, with the advent of cut stone, the miniature arcades were frequently given a more sculptured appearance.

An alternative means of giving relief and depth to wall surfaces was through the use of a blind arcade. Sometimes such arches were employed on a 'giant' scale, defining each bay of the building, while elsewhere they were used as an ornamental ribbon running around the outer walls. The technique is so common in Romanesque that it is easy to overlook its significance. In Tuscany a sequence of arches resting on thin pilasters was used to enliven the outer walls, a local variation being the sunken diamonds which frequently occupy the head of the arches [136]. In vaulted buildings, such systems were usually linked to buttresses, as at Aulnay, where each bay is defined by a single arch [127]. In twelfth-century buildings the arches were usually supported on engaged shafts, rather than pilasters, giving a more rounded sculptural impression. In a few (rare) instances detached columns were used; this is the case at Troia Cathedral, where a double row of columns, evidently filched from some Antique monument, was deployed around the apse. Both in Apulia and parts of southern France an even more dramatic effect was achieved by the construction of arches between a sequence of buttresses, throwing the outer skin of the churches into powerful relief. This technique was employed at San Nicola, Bari, where a line of such arches along the nave was continued across the face of the transept in the form of a delicate wall arcade, a subtle combination of two alternative approaches.

More universal was the use of smaller arcades, which lined both the internal and external walls of many a Romanesque church, often acting as a horizontal band which helps to pull a design together. In the choir of Canterbury Cathedral (c.1096–1130) a richly-decorated arcade on

129 Shrine of Santo Domingo from the abbey of Silos, *c.*1140–50, Burgos, Museo Arqueológico

The placing of saints under arches reinforced the link between arcading and celestial Jerusalem. In this case the impression is enhanced by the towers and domes which extend along the top of the arches.

the outer wall establishes the division between the crypt and the main church above. In western France blind arcades were often located at the top of the outer walls, immediately below the roof line. This made good sense in barrel-vaulted buildings, where the upper walls could not be pierced by windows. As well as concealing a redundant section of masonry, a blind arcade in this position furnished an attractive climax to the architectural composition. While such arcades were designed principally as decoration, there are occasions when their use was restricted to particular parts of a building, to highlight the importance of the chancel or a portal, for example. There are many cases in which small arcades were fitted above a doorway, either set within a gable, or stretched across the façade of the building. While such arrangements added visual emphasis, they also lent themselves to symbolic interpretation. When medieval artists depicted the Heavenly Jerusalem, as in the famous *Last Judgment* at Autun, they did so in terms of arcaded structures. Arcades added status and a hint of divine glory [**129**].

By the middle years of the twelfth century, superimposed rows of arches were used to create rich, ornamental effects, as on the façades of the Cluniac priory of Castle Acre [**115**] and the Benedictine abbey of Malmesbury, parts of the building which medieval commentators likened to the *portae caeli*, the gates of Heaven. And every time the Cluniac monks at Much Wenlock gathered in their chapter house, they had the opportunity of gazing at a truly exotic display of ornamental arcading [**130**], their vision, perhaps, of heavenly Paradise.

A natural extension of the blind arcade was the arcaded gallery built within the thickness of the wall, a technique which was exploited in a variety of different ways. One of the most dramatic compositions of this type can be found at the east end of Speyer Cathedral [**132**], a

Intersecting arcades became
a favourite device of
Romanesque architects,
especially in England. The
chapter house was also
embellished with a ribbed
vault, traces of which survive
alongside the decorative
arcading.

composition which could be seen from every boat passing along the
Rhine. A 'dwarf gallery' encircles the top of the apse, underlining its
rounded form. When seen in conjunction with the blind arcade on the
lower walls of the apse, and the employment of 'Lombard arcades', the
result is one of the most memorable pieces of Romanesque design.
Galleries added depth to the building, and provided an element of
chiaroscuro, with the outer columns silhouetted against the shaded
background. But they could only be constructed if the basic walls of the
building had a thickness of five feet or more, which in many instances
meant that they were used in conjunction with stone vaults. External
galleries became a familiar characteristic of Romanesque architecture
along the Rhine, and they are especially prominent in the churches of
Cologne. There has been much debate about their origin: among the
earliest examples in northern Europe are those in the west façade of
Trier Cathedral (c.1016-47), but whether the technique had a German
or Italian background is an open question. Long before the
Romanesque era, external passages had been constructed in the fifth-
century church of Sant'Aquilino at Milan, so their roots appear to lie in
the architecture of the late Roman world.

In Italy, Germany, and occasionally Spain, dwarf galleries were constructed around the apse, where they were located above the springing point of the half-domes within the building. A number of eleventh-century churches were furnished with a sequence of niches in this position, as at Lomello in Lombardy [30] or Hersfeld in Germany, but there is no doubt that the continuous gallery provided a more attractive alternative. In many cases the galleries were divided into a series of bays, a beautifully integrated example of which can be seen at Modena Cathedral, dating from soon after 1100 [133]. In contrast to Speyer, the blind arcade embraces the gallery, providing the type of hierarchical composition beloved by Romanesque architects. The same system was continued along the flanks of the cathedral. Architects exploited the external gallery in a variety of different contexts. In Germany they were sometimes fitted around the base of church towers, a method which was copied in some of the splendid Romanesque monuments of Gotland, as at Stenkyrka [81]. They also decorate the brick façades of Lombardy, where the stepped galleries provide a point

131 Cashel (Tipperary), Cormac's Chapel, 1127–34

With its blind arcades, sculptured portals, and decorative string courses, the chapel forms one of the most complete examples of Romanesque in Ireland.

**132 Speyer Cathedral, begun
c.1030, completed first half
of twelfth century, view from
the east**

A giant order of blind arches
runs around the apse, above
which is an open gallery, set
immediately below the eaves.

133 Modena Cathedral, begun 1099, view from the east

Although related to the design at Speyer, the blind arches at Modena embrace the gallery, producing a more integrated composition.

134 Modena cathedral, begun 1099, south wall of the nave

The use of embracing arches creates a 'hierarchical' system of design, characteristic of Romanesque. Note the 'putlog' holes for scaffolding in the external masonry.

135 Lucca, San Michele, façade, c.1200

Designed as an exotic screen with ornamented columns and inlaid decorative patterns. The 'knotted' columns at the end of the middle level were a favourite device of Tuscan masons.

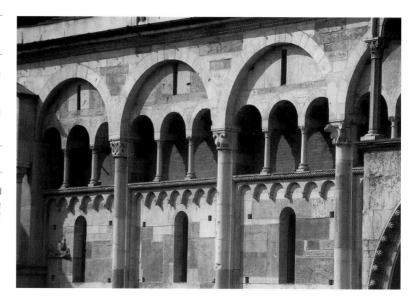

of emphasis below the crest of the gables. Further south, they were exploited in dazzling fashion by the masons of Tuscany, who stacked one arcade upon another. With their inlaid marble and variegated columns, church façades in Pisa, Lucca [**135**], and Pistoia provide a symphony of arches, the Romanesque equivalent to the classical theatre with its *scenae frons*. Even more spectacular is the famous 'Leaning Tower' of Pisa [**136**], encircled by six superimposed galleries, a veritable *tour de force*.

Although external galleries can usually be reached by staircases from inside the structure, they do not appear to have served any utilitarian purpose. On a few rare occasions they might have been exploited for defensive reasons, but their principal purpose was to enhance the look of the building; open galleries, set high in the building, increased the visual splendour of the architecture, and, for some spectators, may have inspired thoughts of the celestial city.

In Normandy and England the arcaded gallery was used in a very different context. Here passages, placed at clerestory level, opened onto the interior rather than the exterior of the buildings [**152, 156**]. These 'clerestory passages' are one of the most exciting features of English Romanesque and they remained a characteristic of English architecture far into the Gothic era.[8] The most common arrangement in England was for each bay of the clerestory to be furnished with one large arch, corresponding to the window, which was flanked by a sub-arch on either side [**156**]. This stepped arrangement required two free-standing columns in each bay. The alternating rhythm of low and high arches, the suggestion of depth and hidden spaces, along with the contrasting effects of light and shade, create a lively visual effect. The passages continue unbroken through the centre of the clerestory, offering

136 Pisa, campanile or 'Leaning Tower', c.1153

Popular interest in the lean has tended to overshadow the architectural qualities of this exotic belfry. The delight in superimposed arcades was characteristic of architecture in Tuscany.

exhilarating vistas for those fortunate enough to experience them. What purpose was served by these semi-secret passages high in the walls of the church? In view of the way in which church buildings were regarded as a representation of the Heavenly Jerusalem, it would not be difficult to imagine them as empty spaces, waiting to be inhabited by the elect. To one medieval writer, they suggested a honeycomb, an intriguing comparison given the identification of Heaven as a land flowing with milk and honey.[9] At a more prosaic level, the passages provided easy access to the upper parts of the structure, useful for cleaning or repairing windows, for example, though it is hard to believe such utilitarian needs justified the expense required. The aesthetic effect should not be taken for granted. Had clerestory arcades not looked impressive, it is unlikely that the clergy of England and Normandy would have been willing to pay for them. So successful was the scheme that similar arcades were inserted into other parts of the buildings, in the apse at La Trinité, Caen, for example, or in the transept walls and central tower at Norwich Cathedral.

Clerestory passages originated in eleventh-century Normandy, where they were first used in transepts as means of access to the crossing towers. In subsequent churches they were extended along the rest of the clerestory, initially with arches of equal height. Although the scholar Jean Bony argued that the huge walls required to contain such passages furnished an internal buttressing system, it is unlikely that structural considerations were uppermost in the minds of the builders. Moreover, Bony's term 'thick wall', which he used to describe a structure with clerestory passages, has proved misleading and it is preferable to use the term 'hollow wall'. It is worth noting that passages within the thickness of a wall were an important element of castle design, and it is possible that their popularity in church architecture had something to do with the development of the keep. As we have seen, in some castles they were constructed like clerestory passages around the upper walls of the main chamber [**51, 137**].

In contrast to their predecessors, Romanesque architects explored the masonry wall as a three-dimensional entity, hollowing out the fabric with galleries and niches, and modelling the surfaces with arches and engaged shafts. A similar approach governed the design of doors, where the sheer thickness of Romanesque masonry promoted the development of recessed orders. Many twelfth-century portals are so enveloped in ornament that it is easy to overlook this basic structure. The standard arrangement is for a pair of columns or engaged shafts to support each order of archivolts, the basic grammar of which is clearly illustrated in the south portal at Aulnay [**138**]. Here the inner order rests on relatively plain jambs, with the next three orders supported on detached columns. Although the actual opening for the door is quite narrow, the four concentric orders, gradually expanding

137 Castle Hedingham (Essex), *c.*1140

View taken in 1920 before restoration. The double-level hall is surrounded by wall-passages and decorated with chevron ornament like that in contemporary churches. The fireplace is furnished with a Romanesque arch. The keep, which was built for Aubrey de Vere, earl of Oxford, was evidently intended primarily for show.

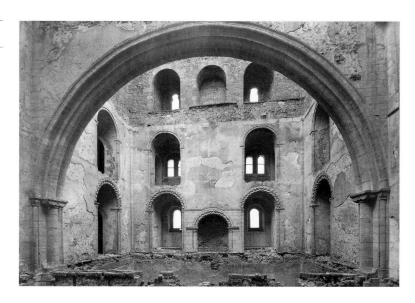

138 Aulnay-de-Saintonge (Charente-Maritime), church of St Pierre, south transept portal, *c*.1130

With its sequence of recessed arches, each highly sculptured, this is a classic statement of Romanesque portal construction.

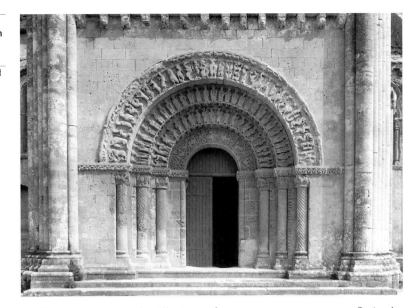

in diameter, create the illusion of an enormous entrance. It is the width of the outer order, not the narrow inner arch, that determines the spectator's impression of scale. Equally characteristic is the way in which the orders are recessed in depth, drawing the eye inwards, as if anticipating movement into the church. In order to provide room for additional archivolts, the depth of the portal was often enlarged, so that it extended in front of the wall of the church. It is easy to forget that these techniques were quite unknown before the Romanesque period. By the twelfth century such methods had been adopted in virtually every country of Europe and, while there were local variations in the way they were applied, the basic syntax remained the same. In some cases the square edge of the jambs was allowed to peep out between each column, but in others a continuous line of shafts occupies the entire space, as can be seen in the west portal of Chadenac (Charente–Maritime) [**144**]. In many instances the semicircular space below the arch was filled with a tympanum, usually supported by a lintel, both of which became important fields for sculpture.

Although scholars have devoted much attention to the sculpture of Romanesque portals, very little research has been devoted to their underlying form. It is not clear where the portal with multiple orders first developed, though it clearly evolved out of architectural practice in the eleventh century.[10] Windows and doorways with a single recessed order were common at this time, but it was not until the twelfth century that portals with multiple orders became a universal feature. The roots of the system go back to late Antique architecture (there are simple rebates in the windows of the churches at Ravenna, for example), but Antiquity provides no more than a hint of the system which was to be so vigorously exploited by Romanesque architects.

Of all the expressive techniques at the disposal of the Romanesque architect, the most fundamental was the engaged shaft. In virtually every aspect of church design—in portals, chancel arches, piers, and façades—the engaged shaft offered the principal means of modelling and articulation. The method was ultimately derived from Roman architecture, where engaged columns, set against solid rectangular piers, were used in a wide variety of contexts. In superimposed rows, they can be seen around the outer walls of the Colosseum, as well as in numerous amphitheatres throughout the empire. In Roman buildings, however, engaged columns were governed by proportional rules, which were completely disregarded by medieval architects. In the hands of masons of the eleventh or twelfth century the shaft became an elastic feature, which could be enlarged or extended as required. In contrast to Roman practice, they were gathered together in well-ordered groups. Nowhere was the enthusiasm for shafts greater than in western France, a region in which masons indulged their passion for the feature by planting them in bundles at key points along the periphery of their buildings.

The most critical function of the engaged shaft was in the articulation of interior space. In many Romanesque churches, this task was performed by the pilaster, but the rounded shaft, providing a more sculptured effect, tended to become the preferred option. Often the two were combined, with the shaft laid against a flat pilaster or 'dosseret'. Thus at Santiago de Compostela or Vézelay [**101**, **114**], the interior is divided into bays by vertical lines of shafts, which emphasize the position of each of the piers. By linking together the various levels of the fabric, shafts brought unity and coherence to the composition, endowing the elevation with an element of three-dimensional modelling. Engaged shafts also transformed the simple square pier of earlier centuries into a highly articulated feature, creating what is generally known as the compound pier.[11] At Santiago a clear, but relatively simple version of this was adopted [**101**]. The main piers are basically square in plan, with an engaged shaft on each side. That facing the main space is extended up to the base of the vault where it supports a transverse arch. The two underneath the main arches support the inner order, and that facing the aisle corresponds to a transverse arch between each bay of groin vaulting. Thus each shaft was allotted its own specific task, and seen together they bring a visual coherence to the whole design. A note of subtlety, easily missed, was provided in the core of the piers, which have alternating square and rounded corners. In Normandy the approach to pier design was taken a stage further. In the choir at Lessay, for example, there are eight shafts grouped around the basic core, allowing both orders in the main arcade to be provided with shafts [**139**]. Despite this careful organization of the piers, there is one obvious weakness in the design. The ribs of the vault are left

139 Lessay (Manche), abbey church, interior of choir, c.1098

The compound piers were carefully designed to suit the elevation above, though no provision was made for the ribbed vault, which appears to have been an afterthought.

without a supporting element, being squeezed into an angle at the base of the clerestory, a solecism which suggests that ribbed vaults were not envisaged when the building was first laid out.[12] As in most Norman churches, the shafts at Lessay are arranged in a stepped formation, with the intermediate shafts set in re-entrant angles.

Compound piers of far greater complexity than those at Lessay were developed in England following the Norman Conquest of 1066: in the nave of Durham Cathedral the major piers have 12 shafts of varying diameters organized around a basic core, a design which helped to reduce the impact of what were in fact monumental supports, over eight feet in width [146]. The underlying principle of Romanesque pier design was the correspondence between the pier itself and the arches, walls, and vaults it supported. In theory this required forward planning, since the architect had to know in advance what the upper levels of the building were going to look like; in practice things did not always work out so smoothly.

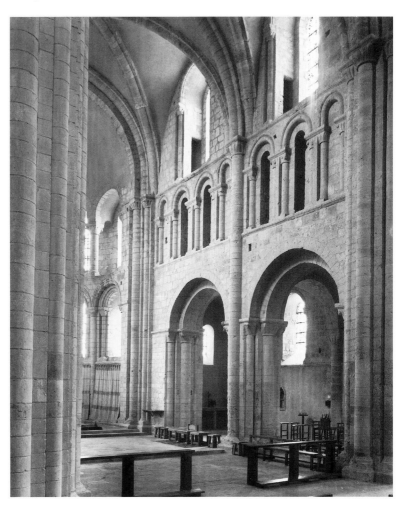

140 Saint-Savin-sur-
Gartempe (Vienne), nave,
c.1100

One of the most distinguished
'hall churches' of western
France, with a painted barrel
vault and tall cylindrical piers.
The unity of design was
compromised, however, by
the introduction of compound
piers and transverse arches
(seen in the foreground),
introduced as work proceeded
westwards.

The compound pier, with its many variants, was one of the most far-reaching innovations of the Romanesque era. But in many places there was considerable reluctance to abandon the traditional column, associated with the basilicas of the Early Christian period. In central and southern Italy the columnar basilica remained the basic building type [106], and even north of the Alps churchmen were slow to abandon this prestigious form. The abbey church at Limburg an der Hardt, for example, founded by the German emperor Conrad II in 1024, was constructed with a line of columns made of huge monoliths, great chunks of which still survive at the site. But monolithic columns were difficult to acquire and they could not sustain a heavy superstructure. It was virtually impossible to use them in buildings covered by stone vaults. One solution was to construct much thicker columns out of coursed masonry, in the form of giant cylinders, a type used sporadically in various parts of Europe. The nave of St Philibert at Tournus is built in this manner [90], so too a number of hall churches in western France, a group which includes Saint-Savin-sur-Gartempe, famous for its painted ceiling [140]. After the Norman Conquest, the cylindrical pier was introduced to England where it became one of the most characteristic features of English Romanesque, especially in the West Country. At Tewkesbury and Gloucester, vast circular piers dominate the interior of the nave, occupying over half the height of the elevation. Despite its historical and religious associations, the cylindrical pier had one aesthetic limitation: as an autonomous element, it was not easily combined with vertical wall shafts, which in turn made it difficult to link the various parts of the elevation. The column implied spatial continuity, whereas the compound pier allowed for vertical articulation.

To resolve this dilemma, various compromises were attempted. One solution involved the alternation of compound and cylindrical piers, so that a 'double-bay' system was created with major and minor piers.[13] An early example of this approach can be found at Jumièges (c.1040–67) [141]; in this case the major piers appear to have supported a 'diaphragm' arch across the nave, which accentuated the division of the space into four large compartments. A similar arrangement can be seen in Florence in the church of San Miniato al Monte (c.1062–90). The system adopted at Jumièges provided a prototype for Durham Cathedral, where alternation was carried out on a truly monumental scale [146]. Further south in East Anglia, architects experimented with alternation in a more subtle manner. At Ely, for example, hybrid 'minor' piers were designed, in which only part of the surface was curved [142]. These unorthodox shapes meant that every pier could be furnished with a shaft facing towards the nave, thus establishing a regular sequence of bays. Retaining a faint memory of the cylindrical pier (and, behind that, the tradition of the column), one wonders what twelfth-century spectators made of such subtleties. For modern ob-

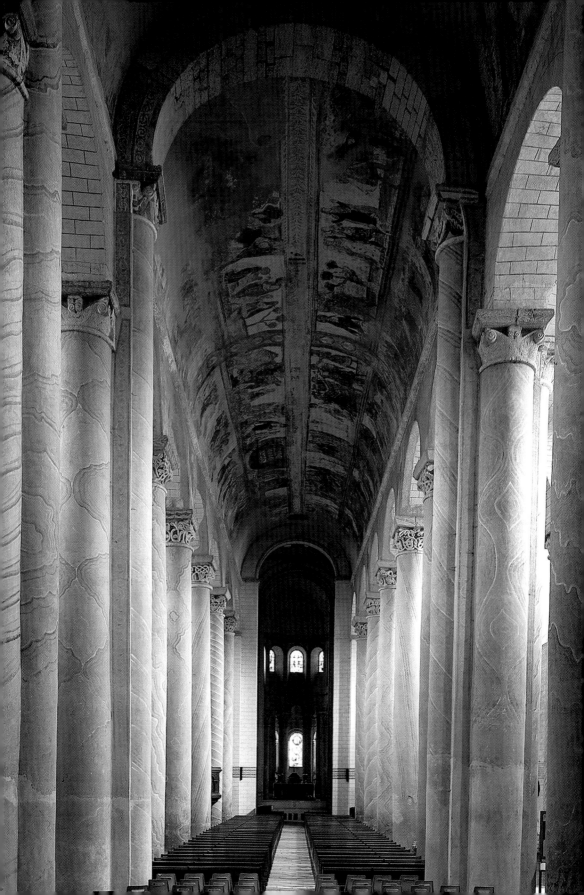

141 Jumièges (Seine-Maritime), abbey church, 1040–67, nave, looking west
Designed with an alternating system, so that the main piers corresponded with transverse arches (now destroyed). The relatively thin character of the walls did not allow for stone vaulting.

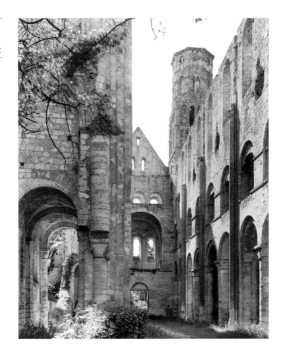

142 Ely Cathedral, nave, c.1110–50
Despite the regular sequence of vertical shafts, there is a sophisticated system of alternation, with the 'minor' piers suggesting a half-disguised column. The high gallery and passageways at clerestory level were characteristic of Romanesque architecture in eastern England.

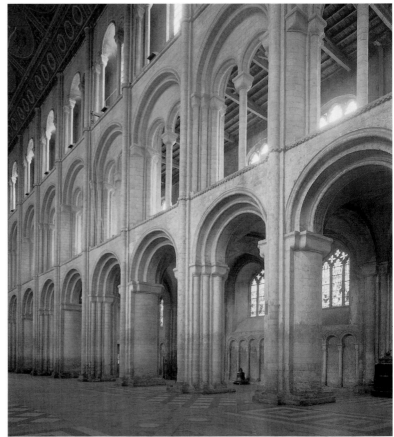

servers, they offer a useful reminder of the conflict that existed in Romanesque design between the column and the compound pier.[14] A more radical solution was the use of the 'giant order', in which a cylindrical pier rose unbroken through two storeys, as in St Frideswide's at Oxford [104], a solution which some authorities claim was inspired by descriptions in the treatise by the Roman author Vitruvius.[15]

In Germany and northern Italy, alternation was often combined with the deployment of stone vaults, constructed over double bays. In such cases the major piers had the more important supporting function, a point neatly expressed in the design. These double bays are usually square in plan, creating a slow but impressively weighty rhythm, a point evident in Saenredam's painting of the Mariakerk in Utrecht [92]. Following the example of Speyer Cathedral [148], many monuments along the Rhine adopted the double-bay system. The Cistercian abbey church at Eberbach is a good example, though the piers themselves were not differentiated except through the introduction of emphatic pilasters, which are corbelled off above the 'major' piers [119].

By the middle years of the twelfth century, Romanesque masons had learnt to embellish their buildings with all manner of applied ornament—zigzags, beads, billets, nail heads, cusps, fret patterns, 'beakheads', foliage, and numerous other motifs. In England chevron patterns—in dozens of different forms—were applied to arch mouldings in almost every conceivable context. Given the imaginative powers of Romanesque masons, sculptural ornament could easily have overwhelmed the buildings, but this was rarely allowed to happen. Ornament was normally carved on architectural components, reinforcing rather than obscuring the visual framework of the building. The architecture of the Romanesque era has been admired for many reasons—its monumentality, its rhythm, its sense of order—but its fundamental aesthetic quality lies in the fact that the architectonic framework was never subverted by decoration. Thus in the nave at Durham chevron patterns embellish not just the main arcades, but also the arches of the gallery and clerestory, as well as the ribs of the vault, highlighting the structural skeleton of the entire building [146]. Even at its most extravagant, Romanesque ornament was exploited with a discipline not far removed from the aesthetic concepts propounded by the scholars.

From time to time modern writers have questioned whether the notion of the 'Romanesque style' has any validity. So much variation exists between different regions in planning, structure, and sculptural embellishment, that it is easy to despair of finding any consistency. It is obvious, however, that architects in widely differing areas employed similar techniques to give expression to their buildings. Rather than insisting on Romanesque as a unified style, it is more useful to think of it in terms of a language, utilized by local masons according to their own traditions and aesthetic choices.

Diversity in the Romanesque Era

Near the Atlantic coast of France, between the river Charente and the estuary of the Gironde, almost every village seems to possess a Romanesque church, adorned with an exhilarating display of architectural ornament. Names such as Rioux, Rétaud, Corme-Écluse, Échillais, Marignac, Chadenac, or Échebrune are synonymous with Romanesque at its most sumptuous and baroque [**144**].[1] The Saintonge, as this area is generally known, was one of the most prosperous areas of Europe in the twelfth century, its wealth founded on wine production and the commercial potential of the Atlantic seaways. When it came to the design of churches, the local communities were much concerned with external display, revealing to everyone the prosperity and confidence which they felt at the time.

The churches of the Saintonge form a particularly eye-catching example of the steady expansion in church building which affected almost every corner of western Europe during the eleventh and twelfth centuries. By the year 1100 the quantity of building had reached a level which was unprecedented in the years after the fall of the Roman Empire. Cathedrals, great abbey churches, more modest priories, nunneries, parish churches, and manorial chapels all enjoyed the fruits of a great building boom. The main causes of this expansion are not difficult to identify: a greater level of political stability, rising populations, economic developments, particularly in agriculture, and the incentives provided by monastic and church reform. The passing of the year 1000 has traditionally (but perhaps mistakenly) been regarded as a symbolic turning point, when millennial fears were laid to rest and the future confronted in a more confident manner. This at least is the impression given by the oft-quoted statement of Raoul Glaber:

So on the threshold of the aforesaid thousandth year, some two or three years after it, it befell almost throughout the whole world, but especially in Italy and Gaul, that the fabrics of churches were rebuilt, although many of these were seemly and needed no such care; but every nation of Christendom rivalled

143 St Gilles (Bouches-du-Rhône), façade, mid-twelfth century

The detached columns, classical ornament, and sculptured friezes of this Provençal façade represent an explicit homage to the architecture of ancient Rome.

144 Chadenac (Charente-Maritime), parish church, mid-twelfth century

One of many churches in the Saintonge designed with sumptuous façades, based on the motif of the triple arch. The inscription commemorating William the structor is located around the corner to the right of the photograph.

with the other, which should worship in the seemliest buildings. So it was as though the very world had shaken herself and cast off her old age, and were clothing herself everywhere in a white garment of churches.[2]

Raoul Glaber was a well-travelled monk, in a good position to see what was going on. He was a member of the community of St Bénigne of Dijon at the time when the church there was rebuilt with a massive three-storey rotunda at its east end (1001–18) [**99**]. Whatever the significance of the year 1000, there is no doubt that the early decades of the eleventh century witnessed a substantial increase in architectural activity. The developments recorded by Glaber, however, were modest compared with what was to come a century later.

Romanesque is often regarded as a monastic style, in contrast to Gothic which is generally associated with cathedral building. This is a misleading assumption, for Romanesque architecture had an impact at all levels of society, from the humble parish church to the great cathedral. Many of the finest Romanesque monuments are in fact cathedral churches—Winchester and Durham [**146**, **156**], Speyer [**132**, **148**], and Mainz, Piacenza and Modena [**133**], to name just a few. While monasteries, particularly in France, provide some of the most photogenic buildings of the age, Romanesque was a universal style that affected castles and houses as well as churches. The distinction between prestigious monuments and small local buildings became less acute, with high-quality workmanship being found even in the humblest chapel. Romanesque was also universal in a geographic sense. The spread of the style coincided with the expansion of Christian Europe, a process advanced during the course of the eleventh and twelfth centuries through colonization, conquest, and church reform.[3] By 1200 the

authority of the Pope was acknowledged everywhere in the West; each country was organized into dioceses, parishes were being clearly defined, and the Roman liturgy was adopted universally. Vast regions of Scandinavia, for example, had been brought into the Christian fold, whilst in Spain Christian armies made deep inroads into territories controlled by Moslem rulers. The distribution of Romanesque architecture mirrors in quite a precise way this expansion of Latin Christendom. Thus, shortly after 1103 a Romanesque cathedral, in part modelled on those in the German Rhineland, was started at Lund, the seat of a new archbishopric for Scandinavia, and when work commenced in 1137 on the cathedral at Kirkwall in the Orkney islands, Romanesque had indeed reached the outer limits of Christian Europe.

The sheer quantity of monuments that survive from the Romanesque era presents problems for historians. There is so much diversity that it seems almost pointless to use the same stylistic label to cover everything. What for example does Durham Cathedral [146] have in common with the abbey church of St-Benoît-sur-Loire [145] or for that matter with Pisa Cathedral? In such circumstances it is difficult to discern any meaningful evolution which has validity for Europe as a whole. The nineteenth-century preoccupation with progress encouraged historians to see Romanesque as a prelude to the spectacular achievements of the Gothic style, with a consequent emphasis on structural matters, particularly the development of the stone vault. The problems of the 'evolutionary' approach are compounded by

145 St-Benoît-sur-Loire, choir, begun c.1080

Also known as Fleury, the church of St Benoît housed the relics of St Benedict, the father of western monasticism. The line of closely spaced columns reflected the tradition of the ancient Christian basilicas.

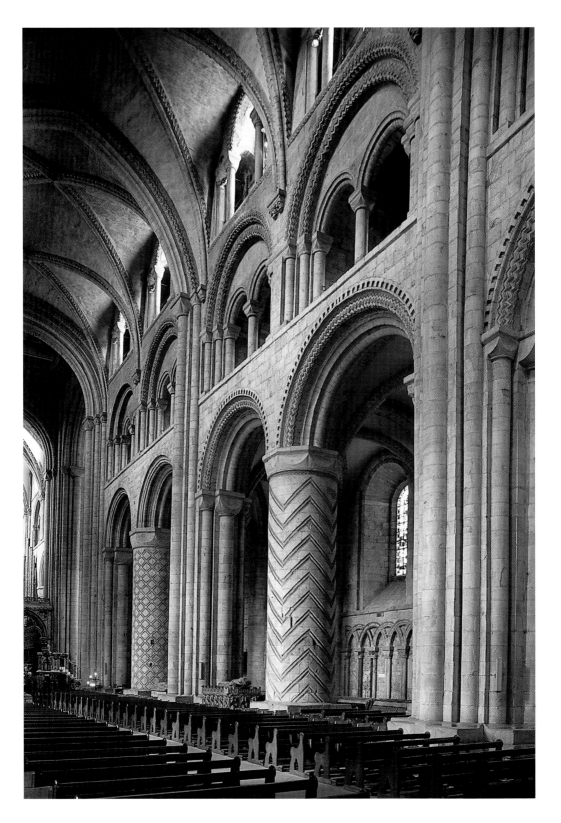

146 Durham Cathedral, nave, completed 1133

Clearly apparent is the monumental scale of the building, with its emphatic alternation of piers and ribbed vaulting. Note the slight change of design in the arches.

the fact that Romanesque did not develop in a single place or region, making it impossible to identify neat linear developments. Looking at major ecclesiastical workshops active in the year 1100 it is hard to identify much consistency, a point which becomes obvious when one examines four of the most ambitious projects of the time: the cathedrals of Speyer, Durham, and Santiago de Compostela, along with the abbey church of Cluny. All were started within a few years of each other, but they offered radically different approaches to the question of how to design a great Christian church. The plan of the liturgical choir differed in each case, though both Santiago and Cluny III made use of an ambulatory and radiating chapels [**100, 110**]. Two of the buildings had galleries (Santiago and Durham [**101, 146**]); the piers in one instance (Durham) alternated dramatically in form; in another case (Cluny) classical pilasters were given prominence. The main spaces in all four churches were covered by stone vaults, but in each building a different system was employed: pointed barrel vaults at Cluny III, semicircular barrel vaults at Santiago, groin vaults at Speyer, and ribbed vaults at Durham [**112, 101, 148, 146**]. In their choice of plan, structural system, and visual expression, the four buildings appear to offer more points of contrast than similarity; what, one wonders, did twelfth-century observers make of these disparities, assuming that they were aware of them?

Faced with questions of this sort, historians have preferred to approach Romanesque architecture as a series of regional styles, studying groups of monuments in a local context. While this approach is instructive, it is not without its limitations. In some cases the method has been taken to an extreme, with overly rigid attempts to classify buildings as if they belonged to botanical species. The study of French Romanesque has suffered in this regard, ever since Robert de Lasteyrie

147 Durham Cathedral

Plan of the church as it was in the twelfth century

Note the irregular spacing of piers in the transepts, which suggests that ribbed vaulting was not originally intended in this part of the building.

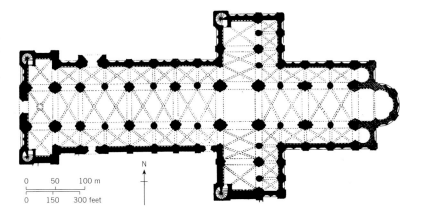

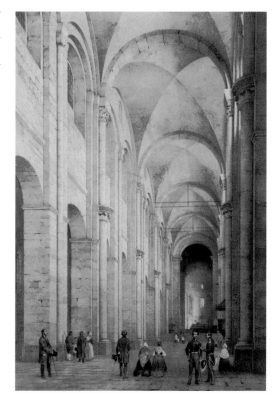

148 Speyer Cathedral, nave as remodelled c.1081–1106

Engraving by Von Bachelier (1844)

The use of plain groin vaults is one of several features which evoke the buildings of ancient Rome. Compared with Durham (**146**) the architecture is plain and prismatic.

in 1929 believed he could identify eight distinct 'regional schools'. Subsequent scholars attempted to refine the system with sub-groups and additional 'schools', imposing an artificial pattern on what are often very varied collections of buildings. The so-called 'schools' of French Romanesque are not as uniform as sometimes imagined, the boundaries between them are often ill-defined, and there are many exceptional buildings which do not fit comfortably into regional patterns. Even the use of the word 'school' implies a doctrinaire approach that is at odds with the flexibility and imagination evident in many Romanesque workshops. It is better to think in terms of local clusters, where some buildings (but not all) may share common characteristics. Nor did the architectural vitality of the various regions necessarily coincide in time: Norman architecture was most enterprising in the 50 years between 1030 and 1080, a period when other 'schools' had yet to develop. Lombard Romanesque reached a peak between 1080 and 1120, but it was not until the middle years of the twelfth century that the classically-inspired style of Provence began to flourish. As new workshops were opened, the emphasis could shift from one area to another, creating disjunctions in the overall picture of Romanesque. To gain a more exact impression of what occurred, it is important to examine a few regional groups in detail, beginning with the so-called school of the Auvergne in central France.

As a geographical term, the Auvergne covers a vast area of the Massif Central, but in the context of architecture its reputation depends on a handful of churches situated within a radius of 25 miles of Clermont-Ferrand, an area more accurately known as the Limagne. Several characteristics of the group are illustrated at St Saturnin [**149**]. This well-preserved church is surmounted by an octagonal crossing tower, supported on a curious 'haunch' or oblong block, which rises above the roofs of the choir and transepts. The exterior walls of the nave are furnished with arched recesses, surmounted by a blind arcade at the level of the gallery (a feature that was to reappear in exaggerated form in Apulia). The walls of the apse are decorated with discreet polychrome patterns, used more extravagantly in other churches of the group. The interior also contains distinctive features, not least an unusual treatment of the crossing, where diaphragm arches, pierced by open screens, reinforce the tower [**150**]. The elevation of the nave is divided into two storeys, a high arcade opening into the aisles, with a modest gallery above. A continuous barrel vault, lacking transverse arches, covers the main space and this is buttressed by quadrant vaults in the gallery, forming a solid structural system that has been compared to the formula used in the 'pilgrimage' churches at Conques, Toulouse, and Santiago de Compostela [**89a**]. The piers are curious in that they consist of a square core with engaged shafts on only three sides, that to-

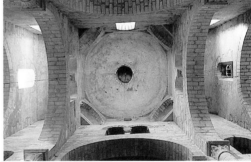

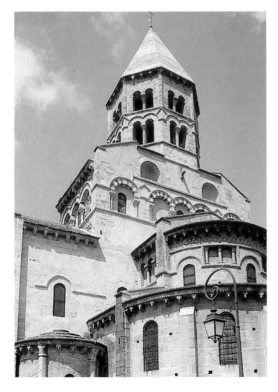

wards the nave being left blank. In all these respects St Saturnin is characteristic of the group. However, it lacks the radiating chapels found in the other buildings; nor does it have a western gallery opening into the church, as found for example at St Nectaire and Orcival.

The church at St Saturnin is thought to date from the first half of the twelfth century, and, compared with other French buildings of this time, it is robust rather than subtle in design. The bays of the nave are not accentuated and the unmoulded arcades provide a rather stark impression. But the critical question is why several churches in the locality adopted, with only minor variations, the same design. What associations did it have and what meaning did the scheme convey? What was the rationale behind the unusual buttressing of the tower? Why did the clergy need a western gallery and how was it used? Although most of the buildings were monastic, the same architectural formula was applied irrespective of the status of the church. In at least three cases (St Nectaire, Issoire, and Orcival) the buildings were the focus of local pilgrimage, a context in which the ambulatory layout was particularly appropriate. The more archaic features of the buildings are reminiscent of Carolingian architecture, not least the western gallery and the 'flying screens' at the crossing, which suggests that they were modelled on an ancient prototype; some authorities believe this was the old cathedral of Clermont-Ferrand, consecrated in 946. It is possible that the geographical isolation of the Limagne discouraged builders from looking at more recent models further afield. Whatever the explanation for the similarities, it is important to appreciate that this cluster of monuments was not typical of the Auvergne as a whole, where there was greater variation than is sometimes realized.[4]

In the Duchy of Burgundy, encouraged by the presence of Cluny and other wealthy monastic houses, the architectural workshops were more enterprising and varied. A conspicuous group of buildings was dependent on the design of Cluny III. Despite its exceptional scale, details of the interior elevation were repeated in an almost literal manner: tall arcades with pointed arches, compound piers with fluted pilasters, a blind triforium (rather than a gallery) decorated with distinctive cusped ornament, clerestory lighting, along with pointed barrel vaults over the main spaces [112]. The formula was reproduced precisely at Paray-le-Monial [113] and repeated with only minor modifications at Beaune and Autun. The size and character of the institution do not seem to have had a bearing on the matter: while Paray and Autun were both Cluniac houses, Beaune was a collegiate church. The classical features of Cluny III—the fluted pilasters and Corinthian capitals—added to the historical and political status of the great abbey, but these associations may have been lost in more modest buildings nearby. While the influence of Cluny demonstrates the impact that one illustrious model could exert in its own locality, alternative prototypes were

available, and it is wrong to suppose that all twelfth-century churches in Burgundy were clones of Cluny III. Builders and their patrons were prepared to make their own choices. Following the fire at Vézelay in 1120, for example, the abbot and his advisers ignored the Cluny formula, despite their allegiance to the Cluniac order, opting for a more traditional two-storey scheme, with groin vaults instead of pointed barrels [114].[5] The decision may have been affected by a desire to follow the broad lines of the building destroyed in 1120. There must have been many occasions when Romanesque design depended on the personal choice of an abbot or some other senior official; the diversity encountered in Burgundy merely underlines the lack of homogeneity that existed in most of the so-called regional 'schools'.

Regional distinctions are particularly acute in Italy. The rather dour monuments of Lombardy scarcely belong to the same world as the churches of Pisa or Lucca [135], with their scintillating displays of polished marble, and neither region has all that much in common with the Romanesque of Apulia. Separated by considerable distances, and with cultural distinctions sharper than any that existed in France, their lack of consistency is scarcely surprising. Apulia was a province of the Byzantine Empire until it was overrun by Norman knights during the course of the eleventh century (the Byzantines were finally driven out by Robert Guiscard in 1071). Its population was racially mixed, with Arabs, Greeks, Lombards, and Normans living beside each other in the towns and cities along the Adriatic coast, a cultural maelstrom that produced some interesting architectural results. This was a meeting point of East and West, where the traditions of the Byzantine and the Latin church confronted each other. There was a bishop in almost every town, each jealously guarding his rights and privileges, and keen to maintain his status. In fact Apulia had a greater concentration of cathedrals than anywhere else in Italy, and cathedral building dominates the architectural landscape.

One important element in Apulian architecture was the use of the dome, seen for example at Canosa Cathedral (c.1040), where a Latin-cross plan was covered by five domes on pendentives. The inspiration for this may ultimately lie in the church of the Holy Apostles in Constantinople, an appropriate model given that Canosa was built as a shrine for a local saint, Sabinus.[6] The cathedral combined the tradition of domed construction with the basilican plan, a solution favoured in a number of Apulian churches, as at Valenzano [151]. A later example can be found in the cathedral church of San Corrado, which dominates the harbour at Molfetta. The popularity of the dome may owe something to vernacular building, for Apulia is one of the areas of Europe where corbelled structures, known locally as *trulli*, have a long history.

An alternative approach to church architecture was offered by the wooden-roofed basilica, a tradition given a boost by San Nicola at Bari

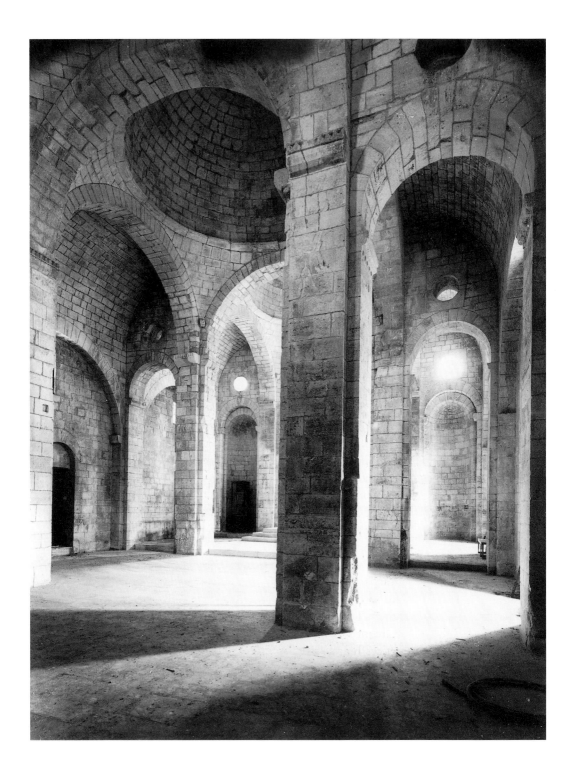

151 Valenzano (Apulia), church of the Ognissanti di Cuti, seen from the south aisle, c.1078–1100

The central nave, which is covered by a line of domes resting on pendentives, is buttressed by half-barrel vaults in the aisles.

(1087), which set the pattern for a number of local cathedrals. Although these buildings employed monolithic columns, like their Early Christian predecessors, they were taller in proportion and furnished with vaulted aisles and spacious galleries, innovations thought to derive from Lombardy or Emilia [106]. The most dramatic features of the 'Bari' group are the deeply-arched buttresses along the nave, and the arcaded galleries that surmount them, sumptuous examples of which can be found at Bitonto. Contrary to the prevailing impression, there is no evidence that the Norman aristocracy brought armies of masons with them from Normandy or other parts of France. Apulian architecture is grounded in local experience and customs, and ideas introduced from outside the region generally had their origin in Italy rather than further afield. One noticeable characteristic is the absence of a developed choir, a feature that Apulian buildings share with other Italian churches. In most cases a simple apse opened from the space of the transept or crossing [107], which meant that the liturgical choir had to be pushed well down the nave. The French system of an ambulatory with radiating chapels was employed on just two occasions, in the cathedral at Acerenza, a hill town to the west of Bari, and in the unfinished choir at Venosa [64]. The contrasts encountered in the south of Italy thus defy attempts at simple generalization: while the derivatives of San Nicola at Bari form an obvious group, there was no Apulian 'school' as such; rather, a number of alternative approaches, interacting in a subtle and intriguing way. Indeed, the numerous cathedrals of Apulia, many of them situated within a few miles of each other, provide a striking illustration of the degree to which local traditions and circumstances dictated the development of Romanesque. It was also an area in which Gothic architecture made very little impression, with Romanesque modes of construction surviving far into the thirteenth century, as at Trani, Ruvo, or Bitonto.

The increasing diversity of ecclesiastical architecture in the twelfth century came at a time when one might have expected the opposite, for there were many factors which encouraged uniformity within the Church. The assertion of Papal authority which followed the reforms of Gregory VII, combined with the replacement of local liturgical practices by the Latin rite, brought greater consistency to Christian observance. But this was not always matched by consistency in planning. The reorganization of the English dioceses after the conquest of 1066 provoked massive investment in cathedral building, without bringing any agreement in matters of layout. English Romanesque churches in fact display a range of variations (some of them quite bizarre) on two contrasting arrangements, the system of staggered apses and the ambulatory with radiating chapels. While the liturgical practices of the time called for certain general requirements—space for the choir stalls, a suitable range of chapels, and plenty of room for the

clergy to move around the church with dignity in processions—the precise arrangements were a matter of local choice.[7]

As well as church reform, there were other forces in society which might have brought greater architectural consistency, not least the fact that the upper echelons of society were now more mobile than at any point since the fall of the Roman Empire. Well-educated clerics could find jobs almost anywhere: Englishmen were employed at the court of Roger II in Sicily and many Frenchmen developed their careers in northern Spain.[8] The fact that the authority of the German emperors extended into much of northern Italy sustained continual diplomatic and administrative traffic across the Alpine passes. This was a cosmopolitan world in which the great men of the day spent a lot of time on the road. The church generated a huge amount of traffic. Rome was a centre for religious officials and pilgrims, and in spring and summer visitors descended on Santiago de Compostela like a tidal wave, combining their journey with visits to churches along the way. The monastic 'empires' of Cluny and Cîteaux encouraged further movement, as abbots and monks journeyed from house to house within their orders. Artists were likewise peripatetic, some travelling great distances to fulfil important commissions: masons from northern Italy were employed in Germany at Speyer and Quedlinburg, and a sculptor from central France produced some exquisite capitals at Nazareth in the Holy Land. In the twelfth century people with education or with artistic skills had plenty of opportunities to discover what was going on abroad and they must have been well informed about the architecture of other countries.

While mobility encouraged artistic interchange, it failed to bring uniformity of practice; if anything it seems to have intensified local identities, a point illustrated by the history of the Cistercian order. From the start, the Cistercians laid great stress on uniformity of observance, and their centralized system of government was designed to enforce it: 'unity of customs, of chants, of books; one charity, one Rule, one life'. As we have already seen, the monasteries of the order shared many common features, the most visible of which was the absence of painted and carved decoration. But despite the centralized organization, the vast majority of Cistercian buildings were built in the style of their own locality, albeit with a degree of austerity and restraint. Thus the design of the nave of the English abbey at Fountains is centred on massive cylindrical piers in the Anglo-Norman manner, and the arches they support are embellished with relatively complex mouldings. By the middle years of the twelfth century, the design of Cistercian buildings generally reflected current practices in the neighbourhood, a triumph for the forces of localism. What therefore were the factors which brought so much local diversity to the architecture of the Romanesque age?

The most commonly cited reason is the political fragmentation which followed the break-up of the Carolingian Empire. Following the onslaught of the Vikings, Arabs, and Magyars, power descended to a local level, leading to the creation of separate territorial principalities. The process was particularly marked in France, which remained a patchwork of independent duchies and local lordships until the reign of Philip Augustus (1180–1220). Although many of the great magnates technically paid homage to the crown for their fiefs, the actual influence of the Capetian kings was very limited. As well as the great duchies of Normandy, Aquitaine, and Burgundy, there were many smaller lordships or counties such as Anjou, Blois, Nevers, Auvergne, or Toulouse. In some cases the boundaries were based on ethnic or geographical divisions, but there was also a major linguistic difference between north and south, the territories of *Langue d'oil* and *Langue d'oc* (the words used for 'yes'). Whereas the north of France was heavily feudalized, in the south there was a more fluid society, with its own distinctive culture and customs. This was the area from which the poetry of the troubadours and the cult of 'courtly love' were to emerge at the close of the eleventh century. Regional variations in architecture, it might be supposed, were merely a reflection of these political and cultural distinctions. It is significant that the architectural variations are not so acute in Germany, where the emperors had more authority over the five main principalities.

In Normandy there was a particularly close correlation between architecture and political power. Under the direction of a series of energetic and ruthless dukes—Richard II (996–1026), Robert I (1027–35), and his bastard son William the Conqueror (1035–87)—the duchy emerged as one of the most dynamic and forceful principalities in Europe, with 'a new aristocracy, a new Church, a new monasticism and a new culture'.[9] In the year 1000 there were only 5 monasteries in the duchy; by 1066 there were over 30, several of them founded by the dukes or members of their families. Norman monasticism was dominated by the customs of Cluny, which had been introduced at Fécamp in 1001 by the Italian abbot, William of Volpiano, one of many foreigners drawn to the region. The school at the abbey of Bec attracted scholars from all over Europe, and these included two of the best intellects of the age, Lanfranc and Anselm. By the second half of the eleventh century much of the wealth of the Norman Church was being invested in architecture, producing a series of monumental and ambitious buildings in such places as Jumièges, Rouen, Bernay, Mont-St-Michel, and Caen.

Norman Romanesque was far from homogeneous, though there are a number of features which set it apart.[10] Most of the buildings were designed with aisled choirs, often with staggered apses at the east end, as at La Trinité at Caen. On the exterior an imposing tone was set by the square 'lantern' towers erected over the crossing. The interior space

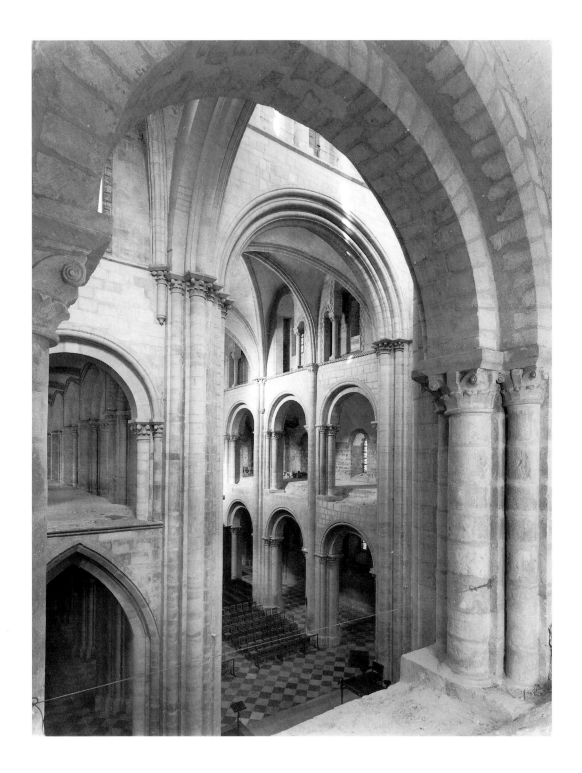

152 Caen, St Etienne, built c.1060–77, view from the south transept looking west along the nave

The abbey was founded by William the Conqueror. The high gallery and clerestory wall passages were among many Norman features subsequently copied in England. The clerestory was remodelled and the vaults added in c.1130.

was robustly articulated through the use of engaged shafts. Even parish churches, like that of St Nicholas, in the suburbs of Caen, were provided with three-storey elevations, the middle storey designed either as a gallery or with some form of triforium. Compound piers supported walls of great thickness, which at clerestory level allowed the construction of 'hollow-wall passages', one of the most attractive innovations of Norman Romanesque. The outstanding monument is the abbey church of St Etienne in Caen [152], founded by William the Conqueror in about 1060, its dour west façade a reminder of the ruthless efficiency that brought its founder so much success. The background of Norman architecture is difficult to define. It included an important substratum of Carolingian ideas, reflected in the 'westwork' at Jumièges [23],[11] but Norman architects were aware of contemporary developments in the Loire valley, as well as further afield in Ottonian Germany and Northern Italy. The success of the Norman dukes in attracting talent from abroad evidently extended to the building yards.

Normandy thus provides an example in which the development of a local 'school' of Romanesque coincided with the rise of a well-organized principality. But it was a rather exceptional case and in other parts of Europe the link between architecture and political boundaries was not so exact. The vast duchy of Aquitaine, for example, was composed of a disparate collection of counties and lordships with diverse architectural traditions: domed churches centred on the Périgord, for example, and hall churches with barrel vaults in the region of Poitou.

153 Fontevrault (Maine-et-Loire), nave of the abbey church, begun c.1120

During construction the original design for the nave, which incorporated aisles, was replaced by a single space covered with domes. The latter were rebuilt in c.1910.

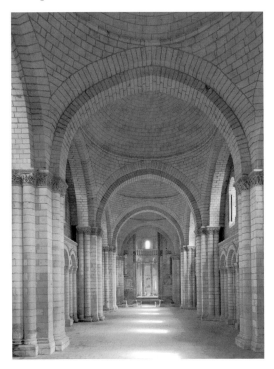

154 Fontevrault (Maine-et-
Loire), abbey church

Plan

There is an obvious
discrepancy between the
aisled choir, consecrated in
1119, and the domed nave
erected later.

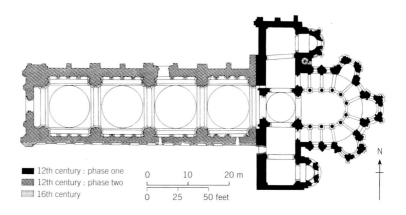

■ 12th century : phase one
▨ 12th century : phase two
▤ 16th century

0 10 20 m

0 25 50 feet

N

The domed churches are concentrated in a band stretching from
Rodez to Saintes, a geographical distribution which is not related to
any political entity. There are many outliers, including one as far north
as the Loire valley: this is the church of the double monastery at
Fontevrault, founded by Robert d'Arbrissal in 1100 [**153, 154**].
Although designed as a three-aisled structure, at some point after the
consecration of the choir in 1119 a decision was made to cover the nave
as a single space with a series of domes (a similar change of design took
place in the church of Notre Dame in Saintes).[12] While the frag-
mented politics of Europe undoubtedly contributed to the diversity of
Romanesque, there were many other factors involved, not least the
power of local tradition and the survival of distinguished buildings
from the past.

The presence of Roman monuments fostered a distinctive brand of
Romanesque in Provence, an area which in the twelfth century was di-
vided between the counts of Toulouse and the counts of Barcelona.
Provençal churches have a number of memorable features: walls and
piers tend to be articulated through sharply-defined pilasters, rather
than engaged shafts; the interiors are frequently dark and covered by
pointed barrel vaults, the latter buttressed by quadrant vaults over high,
narrow aisles.[13] This is the system found at Vaison and at St Trophime
at Arles [**89d**] and it was repeated by the Cistercians at Le Thoronet
[**120**] and Sénanque. The Cistercians did not, however, copy the most
conspicuous feature of Provençal design, the taste for classical details.
Corinthian capitals, classical pediments, fluted pilasters, acanthus fo-
liage, egg and dart motifs, sculptured friezes, and detached columns
were reproduced so accurately that it is sometimes hard to believe they
belong to the twelfth century. The façade of the abbey church of St-
Gilles, one of the great pilgrimage centres of the south of France, is
composed like a series of triumphal arches, evoking the spirit though
not the rigour of Roman architecture [**143**]. Classical elements were
treated as decorative features, often in unexpected or incongruous con-

texts, as in the façade of the tiny church of St Gabriel near Arles. Provence had formed part of the Roman province of Gallia Narbonensis and the monuments of Antiquity must have excited the admiration of medieval observers as much as they do today. But there were other regions of Europe that retained equally splendid examples of Roman architecture—Lombardy for instance—where the medieval builders showed little interest in the classical past. Perhaps it was the abundant supplies of good freestone that encouraged Provençal masons and their patrons to emulate their Roman forbears.

In some areas geological conditions added to the diversity of twelfth-century building. The ornate churches of the Saintonge, for example, could not have been created without a ready supply of easily-worked limestone and the colourful façades of Tuscan churches depended on the availability of marble, much of it recycled from Roman monuments. Local masons were adept at handling this material, which they used to good effect on the arcaded façades of buildings in Pisa, Lucca [135], and Pistoia. Columns were given exotic twists, some were even knotted, tricks that would have lost their impact had they been carried out in a plain freestone. Geological factors, however, were not necessarily decisive. If local supplies were inadequate or unsuitable, stone could be transported from distant quarries, as was the case in England after the Norman Conquest, when vast consignments of Caen stone were shipped to workshops along the south and east coasts. Canterbury and Norwich were among the cathedrals which made use of the imported material.

Regional identities were frequently established through the prestige of one particular monument that served as a model for the neighbourhood. Cluny III is an obvious example, so too the church of San Nicola at Bari. In the north of Britain the impact of Durham is very obvious, its influence reflected in the taste for giant cylindrical piers, decorated with incised patterns [63, 146].[14] Durham, San Nicola at Bari, and Cluny III were innovative buildings that established new modes of design. In some cases the original model or *exemplum* remains unknown, as with the domed churches of the Périgord. The construction of the first dome must have been a dramatic moment, but scholars are still undecided as to where and when this occurred. Romanesque architecture was thus based on a patchwork of 'privileged centres', wealthy foundations from which influence radiated into the immediate neighbourhood. Such workshops provided concentrations of expertise, where masons acquired the knowledge and experience that was subsequently applied to other projects in the locality.[15]

It is rarely possible to uncover the personal factors that lay behind the choice of designs or indeed the selection of specific master masons. Accidents, chance meetings, the whims of a patron, family connections—all on occasions played their part. It is easy to forget that me-

dieval buildings were not the result of some preordained process, but the consequence of individuals expressing their own views and preferences, sometimes with vehement disagreements. One gets a glimpse of this at Canterbury after the fire of 1174, as the monks argued about what to do with their ruined church, having received conflicting advice from the experts they had called together. Personal interventions could be crucial, as at Ely, where the abbey church was rebuilt following the arrival of Abbot Simeon in 1081. This is an instructive example, since the design of Ely helped to determine the future of Romanesque in East Anglia. It was here that the fashion for dividing the elevation into three approximately equal storeys was established, with spacious, well-lit galleries and tall clerestories, the latter designed with wall passages in the Anglo-Norman manner [**142, 155**]. Compound piers of great complexity became a feature of the region, some of them ingeniously designed to provide a hint of a circular pier. There is a strong emphasis on bay division, with engaged shafts rising to the full height of the building. Abbot Simeon deserves some of the credit for these developments. The principal source of the design at Ely is to be found at Winchester [**156**], where Simeon had previously been prior and where his brother Walkelin was bishop. Simeon and Walkelin came from Normandy (in fact they were relatives of William the Conqueror) and the eleventh-century cathedral at Winchester was modelled on buildings in the duchy. The career of Abbot Simeon, as he moved from Normandy to Winchester and then to Ely, was to some extent mirrored in the buildings with which he was associated.

155 Ely Cathedral, begun c.1081–3, north transept

The main lines of the composition were derived from Winchester (**156**), where Abbot Simeon's brother served as bishop. Note the subtle developments in design at gallery level. The scheme was further refined in the nave (**142**).

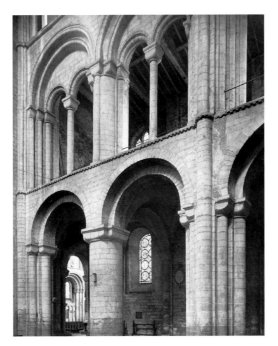

**156 Winchester Cathedral,
begun 1079, south transept**

Engraving by John Britton

The Norman cathedral at
Winchester was designed on a
gigantic scale, but only the
transepts, crossing tower, and
crypt survive intact from the
Romanesque era. Features
derived from Normandy
include the high gallery and
clerestory passages (compare
152), as well as the 'platform'
linking the two sides of the
transept.

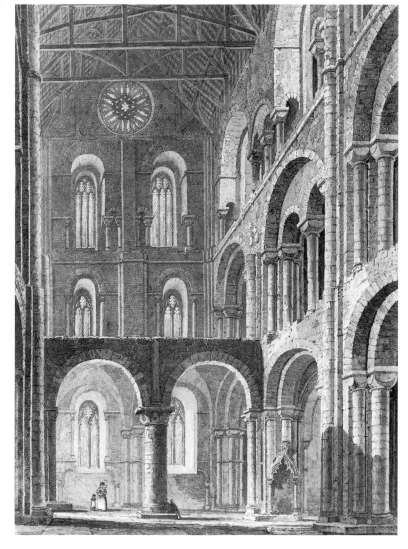

In the last resort, the diversity encountered in Romanesque has much to do with developments in architecture itself. This was an experimental era, which coincided with the arrival of new structural methods, and which brought a vast expansion in the way that architects gave expression to their buildings, through the use of engaged shafts, mouldings, and decorative sculpture. A master mason of the twelfth century had far more options than his counterpart two or three centuries earlier. While political fragmentation, local traditions, personal choice, and geographical and geological conditions each contributed to the architectural diversity of the era, there were other potent factors at work, not least the scope offered by aesthetic and structural innovations, combined with the increasing affluence and confidence of the age.

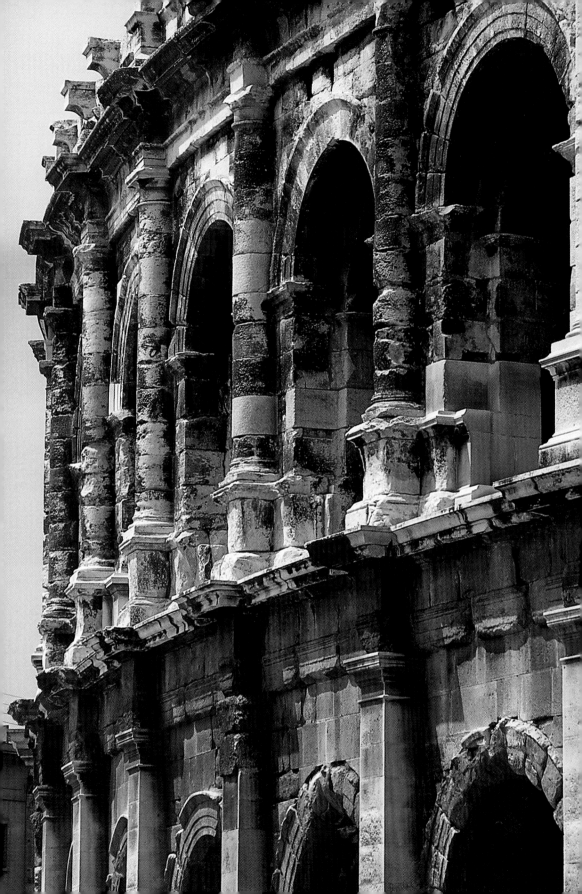

Epilogue: The Shadow of Rome

The architecture of the early Middle Ages was shaped by a range of different factors—changes in the nature of Christian worship, the fragmentation of political power, political ideologies, economic fluctuations, shifts in aesthetic sensibilities, improvements in the professional skills available to patrons, to name just a few. There were also external influences, especially from the East, from the Holy Land and the Byzantine world. In addition there were contacts with Islam, though these affected architecture less than sculpture and the decorative arts. But a more pervasive influence was the heritage of Rome, which cast a persistent shadow over building activities in the West. During the early Middle Ages the monuments of classical Antiquity were far more prominent in the landscape than they are today, and for many observers the abandoned temples, amphitheatres, bath houses, and mausolea evoked feelings of nostalgia and awe. In the seventh century, St Cuthbert was given a tour of the monuments of Carlisle, 'built in a wonderful manner by the Romans', and the same spirit of admiration is found a century later in the famous Anglo-Saxon poem *The Ruin*, thought to be a description of the city of Bath: 'Wondrous is this wall-stone; broken by fate, the castles have decayed; the work of giants is crumbling'.[1]

Although the admiration for Roman monuments remained constant throughout the period, the willingness and capacity of builders to exploit this interest fluctuated considerably. During the 'sub-Antique' period, following the collapse of the Roman Empire in the West, the decline in both skills and resources made it increasingly difficult to emulate classical architecture, especially after the mid-sixth century. This was an era of simplification, when even the act of building in stone could be taken as a sign of *Romanitas*. But with the Carolingian Renaissance came a renewed and deeper interest in the buildings of the past, albeit inspired by political and ideological factors rather than aesthetic considerations. At this time it was the buildings of the Early Christian era, not those of pagan Rome, that exercised the most influ-

157 The Roman amphitheatre at Nîmes, late 1st century AD

The system of engaged columns or shafts, used to articulate the design of the amphitheatre, was revived by Romanesque architects in the eleventh century.

ence. This changed with the advent of the Romanesque style in the eleventh century, when builders drew on a wider range of Roman techniques, derived from pagan and Christian monuments. So abundant were the links with Antiquity, especially in Italy and southern France [143], that scholars have come to speak in terms of a proto-Renaissance.

One fundamental question is the extent to which methods of construction survived unbroken from the Roman era. There is some evidence that proportional systems, especially those involving the square root of two, remained in use throughout the period, and a knowledge of how to build small-scale vaults was also retained. But much had to be relearnt. There were a number of avenues through which a greater understanding of Roman architecture might have filtered into the building yards. First, there were the *Ten Books of Architecture* by the Roman author Vitruvius, copies of which survived in monastic libraries. But the extent to which the text was read and understood by those actually involved in building is an open question. Occasionally one encounters hints of the *Ten Books*, as with the giant order of Oxford St Frideswide's [104] or the fact that two of the cylindrical piers at Durham have 24 vertical flutes, exactly as Vitruvius prescribed when describing Ionic.[2] More important than Vitruvius, however, were visits to monuments in Rome and the excitement they engendered. This is well reflected in the famous poem *Par tibi Roma nihil* by the twelfth-century archbishop of Tours, Hildebert of Lavardin:

> Nothing can equal Rome, even Rome in ruins.
> Your ruins themselves speak even louder than your former greatness.[3]

In the middle years of the twelfth century an Englishman, Master Gregory, was spellbound by what he saw in the ancient capital.[4] He was deeply impressed by the Baths of Diocletian, explaining that he could not do justice in writing to 'their ample dimensions and superb proportions'; the columns were so tall that 'their summits were beyond a pebble's throw'. But did such visits really affect the design of new buildings? Without sketches and drawings it must have been hard to convey architectural compositions in any coherent manner. Patrons were usually more interested in acquiring materials than in borrowing complete designs. Significantly, Master Gregory measured a number of monuments, dimensions being one of the few things that could be conveyed without difficulty from site to site. Thus measurements derived from St Peter's in Rome were exploited in monuments north of the Alps, including that of Durham Cathedral. But an even better way to understand classical buildings was to dismantle them. Throughout the early Middle Ages builders foraged in the ruins, and the reuse of classical components must surely have helped masons to appreciate

such features as the engaged column or the Corinthian capital.

Although Romanesque masons took much of their architectural vocabulary from Antiquity—columns, capitals, arches, stone vaults, engaged shafts—they deployed them in a way that was quite unclassical. Roman monuments provided a stock of forms which were exploited as the need arose, a process of selective pickings. Apart from the retention of the traditional basilica, particularly in central Italy, complete designs were rarely copied. The nearest one gets to such an approach occurs in the triforium at Cluny III [112], which is uncannily reminiscent of that found on a Roman gateway at Autun, or the series of circular towers in France and Spain which have been compared with Antique mausolea [80]. For the most part Roman techniques were used with freedom and imagination, and were often combined with non-classical elements, like the Islamic-flavoured cusps which found their way into the triforium of Cluny III. Thus the Romanesque style did not constitute a renaissance of Rome: it was a new style created out of a vocabulary inherited from the past. Builders displayed little interest in the principles of classical architecture, merely looking to ancient monuments to solve their own practical problems. There were, admittedly, occasions when Roman features were employed in a more self-conscious manner for reasons of status and symbolism; the desire by ambitious patrons like Angilbert of St Riquier or Abbot Suger of St Denis to obtain authentic Roman material is one clear reflection of this. More bizarre is the flagrant reuse, especially in Italian churches, of stones carved with Roman inscriptions, which were set upside down or on their side, and displayed like trophies from a bygone age. Thus at Pisa and Modena the fabric of Christian buildings came to be embellished with references to pagan emperors, one of many anomalies that underline the complexity of the relationship that existed between the architecture of Antiquity and that of the early Middle Ages.

Notes

Chapter 1. The Christian Basilica

1. The modern concrete lattices are modelled on fragments of the original stucco found during the restoration of 1914–19, R. Krautheimer, *Corpus Basilicarum Christianarum Romae*, IV (Rome, Vatican City, and New York, 1970), 72–98.

2. C. Coüasnon, *The Church of the Holy Sepulchre in Jerusalem* (Oxford, 1974), 43.

3. C. Davis-Weyer, *Early Medieval Art 300–1150* (Englewood Cliffs, 1971), 11–13.

4. Coüasnon, *Church of the Holy Sepulchre*, 41–6; R. Krautheimer, *Early Christian and Byzantine Architecture* (Harmondsworth, 1986), 61–3. Although part of the west end has been uncovered by excavation, it is uncertain whether the basilica terminated in an apse or in something closer to a rotunda, as Krautheimer supposed.

5. Krautheimer, *Early Christian and Byzantine Architecture*, 458, n. 6.

6. *Eusebius, The History of the Church from Christ to Constantine*, trans. G. A. Williamson (Harmondsworth, 1965), 393–4.

7. Krautheimer, *Corpus*, V, 43–4.

8. E. Gibbon, *The History of the Decline and Fall of the Roman Empire*, ch. 28.

9. Krautheimer, *Corpus* III, 277–302; R. Krautheimer, *Rome: Profile of a City, 312–1308* (Princeton, 1980), 39, 71–2.

10. Krautheimer, *Corpus*, V, 1–92.

11. Krautheimer, 'The building inscriptions and the date of construction of old St Peter's: A reconsideration', *Römisches Jahrbuch für Kunstgeschichte*, 25 (1989), 3–23.

12. P. Brown, *The Cult of the Saints, Its Rise and Function in Early Christianity* (London and Chicago, 1981), 36.

13. *Eusebius, History of the Church*, 393.

14. Although defined as cemetery churches by Richard Krautheimer, the German scholar F. W. Deichmann has argued that these buildings were intended as regular churches, F. W. Deichmann, 'Märtyrerbasilika, Märtyrion, Memoria und Altargrab', *Mitteilungen des Deutschen Archäologischen Instituts, Römische Abteilung*, 77 (1970), 144–69.

15. C. Heitz, *La France Pré-Romane* (Paris, n.

d.), 23–5, 92–5, 123.

16. J. Fontaine, *L'Art Pré-Roman Hispanique* (La-Pierre-qui-vire, 1973), 55–8.

17. William of Malmesbury, *Gesta Pontificum* (Rolls Series), 255. Wilfrid's biographer and admirer, Eddius Stephanus, claimed that he had not heard of 'any other house on this side of the Alps built on such a scale'.

18. This view has been rejected by R. N. Bailey, 'Seventh-century work at Ripon and Hexham' in T. Tatton-Brown and J. Munby (eds), *The Archaeology of Cathedrals* (Oxford University Committee for Archaeology, 1996), 9–18.

Chapter 2. The Carolingian Renaissance: The Basilica Transformed

1. It has been estimated that between 768 and 855 some 420 monasteries were constructed or reconstructed within the Carolingian realms, C. Heitz, *L'architecture religieuse carolingienne, les formes et leur fonctions* (Paris, 1980), 6.

2. *Einhard and Notker the Stammerer, Two Lives of Charlemagne*, (ed.) L. Thorpe (London, 1969), 71.

3. S. McK. Crosby, *The Royal Abbey of Saint Denis* (London and New Haven, 1987), 51–83.

4. C. MacLendon in the *Macmillan Dictionary of Art*, 'Carolingian Art, II, Architecture' (London, 1996), suggests that the Carolingian church at Hersfeld had segmented rather than continuous transepts. Other Carolingian examples of the continuous transept included the Abdinghof church at Paderborn (*c.* 836), Regensburg (St Emmeram), Fulda, and possibly St Denis.

5. Heitz, *L'architecture carolingienne*, 161.

6. D. Parsons, 'The Pre-Romanesque church of St Riquier', *The Journal of the British Archaeological Association*, 130 (1977), 21–55. The triple-storeyed lanterns were presumably made of wood.

7. Although some features of the drawing have been confirmed by the excavations of H. Bernard, the ancient drawing does not illustrate a courtyard, measuring approximately 40 metres in length, which was located between the church and the great court, Heitz, *L'architecture carolingienne*, 238, n. 7.

8. H. Thümmler, 'Carolingian Period', *Encyclopedia of World Art* III (New York, London, and Toronto, 1960), 90.

9. H. Reinhardt, *La Cathédrale de Reims* (Paris, 1963), 35, 225n. Carol Heitz has pointed out that Carolingian ivory carvings depict the Holy Sepulchre in Jerusalem in the form of multi-storey towers, the designs of which can be compared with westworks. He argued that in the eyes of the Carolingian clergy the westwork was nothing less than a monumental image of the tomb of Christ, C. Heitz, 'The iconography of architectural form' in L. A. S. Butler and R. K. Morris (eds), *The Anglo-Saxon Church* (London, Council for British Archaeology, 1986), 90–100.

10. Although twin towers were employed at an earlier age in the East (in Greece and Syria, for example), as well as in Italy (Ravenna), the twin-towered façade in the West appears to owe more to the Carolingian westwork, despite the views of H. Schaeffer, 'The origin of the two-tower façade in Romanesque architecture', *Art Bulletin*, 27 (1945), 85–108.

11. A. Klukas, *Altaria Superioria: The Function and Significance of the Tribune Chapel in Anglo-Norman Romanesque* (Ann Arbor, 1979), 70.

12. The origin of this alternating system remains obscure. In the late fifth century something similar had been seen at Salonika (Hagios Demetrios) and there may have been equivalent examples in the West. On a miniature scale alternation can be found in ivory carving, suggesting that the arrangement appealed to tenth-century taste.

13. The 'square schematism' of St Michael's at Hildesheim is not in fact geometrically exact. The approach, with the square of the crossing repeated for each transept, was foreshadowed in Carolingian churches, as at Reichenau (Mittelzell), Seligenstadt (Hesse), Inden-Kornelmünster (North Rhine-Westphalia), and on the St Gall plan.

Chapter 3. Symbolic Architecture

1. Romans 6: 3–4; Colossians 2: 12.

2. The water basin at the Lateran was inscribed with verses, one of which (in translation) ran: 'This is the fountain of life which purges the whole world, taking its course from the wound of Christ', P. A. Underwood, 'The Fountain of Life in manuscripts of the Gospels', *Dumbarton Oaks papers*, 5 (1950), 55.

3. Revelation 22: 1. There are four depictions of a baptistery in Carolingian gospel books, Underwood, 'The Fountain of Life', 41–138.

4. Some scholars believe the Rotunda was built soon after 325: for a review of the arguments see J. Wilkinson, *Egeria's Travels* (London, 1971), 40–6, 164–171.

5. Krautheimer, *Early Christian and Byzantine Architecture*, 81

6. Not all scholars accept that San Vitale was the principal source, G. Bandmann, 'Die Vorbilder der Aachener Pfalzkapelle' in *Karl der Grosse, Lebenswerk und Nachleben, III, Karolingische Kunst*, ed. W. Braunfels and H. Schnitzler (1966), 424–62. The audience hall of the Byzantine emperors in Constantinople, the Chrysotriclinion, along with Constantine's Golden Octagon at Antioch have been cited among the potential sources.

7. Loosely translated from the Latin it reads: 'When the living stones are assembled harmoniously, and the numbers coincide in an equal manner, then rises resplendently the work of the Lord who has constructed the entire hall', Heitz, *La France Pré-Romane*, 146.

8. Heitz, *L'Architecture carolingienne*, 74.

9. R. Will, *Alsace Romane* (La-Pierre-qui-vire, 1970), 47–9. At Ottmarsheim the outer wall was octagonal, rather than 16-sided as at Aachen.

10. H. J. Böker, 'The Bishop's Chapel of Hereford Cathedral and the question of architectural copies in the Middle Ages', *Gesta*, 37 (1998), 44-54. This controversial article cites the extensive literature associated with the Hereford Chapel.

11. The church is known only from excavations, L. Grodecki, *L'architecture ottonienne* (Paris, 1958), 160–1. Meinwerk's emissary in the Holy Land was Wino, abbot of Helmarshausen, who returned from the East in 1033.

12. R. Krautheimer, 'Introduction to an "Iconography of Medieval Architecture"', *Journal of the Warburg and Courtauld Institutes*, V (1942), 1–33, reprinted in *Studies in Early Christian, Medieval and Renaissance Art* (London, 1971).

13. R. G. Ousterhout, 'The Church of Santo Stefano: A "Jerusalem" in Bologna', *Gesta*, 20 (1981), 311–21.

14. La Vera Cruz has been attributed to the Knights Templars, L. M. de Logendio and A. Rodriguez, *Castille romane*, II (La-Pierre-qui-vire, 1966), 249–54. For their headquarters in Jerusalem the Knights acquired the mosque of Omar, which, as a dodecagon, may have had some bearing on the design.

15. A. Anker and A. Andersson, *The Art of Scandinavia*, vol. II (London, 1970), 141–7. It is difficult to accept the assertion that the hollow pier is 'simply an architectural solution to the problem of vaulting' (Anker, 144).

Chapter 4. Secular Architecture in the Age of Feudalism

1. R. A. Brown, *English Castles* (London, 1970), 22.

2. A. Canellas-Lòpez and A. San Vicente, *Aragon roman* (La-Pierre-qui-vire, 1971), 193–226.

3. R. A. Brown, *Castle Rising* (London, Department of the Environment, 1978), 11.

4. J. Mesqui, *Châteaux et enceintes de la France médiévale*, I (Paris, 1991), 94.

5. P. Dixon and P. Marshall, 'The great tower at Hedingham castle: a reassessment', *Fortress*, 18 (1993), 16–23.

6. Brown, *English Castles*, 36.

7. Mesqui, *Châteaux et enceintes de la France médiévale*, I, 116–7.

8. Brown, *English Castles*, 30.

9. E. Impey, E. Lorans and J. Mesqui, *Deux Donjons Construits autour de l'an mil en Touraine, Langeais et Loches* (Paris, Société Française d'Archéologie, 1998).

10. D. F. Renn, 'The Anglo-Norman Keep, 1066–1138', *Journal of the British Archaeological Association*, 3rd ser. XXII (1960), 1–23.

11. H. M. Colvin, A. J. Taylor, and R. A. Brown, *A History of the King's Works* (London, 1963), 73–5, 630–2.

12. For the dendrochronological evidence see T. Condit, 'Rings of truth at Trim Castle, Co. Meath', *Archaeology Ireland*, 37 (1996), 30–3.

13. J. Mesqui, *Châteaux et enceintes de la France médiévale*, II, (Paris, 1993), 7.

14. Gerald of Wales, *The Journey Through Wales, The Description of Wales*, ed. L. Thorpe (Harmondsworth, 1978), 150.

15. Davis-Weyer, *Early Medieval Art 300–1150*, 84–8.

16. *Beowulf*, trans. M. Alexander (Harmondsworth, 1973), *passim*.

17. As cited by T. A. Heslop, *Norwich Castle Keep* (Norwich, 1994), 65.

18. G. H. Orpen, *Ireland Under the Normans 1169–1216* (Oxford, 1911), I, 267; Mesqui, J., *Châteaux et enceintes de la France médiévale*, II, 7.

Chapter 5. Patron and Builder

1. R. Oursel, *Invention de l'architecture romane* (La-Pierre-qui-vire, 1970), 28.

2. N. Pevsner, 'The term "Architect" in the Middle Ages', *Speculum* 17, No. 4, 1942, 549–62.

3. Davis-Weyer, *Early Medieval Art*, 135–41.

4. *Ibid.*, 122–3.

5. L. F. Salzman, *Building in England down to 1540* (Oxford, 1967), 2.

6. R. Stevick, 'Page design of some illuminations in the Book of Kells', in F. O'Mahony (ed.), *The Book of Kells, Proceedings of a conference at Trinity College Dublin 6–9 September 1992* (Aldershot, 1994), 243–56.

7. V. Mortet, *Recueil de Textes relatifs à l'histoire de l'architecture et à la condition des architectes en France au moyen âge XIe–XIIe siècles* (Paris, 1911), 292–4.

8. Bernard of Clairvaux, *The Life and Death of Saint Malachy the Irishman*, trans. R. T. Meyer (Kalamazoo, Michigan, 1978), 31–2.

9. F. Eygun, *Saintonge Romane* (La-Pierre-qui-vire, 1979), 181. In the cloisters of St Trophime at Arles there is an epitaph to Poncius Rebolii, a priest and canon regular, who served as *operarius* of the church of St Trophime, cited by Briggs, *The Architect in History* (Oxford, 1927), 82.

10. Mortet, *Recueil de Textes*, 353–4.

11. Davis-Weyer, *Early Medieval Art*, 168.

12. E. Castelnuovo, 'The Artist' in J. Le Goff (ed.), *The Medieval World* (London, 1990), 227.

13. R. Gem, 'Canterbury and the cushion capital' in *Romanesque and Gothic, Essays for George Zarnecki* (Woodbridge, 1987), 88–9; W. Melczer, *The Pilgrim's Guide to Santiago de Compostela* (New York, 1993), 130.

14. Mortet, *Recueil de Textes*, 105–6.

15. Mortet, *Recueil de Textes*, 109-11, 229–32; J. Harvey, *Medieval Architect* (London, 1972), 243–5.

16. M. D'Onofrio, 'L'Abbatiale Normande Inachevée de Venosa', in M. Baylé (ed.), *L'Architecture Normande au Moyen Age*, I (Caen, 1997), 111–24.

17. Salzman, *Building in England*, 364.

18. D. Stocker and P. Everson, 'Rubbish Recycled: A Study of the Re-Use of Stone in Lincolnshire' in D. Parsons, *Stone; Quarrying and Building in England AD 43–1525* (Chichester, 1990), 83–101. At Giblet in the Holy Land, Antique columns were laid horizontally through the walls of the Crusader castle to give added strength, Kennedy, *Crusader Castles*, 65.

19. E. Vergnolle, 'La pierre de taille dans l'architecture religieuse de la première moitié du XIe siècle', *Bulletin Monumental*, 154 (1996), 229–34.

20. Gem, 'Canterbury and the cushion capital' in *Romanesque and Gothic*, 83–101.

21. Krautheimer, *Early Christian and Byzantine Architecture*, 267.

22. Briggs, *Architect in History*, 47–8.

23. Cited by C. Hahn, 'Seeing and believing: the construction of sanctity in early-medieval saints' shrines', *Speculum*, 72 (1997), 1,102.

24. For a brief critique of the method see E. Fernie, 'The grid system and the design of the Norman cathedral', *Medieval Art and Architecture at Winchester Cathedral,* British Archaeological Association Conference Transactions for the year 1980, eds T. A. Heslop and V. A. Sekules (London, 1983), 12–19.

25. H. Hahn, *Die Frühe Kirchenbaukunst der Zisterzienser* (Berlin, 1957).

26. E. Fernie, 'The ground plan of Norwich Cathedral and the square root of two', *Journal of the British Archaeological Association,* 129 (1976), 77–86.

27. For example, the height of the capitals (29 feet) multiplied by $\sqrt{2}$ generates the height of the gallery string course (41 feet) and this multiplied by $\sqrt{2}$ generates the clerestory string: figures presented by Professor Peter Kidson to the annual conference of the British Archaeological Association, Durham, 1977.

28. T. A. Heslop, 'Orford castle, nostalgia and sophisticated living', *Architectural History,* 34 (1991), 36–58.

29. P. Kidson, 'Architectural proportion', *Macmillan Dictionary of Art,* 351.

Chapter 6. Art and Engineering

1. J. Harvey, *The Medieval Architect* (London, 1972), 39–40.

2. W. Rodwell, 'Anglo-Saxon church building: aspects of design and construction', in L. A. S. Butler and R. K. Morris (eds), *The Anglo-Saxon Church, Papers on history, architecture and archaeology in honour of Dr H. M. Taylor* (London, 1986), 156–75.

3. J. Crook, 'Recent archaeology in Winchester Cathedral', in T. Tatton-Brown and J. Munby, *The Archaeology of Cathedrals* (Oxford, 1996), 135–51.

4. L. Bosman, 'Speaking in stone—On the meaning of architecture in the Middle Ages', *Argumentation,* 7 (1993), 13–28.

5. R. Gem, 'Staged timber spires in Carolingian north-east France and late Anglo-Saxon England, *Journal of the British Archaeological Association,* 148 (1995), 29–54.

6. M. Hare and A. Hamlin, 'The study of early church architecture in Ireland', in L. A. S. Butler and R. K. Morris (eds), *The Anglo-Saxon church. Papers on history, architecture and archaeology in honour of Dr H. M. Taylor* (London, 1986), 131–45.

7. Mortet, *Recueil de Textes,* 142.

8. Mortet, *Recueil de Textes,* 85; Harvey, *Medieval Architect,* 39.

9. M. Durliat, 'La Catalogne et le premier art roman', *Bulletin Monumental,* 147 (1989), 209–38.

10. J. Henriet, 'Saint Philibert de Tournus. L'Oeuvre du second maître: la galilée et la nef', *Bulletin Monumental,* 150 (1992), 101–64.

11. P. Kidson, 'The Mariakerk at Utrecht, Speyer, and Italy', in *Utrecht: Britain and the Continent, Archaeology, Art and Architecture,* ed. E. de Bièvre, British Archaeological Association Conference Transactions, 18 (London, 1996), 123–36.

12. Kidson, 'Mariakerk', 131–5.

Chapter 7. Architecture and Pilgrimage

1. J. Crook, 'The architectural setting of the cult of St Cuthbert in Durham Cathedral (1093–1200)' in D. Rollason, M. Harvey, M. Prestwich (eds), *Anglo-Norman Durham* (Woodchester, 1994), 235–50.

2. C. and R. Brooke, *Popular Religion in the Middle Ages* (London, 1984), 19.

3. It was an aspect of Christianity despised by its enemies, not least the emperor Julian the Apostate (361–4) who complained: 'You keep adding many corpses newly dead to the corpses of long ago. You have filled the whole world with tombs and sepulchres', P. Brown, *The Cult of the Saints. Its Rise and Function in Latin Christianity* (London and Chicago, 1981), 7.

4. Brown, *Cult of Saints,* 36–7.

5. E. Panofsky, *Abbot Suger on the Abbey Church of St Denis and its Art Treasures* (Princeton, 1979, 2nd edn), 88–9.

6. Davis-Weyer, *Early Medieval Art 300–1150,* 126.

7. A rotunda, evidently modelled on Dijon, was started *c.* 1047 by Abbot Wulfric at St Augustine's, Canterbury, R. Gem (ed.), *English Heritage Book of St Augustine's Abbey at Canterbury* (London, 1997), 109–11.

8. Krautheimer, *Early Christian and Byzantine Architecture,* 242. The Church of the Apostles at Constantinople was razed in 1461.

9. Melczer, *Pilgrim's Guide,* 107, 174.

10. For Oxford see R. Halsey, 'The 12th century church of St Frideswide's Priory' in J. Blair, *Saint Frideswide's Monastery at Oxford: Archaeological and Architectural Studies* (Gloucester, 1990), 115–67, and J. Blair, 'The archaeology of Oxford Cathedral', in T. Tatton-Brown and J. Munby, *The Archaeology of Cathedrals* (Oxford Committee for Archaeology, 1996), 95–102.

11. Cited by C. Rudolph, *The 'Things of Greater Importance'. Bernard of Clairvaux's Apologia and the medieval attitude towards art* (London, 1990), 72.

12. *Ibid.*, 78.

13. *Jocelin of Brakelond, Chronicle of the Abbey of Bury St Edmunds*, eds D. Greenway and J. Sayers (Oxford, 1989), 94–5.

14. J. Sumption, *Pilgrimage, an Image of Medieval Religion* (London, 1975), 35.

15. R. Willis, 'The architectural history of Canterbury Cathedral', in R. Willis, *Architectural History of Some English Cathedrals*, I (Chicheley, 1972), 44. A similar beam at Bury St Edmunds is described in *Jocelin of Brakelond*, 95.

16. Brooke, *Popular Religion* (London, 1984), 21.

17. Sumption, *Pilgrimage*, 161.

18. Rudolph, *The 'Things of Greater Importance'*, 48.

19. Sumption, *Pilgrimage*, 69–70.

20. Willis, 'Canterbury Cathedral', 10.

Chapter 8. Architecture and Monasticism

1. C. Brooke, *The Monastic World 1000–1300* (London, 1974), 90, 235–7.

2. G. Duby, *St Bernard—L'Art Cistercien* (Paris, 1976), 44.

3. Life of St Hugh, cited in W. Braunfels, *Monasteries of Western Europe: the architecture of the orders* (London, 1972), 241.

4. Braunfels, *Monasteries of Western Europe*, 241.

5. Pointed arches (*fornices spiculos*) were evidently used in the narthex and nave arcades of the church at Montecassino (1071). Architectural historians have made much of the fact that Abbot Hugh visited Montecassino in 1083.

6. K. J. Conant, *Cluny. Les églises et la maison du chef d'ordre* (Mâcon, 1968); F. Salet, 'Cluny III', *Bulletin Monumental*, 126 (1968), 235–92.

7. M. Chibnall (ed.), *The Ecclesiastical History of Orderic Vitalis*, VI (Oxford, 1978), 314–5.

8. E. Armi, *Masons and Sculptors in Romanesque Burgundy* (Pittsburgh, 1983), *passim*, has argued the case for a local origin.

9. Rudolph, *The 'Things of Greater Importance'*, 109.

10. P. J. Geary, *Furta Sacra. Thefts of relics in the Central Middle Ages* (Princeton, 1978), 67.

11. Apologia to William of St Thierry, *Cistercians and Cluniacs, St Bernard's Apologia to Abbot William*, trans. M. Casey (Kalamazoo, Michigan, 1970).

12. The English abbot, Ailred of Rievaulx, echoed St Bernard's arguments, complaining of the type of monk that was 'occupied with so much chanting, so many ornaments, so many lights, and other beautiful things of this sort' that he could not think of 'anything else except that which he sees with his eyes, hears with his ears, or perceives through the senses of the flesh', Rudolph, *The 'Things of Greater Importance'*, 68–9.

13. Wooden claustral buildings of the pre-Carolingian era have been excavated at Augsburg (St Ulric and St Afra), W. Horn, 'On the Origins of the Medieval Cloister', *Gesta*, 22 (1972), 36.

14. Braunfels, *Monasteries of Western Europe*, 240.

15. The Customs of Farfa 1030–48, Braunfels, *Monasteries of Western Europe*, 238.

16. The most extensive study of the plan is that by W. Horn and E. Born, *The Plan of Saint Gall. A Study of the Architecture and Economy of, and Life in, a Paradigmatic Carolingian Monastery*, 3 vols. (Berkeley, 1979), though many of its conclusions cannot be sustained. Issues which have still not been settled include the scale of the plan, the length of the foot that was intended, the inconsistencies between the apparent scale and the measurements noted on the plan, and the relationship between the plan and what was actually built.

17. Eusebius did however note that the fourth-century atrium at Tyre had 'wooden screens of trellis work' between the pillars reaching up 'to a proportionate height', *Eusebius*, 393.

18. Cloister arcades existed in the mid-eighth century, when there is reference at Jumièges to 'cloisters carefully built of stone accompanied by arches', Braunfels, *Monasteries of Western Europe*, 234. The monastery at Aniane, begun after 782, included cloisters 'with very many marble columns', located in porticoes, Davis-Weyer, *Early Medieval Art*, 98.

19. Braunfels, *Monasteries of Western Europe*, 236.

20. The Customs of Farfa (1030–48) state that the chapter house at Cluny measured 45 by 34 feet, which suggests an arrangement of 4 x 3 bays, Braunfels, *Monasteries of Western Europe*, 238.

Chapter 9. The Language of Architecture

1. Mortet, *Recueil de textes*, 33–4. Scholars have doubted the *c.* 1026 date for Gauzlin's tower, on the basis that the carved capitals are too precocious, but for recent opinion see E. Vergnolle, *L'Art Roman en France* (Paris, 1994), 88–90.

2. M. Schapiro, 'On the aesthetic attitude in Romanesque art', in M. Schapiro, *Romanesque Art* (London, 1977), 1–27.

3. William of Malmesbury, *Historia Novella*, ed. K. R. Potter (London, 1955), 38.

4. Mortet, *Recueil de textes*, 27.

5. Schapiro, 'On the aesthetic attitude in

Romanesque art', in Schapiro, *Romanesque Art*, 5.

6. Concepts of order were frequently emphasized by theologians and religious readers. As St Bernard of Clairvaux explained, 'God disposes all things in beautiful order', K. Hufgard, *Saint Bernard of Clairvaux: a theory of art formulated from his writings* (Lampeter, 1989), 51. The depiction of God creating the world in the guise of an architect takes on a special significance in this context.

7. U. Eco, *Art and Beauty in the Middle Ages* (London and New Haven, 1986), 48.

8. J. Bony, 'La technique normande du mur épais à l'époque romane', *Bulletin Monumental*, 98 (1939), 153–88; L. Hoey, 'The design of Romanesque clerestories with wall passages in Normandy and England', *Gesta*, 28 (1989), 78–101.

9. The metrical life of St Hugh of Lincoln, J. Harvey, *The Medieval Architect* (London, 1972), 238.

10. Already in the eleventh century Speyer Cathedral had a doorway with multiple square-edged orders, executed in masonry of different colours.

11. While the compound pier is essentially an eleventh-century development, it is worth noting a Carolingian precedent in the gatehouse at Lorsch.

12. A new and peculiar form of pier was introduced halfway down the nave at Lessay, designed to create a better relationship with the ribbed vaults.

13. Alternation first appeared in western Europe in Ottonian architecture at Gernrode (founded 961) and at St Michael's, Hildesheim (1010–33), but without compound piers or engaged shafts. In this simple form it survived in Saxony, as at Quedlinburg, W. Wulf, *Saxe romane* (La-Pierre-qui-vire, 1996), and S. Heywood, 'Alternation', *Macmillan Dictionary of Art*.

14. L. Hoey, 'Pier form and vertical wall articulation in English Romanesque architecture', *Journal of the Society of Architectural Historians*, 48 (1989), 258–83; L. R. Hoey, 'A problem in Romanesque aesthetics: the articulation of groin and early rib vaults in the larger churches in England and Normandy', *Gesta*, 35 (1996), 156–76.

15. Vitruvius, *The Ten Books on Architecture*, bk V, ch. 1.

Chapter 10. Diversity in the Romanesque Era

1. F. Eygun, *Saintonge Romane* (La-Pierre-qui-vire, 1979), *passim*.

2. Davis-Weyer, *Early Medieval Art*, 124.

3. R. Bartlett, *The Making of Europe* (Harmondsworth, 1993), ch. 1.

4. B. Craplet, *Auvergne Romane* (Zodiaque, 1978), *passim*.

5. The scheme had already been employed at Anzy-le-Duc and at the priory church at Charlieu.

6. A. Wharton Epstein, 'The date and significance of the cathedral of Canosa in Apulia, South Italy', *Dumbarton Oaks Papers*, 37 (1983), 79–90.

7. Churches that followed the same liturgy often had very different designs, suggesting that the diversity found in Romanesque was not the result of differences in 'function', A. Klukas, *Altaria Superioria*.

8. In the kingdom of Sicily English officials included Robert of Selby, chancellor of Roger II, and Walter of the Mill, who was tutor to William II and the Archbishop of Palermo (1169–87). In the first half of the twelfth century John of Lincoln, Herbert of Braose, and Robert of Salesbury were among the many Englishmen employed there.

9. R. H. C. Davies, *The Normans and their Myth* (London, 1976), 44.

10. The most recent authority is R. Liess, *Der frühromanischer Kirchenbau des 11. Jahrhunderts in der Normandie: Analysen und Monographien der Hauptbauten* (Munich, 1967).

11. There had been a number of important Carolingian abbeys in the region, but how far they survived the destruction of the late ninth century is not clear. Jumièges was reoccupied in 940, Fontanelle (St Wandrille) in 961.

12. The existing domes are reconstructions of *c.* 1910.

13. The quadrant vaults in the aisles are in fact often more than quadrants, more like two-thirds of a complete barrel vault.

14. E. C. Fernie, 'The architectural influence of Durham Cathedral', D. Rollason, M. Harvey, M. Prestwich (eds), *Anglo-Norman Durham* (Woodbridge, 1994), 269–79.

15. This process has been variously described as the 'impact theory' or the 'vulgarization' of techniques employed in 'privileged centres', E. Vergnolle, *L'Art Roman en France*, 10.

Epilogue: The Shadow of Rome

1. Bede, *Historia Ecclesia*, I, ii; *Anglo Saxon Poetry*, trans. R. K. Gordon (London, 1962), 84.

2. Vitruvius, *The Ten Books on Architecture*, III.

3. Davis-Weyer, *Early Medieval Art 300–1150*, 159.

4. *Ibid.*, 158-62.

List of Illustrations

The publishers would like to thank the following individuals and institutions who have kindly given permission to reproduce the illustrations listed below.

1. Rome, Santa Sabina, 422-32. Canali Photobank, Milan.
2. Rome, Santa Sabina, 422–32, spandrel decoration. Photo Roger Stalley.
3. Trier, Aula Nova, 305–12. Bildarchiv Foto Marburg.
4. Ravenna, Sant'Apollinare Nuovo, mosaic of the palace of Theodoric (491–526). Photo Scala, Florence.
5. Rome, St Peter's, founded c.321-2, drawing (c.1620) by Giacomo Grimaldi, showing a section of the nave. Biblioteca Apostolica Vaticana (Cod.Barb.Lat.2733, ff.104v–105r), Rome.
6. Rome, St Peter's, plan from E. Fernie, *The Architecture of the Anglo-Saxons* (London: Batsford, 1983), p.76.
7. Rome, San Paolo fuori le mura, c.382–400. Engraving by G.B. Piranesi, from *Le vedute di Roma*, vol. I (1748). © The British Museum, London.
8. Ravenna, Sant'Apollinare in Classe, consecrated in 549, nave. Canali Photobank, Milan.
9. San Juan de Baños de Cerrato (Palencia), c.661. Photo Hirmer Verlag, Munich.
10. San Pedro de la Nave (Zamora), c.691. Photo Henri Stierlin, Geneva.
11. San Pedro de la Nave (Zamora), c.691, north wall of the chancel. Photo Hirmer Verlag, Munich.
12. Reculver, St Mary's church (Kent), 669, plan from P. Kidson, *The Medieval World* (London: Hamlyn, 1967), p.35.
13. Abbey church of Maria Laach (Rhineland Palatinate), begun c.1093, completed thirteenth century. Photo Erik Bohr/AKG London.
14. Lorsch (Hesse), 'gatehouse' of the monastery, late eighth century. © Könemann Gmbh/photo Achim Bednorz, Cologne.
15. Fulda (Hesse), monastic church, c.790–819, plan from D. Bullough, *The Age of Charlemagne* (Elek, 1965), p.191
16. Seligenstadt (Hesse), Sankt Marcellinus and Sankt Petrus, founded 831, north arcade of the nave. Bildarchiv Foto Marburg.
17. Steinbach im Odenwald (Hesse), Sankt Marcellinus and Sankt Petrus, consecrated in 827, plan from H.E. Kubach, *Romanesque Architecture* (New York: Harry Abrams, 1975; originally published by Electa, Milan), p.37.
18. St Riquier (Somme, also known as Centula), built c.790-9, engraving of 1612 based on a lost drawing of the eleventh century, from Petau, *De Nithardo Caroli Magni Nepote* (1612). Bibliothèque Nationale de France, Paris.
19. Corvey (Westphalia), westwork of abbey church, c.873–85, plan and cross-section from O.L. Schaefer and H.R. Sennhauser, *Vorromanische Kirchenbauten. Katalog der Denkmaler bis zum Ausgang der Ottonen*, 3 vols (Munich: Prestel-Verlag, 1966–90). By permission Zentralinstitut für Kunstgeschichte.
20. Corvey (Westphalia), westwork of abbey church, c.873–885. Photo Claude Huber, Chavannes.
21. Corvey (Westphalia), westwork of abbey church, c.873–85, the upper chapel. © Könemann Gmbh/photo Achim Bednorz, Cologne.
22. Marmoutier (Alsace), west façade of the abbey church, c.1150–60. Photo Zodiaque, St Léger Vauban.
23. Jumièges (Seine-Maritime), abbey church, west façade, 1040–67. Photo Roger Stalley.
24. Gernrode (Saxony Anhalt), founded 961, nave. © Könemann Gmbh/photo Achim Bednorz, Cologne.
25. Hildesheim, St Michael, 1010–33, nave. Photo A.F. Kersting, London.
26. Hildesheim, St Michael, 1010–33, external form, from K.J. Conant, *Carolingian and Romanesque Architecture* (London, 1966). First published 1959 by Penguin Books Ltd. Fourth edition 1978. New impression 1993 by Yale University Press. Copyright © Kenneth John Conant, 1959, 1966, 1974, 1978.
27. Hildesheim, St Michael, 1010–33, plan

from W. Wulf, *Saxe Romane* (St Léger Vauban: Zodiaque, 1996), p.282.

28. Fountain of Life, miniature from the *Gospel Book of St Médard of Soissons*, early ninth century. Bibliothèque Nationale de France (MS lat.8850, f.6v), Paris

29. Nocera (Campania), baptistery, sixth century. Engraving, 1783, by L.J. Desprèz. Nationalmuseum, Stockholm/photo Statens Konstmuseer.

30. Lomello (Lombardy), Santa Maria Maggiore, eleventh-century church with baptistery attributed to eighth century alongside. Photo Roger Stalley.

31. Rome, Santa Costanza, *c.*350. Photo Scala, Florence.

32. Rome, Santa Costanza, *c.*350, plan from G. Dehio and G. von Bezold, *Die Kirchliche Baukunst des Abendlandes* (Stuttgart, 1884–1901).

33. Ravenna, mausoleum of Theodoric (d.526). Canali Photobank, Milan.

34. Jerusalem, Holy Sepulchre, plan of *c.*380, from S. McCormack, 'Locus Sancta: The Organization of Sacred Topography in Late Antiquity', *The Blessings of Pilgrimage*, ed. R. Ousterhout (Urbana, IL, and Chicago: University of Illinois Press, 1990).

35. Ravenna, San Vitale, consecrated 547. Canali Photobank, Milan.

36. Ravenna, San Vitale and Aachen, palace chapel, comparative plans: (a) San Vitale, after G. Dehio and G. von Bezold, *Die Kirchliche Baukunst des Abendlandes* (Stuttgart, 1884–1901), illn vols, bk.1, cap.2, Tafel 4, no.2; (b) Aachen, after J. Beckwith, *Early Medieval Art* (London: Thames & Hudson, 1964), p.12.

37. Aachen, palace chapel, completed 805. © Könemann Gmbh/photo Achim Bednorz, Cologne.

38. Ottmarsheim (Alsace), abbey church, *c.*1030. © Könemann Gmbh/photo Achim Bednorz.

39. Mainz Cathedral, St Godehard's chapel, twelfth century. Bildarchiv Foto Marburg.

40. Kalundborg (Denmark), church of Our Lady, late twelfth century. Photo Paul Larsen, Lechlade.

41. Cambridge, St Sepulchre, *c.*1130, engraving by V. Rupricht Robert from *L'Architecture Normande aux XIe et XIIe Siècles en Normandie et en Angleterre* (Paris, 1884).

42. Almenno (Lombardy), San Tomaso, twelfth century. Photo Zodiaque, St Léger Vauban.

43. Torres del Rio (Navarre), *c.*1200, the dome. © Könemann Gmbh/photo Achim Bednorz, Cologne.

44. Segovia, La Vera Cruz, *c.*1200. Photo Zodiaque, St Léger Vauban.

45. Dover Castle, view from the north. Photo English Heritage Photograph Library, London/Skyscan Balloon Photography.

46. Loarre Castle (Aragon), eleventh century. Photo Institut Amatller d'Art Hispànic, Barcelona.

47. Castle Rising (Norfolk), *c.*1140, the keep. Photo A.F. Kersting, London.

48. Castle Rising (Norfolk), *c.*1140, plan of the keep at first floor level, from R. Allen Brown, *Castle Rising* (London: HMSO, 1978), p.32. Crown copyright, reproduced with permission of the Controller of Her Majesty's Stationery Office.

49. Bayeux tapestry, *c.*1066–82 (detail), King Harold feasting at Bosham. Musée de la Tapisserie/by special permission of the City of Bayeux.

50. Loches, castle (Indre-et-Loire), *c.*1012–35, the keep. Photo Roger Stalley.

51. Loches, castle (Indre-et-Loire), *c.*1012–35, plan of the keep at first-floor level, from E. Impey, E. Lorans, and J. Mesqui, 'Deux Donjons Construits autour de l'an mil en Touraine, Langeais et Loches', *Bulletin Monumental,* 156 (Paris: Société Française d'Archéologie, 1998), pl.1.

52. Carrickfergus Castle (Antrim), *c.*1180, keep with latrines. Photo Roger Stalley.

53. Ambleny (Aisne), the keep, *c.*1140–3. Photo Lefèvre Pontalis/© Archives Photographiques, Paris/Caisse Nationale des Monuments Historiques et des Sites.

54. Twelfth-century keeps, comparative plans: (a) Ambleny, from J. Mesqui, *Chateaux et Enceintes de la France Médiévale*, vol.I (Paris: Picard, 1991), fig.127; (b) Etampes and (c) Provins, from S. Toy, *A History of Fortification* (London: Heinemann, 1955), pp. 109 and 107; (d) Conisborough and (e) Orford, from R. Allen Brown, *Orford Castle* (London: HMSO, 1968), fold-out and p.15. Crown copyright, reproduced with the permission of the Controller of Her Majesty's Stationery Office.

55. Conisborough Castle (Yorkshire), *c.*1180, the keep. Photo English Heritage Photograph Library, London.

56. Avila, city walls, *c.*1090. Photo Roger Stalley.

57. Naranco (Asturias), palace of King Ramiro I (842–50). Photo Roger Stalley.

58. Oakham Castle (Rutland), aisled hall, *c.*1180. Photo A.F. Kersting, London.

59. Gelnhausen (Hesse), palace, 1170–1200. Bildarchiv Foto Marburg.

60. Desiderius, abbot of Montecassino

(1072–87), fresco in Sant'Angelo in Formis (Campania). Canali Photobank, Milan.

61. Setting-out marks at Christ Church Cathedral, Dublin, section of engaged shafts, c.1200. Photo Roger Stalley.

62. Masons' marks at Sénanque (Vaucluse). Photo Zodiaque, St Léger Vauban.

63. Durham Cathedral, detail of a pier in the nave, c.1104–28. Photo Roger Stalley.

64. Venosa (Basilicata), La Trinità, early twelfth century, unfinished. Photo Alinari, Florence.

65. San Miguel de Escalada (Léon), consecrated in 913. Photo Henri Stierlin, Geneva.

66. Sant'Angelo in Formis (Campania), west porch. Photo Roger Stalley.

67. Gravedona (Lombardy), Santa Maria del Tiglio, banded ashlar masonry, twelfth century. Photo Zodiaque, St Léger Vauban.

68. Pomposa (Emilia-Romagna), Santa Maria, narthex, eleventh century. © Könemann Gmbh/photo Achim Bednorz, Cologne.

69. Medieval builders: detail of painting on the nave vault at St-Savin-sur-Gartempe (Vienne): building the Tower of Babel. © Könemann Gmbh/photo Achim Bednorz, Cologne.

70. Lomello (Lombardy), Santa Maria Maggiore, eleventh century, plan from S. Chierici, Lombardie Romane (St Léger Vauban: Zodiaque, 1978), p.310.

71. Eberbach (Hesse), Cistercian church, completed c.1170–86, plan from H. Hahn, Die Frühe Kirchenbaukunst der Zisterzienser (Berlin: Verlag Gebr. Mann, 1957), p.67.

72. The square root of two. Roger Stalley.

73. The square root of two, drawing by Roger Stalley after E. Fernie, 'The Ground Plan of Norwich Cathedral and the Square Root of Two', Journal of the British Archaeological Association, 129 (London, 1976), p.79.

74. Salamanca, Old Cathedral, begun 1152, finished early thirteenth century, ribbed dome. © Könemann Gmbh/photo Achim Bednorz, Cologne.

75. Earls Barton (Northamptonshire), Anglo-Saxon tower, late tenth century. Photo Roger Stalley.

76. Anzy-le-Duc (Saône-et-Loire), Cluniac priory church, crossing tower, first half of twelfth century. Photo Roger Stalley.

77. Tewkesbury Abbey (Gloucestershire), crossing tower, first half of the twelfth century. Photo Paul Larsen, Lechlade.

78. Toro (Zamora), Collegiate Church of Santa Maria Mayor, dome over crossing, c.1200. © Könemann Gmbh/photo Achim Bednorz.

79. Selby abbey (Yorkshire), settlement in the nave, c.1100–20. Photo Roger Stalley.

80. Cruas (Ardèche), abbey church of Sainte-Marie, twelfth-century crossing tower. Photo Roger Stalley.

81. Stenkyrka (Gotland), helm tower, late thirteenth century. Photo Roger Stalley.

82. Chartres Cathedral, south-west tower, third quarter of the twelfth century. Photo Roger Stalley.

83. Kilmacduagh (Galway), round tower, probably eleventh century. Photo Roger Stalley.

84. Stone vaulting in the early Middle Ages: (a) barrel vault, (b) groin vault, (c) ribbed vault, after P. Kidson, The Medieval World (London: Hamlyn, 1967), p.69.

85. Santiago de Compostela, Collegiata del Sar, twelfth century. Photo Institut Amatller d'Art Hispànic, Barcelona.

86. San Pedro de Roda (Catalonia), c.1035, nave. Photo Zodiaque, St Léger Vauban.

87. Cardona (Catalonia), San Vincent, consecrated in 1040. Left: plan after A. Mazcunan and F. Junyent. Right: isometric elevation by J.A. Adell after Puig y Cadafalch, both from M. Durliat, 'La Catalogne et le "Premier art Roman"', Bulletin Monumental, 147 (Paris: Société Française d'Archéologie, 1989), p.222.

88. Tournus (Saône-et-Loire), St Philibert, interior of the narthex, 1023–56, ground floor. Photo Zodiaque, St Léger Vauban.

89. Alternative structural forms: cross-sections. (a) Santiago de Compostela, after K.J. Conant, The Early Architectural History of Santiago (Cambridge MA, 1926); (b) Notre-Dame-la-Grande, Poitiers (hall church), after G. Dehio and G. von Bezold, Die Kirchliche Baukunst des Abendlandes (Stuttgart, 1884–1901), Bk II, Cap.8, Tafel 124, no.2; (c) Cluny III, after K.J. Conant, Cluny. Les églises et la maison du chef d'ordre (Macon, 1968), fig.84; (d) St Trophime, Arles (Provençal type) after G. Dehio and G. von Bezold, Die Kirchliche Baukunst des Abendlandes (Stuttgart, 1884–1901), Bk II, Cap.9, Tafel 134, no.6.

90. Tournus (Saône-et-Loire), St Philibert, nave vault, c.1060. © Könemann Gmbh/photo Achim Bednorz, Cologne.

91. Durham Cathedral, ribbed vaults in the north transept, c.1104–10. Photo Roger Stalley.

92. Utrecht, Mariakerk, view of the nave, built after 1081. Painting, 1638, by Pieter Saenredam. Kunsthalle, Hamburg/photo

Elke Walford.

93. St James as a pilgrim. St Marta de Tera (Zamora), south portal, early twelfth century. Photo Roger Stalley.

94. Reliquary of St Andrew's sandal, made between 977 and 993. Trier Cathedral Treasury/Amt für kirchliche Denkmalpflege/photo Rita Heyen.

95. Auxerre, St Germain, the confessio. Photo Zodiaque, St Léger Vauban.

96. Auxerre, St Germain, plan of the crypt, from H.E. Kubach, *Romanesque Architecture* (London: Faber & Faber, 1988), p.24.

97. Agliate (Lombardy), San Pietro, crypt. Photo Zodiaque, St Léger Vauban.

98. Canterbury Cathedral, crypt under Anselm's choir, begun *c*.1096. Photo National Monuments Record, Swindon/© Crown copyright. RCHME.

99. Dijon, St Bénigne, consecrated 1018, cross-section of the rotunda. Engraving from Dom Urbain Plancher, *Histoire générale et particulière de la Bourgogne*, vol.I (Dijon, 1739). Bibliothèque Municipale (Côté IV.323), Dijon.

100. Santiago de Compostela, plan of the church in the twelfth century, from K.J. Conant, *The Early Architectural History of Santiago* (Cambridge, MA, 1926), pl.VIII.

101. Santiago de Compostela, *c*.1078–1122, view across the transepts. © Könemann Gmbh/photo Achim Bednorz, Cologne.

102. Périgueux, St Front, begun *c*.1120, nave. Photo © Archives Photographiques, Paris/Caisse Nationale des Monuments Historiques et des Sites.

103. Périgueux, St Front, plan from K.J. Conant, *Carolingian and Romanesque Architecture* (London, 1966), p.168. First published 1959 by Penguin Books Ltd. Fourth edition 1978. New impression 1993 by Yale University Press. Copyright © Kenneth John Conant, 1959, 1966, 1974, 1978.

104. Oxford, St Frideswide's Cathedral, interior of the choir, 1160s. Photo Paul Larsen, Lechlade. By permission of the Dean and Canons of Christ Church.

105. Bari, San Nicola, plan from P. Belli d'Elia, *Pouilles Romanes* (St Léger Vauban: Zodiaque, 1987), p.184.

106. Bari, San Nicola, founded 1087. Photo Roger Stalley.

107. Trani Cathedral (Apulia), begun 1089, completed in thirteenth century. © Könemann Gmbh/photo Achim Bednorz, Cologne.

108. Display of relics.

109. Rome, San Paolo fuori le mura, cloister arcades, *c*.1200. © Könemann Gmbh/photo Achim Bednorz, Cologne.

110. Cluny III, plan and elevation of the abbey church, *c*.1700, engraving by P.F. Giffart. Frances Loeb Library, Graduate School of Design, Harvard University Cambridge, MA.

111. Cluny III, the east end, reconstruction by K.J. Conant. Frances Loeb Library, Graduate School of Design, Harvard University, Cambridge, MA.

112. Cluny III, the sanctuary and entrance to the ambulatory, reconstruction by K.J. Conant. Frances Loeb Library, Graduate School of Design, Harvard University, Cambridge, MA.

113. Paray-le-Monial (Saône-et-Loire), priory church, first half of twelfth century. Photo Zodiaque, St Léger Vauban.

114. Vézelay, La Madeleine, the nave, *c*.1120–32. Photo Zodiaque, St Léger Vauban.

115. Castle Acre Priory (Norfolk), west façade of the church, mid-twelfth century. Photo James Austin, Cambridge.

116. Fontenay, Cistercian abbey church, begun 1139. Photo Henri Stierlin, Geneva.

117. Fontenay, plan of the Cistercian abbey, from K.J. Conant, *Carolingian and Romanesque Architecture* (London, 1966), p.131. First published 1959 by Penguin Books Ltd. Fourth edition 1978. New impression 1993 by Yale University Press. Copyright © Kenneth John Conant, 1959, 1966, 1974, 1978.

118. Presentation scene, miniature from *St Jerome's Commentary on Jeremiah*, twelfth century. Bibliothèque Municipale (MS 130, f.104), Dijon.

119. Eberbach (Hesse), Cistercian church, *c*.1170–86. Photo Zodiaque, St Léger Vauban.

120. Le Thoronet (Var), Cistercian church, founded 1146. Photo James Austin, Cambridge.

121. Sénanque (Vaucluse), Cistercian cloister, late twelfth century. Photo Zodiaque, St Léger Vauban.

122. Le Puy Cathedral, twelfth-century cloister. Photo Zodiaque, St Léger Vauban.

123. The Plan of St Gall, *c*.830, detail showing the church and cloister. Stiftsbibliothek (MS Cod. Sang. 1092), St Gall.

124. Noirlac (Cher), Cistercian chapter house, second half of the twelfth century. Photo Roger Stalley.

125. Château Gontier (Mayenne), nave, eleventh century. Photo Roger Stalley.

126. St Benoît-sur-Loire, west tower, *c*.1026. Photo James Austin, Cambridge.

127. Aulnay-de-Saintonge (Charente-Maritime), church of St Pierre, *c*.1130. Photo

Zodiaque, St Léger Vauban.

128. Santa Cruz de la Seros (Aragon), church of San Caprasio, last quarter of the eleventh century. Photo Roger Stalley.

129. Shrine of Santo Domingo, from the abbey of Silos, *c.*1140–50. Museo Arqueológico, Burgos/photo Institut Amatller d'Art Hispànic, Barcelona.

130. Much Wenlock (Shropshire), Cluniac priory, chapter house, twelfth century. Photo Roger Stalley.

131. Cashel (Tipperary), Cormac's Chapel, 1127–34. Photo Dúchas, The Heritage Service, Dublin.

132. Speyer Cathedral, begun *c.*1030, completed first half of twelfth century. Photo AKG London.

133. Modena Cathedral, begun 1099, view from the east. Photo Claude Huber, Chavannes.

134. Modena Cathedral, begun 1099, south wall of nave. Photo Roger Stalley.

135. Lucca, San Michele, façade, *c.*1200. Photo Roger Stalley.

136. Pisa, Campanile or 'Leaning Tower', *c.*1153. Photo Conway Library, Courtauld Institute of Art, University of London.

137. Castle Hedingham (Essex), *c.*1140. The Country Life Picture Library, London.

138. Aulnay-de-Saintonge (Charente-Maritime), church of St Pierre, south transept. Photo James Austin, Cambridge.

139. Lessay (Manche), abbey church, interior of choir, *c.*1098. Photo Zodiaque, St Léger Vauban.

140. St-Savin-sur Gartempe (Vienne), nave, *c.*1100. © Könemann Gmbh/photo Achim Bednorz, Cologne.

141. Jumièges (Seine-Maritime), abbey church, 1040–67, nave looking west. Photo Bildarchiv Foto Marburg.

142. Ely Cathedral, nave, *c.*1110–50. Photo A.F. Kersting, London.

143. St Gilles (Bouches-du-Rhône), façade, mid-twelfth century. © Könemann Gmbh/photo Achim Bednorz, Cologne.

144. Chadenac (Charente-Maritime), parish church, mid-twelfth century. Photo Roger Stalley.

145. St-Benoît-sur-Loire, choir, begun *c.*1080. Photo James Austin.

146. Durham Cathedral, nave, completed 1133. Photo Claude Huber, Chavannes.

147. Durham Cathedral, plan of the church as it was in the twelfth century, from A.W. Clapham, *English Romanesque Architecture after the Conquest* (Oxford, 1934), p.24.

148. Speyer Cathedral, nave as remodelled *c.*1081–1106, lithograph, 1844, by von Bachelier. Kurpfälzisches Museum der Stadt Heidelberg.

149. St Saturnin (Puy-de-Dome), choir and crossing tower, probably early twelfth century. Photo Roger Stalley.

150. St Saturnin (Puy-de-Dome), dome over the crossing. Photo Roger Stalley.

151. Valenzano (Apulia), church of the Ognissanti di Cuti, seen from the south aisle, *c.*1078–1100. Photo Zodiaque, St Léger Vauban.

152. Caen, Abbaye-aux-Hommes, built *c.*1060–77, view from the south transept looking west along the nave. Photo Zodiaque, St Léger Vauban

153. Fontevrault (Maine-et-Loire), nave of the abbey church, begun *c.*1120. Photo James Austin, Cambridge.

154. Fontevrault (Maine-et-Loire), abbey church, plan from M. Deyres, *Anjou Roman* (St Léger Vauban: Zodiaque, 1987), p.196.

155. Ely Cathedral, begun *c.*1081–3, north transept. Photo A.F. Kersting, London.

156. Winchester Cathedral, begun 1079, south transept, engraving from J. Britton, *The History and Antiquities of the See and Cathedral Church of Winchester* (1817). Reproduced by permission of the Library, Trinity College, Dublin.

157. The Roman amphitheatre at Nîmes, late first century AD. Photo Roger Stalley.

The publisher and author apologize for any errors or missions in the above list. If contacted they will be pleased to rectify these at the earliest opportunity.

Bibliographic Essay

The study of early medieval buildings is potentially an exciting field, though regrettably this is not always the impression given by the literature. Many interesting issues which have been hotly debated by scholars in recent years have yet to find their way into 'standard' works. The latter tend to follow a predictable path, preoccupied with chronological narrative, with much stress on such matters as development and evolution. Romanesque is still seen as the style which foreshadowed Gothic and as a result emphasis is given to those buildings which appear to anticipate Gothic. The literature also tends to be structured around regional frameworks, with a high proportion of publications devoted to local or national groups of buildings. Important thematic questions, such as the role of the patron in architectural design or the ways in which architecture was affected—or in many cases *not* affected—by changes in worship, have been barely tackled. Similarly we lack a modern critical text dealing with the 'iconography' of architecture, a subject which has prompted much debate in recent years. Relatively few architectural historians have shown an interest in the type of sociological issues that have fascinated art historians in other fields; the fact that castles and secular dwellings are rarely considered as architecture is one symptom of this.

It has become the custom on the part of many scholars to focus their attention on a single monument, analysing its history, function, architectural form, and stylistic associations, an activity akin to that of the historian who labours to produce a reliable edition of an ancient chronicle or document. Confronted with an ever increasing mountain of facts, however, it has become difficult for the student to discern the coordinating principles. Adding to the complexity are the results of archaeological research, which, since the end of World War II, have magnified our knowledge. Then there are the catalogues of monuments, vast compendia of information, often running to several volumes, that have been published at regular intervals. What follows, therefore, is an attempt to steer readers through a bibliographical labyrinth, with an emphasis on books in the English language.

General Works

A number of textbooks on early medieval art incorporate sections on architecture, providing useful introductions. Three such works are P. Kidson, *The Medieval World* (London, 1967), G. Zarnecki, *Art of the Medieval World: Architecture, Sculpture, Painting, the Sacred Arts* (New York, 1975), and M. Stokstad, *Medieval Art* (New York, 1986).

For more advanced study, there are two essential volumes in the Pelican History of Art series: R. Krautheimer, *Early Christian and Byzantine Architecture* (Harmondsworth, 1965, 4th edn 1986), and K. J. Conant, *Carolingian and Romanesque Architecture 800–1200* (Harmondsworth, 1959, 4th edn 1978). Conant offers a comprehensive survey of Romanesque in all its regional expressions, but its geographical sweep allows little scope for interpretation and deeper analysis. The regional approach to Romanesque was also adopted by Sir Alfred Clapham, whose book *Romanesque Architecture in Western Europe* (Oxford, 1936, 3rd edn 1967) remains a lucid and concise geographical survey. A similar approach was adopted by Eric Fernie in the lengthy entry on Romanesque architecture in the *Macmillan Dictionary of Art* (London, 1996). An introduction to early medieval architecture which deserves to be better known is that by the German scholar Ernst Adam, *L'architecture médiévale*, I (Paris, 1965, first published as *Baukunst des Mittelalters*, Frankfurt, 1963), which offers an excellent survey of architecture between 800 and 1200. Modern interpretations of the Romanesque style have been much influenced by the French scholar Henri Focillon, one of whose books has been translated into English as *The Art of the West in the Middle Ages, Part One, Romanesque Art* (London, 1963, 3rd edn Oxford, 1980). A more recent publication is H. E. Kubach, *Romanesque Architecture* (London, 1979, pb. 1987), which has excellent illustrations; although valuable for German buildings

(which receive far too much emphasis), the text will leave the uninitiated in a state of confusion. Far more impressive is R. Oursel, *Invention de l'Architecture Romane* (La-Pierre-qui-vire, 1970), which has never been translated into English and is little known outside France. It is one of the best books on Romanesque, tackling such matters as the role and function of the master mason, the importance of consecration ceremonies, the validity of regional schools, structural issues etc.

There are many studies devoted to the architecture of particular countries, but apart from those relating to Britain and Ireland most have not been published in English. For Britain there is the Pelican History of Art publication by G. Webb, *Architecture in Britain, the Middle Ages* (Harmondsworth, 1956, 2nd edn 1965), and a shorter account by Peter Kidson in P. Kidson, P. Murray, and P. Thompson, *A History of English Architecture* (revised edn Harmondsworth, 1979). A good impression of the impact that archaeology has made on the study of early medieval architecture can be gleaned from W. Rodwell, *English Heritage Book of Church Archaeology* (London, 1989).

The *Macmillan Dictionary of Art* contains many useful thematic entries on such subjects as the crypt, transept, westwork, pier, vault, stave church etc., as well as brief essays on major monuments and important individuals.

There is one outstanding collection of documents in translation: C. Davis-Weyer, *Early Medieval Art 300–1150* (Englewood Cliffs, 1971).

Further information can be acquired from various bibliographical source books. These include a magisterial survey of writings on Early Christian architecture by Eugene Kleinbauer, *Early Christian and Byzantine Architecture, an Annotated Bibliography and Historiography* (Boston, 1992). The companion volume on Romanesque architecture is disappointing in comparison, since it deals only with books, it lacks annotations, and is organized along very conventional lines: M. Davies, *Romanesque Architecture, a Bibliography* (New York, 1993).

Chapter 1: The Christian Basilica

The study of Early Christian architecture has been dominated by the work of Richard Krautheimer, whose Pelican History, *Early Christian and Byzantine Architecture* (Harmondsworth, 1965, 4th edn 1986) remains the standard authority. The writings of another distinguished German scholar, F. W.

Deichmann, who had his disagreements with Krautheimer, are not available in English, except in the form of a survey entitled 'Late-Antique and Early Christian Art: Architecture', in the *Encyclopedia of World Art*, IX (New York, London, and Toronto, 1964), 68–99. There are sections on architecture in R. Milburn, *Early Christian Art and Architecture* (Aldershot, 1988), but this is a conventional work which adds little to Krautheimer.

The origin and background of the basilica as a building type have been studied in three important articles: R. Krautheimer, 'The Beginning of Early Christian Architecture', *The Review of Religion*, 3 (1939), 127–48, reprinted in R. Krautheimer, *Studies in Early Christian, Medieval and Renaissance Art* (London, 1971); J. B. Ward-Perkins, 'Constantine and the origins of the Christian basilica', *Papers of the British School of Rome*, 22 (1954), 69–90; and R. Krautheimer, 'The Constantinian Basilica', *Dumbarton Oaks Papers*, 21 (1967), 115–40. For a first-hand view of the impact of the religious changes that took place under Constantine it is well worth reading *Eusebius, The History of the Church from Christ to Constantine*, translated by G. A. Williamson (Pelican pb., Harmondsworth, 1965). The best introduction to the history of the early Church is H. Chadwick, *The Early Church* (Pelican pb., 1967), which has a useful chapter on worship and art.

More detailed information about the basilicas of Rome can be gleaned from R. Krautheimer, *Rome: Profile of a City, 312–1308* (Princeton, 1980) and from R. Krautheimer, *Corpus Basilicarum Christianarum Romae*, I–V (Rome, Vatican City, and New York, 1937–77). The best insight into the relationships between architecture and liturgy is provided by Thomas Mathews; see in particular T. F. Mathews, *The Early Churches of Constantinople: Architecture and Liturgy* (University Park, Chicago, 1971) and T. F. Mathews, 'An Early Roman Chancel Arrangement and Its Liturgical Functions', *Rivista di archeologia cristiana*, 38 (1962), 73–95. On the use of the orders in early basilicas there is a short but instructive essay by A. Frazer, 'Architecture', in *Age of Spirituality: Late Antique and Early Christian Art, Third to Seventh Century*, catalogue ed. K. Weitzmann (New York, 1979), 263–8. The same volume (pp. 630–69) also contains a more general introduction to Early Christian architecture. For the fate of Roman pagan monuments there is an excellent discussion in M. Greenhalgh, *The Survival of Roman Antiquities in the Middle Ages* (London, 1989).

It is not easy to follow the history of the basilica in the post-Roman period. The best guides are probably C. Heitz, *La France Pré-Romane* (Paris, n.d.) and J. Fontaine, *L'Art Pré-Roman Hispanique* (La-Pierre-qui-vire, 1973). In English the most detailed information is probably supplied by P. Verzone, *From Theodoric to Charlemagne, A History of the Dark Ages in the West* (London, 1968), but this is now rather dated. A more superficial survey is provided by J. Hubert, J. Porcher, and W. F. Volbach, *Europe of the Invasions* (London and New York, 1969). There are useful introductions to early Spanish architecture in *The Art of Medieval Spain*, AD *500–1200*, ed. J. P. O'Neill (New York, 1993) and in P. de Palol and M. Hirmer, *Early Medieval Art in Spain* (London, 1967). Information about Anglo-Saxon architecture can be gained from E. Fernie, *The Architecture of the Anglo-Saxons* (London, 1983), and A. W. Clapham, *English Romanesque Architecture, I, Before the Conquest* (Oxford, 1930, reprinted 1964). For specific buildings in Anglo-Saxon England consult H. M. Taylor and J. Taylor, *Anglo-Saxon Architecture*, 3 vols (Cambridge, 1965–78).

Chapter 2: The Carolingian Renaissance: The Basilica Transformed

The fundamental study of Carolingian architecture is C. Heitz, *L'architecture religieuse carolingienne. Les formes et leurs fonctions* (Paris, 1980), for which there is no English translation. An insight into his approach can be gleaned from C. Heitz, 'The iconography of architectural form' in L. A. S. Butler and R. K. Morris (eds), *The Anglo-Saxon Church* (London, Council for British Archaeology, 1986), 90–100. Older surveys of Carolingian architecture can be found in J. Hubert, J. Porcher, and W. F. Volbach, *Carolingian Art* (London and New York, 1970), Hans Thümmler, 'Carolingian Period' in the *Encyclopedia of World Art*, III (New York, London, and Toronto, 1960), 81–103, and K. J. Conant, *Carolingian and Romanesque Architecture 800–1200* (Harmondsworth, 1959, 4th edn 1978). A more recent survey by C. B. McClendon appears in the *Macmillan Dictionary of Art*, 'Carolingian art, II, Architecture', and the same author has much to say about Carolingian architecture in C. B. McClendon, *The Imperial Abbey of Farfa. Architectural Currents of the Early Middle Ages* (London and New Haven, 1987). For the history of the basilica there is a crucial article by R. Krautheimer, 'The Carolingian Revival of Early Christian Architecture', *Art Bulletin*, 24

(1942), 1–38, reprinted in R. Krautheimer, *Studies in Early Christian, Medieval and Renaissance Art* (London and New York, 1971), 203–56. Problems associated with St Riquier are examined by D. Parsons, 'The Pre-Romanesque Church of St Riquier: The Documentary Evidence', *Journal of the British Archaeological Association*, 130 (1977), 21–51, and V. Jansen, 'Round or square? the axial towers of the abbey church of St Riquier', *Gesta*, 21 (1982), 83–90. The exciting discoveries at San Vincenzo al Volturno have been reported in a series of publications by R. Hodges, the most recent being *Light in the Dark Ages, The Rise and Fall of San Vincenzo al Volturno* (London, 1997).

For the historical context of Charlemagne's reign consult R. McKitterick (ed.), *The New Cambridge Medieval History, II, 700–900* (Cambridge, 1996) and D. Bullough, *The Age of Charlemagne* (London, 1965). Einhard's life has been translated by L. Thorpe, *Einhard and Notker the Stammerer, Two Lives of Charlemagne* (Harmondsworth, 1969).

It is difficult for English readers to acquire more than a superficial knowledge of the architecture of the Ottonian and Salian eras. The most useful survey is probably H. E. Kubach, *Romanesque Architecture* (London, 1979, pb. 1988). There is also E. Gall, *Cathedrals and Abbey Churches of the Rhine* (London and New York, 1963). The most influential work on Ottonian architecture is L. Grodecki, *Au seuil de l'art roman: L'architecture ottonienne* (Paris, 1958), and readers of French should also note W. Wulf, *Saxe romane* (La-Pierre-qui-vire, 1996). The development of the twin-towered façade is considered by H. Schaeffer, 'The Origin of the Two-Tower Façade in Romanesque Architecture', *Art Bulletin*, 27 (1945), 85–108, though Schaeffer's conclusions are not universally accepted now.

Amongst the numerous works in German are two huge catalogues: H. E. Kubach and A. Verbeek, *Romanische Kirchen an Rhein und Maas. Katalog der vorromanischen und romanischen Denkmäler*, 4 vols (Neuss, 1971–88), and F. Oswald, L. Schaefer, and H. R. Sennhauser, *Vorromanische Kirchenbauten. Katalog der Denkmäler bis zum Ausgang der Ottonen*, 3 vols (Munich, 1966–90).

Chapter 3: Symbolic Architecture

The starting point for a study of architectural iconography and symbolism is R. Krautheimer, 'Introduction to an "Iconography of Medieval Architecture"', *Journal of the Warburg and Courtauld Institutes*, V (1942), 1–33, reprinted in

R. Krautheimer, *Studies in Early Christian, Medieval and Renaissance Art* (London, 1971). His approach was taken to a much greater extreme by Günther Bandmann, *Mittelalterliche Architektur als Bedeutungsträger* (Berlin, 1951, 10th edn 1994), a work that has had enormous influence in Germany but has never been translated into English. Bandmann's book was reviewed with justifiable scepticism by R. Branner in *Art Bulletin*, 35 (1953), 307–10. For a judicious critique of such approaches see P. Crossley, 'Medieval architecture and meaning: the limits of iconography', *Burlington Magazine*, 130 (1988), 116–21.

Centralized buildings in the Early Christian era are covered extensively in R. Krautheimer, *Early Christian and Byzantine Architecture* (Pelican History of Art, 1965, 4th edn Harmondsworth, 1986). The comprehensive study by A. Grabar, *Martyrium. Recherches sur le culte des reliques et l'art chrétien antique*, 3 vols (Paris, 1946), was conveniently summarized in A. Grabar, 'Christian Architecture East and West', *Archaeology*, II (1949), 95–104. Grabar's ideas about the background of Early Christian martyria were criticized by J. B. Ward-Perkins, 'Memoria, Martyr's Tomb and Martyr's Church', *Journal of Theological Studies*, 17 (1966), 20–38. There is a useful introduction to the architecture of baptisteries in R. Milburn, *Early Christian Art and Architecture* (Aldershot and Berkeley, 1988), and R. Krautheimer has much to say about the same subject in his article 'Introduction to an "Iconography of Medieval Architecture"', cited above. For a detailed account of Santo Stefano Rotondo in Rome see R. Krautheimer, *Corpus Basilicarum Christianarum Romae*, V (Vatican and New York (1977), 1–92; for other centralized churches in Rome consult R. Krautheimer, *Rome: Profile of a City, 312–1308* (Princeton, 1980).

Charlemagne's palace chapel at Aachen is discussed by K. J. Conant, *Carolingian and Romanesque Architecture 800–1200* (Harmondsworth, 1959, 4th edn 1978), which should be read alongside the comments provided by C. Heitz, *L'architecture religieuse carolingienne. Les formes et leurs fonctions* (Paris, 1980). The most extensive account of its origins is by G. Bandmann, 'Die Vorbilder der Aachener Pfalzkapelle' in *Karl der Grosse, Lebenswerk und Nachleben, III, Karolingische Kunst*, ed. W. Braunfels and H. Schnitzler (1966), 424–62. There is a short review of buildings influenced by Aachen in W. E. Kleinbauer, 'Charlemagne's Palace Chapel at Aachen and its Copies', *Gesta*, 4 (1965), 1–11.

The history of the church of the Holy Sepulchre is explained by C. Coüasnon, *The Church of the Holy Sepulchre in Jerusalem* (Oxford, 1974), and its rebuilding in the eleventh century is discussed by R. Ousterhout, 'Rebuilding the temple: Constantine Monomachus and the Holy Sepulchre', *Journal of the Society of Architectural Historians*, 48 (1989), 66–78. The architecture of the Holy Sepulchre and other centralized churches in the Holy Land is briefly discussed by J. Wilkinson, *Egeria's Travels* (London, 1971). The key documentary source has been translated and analysed by D. Meehan (ed.), *Adamnan's De Locis Sanctis* (Dublin, 1958). As well as Krautheimer's article on iconography, the process by which the building was copied elsewhere is examined by R. G. Ousterhout, 'Loca Sancta and the Architectural Response to Pilgrimage' in R. G. Ousterhout (ed.), *The Blessings of Pilgrimage* (Urbana and Chicago, 1990), 108–24. For one remarkable example of Jerusalem's influence in the West see R. G. Ousterhout, 'The Church of Santo Stefano: A "Jerusalem" in Bologna', *Gesta*, 20 (1981), 311–21.

Unfortunately there is no general review of centralized churches in the Romanesque era; many are covered in the Zodiaque series, *La nuit des temps*. The unorthodox church at Neuvy-Saint-Sépulcre, for example, is described by J. Favière and J. de Bascher, *Berry roman* (La-Pierre-qui-vire, 1976).

Chapter 4: Secular Architecture in the Age of Feudalism

Although there is a vast literature on castles, much of it is written from an archaeological or historical perspective, with little consideration of purely architectural issues. Furthermore, most authors take a nationalist viewpoint, which means that as far as the English language is concerned there are dozens of works on English castles, but almost none on those elsewhere in Europe. The only general discussion appears to be W. Anderson, *Castles of Europe* (London, 1970). Despite a rather dated approach, the best introduction to English castles is still R. A. Brown, *English Castles* (London, 3rd edn 1976). The appearance of wooden castles, which before 1200 far outnumbered those in stone, has been examined by R. Higham and P. Barker, *Timber Castles* (London, 1992). A lively though controversial book that investigates the origin of the design of stone castles is M. W. Thompson, *The Rise of the Castle* (Cambridge, 1991). Among the plethora of other works the

most useful are D. F. Renn, *Norman Castles in Britain* (London, 2nd edn 1973), C. P. S. Platt, *The Castle in Medieval England and Wales* (London, 1982), which dwells on the social background of the buildings, and D. J. C. Cathcart King, *The Castle in England and Wales* (London, 1988), which emphasizes defensive and military concerns. For buildings constructed by the Crown the main authority is H. M. Colvin, A. J. Taylor, and R. A. Brown, *A History of the King's Works*, 2 vols (London, 1963). Individual monuments in England are covered by the excellent guides published by the Department of the Environment, for example those written by R. A. Brown on *Dover Castle* (1966), *Rochester Castle* (1969), and *Castle Rising* (1978). The short-lived journal *Fortress* contained valuable and accessible articles, such as that by M. W. Thompson, 'A Suggested Dual Origin for Keeps', *Fortress*, 15 (1992), 2–15.

A stimulating approach to castle design has been taken by T. A. Heslop, who is almost alone in considering questions of visual meaning and symbolic significance: T. A. Heslop, 'Orford castle, nostalgia and sophisticated living', *Architectural History*, 34 (1991), 36–58, and T. A. Heslop, *Norwich Castle Keep, Romanesque Architecture and Social Context* (Norwich, 1994). The design of the hall is examined by M. W. Thompson, *The Medieval Hall, The Basis of Secular Domestic Life 600–1600 AD* (Aldershot, 1995), and individual domestic features are exhaustively studied by M. Wood, *The English Medieval House* (London, 1965). For the Hohenstaufen castle at Gelnhausen see G. Binding, *Pfalz Gelnhausen, ein Bauuntersuchung* (Bonn, 1965), and for German palaces in general there is K. M. Swoboda, *Römische und Romanische Paläste* (Vienna, Cologne, Graz, 3rd edn 1969). French castles are now covered in a comprehensive manner by Jean Mesqui, *Châteaux et Enceintes de la France Médiévale*, 2 vols (Paris 1991–3), a veritable encyclopedia of drawings and photographs. For keeps in western France the key works are by A. Châtelain, *Donjons romans des pays d'Ouest* (Paris, 1973) and *L'évolution des châteaux forts dans la France au moyen âge* (Strasbourg, 1988). The latest research at Langeais and Loches is summarized in E. Impey, E. Lorans, and J. Mesqui, *Deux Donjons Construits autour de l'an mil en Touraine, Langeais et Loches* (Paris, Société Française d'Archéologie, 1998), which represents the first fascicule of *Bulletin Monumental*, 156 (1998). There are many works on Crusader castles, but the most recent and accessible summary is that by H. Kennedy, *Crusader Castles* (Cambridge, 1994). Also worth reading is D. Pringle, 'Crusader Castles: The First Generation', *Fortress*, 1 (1989), 14–25. Finally, it is important to note the volumes of the journal *Château Gaillard*, which publishes the research papers read at the biennial conference of castle studies.

Chapter 5: Patron and Builder

References to patrons and builders are scattered throughout the Latin sources: useful anthologies in translation are available in C. Davis-Weyer (ed.), *Early Medieval Art 300–1150* (Sources and Documents in the History of Art Series, Englewood Cliffs, 1971), J. Harvey, *The Medieval Architect* (London, 1972), and L. F. Salzman, *Building in England down to 1540* (Oxford, 1967, 2nd edn). One of the most valuable collections, V. Mortet, *Recueil de Textes relatifs à l'histoire de l'architecture et à la condition des architectes en France au moyen âge XIe-XIIe siècles* (Paris, 1911), has never been translated. There is a brief but stimulating essay on the status of medieval artists, including architects and master masons, by Enrico Castelnuovo, 'The Artist' in Jacques Le Goff (ed.), *The Medieval World*, (London, 1990), 211–42, and for the Early Christian era there is G. Downey, 'Byzantine Architects, Their Training and Methods', *Byzantion*, 18 (1948), 99–148. The meaning of the word 'architect' is ambiguous and to understand medieval usage the indispensible study is N. Pevsner, 'The Term "Architect" in the Middle Ages', *Speculum*, 17, No. 4 (1942), 549–62. For other contributions on the role of masons and builders see the articles in Xavier Barral I Altet (ed.), *Artistes, artisans et production artistique au moyen-age, Actes du Colloque de Rennes* (Paris, 1987). The importance of Desiderius is explained at length in H. Bloch, *Monte Cassino in the Middle Ages*, vol. I (Cambridge, Mass., 1981).

Much-neglected issues associated with quarrying stone are covered by J. B. Ward-Perkins, 'Quarrying in Antiquity: Technology, Tradition and Social Change', *Proceedings of the British Academy* (Oxford, 1972) and D. Parsons (ed.), *Stone: Quarrying and Building in England AD 43–1525* (Chichester, 1990). The implications of quarries for the transmission of style are considered by R. Gem, 'Canterbury and the Cushion Capital' in N. Stratford (ed.), *Romanesque and Gothic, Essays for George Zarnecki*, (Woodbridge, 1987), 83–101. For the introduction of ashlar masonry in the eleventh century see E. Vergnolle, 'La pierre de taille

dans l'architecture religieuse de la première moitié du XIe siècle', *Bulletin Monumental*, 154 (1996) 229–34. The progress towards standardization is considered by J. Bony, 'The Stonework Planning of the First Durham Master', in E. Fernie and P. Crossley (eds), *Medieval Architecture and Its Intellectual Context, Studies in Honour of Peter Kidson* (London and Ronceverte, 1990), 19–34. The best recent discussion of masons' marks is by J. S. Alexander, 'Masons' Marks and Stone Bonding', in T. Tatton-Brown and J. Munby (eds), *The Archaeology of Cathedrals* (Oxford Committee for Archaeology, Monograph no. 42, 1996), 219–36.

Apart from studies of the St Gall Plan, there has been little discussion of the use of drawings in the late Antique and Early Christian period; there is a useful survey by W. E. Kleinbauer, 'Pre-Carolingian Concepts of Architectural Planning' in *The Medieval Mediterranean: Cross-Cultural Contacts*, eds M. J. Chiat and K. L. Reyerson (Minnesota, 1988), 67–79. A useful starting point for exploring the issues associated with the use of proportional ratios is the entry 'Architectural Proportion', written by Peter Kidson in the *Macmillan Dictionary of Art*. Eric Fernie has published a number of important articles illustrating how the ratio of 1:√2 was applied; see for example E. Fernie, 'The Ground Plan of Norwich Cathedral and the Square Root of Two', *Journal of the British Archaeological Association*, 129 (1976), 77–86. For geometrical investigations of twelfth-century castles see T. A. Heslop, 'Orford castle, nostalgia and sophisticated living', *Architectural History*, 34 (1991), 36–58. An extensive investigation into the proportional systems found in Cistercian abbeys was carried out by Hanno Hahn, the results of which are briefly summarized in R. A. Stalley, *The Cistercian Monasteries of Ireland* (London and New Haven, 1987).

Chapter 6: Art and Engineering

The structural issues which confronted early medieval masons have rarely been discussed at length, though they are mentioned in most of the general books on early medieval architecture. For a practical introduction to the problems see R. J. Mainstone, *Developments in Structural Form* (London, 1975) and J. E. Gordon, *Structures or Why Buildings Don't Fall Down* (Harmondsworth, 1978). For more technical assessments there is J. Heyman, *The Stone Skeleton* (Cambridge, 1995). The structure of Anglo-Saxon stone towers has been analysed by W. Rodwell, 'Anglo-Saxon

church building: aspects of design and construction', in L. A. S. Butler and R. K. Morris (eds), *The Anglo-Saxon Church, Papers on history, architecture and archaeology in honour of Dr H. M. Taylor* (London, 1986), 156–75. Richard Gem has much to say about the early development of the spire in R. Gem, 'Staged timber spires in Carolingian north-east France and late Anglo-Saxon England, *Journal of the British Archaeological Association*, 148 (1995), 29–54. For a more general account of Anglo-Saxon towers there is E. A. Fisher, *Anglo-Saxon Towers: an architectural and historical study* (Newton Abbot, 1969). French towers are surveyed in D. Jalabert, *Clochers de France* (Paris, 1968) and the domed crossing towers of Spain are analysed by C. K. Hersey, *The Salamantine lanterns: their origins and development* (Cambridge, Mass., 1937).

There is a huge literature on the mechanics of stone vaulting, particularly on ribbed vaulting, but not much specifically on the early Middle Ages. General books which give some emphasis to the issues include Raymond Oursel, *Invention de l'architecture Romane* (La-Pierre-qui-vire, 1970). The *Macmillan Dictionary of Art* has a useful essay entitled 'Vault' and see also K. J. Conant, 'Observations on the Vaulting Problems of the Period 1088–1211', *Gazette des Beaux Arts*, 26 (1944), 127–34. On the more technical aspects, there is still nothing to supersede the study first published by Robert Willis in 1842, 'On the construction of vaults in the Middle Ages', reprinted as an appendix in R. Willis, *Architectural History of Some English Cathedrals*, vol. II (Chicheley, 1973). Viollet-le-Duc's rationalist approach is discussed by J. Summerson, 'Viollet-le-Duc and the Rational Point of View' in *Heavenly Mansions and other Essays on Architecture* (London, 1948), 135–58, and in M. F. Hearn, *The Architectural Theory of Viollet-le-Duc. Readings and Commentary* (Cambridge, Mass., 1990). There is no English alternative to the critique of Viollet's ideas provided by Pol Abraham, *Viollet-le-Duc et le rationalisme médiéval* (Paris, 1934). For a brief summary of recent opinions see Malcolm Thurlby, 'The Purpose of the Rib in the Romanesque Vaults of Durham Cathedral', in *Engineering a Cathedral*, ed. M. J. Jackson (London, 1993), 64–76, and M. Thurlby, 'Observations on Romanesque and Gothic Vault Construction', *Arris*, 6 (1995), 22–9. For the aesthetic reaction to different types of vault see L. Hoey, 'A Problem in Romanesque Aesthetics: The Articulation of Groin and Early Rib Vaults in the Larger Churches of

England and Normandy', *Gesta,* 35 (1996), 156–76. For the ribbed vaults at Durham the basic study is J. Bilson, 'Durham Cathedral and the Chronology of its Vaults', *Archaeological Journal*, 79 (1922), 101–60, the conclusions of which were modified by J. Bony, 'Le projet premier de Durham', in *Urbanisme et Architecture: études en l'honneur de Pierre Lavedan* (Paris, 1954), 41–9. The techniques of Lombard vaulting are described by A. K. Porter, *Lombard Architecture*, 4 vols (London and New Haven, 1915–17, reprinted New York, 1967), though readers should note that Porter's chronology has long been rejected. A recent view about how Lombard techniques spread to the north is offered by P. Kidson, 'The Mariakerk at Utrecht, Speyer, and Italy', in *Utrecht: Britain and the Continent, Archaeology, Art and Architecture*, ed. E.de Bièvre, British Archaeological Association Conference Transactions, 18 (London, 1996), 123–36. There is an excellent summary of recent thinking on vaulted Catalan churches by M. Durliat, 'La Catalogne et le premier art roman', *Bulletin Monumental*, 147 (1989), 209–38. For hall churches there is now the survey by H. E. Kubach and I. Köhler-Schommer, *Romanische Hallenkirchen in Europa* (Mainz, 1997).

Chapter 7: Architecture and Pilgrimage

There are a number of important works which are essential for understanding the phenomenon of pilgrimage, in particular: P. Brown, *The Cult of the Saints. Its Rise and Function in Latin Christianity* (London and Chicago, 1981); P. J. Geary, *Furta Sacra. Thefts of Relics in the Central Middle Ages* (Princeton, 1978); C. and R. Brooke, *Popular Religion in the Middle Ages* (London, 1984); and J. Sumption, *Pilgrimage, an Image of Medieval Religion* (London, 1975). The exploitation of pilgrimage by church builders is analysed by C. Rudolph, *The 'Things of Greater Importance'. Bernard of Clairvaux's Apologia and the medieval attitude towards art* (London, 1990). For travels to Jerusalem see J. Wilkinson, *Egeria's Travels* (London, 1971) and J. Wilkinson, *Jerusalem Pilgrims before the Crusades* (Jerusalem, 1977).

The precise location of shrines is often far from clear. There is a useful survey by W. Jacobsen, 'Saints' Tombs in Frankish Church Architecture', *Speculum,* 72 (1997), 1107–43. For an illustration of the issues in a Romanesque context see J. Crook, 'The Architectural Setting of the Cult of St Cuthbert in Durham Cathedral (1093–1200)' in D. Rollason, M. Harvey, M. Prestwich (eds), *Anglo-Norman Durham* (Woodchester, 1994), 235–50. The

nature of the shrine at St Peter's in Rome is explained by J. C. Toynbee and J. B. Ward-Perkins, *The Shrine of St Peter* (London, 1956).

Although there are plenty of specialist studies, there are no general surveys of crypt design, apart from the entry 'Crypt' by Stephen Heywood in the *Macmillan Dictionary of Art*. For early crypts in Italy see M. Magni, 'Cryptes du haut moyen age en Italie: problèmes de typologie du IXe jusqu'au début du XIe siècle', *Cahiers Archéologiques*, 28 (1979), 41–85, and for northern Europe, W. Sanderson, 'Monastic Reform in Lorraine and the Architecture of the Outer Crypt, 950–1100', *Transactions of the American Philosophical Society*, n.s. LXI/6 (1971), 3–36. The design of the crypt at Canterbury Cathedral is discussed by E. Fernie, 'St Anselm's crypt', in *Medieval Art and Architecture at Canterbury before 1220, British Archaeological Association Conference Transactions for the year 1979*, eds N. Coldstream and P. Draper (London, 1982), 27–38. Fernie has also considered the significance of columns decorated with spirals, E. Fernie, 'The Spiral Piers of Durham Cathedral', in *Medieval Art and Architecture at Durham Cathedral, British Archaeological Association Conference Transactions for the year 1977*, eds N. Coldstream and P. Draper (London, 1980), 49–58.

There is a huge literature on the pilgrimage to Santiago de Compostela and its effects on sculpture and architecture. The crucial document has been translated by W. Melczer, *The Pilgrim's Guide to Santiago de Compostela* (New York, 1993), and by A. Shaver-Crandell, P. Gerson, and A. Stones, *The pilgrim's guide to Santiago de Compostela: a Gazetteer* (London, 1992). There is a brief account of the architecture of Santiago in P. de Palol, *Early Medieval Art in Spain* (London, 1967), but the main authority remains K. J. Conant, *The Early Architectural History of Santiago* (Cambridge, Mass., 1926). The chief authority on St Sernin, Toulouse is Marcel Durliat, who provides a useful summary of the building in M. Durliat, *Haut-Languedoc roman* (La-Pierre-qui-vire, 1978). Apart from C. A. Willemsen and D. Odenthal, *Apulia, Imperial splendour in Southern Italy* (London, 1959), there are no accounts in English of the pilgrimage churches of Apulia. The most recent survey is P. Belli D'Elia, *Pouilles Romanes* (La-Pierre-qui-vire, 1987). For related issues, however, see the valuable article by A. Wharton Epstein, 'The Date and Significance of the Cathedral of Canosa in Apulia, South Italy', *Dumbarton Oaks Papers*, 37 (1983), 79–90.

Chapter 8: Architecture and Monasticism

The volume by W. Braunfels, *Monasteries of Western Europe: the architecture of the orders* (London, 1972) makes an excellent introduction to monastic architecture. For the historical background see R. W. Southern, *Western Society and the Church in the Middle Ages* (Harmondsworth, 1970). The relationships between art and monasticism are also discussed by C. Brooke, *The Monastic World 1000–1300* (London, 1974) and G. Zarnecki, *The Monastic Achievement* (London, 1972). For England the standard history of monasticism is D. Knowles, *The Monastic Order in England* (Cambridge, 1950). An official publication by R. Gilyard-Beer, *Abbeys, An Introduction to the Religious Houses of England and Wales* (London, HMSO, 1959) is still hard to beat, but for a recent, more archaeological survey of the English monasteries there is G. Coppack, *Abbeys and Priories* (London, English Heritage, 1990).

A straightforward introduction to French monasteries is supplied by W. Stoddard, *Monastery and Cathedral in Medieval France* (Wesleyan, 1966, reissued as *Art and Architecture in Medieval France*, 1972). There are not many general works devoted specifically to the architecture of the Benedictine and Cluniac orders, but for the latter there is the now rather dated work by J. Evans, *Romanesque Architecture of the Order of Cluny* (Cambridge, 1938). For Cluny itself the standard authority is K. J. Conant, *Cluny. Les églises et la maison du chef d'ordre* (Mâcon, 1968). Conant's views, which are summarized in his Pelican History of Art volume, *Carolingian and Romanesque Architecture 800–1200* (Harmondsworth, 1959, 4th edn 1978) are not however the last word: F. Salet, 'Cluny III', *Bulletin Monumental*, 126 (1968), 235–92.

In recent decades the architecture of the Cistercian order has given rise to a vast literature, much of it in French and German. For the English houses there is P. Fergusson, *Architecture of Solitude, Cistercian abbeys in twelfth-century England* (Princeton, 1984) and C. Norton and D. Park (eds), *Cistercian Art and Architecture in the British Isles* (Cambridge, 1986). See also R. A. Stalley, *The Cistercian Monasteries of Ireland* (London and New Haven, 1987). For the French houses the standard work is M. Aubert, *L'Architecture Cistercienne en France* (Paris, 1947, 2nd edn). A good pictorial survey across Europe is offered by M. A. Dimier, *L'Art cistercien*, 2 vols (La-Pierre-qui-vire, 1971, 1982). There are many interesting insights contained in G. Duby, *St Bernard—L'Art Cistercien* (Paris, 1976), but for

the best analysis of the Cistercian attitude to art and architecture see C. Rudolph, *The 'Things of Greater Importance'. Bernard of Clairvaux's Apologia and the medieval attitude towards art* (London, 1990). The text of the *Apologia* is also discussed in *Cistercians and Cluniacs, St Bernard's Apologia to Abbot William*, translated by Michael Casey (Kalamazoo, 1970). The excessive claims made for St Bernard's role in the development of Cistercian architecture are considered in R. A. Stalley, 'St Bernard, His Views on Architecture and the Irish Dimension', *Arte medievale* (II serie, Anno VIII, no. 1, vol. 2, 1995), 13–20.

There is no decent survey of the development of the cloister. For the early history see (in addition to Braunfels) A. Frazer, 'Modes of European Courtyard Design Before the Medieval Cloister', *Gesta*, 22 (1972), 1–12, and W. Horn, 'On the Origins of the Medieval Cloister', *Gesta*, 22 (1972), 13–52. The most extensive study of the St Gall plan is by W. Horn and E. Born, *The Plan of Saint Gall. A Study of the Architecture and Economy of, and Life in, a Paradigmatic Carolingian Monastery*, 3 vols. (Berkeley, 1979), though many of its conclusions have since been undermined. The plan is not based on a modular system, as Horn believed, see E. Fernie, 'The proportions of the St Gall plan', *Art Bulletin*, 60 (1978), 583–9; nor was it a paradigm for the Carolingian world as a whole, L. Nees, 'The Plan of St Gall and the Theory of the Program of Carolingian Art', *Gesta*, 25 (1986), 1–8. Moreover, the plan is now known to be an original drawing of *c.*830 and not a copy, as explained by W. Jacobsen, *Der Klosterplan von St. Gallen und die Karolingische Architektur: Entwicklung und Wandel von Form und Bedeutung im fränkischen Kirchenbau zwischen 751 und 840* (Berlin, 1992).

Chapter 9: The Language of Architecture

Current definitions of Romanesque as an architectural style owe a great deal to Henri Focillon; for an introduction to his thinking see H. Focillon, *Art of the West, Part One, Romanesque* (London, 1963), a book first published in Paris in 1938. A more contemporary view of the emergence of the Romanesque style is provided by E. Vergnolle, *L'Art Roman en France* (Paris, 1994). For an understanding of medieval appreciation of Romanesque the classic study is M. Schapiro, 'On the Aesthetic Attitude in Romanesque Art', in M. Schapiro, *Romanesque Art* (London, 1977), 1–27. An excellent introduction to medieval aesthetics is provided by Umberto Eco, *Art and Beauty in the Middle*

Ages (London and New Haven, 1986). The concept of 'first Romanesque' was established by J. Puig y Cadafalch, whose most accessible study is *La géographie et les origines du premier art roman* (Paris, 1935). For specific features, important recent works include: E. Armi, 'Orders and Continuous Orders in Romanesque Architecture', *Journal of the Society of Architectural Historians*, 34 (1975), 173–88; P. Héliot, 'L'ordre colossal et les arcades murales dans les églises romanes', *Bulletin Monumental*, 115 (1957), 241–61; and L. Hoey, 'Pier Form and Vertical Wall Articulation in English Romanesque Architecture', *Journal of the Society of Architectural Historians*, 48 (1989), 258–83. The fundamental work on clerestory passages is J. Bony, 'La technique normande du mur épais à l'époque romane', *Bulletin Monumental*, 98 (1939), 153–88, but see also L. Hoey, 'The Design of Romanesque Clerestories with Wall Passages in Normandy and England', *Gesta*, 28 (1989), 78–101. For alternation and pier design there are no major works in English, but it is worth noting the relevant entries in the *Macmillan Dictionary of Art*.

Chapter 10: Diversity in the Romanesque Era

While a huge effort has been expended on the description and definition of regional 'schools', there has been relatively little analysis of the nature of that diversity and the reasons behind it. The concept of regional groups, which was established for France by Robert de Lasteyrie, *L'Architecture religieuse en France à l'époque romane* (Paris, 1911, revised by M. Aubert, 1929), was extended to the whole of Europe by A. W. Clapham, *Romanesque Architecture in Western Europe* (Oxford, 1936, 3rd edn 1967). The approach was further refined by K. J. Conant, *Carolingian and Romanesque Architecture 800–1200* (Harmondsworth, 1959, 4th edn 1978). The regional approach underlies the series entitled *La Nuit des Temps*, published by Zodiaque (La-Pierre-qui-vire) since 1954. At first devoted to France, this well-illustrated series now extends to most countries of Europe; many of the volumes have English summaries. A pictorial survey of the French regions is offered by M. Aubert, *Romanesque cathedrals and abbeys of France* (London and New York, 1966). For the political conditions that fostered regionalism, useful starting points are R. W. Southern, *The Making of the Middle Ages* (London, 1953), R. Bartlett, *The Making of Europe* (Harmondsworth, 1993), E. M. Hallam, *Capetian France 987–1328* (London, 1980), and R. H. C. Davies, *The Normans and their Myth* (London, 1976).

For the so-called 'impact theory' it is worth looking at the example of Durham Cathedral, E. C. Fernie, 'The architectural influence of Durham cathedral', in D. Rollason, M. Harvey, M. Prestwich (eds), *Anglo-Norman Durham* (Woodbridge, 1994), 269–79. In the context of Cluny III, the validity of the 'impact theory' has been challenged by E. Armi, *Masons and Sculptors in Romanesque Burgundy* (Pittsburgh, 1983).

Epilogue: The Shadow of Rome

There is no recent assessment of the relationships between the architecture of ancient Rome and that of the early Middle Ages, though it is a subject that is mentioned frequently in the general literature. For an idea of what the city of Rome looked like in the Middle Ages the best guide is R. Krautheimer, *Rome: Profile of a City, 312–1308* (Princeton, 1980). The city's impact in the twelfth century is considered by J. B. Ross, 'A Study of Twelfth-Century Interest in Antiquities of Rome', in J. L. Cate and E. N. Anderson (eds), *Medieval and Historiographical Essays in Honor of James Westfall Thompson* (Chicago, 1938), 302–21. A fascinating guide to the way Roman materials were exploited can be found in M. Greenhalgh, *The Survival of Roman Antiquities in the Middle Ages* (London, 1989). On the same subject see J. C. Higgitt, 'The Roman Background to Medieval England', *Journal of the British Archaeological Association*, 3rd series, XXXVI (1973), 1–15. The reuse of Roman materials is examined in a valuable collection of essays in J. Poeschke (ed), *Antike Spolien in der Architektur des Mittelalters und der Renaissance* (Munich, 1996). More wide-ranging is J. Adhémar, *Influences antiques dans l'art du moyen âge français* (London, 1939). There has been much speculation about the influence of Vitruvius, as for example in J. Harvey, *The Medieval Architect* (London, 1972), 19–22. The treatise itself is most easily accessible in *Vitruvius, The Ten Books on Architecture*, trans. M. H. Morgan (New York, 1960). More general points about the revival of Antiquity are raised by E. Panofsky, *Renaissance and Renascences in Western Art* (London, 1970), and there is a useful introduction to wider historical issues in C. Brooke, *The Twelfth-century Renaissance* (London, 1969).

	Historical event	Religious event	Architecture
303	c.303–4 Persecution of Christians under Emperor Diocletian		
	312 Constantine defeats Maxentius at battle of Milvian Bridge and takes control of the Roman Empire		
		313 Edict of Milan: Christianity tolerated as an official religion	c.313–15 Arch of Constantine constructed in Rome
			c.321–2 Foundation of St Peter's in Rome
	330 Constantinople named as capital of the Roman Empire		c.330 Foundation of basilica close to the site of Calvary in Jerusalem
			c.350 Construction of Santa Costanza in Rome
	361–3 Reign of Julian the Apostate; brief restoration of paganism		
		374 Ambrose appointed bishop of Milan (374–97)	
	379 Accession of Emperor Theodosius (379–95) who subsequently bans pagan worship		
			c.380 Completion of the church of the Holy Sepulchre (Anastasis Rotunda) in Jerusalem
			c.382 Work commences on San Paolo fuori le mura in Rome
	395 Roman Empire permanently divided between East and West on death of Theodosius		
	402 Capital of western empire moved from Milan to Ravenna		
	410 Sack of Rome by the Visigoths led by Alaric		
	410 Roman legions withdrawn from Britain		
			422–32 Building of Santa Sabina in Rome
			424 Construction of Mausoleum of Galla Placidia, Ravenna
	455 Rome sacked by Vandals under Genseric		
			c.470 Construction of large church at Tours in honour of St Martin
476	476 Romulus Augustulus, last Roman emperor in the West, deposed		

	Historical event	**Religious event**	**Architecture**
400	488 Ostrogoths under Theodoric (490–526) conquer northern Italy		
			*c.*493–526 Construction of Sant'Apollinare Nuovo, Ravenna
		496 Baptism of Clovis, king of the Franks (481–511)	
			*c.*526 Construction of Mausoleum of Theodoric, Ravenna
	527 Justinian, emperor in Constantinople (527–65), begins first of campaigns to recover western parts of the old empire		
		*c.*529 Foundation of Montecassino. Establishment of the Benedictine order by Benedict of Nursia (c.480–540)	
			532–7 Construction of Hagia Sophia in Constantinople under the emperor Justinian
	540 Byzantine army defeats Ostrogoths and conquers northern Italy		
			547 Dedication of San Vitale, Ravenna
			549 Dedication of Sant'Apollinare in Classe, Ravenna
		563 Columba founds monastery at Iona	
	568 Byzantines driven from northern Italy by Longobards, who subsequently establish their capital at Pavia		
	585 Spain conquered by the Visigoths		
		590 Gregory I (590–604) becomes pope ('Gregory the Great')	*c.*590 Construction of ring crypt at St Peter's in Rome
		597 Gregory I sends Christian mission to Anglo-Saxon England, led by Augustine	
		616 Death of Aethelbert, first Christian king of Kent	
634		634 Foundation of monastery at Lindisfarne; Christianity established in Northumbria	

	Historical event	Religious event	Architecture
638	638 Moslem armies capture Jerusalem		
			661 Foundation of San Juan de Baños by King Recceswinth
			669 Church at Reculver (Kent) built by priest called Bass
			674 Consecration of church at Monkwearmouth
	711 Moslem Arabs invade Spain and conquer Visigothic kingdom		
	732 Moslem advance into France defeated at Poitiers by Charles Martel		
		754 Boniface (c.675–754), apostle of Germany, martyred in Frisia, later buried at Fulda	
			c.755 Abbot Fulrad starts work on new basilica at St Denis
	768 Charlemagne becomes king of the Franks (768–814)		
	774 Charlemagne conquers Lombardy		
	793 Viking attack on monastery at Lindisfarne: start of Viking raids on Britain		c.790 Start of new church at Fulda in honour of St Boniface
			c.792 Start of Charlemagne's palace chapel at Aachen, consecrated 805
			c.799 Construction of church at St Riquier (Centula) under Abbot Angilbert
	800 Charlemagne crowned Holy Roman Emperor in Rome by Pope Leo III		
		813 Discovery of relics of the apostle James at Compostela	
			827 Consecration of Einhard's church at Steinbach
			c.830 Preparation of the plan of St Gall
	842 Accession of Ramiro I, king of Asturias (842–50)		842–50 Construction of royal hall at Naranco near Oviedo
843	843 Treaty of Verdun: Carolingian Empire divided into three parts: East Francia, West Francia, and Lotharingia		

	Historical event	Religious event	Architecture
859			859 Consecration of the crypt at St Germain, Auxerre by emperor Charles the Bald
			873–85 Construction of westwork at Corvey
	c.900 Beginning of Christian reconquest of Spain by Alfonso III of Castille		
		909 Foundation of the abbey of Cluny	
	911 Duchy of Normandy established under the control of Rollo the Norseman		
			913 Consecration of San Miguel de Escalada
	936 Otto I, duke of Saxony becomes king of Germany (936–73)		
	955 Otto I defeats Magyars at the battle of the Lech		
			961 Foundation of nunnery at Gernrode by margrave Gero
	962 Otto I crowned Holy Roman Emperor in Rome by Pope John XII		
			c.971–80 Construction of a westblock at Winchester
			976 Demolition of westwork at Rheims
			c.994 Construction of 'keep' at Langeais by Fulk Nerra, duke of Anjou
	996 Otto III (996–1002) crowned Holy Roman Emperor by Pope Sylvester II		
			1001–18 Rotunda constructed at St Bénigne, Dijon, under Abbot William of Volpiano
			1009 Church of Holy Sepulchre (Anastasis Rotunda) in Jerusalem destroyed by Caliph Al Hakim
			1010–33 St Michael's, Hildesheim constructed under direction of Bishop Bernward
			1012–35 Construction of keep at Loches by Fulk Nerra, duke of Anjou
			c.1025 Crypt constructed at Auxerre Cathedral
1026			c.1026 Tower at St-Benoît-sur-Loire built by Abbot Gauzlin

	Historical event	Religious event	Architecture
1035			*c.*1035 Construction of San Pedro de Roda
			*c.*1030 Start of work on cathedral at Speyer
			*c.*1040 Construction of church of St Vincent at Cardona
			*c.*1040 Stone cloister with marble columns built at Cluny under Abbot Odilo
			1040–67 Building of abbey church at Jumièges
			1048 Church of Holy Sepulchre in Jerusalem rebuilt under direction of Byzantine emperor Constantine Monomachus
		1058 Desiderius becomes abbot of Montecassino (1058–70)	
			*c.*1061 Foundation of monastery of St Etienne, Caen, by William, duke of Normandy
			*c.*1063 Start of work on St Mark's, Venice
	1066 King Harold of England defeated by William, duke of Normandy at the battle of Hastings		1066–71 New church erected at Montecassino under Abbot Desiderius
			1070–7 Canterbury Cathedral rebuilt under Archbishop Lanfranc
	1071 Capture of Bari by Robert Guiscard; Normans establish control over southern Italy		
		1073 Accession of Pope Gregory VII (1073–85): reform of the Church	
	1075 Pope Gregory VII (Hildebrand) denounces lay investiture; start of Investiture Contest (1075–1122) between pope and German emperors		*c.*1075 Construction of San Nazaro, Milan
			*c.*1078 Tower of London started under direction of Gundulf, bishop of Rochester
			1078–1122 Construction of cathedral church of Santiago de Compostela
1079			1079 Start of new cathedral church at Winchester under Bishop Walkelin

Timeline

	Historical event	Religious event	Architecture
1081			1081–1106 Remodelling of Speyer Cathedral with groin vaults
			*c.*1082 Start of St Sernin, Toulouse
	1085 Battle of Toledo. King Alfonso VI of Léon and Castile defeats Moslems		
		1087 Relics of San Nicola of Myra 'stolen' and taken to Bari	1087 Foundation of San Nicola at Bari
			1088 Foundation of new abbey church at Cluny (Cluny III)
			1093–1133 Construction of Durham Cathedral
	1095 Urban II preaches the first Crusade		
		1098 Foundation of monastery at Cîteaux: birth of Cistercian order	
	1099 Capture of Jerusalem by Crusaders		1099 Completion of Westminster Hall
			1099 Foundation of Modena Cathedral
			1099 Foundation of new cathedral at Trani
		1115 Foundation of Clairvaux with Bernard as abbot (1115–53)	
			1120–32 Reconstruction of nave of Vézelay after fire
			*c.*1120 Start of domed church of St Front at Périgueux
	1122 Concordat of Worms terminates Investiture Contest		
			1130 Consecration of abbey church at Cluny (Cluny III)
			*c.*1130 Start of new church at Cîteaux
			*c.*1135–45 New church constructed at Clairvaux
			*c.*1138 Construction of keep at Castle Rising by William d'Albini
			1139–47 Building of abbey church at Fontenay
1140			*c.*1140 Construction of keep at Castle Hedingham by William de Vere, Earl of Oxford

	Historical event	Religious event	Architecture
1140			*c.*1140 Construction of keep at Ambleny
			1140–4 Reconstruction of the choir of St Denis in a Gothic style
			1149 Church of Holy Sepulchre at Jerusalem consecrated after addition of new choir
			1153 Start of construction of Baptistery at Pisa under architect Diotisalvi
			*c.*1150–75 Construction of south-west tower and spire at Chartres
	1152 Frederick I (1152–90) 'Barbarossa' crowned as Holy Roman Emperor		
	1154 Henry of Anjou becomes king of England (1154–89)		
			*c.*1160 Start of Gothic cathedral at Laon
		1170 Murder of Thomas Becket at Canterbury	
			1173 Start of construction of campanile at Pisa under Bonnanus of Pisa
			1174 Fire destroys Romanesque choir at Canterbury Cathedral
	1180 Philip II (1180–1223) 'Augustus' becomes king of France		*c.*1180 Construction of keep at Conisborough
			*c.*1181 Start of work on keep at Dover
			1186 Collapse of vaults at Lincoln Cathedral
	1187 Saladin defeats Crusaders and captures Jerusalem		
1204	1189 Richard I (1189–99) 'Lionheart' becomes king of England		
			1194 Fire destroys Romanesque cathedral at Chartres
			1196–8 Construction of Château Gaillard by Richard I
	1204 Philip II defeats English forces and conquers Normandy		

Index